DETROIT: 138 SQUARE MILES

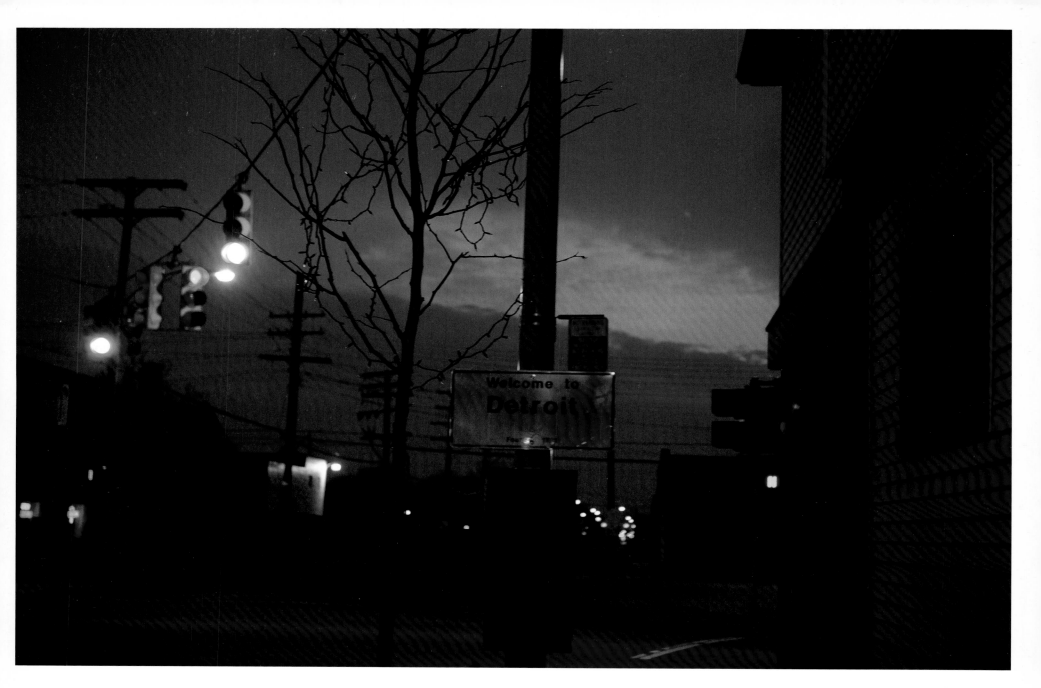

DETROIT: 138 SQUARE MILES Julia Reyes Taubman

FOREWORD BY ELMORE LEONARD

Rust in Peace

JRT

MO
CAD Museum of Contemporary Art, Detroit

D.A.P./Distributed Art Publishers

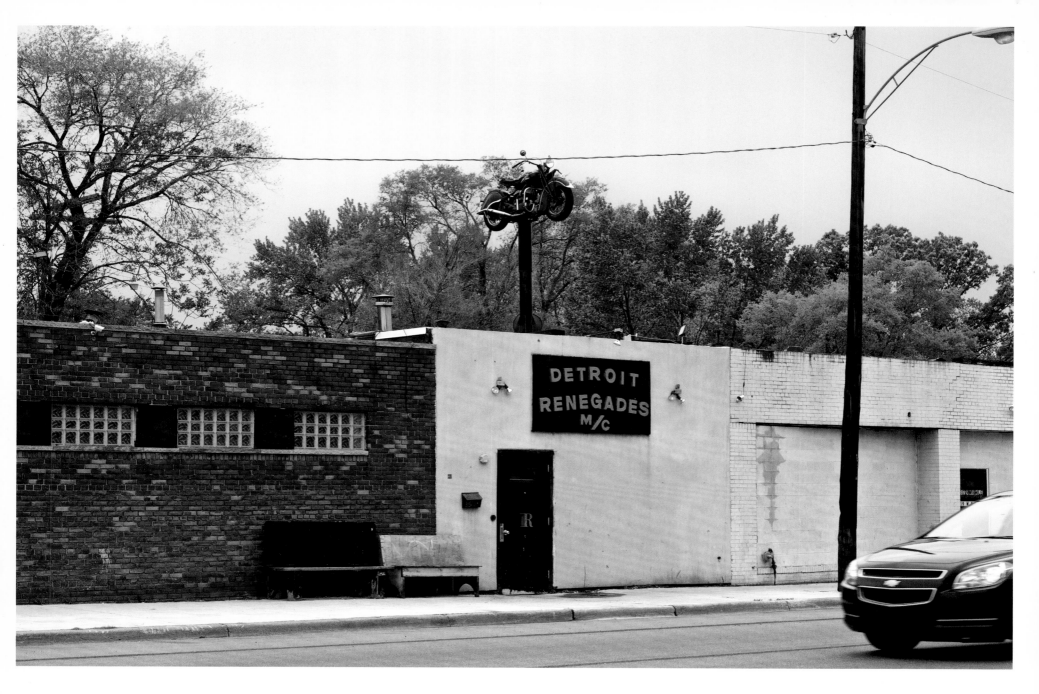

The way it used to work in crime movies: the boss wants a rival taken out and tells one of his guys to "Call Detroit," the place to get a shooter. The reference quite likely influenced by Detroit's Purple Gang, notorious gunmen looking for work once Prohibition was repealed.

What Detroit became, cars now rolling off assembly lines, was a rowdy, workingman's shot and a beer town. It offered few cultural pretentions besides some of its architecture and the Detroit Institute of Arts. During the war, Detroit was known as "The arsenal of Democracy," turning out bombers and tanks, all types of combat material. By the war's end, Detroit was a city of nearly two million people hopping streetcars to shop downtown—no malls in sight yet—while auto plants were working three shifts a day to supply the entire country with new cars.

It lasted until foreign models began to creep ashore.

Our car industry ignored them, holding to the belief Americans preferred big American automobiles, not those toy Japanese models. What do you do, wind them up? Executives who worked in the GM building spoke the name General Motors with reverential tone, my father one of them.

By this time 700,000 working people had left town for ranch homes in the suburbs, ones they could afford, and Detroit, its population down by half, was no longer "The Car Capital of the World."

Ten years ago Julia Reyes Taubman came out of the East, New York and Washington DC, not enthralled with the prospect of living here; and yet the lack of order and expectation seemed, well, interesting, maybe somewhat exciting. It was like living on the edge of a changing civilization with an undefined future. At first it was the ruins of industry that caught her eye: the old Packard plant where ceilings resembled stalactites, the roof a forest of green. Julia began photographing the city as a hobby. It would soon become her vocation, her passion.

She focuses on scenes that offer little or no hope, buildings that appear war-damaged, bombed out, but with a positive feeling of history about them. We view the Michigan Central station, its architecture striking but gone to hell and we wonder if it can be restored. Or is it too late?

There are aerials of empty blocks in the middle of the city gone to overgrown fields; the cemetery still there, no one going anywhere.

How did the Boblo boat get so old? It doesn't seem that long ago we were dancing to live music on a Boblo cruise down the Detroit River. But it was 65 years ago when we had our girlfriends on the dance floor doing the delfoy. Was it Nancy that evening?

Belle Isle still looks pretty good, though no canoes in the lagoons now or horses on the riding trails. We played Detroit Federation baseball on a diamond with a grass infield in 1939. My family came to Detroit five years before that and I've lived here three-quarters of a century with no intention of leaving—even though I was born in New Orleans and the Big Easy is still the Big Easy, despite Katrina. The reason I'm still here must lie in Julia's pictures. I've watched the city deteriorate. I know the factories, the neighborhoods, but Julia's work shows more than what I remember. Maybe that old machinery isn't as ugly as I thought.

Some neighborhoods where she shot, Julia had to have police protection. See if you can pick them out.

I told her she should write a tag line for each shot. It doesn't have to be descriptive, you had fun doing this, say what you want. Like, "Could you imagine taking a shower in here?" But you'll do better than that.

She's thorough, she covers what she's shooting until she gets what she wants you to feel.

In Julia's composition there is beauty in despair, and sometimes a glimmer of hope. We see life and death in Detroit, nothing Chamber of Commerce inspired, but more real than any other reality show. If what happened in Detroit is a crime, Julia's book is the crime story.

~~And Julia believes it should be preserved and appreciated any way it is, not restored.~~

LIVING WITH DETROIT[1]

Jerry Herron

It's all gone according to plan. The city made people rich, generations of them, just as it was supposed to do; it provided them with sufficient skills and self confidence so they felt ready—entitled even—to strike out on their own. "I will build a motor car for the great multitude," Henry Ford boasted in 1907, although the Model T was as yet only a concept, which would not go into production until the following year:

> It will be large enough for the family, but small enough for the individual to run and care for. It will be constructed of the best materials, by the best men to be hired, after the simplest designs that modern engineering can devise. But it will be so low in price that no man making a good salary will be unable to own one—and enjoy with his family the blessing of hours of pleasure in God's great open spaces.[2]

Ford built the cars, and he also produced the consumers who would buy them, with his cost-cutting assembly line and revolutionary five-dollar day. The success he prophesied has left Detroit with an unforeseen problem to solve. What to do with our ruins? The problem is not unique to this city, certainly, but more profound here than anywhere else, making this both the most fully-realized American place, and also, consequently, the most abandoned, with more than half the population having taken off since 1950, all of them seeking—presumably— "the blessing of hours of pleasure in God's great open spaces," just like Henry Ford planned it, and just like the majority of Americans would decide to do by the 1970s, when we became the first suburban society in human history—our love affair with cities having been comparatively short lived.[3] We had only been urban—the majority of us—since the 1920 census, with central cities, like Detroit, peaking in their population and prosperity in the 1950s, which is just when people began to leave, so that by the 1970s, the once great cities were no longer dominant as a destination.

1 This essay is excerpted from a book in progress, "Living With Detroit: An All-Purpose History of American Forgetting."

2 Robert Lacey, *Ford: The Men and the Machine* (Boston: Little, Brown and Company, 1986), 87.

3 Kenneth T. Jackson, *Crabgrass Frontier: The Suburbanization of the United States* (New York: Oxford Univ. Press, 1985), 283-84.

Because so much of this city was abandoned in so short a time—a period of only twenty years or so—and because there was little reason to maintain, let alone demolish, what got left behind—all that outmoded equipment of city life—Detroit has also become the richest site in America when it comes to ruins. There are more ruins here, inside the city limits, than at any other place in this country—stores and houses and whole neighborhoods, banks and ballrooms and civic buildings, libraries and train stations and schools, parks and factories, theaters, restaurants, hospitals, and hotels—all the infrastructure required to house and feed, organize and entertain the million former residents who don't live here any more. And now all that uninhabited stuff just sits there, falling apart. It's hard to describe, much less deal with in terms of urban planning, not that anybody has ever tried very hard.

And this is where it becomes easy to miss the point about Americans' seemingly profligate attitude toward the city. We are—practically all of us in the country—immigrants, and not just in the sense that we originally came from somewhere else, not even primarily that, but in the sense that we are a people always immigrating to something new, something better, something not bound to the past. We have taken seriously Mr. Jefferson's proposition that we are unalienably entitled to the *pursuit* of happiness, which is better even than happiness itself. And that makes our cities different from other people's cities. Here's what I mean, starting with Henry Ford. The point of the five dollar day, along with the Model T, was to provide the resources and equipment needed to get people out of the city. "The city is doomed," Ford proclaimed, prophetically as it turned out, "We shall solve the city problem by leaving the city."[4] So Ford built the cars that would render the city—at least the old, historical city—irrelevant, just as his horseless carriages and modern assembly methods would render irrelevant the products and production techniques of the carriage industry. And it is not by accident that this occurs. On the contrary, this is the necessary working-out of a design inherent to our capitalist economy, whether it's S. S. Kresge's five-and-dime merchandising undermining the patrician culture of the department store, or modern transportation rendering irrelevant the Beaux Arts obeisances of the Michigan Central Station, or the tailfin and annual model change making seem undesirable that perfectly serviceable car you bought only a year or two ago (back when

4 Jackson,
Crabgrass Frontier, 175.

model changes really counted for something). We couldn't get along without these acts of "creative destruction," to use a term of the economist Joseph Schumpeter.[5]

And creative destruction is surely the story of Detroit, where a vast industrial machine made real the promise of a designer future and the happiness that would attend upon it—so long as we remained ready to immigrate moment by moment to someplace we hadn't dreamed of yet. Our loss of the past would be indemnified by a material plenty unimaginable historically, least of all to ordinary working people. So we come naturally by our habit of forgetting how to remember the past; it's no hollow notion, but one based on real life experience, and the prosperity born of forgetting. The question is how to live with the world that forgetting has produced.

Prairie is one of the great, if unexpected, monuments that our forgetting has brought us, with the urban prairie of Detroit being one of the obligatory "discoveries" that every brainless tourist with a cell phone camera can't wait to report. But as usual, things are a lot more complicated than they appear. In fact, the grassland that now overtakes much of the inner city is not a reassertion of some primordial condition; this place was never grassland to begin with. The prairie of Detroit is not elemental at all, then, but altogether new, and of specifically urban making. "City of the future," Detroit was once called, when Fordism was first having its way with place and people alike. And that's what it possibly is again: the city that suggests a future for the whole of urban America, although this future may not be comprehensible to outsiders, or at least not to their ready-made categories of understanding. If the Detroit of today is a product of historic making, then there's no comprehending the future it possibly suggests, except in terms of the past—terms largely by now forgotten.

Thesis, antithesis, synthesis: first the great forests, inhabited by widely dispersed native people; then the European invasion with its villages and towns, assembly lines, freeways and suburbs, riots and evacuations; and finally the synthetic result, a city evolving into a wholly new condition of arable open space unlike any that has existed here before, a result achieved at considerable price. Foot per square foot, this is the most expensive urban landscape ever produced by humans, given all the time and money, blood and strife expended on this extraordinary real estate. But *not* thinking about this is what most people have preferred to do, especially people

5 Thomas K. McCraw, *Prophet of Innovation: Joseph Schumpeter and Creative Destruction* (Cambridge, MA: Belknap Press of Harvard University Press, 2007), 351-52.

from someplace else. And no wonder, taken seriously, the urbanism of Detroit presents a clear and present danger to the way Americans think about cities and ourselves, the way we like to imagine we already know who's who and what's what when it comes to anything urban, especially anything urban and "failed," which is how most people prefer—these days—to think about Detroit: not as the highly evolved expression of our national character, but as an a-typical freak.

I want to represent what I have seen, what I feel, about a city that the term *city* no longer comprehends. That's when I find myself improbably—if only temporarily—in company with the practitioners of "ruin porn," and their urge for drive-by solutions. It's a way out, snapping a picture, and once you've seen this place, you can't help but need one—a way out, that is. There *is* something uniquely arresting here, that much I'll give the drive-by opportunists. But Detroit is not a sight simply to be gawked and groped, and then walked away from. It's not picturesque, either, in the way that a ruin is often thought to be: the Coliseum in the moonlight; an old barn, tumbling to wreck; all those dystopic snap-shots of Detroit that you can see on the web, or else in expensive, coffee-table collectors' editions, each one striving for just the right view that will sum it all up, whatever *it* is, and then be done. Not that, then, but the beauty of a palimpsest— something written over and over and over yet again, each layer giving rise to an increasingly complex figure that can only be apprehended from the inside. It's the figure that comes after the city, yet remains within it, occupying the same ground, now written over by the visible signs of serial forgetting. What remains is surrounded by even more that is gone: an isolated house alone on what was once an urban street, grassland rushing up to the walls of a building still in use, things that have no business together, except they are together, here. What it is emphatically not is an empty waste waiting to be discovered; nor is it an invitation to gestalt therapeutics— you know, the glass that we get to imagine either half empty or half full. Glittering, new office towers downtown, state-of-the art stadiums for sports—or the San-Francisco-sized void inside the city. You choose. It's nothing like that. So what *is* it like? Truth to tell, it is not *like* anything. It just is, and that's the mystery of it, and the wonder. And that's the wonder of the images in this book. There's nothing one-off or drive-by about them; they're an insider's view of what it feels like and looks like to live with this place.

Detroit is America's negative hometown—the place that everybody else is intentionally and adamantly not from, the most definitively moved-out-of spot in this country. We know who we are—all of us in this gun-toting, cantankerous land—because we know, at least, that we are—thank God—not from Detroit, whatever we construe "Detroit" to stand for, which generally has no connection to fact. It's the accident scene we can't help but stare at, and then drive away from (as if that were really possible). Our history, then, is a history of forgetting how to remember what this means.

It's the opposite of really living with Detroit, or what living with Detroit can mean—making conscious our returns to this overwritten place. That's the truth you will find here, if you spend time with these remarkable images, looking and looking again at this oversubscribed city. Go back, I urge you, on behalf of the recursive truth that Julia Reyes Taubman has hidden in plain sight, just like the city hides itself in plain sight. This is not something you arrive at, once for all, which is the failure of the drive-by exploiters of "ruin porn" and their urge for a way out—from the sensational to the faux-sublime, as if there would ever be a last word, a final image, that would settle things. What a naïve joke! But what an entirely understandable desire, to have the last word and then just move away. So that's not the route to understanding; the truth of this place is not something you say or take home in an image, but something you do and keep on doing until you become part of the design. And that's what Julia has done, in these still, silent pictures; and what she has privileged you to do, if you spend time here, returning with her to this most precious of all American places, the one most profoundly ours. If you're lucky, you'll get caught up short by some odd chance encounter, which she offers you here—not a representation, but a presentation vivid and live and real—and for a moment you will recognize yourself in the design. Living with Detroit, then, is a lesson about all of us here in this country, and what we have done, and what we have left undone, what we have seen and what we have been blinded to, and what a conflicted notion that "we" is in the first place—a proposition fundamental to this republic, a fiction both beautiful and alternately false. At least that's the conclusion you might reach—sadder and wiser—living with the complex figure of Detroit.

—*Detroit, January 2011*

East

17

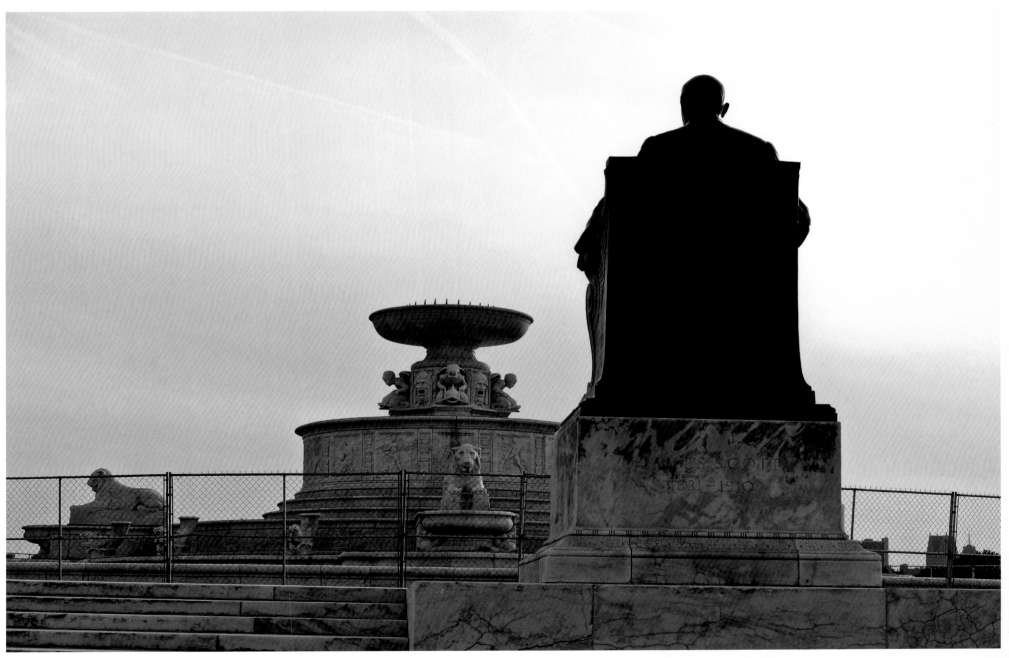

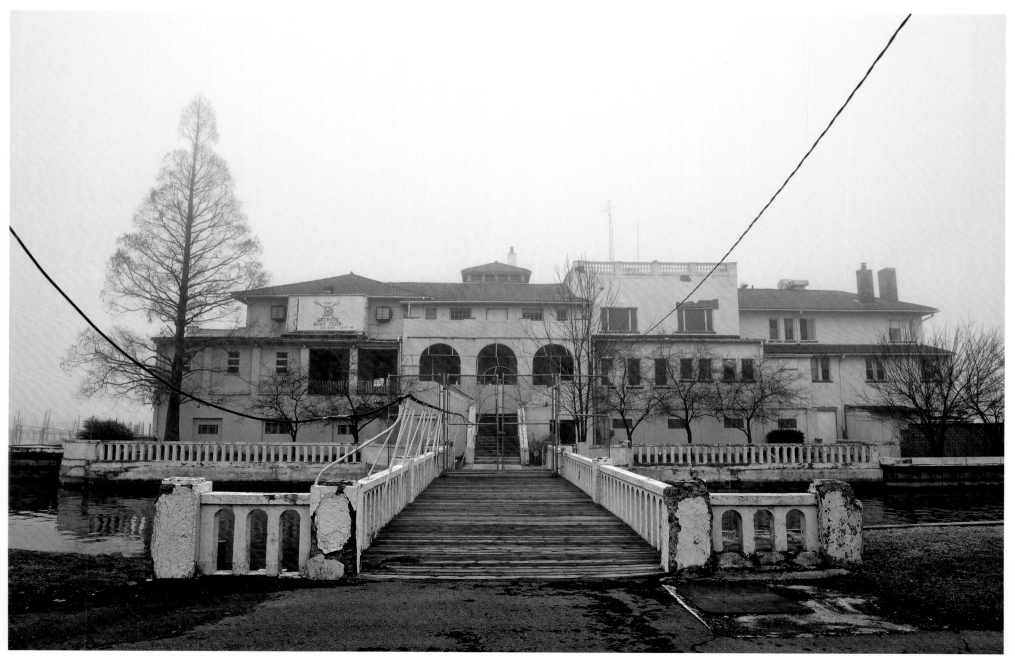

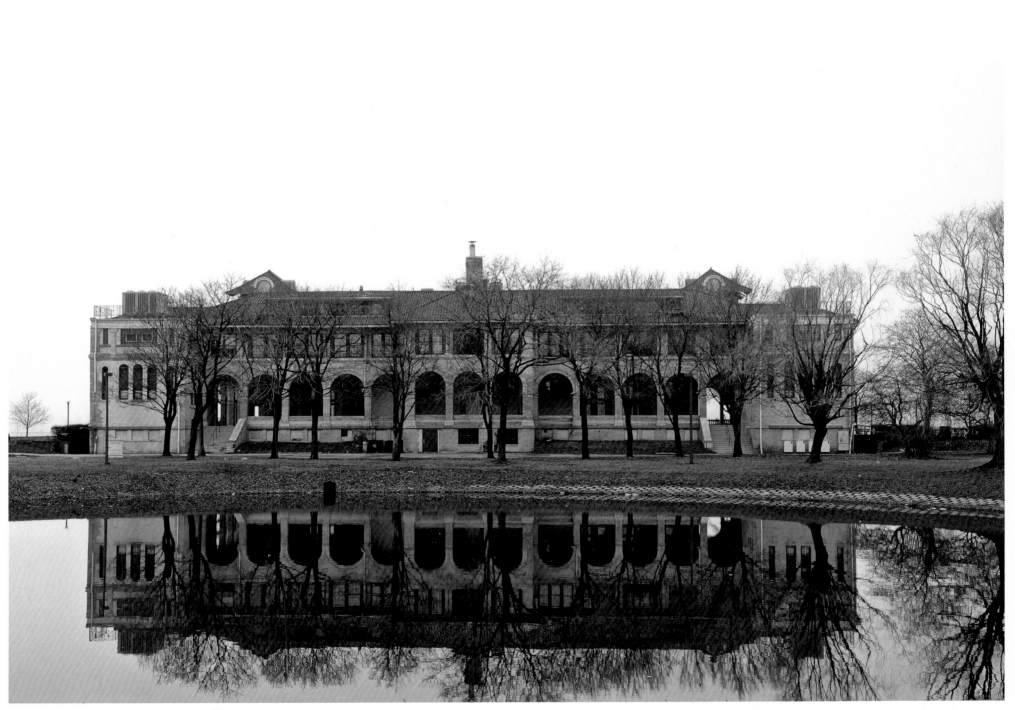

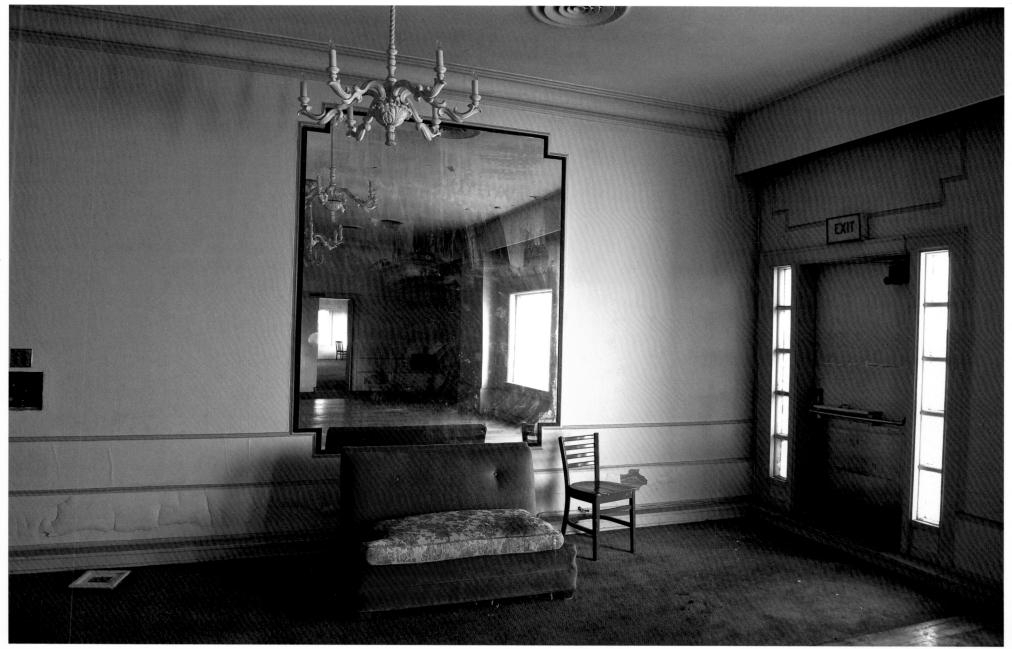

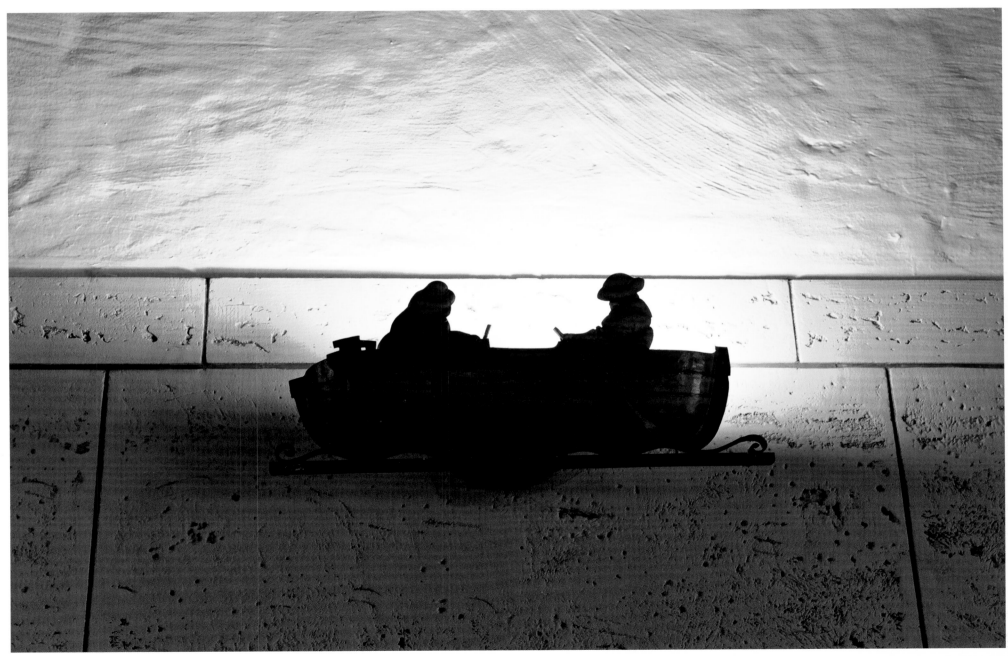

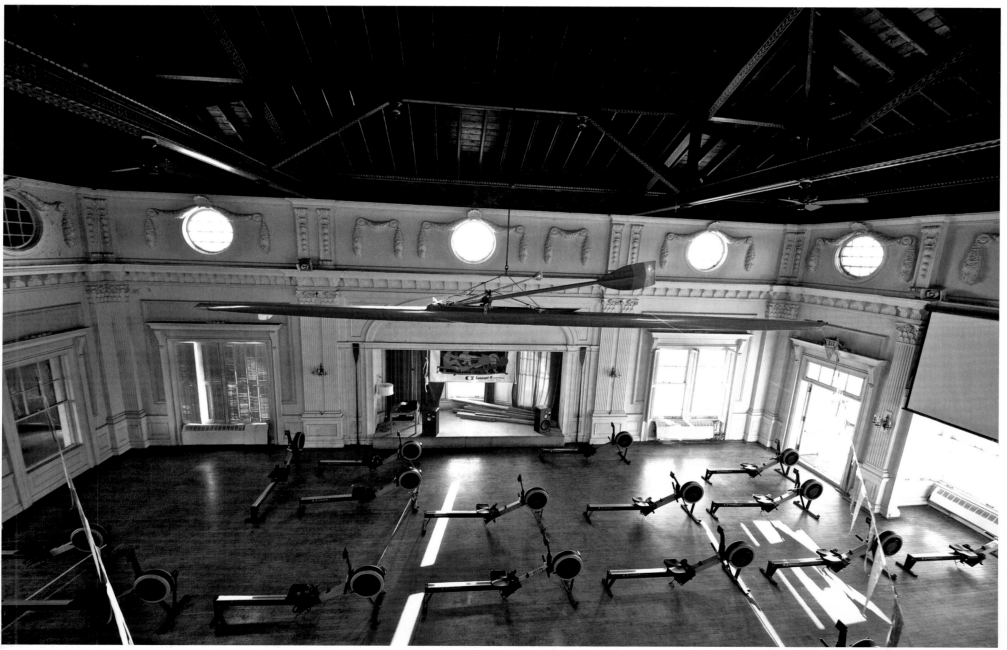

26

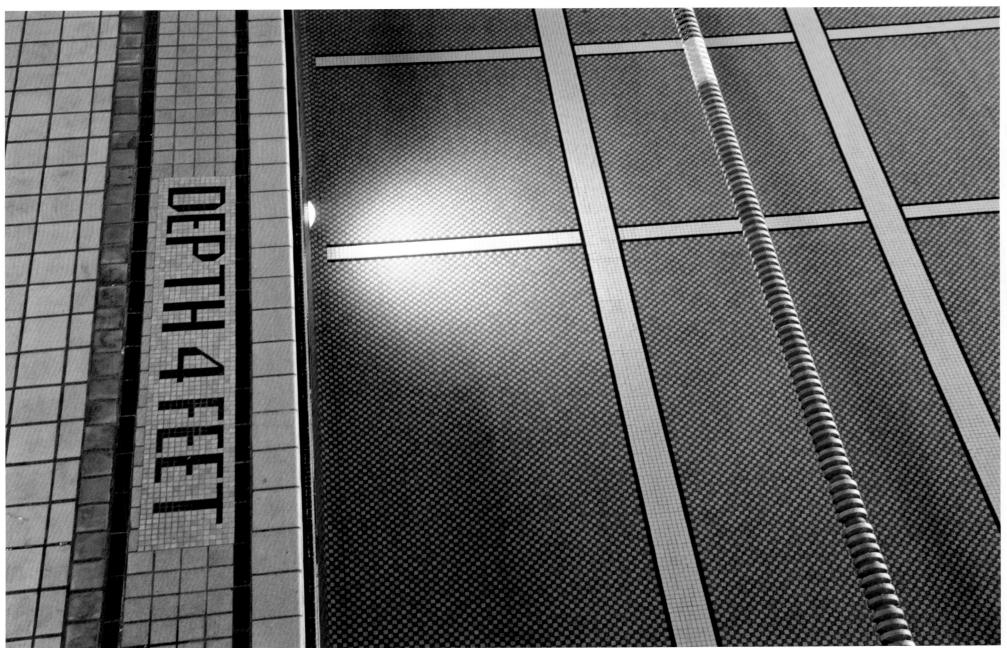

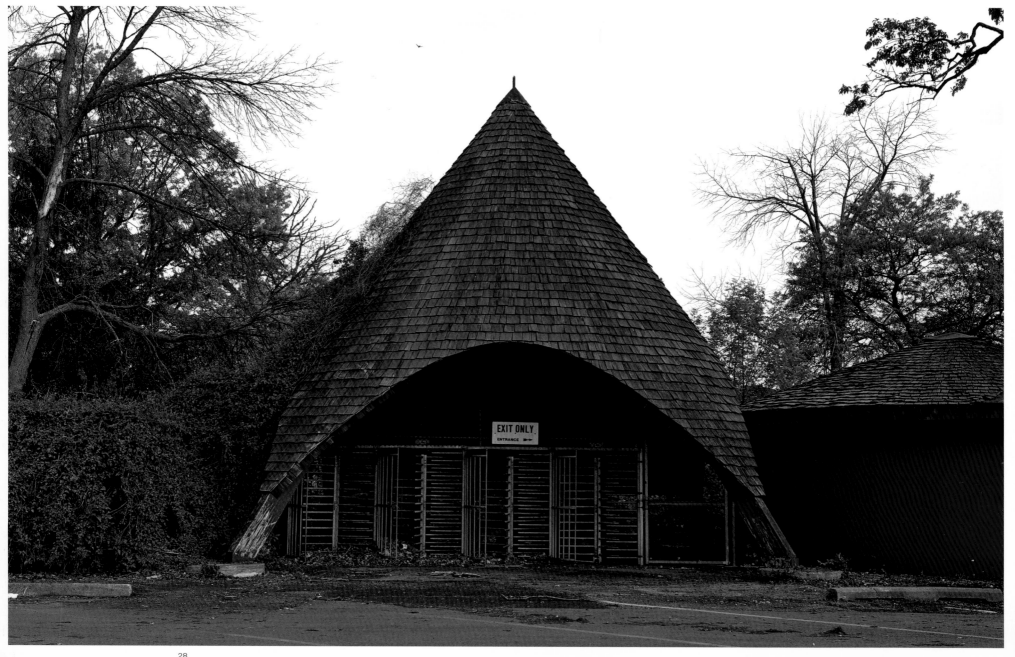

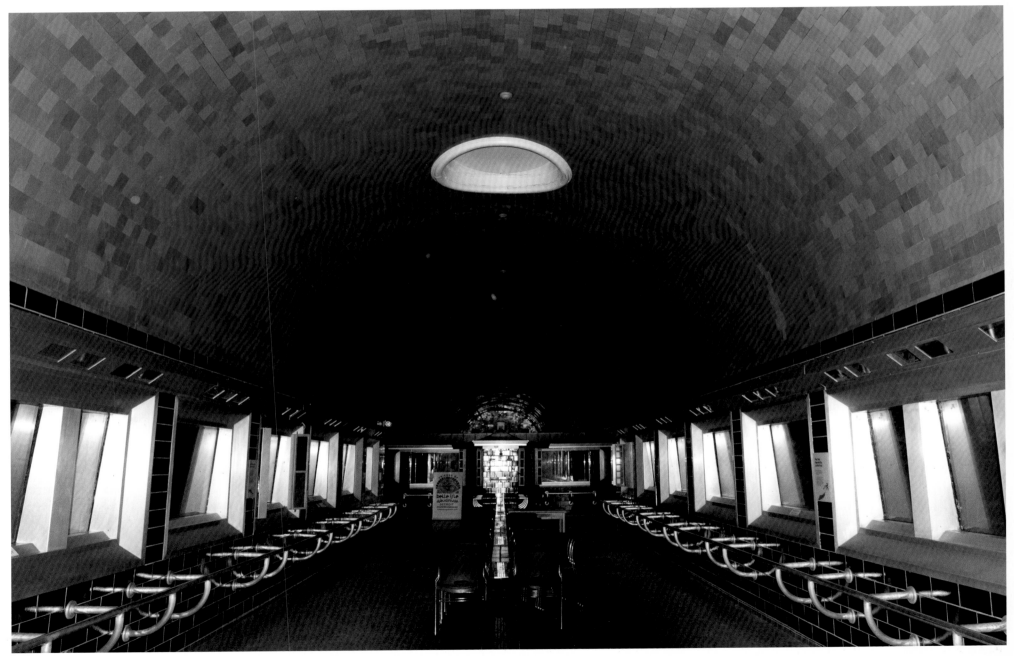

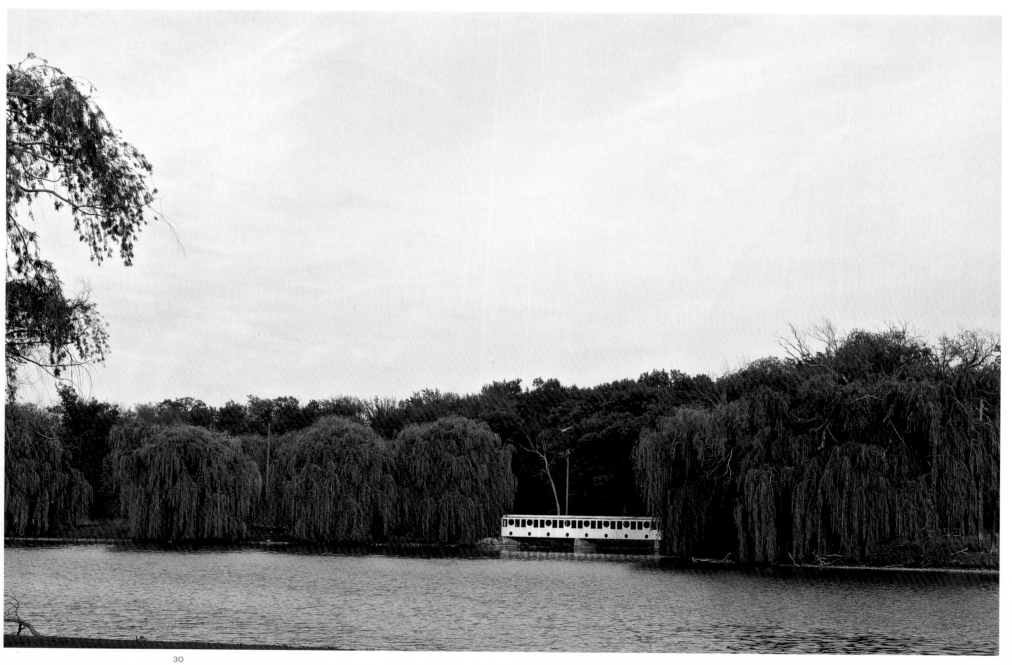

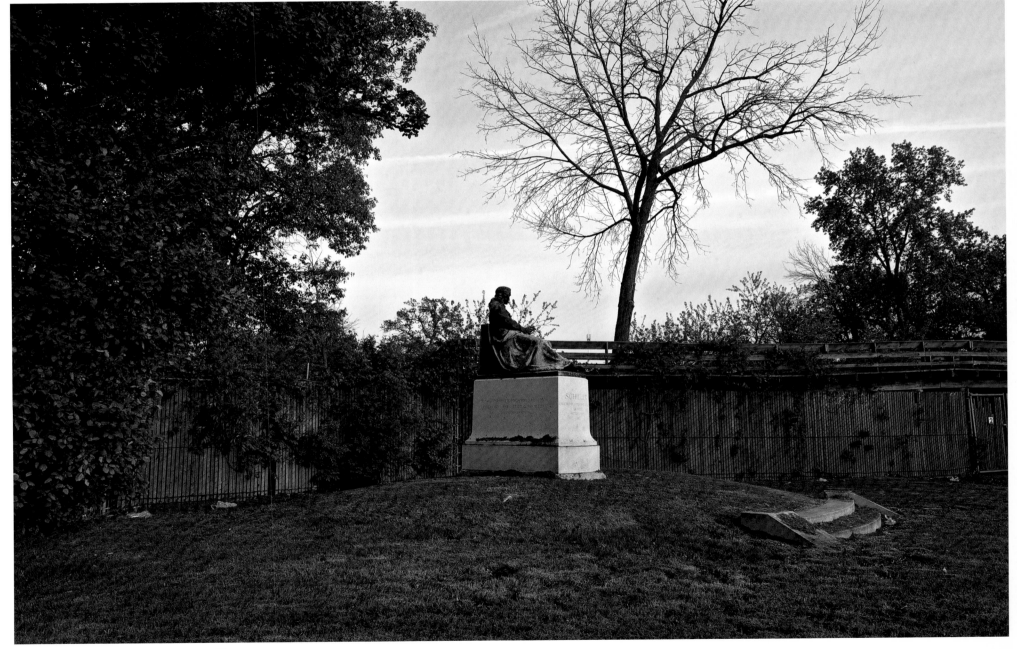

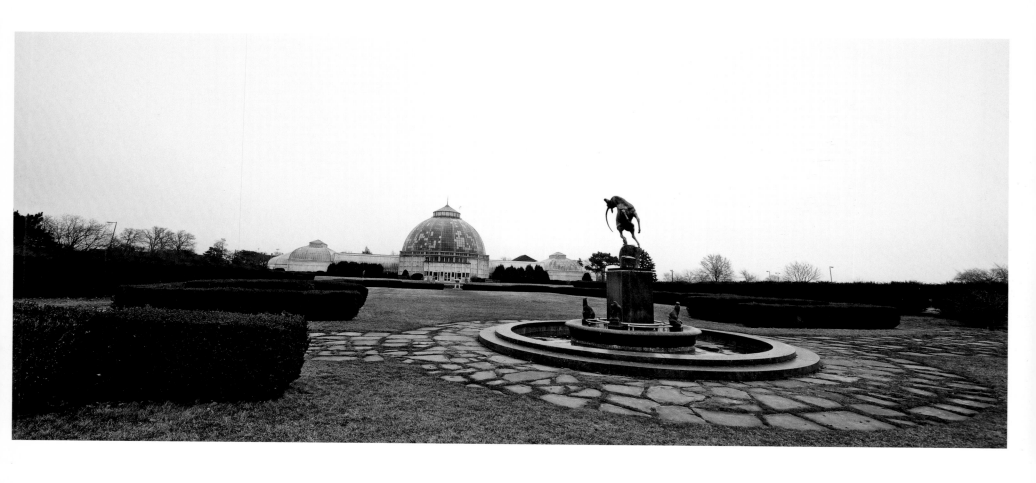

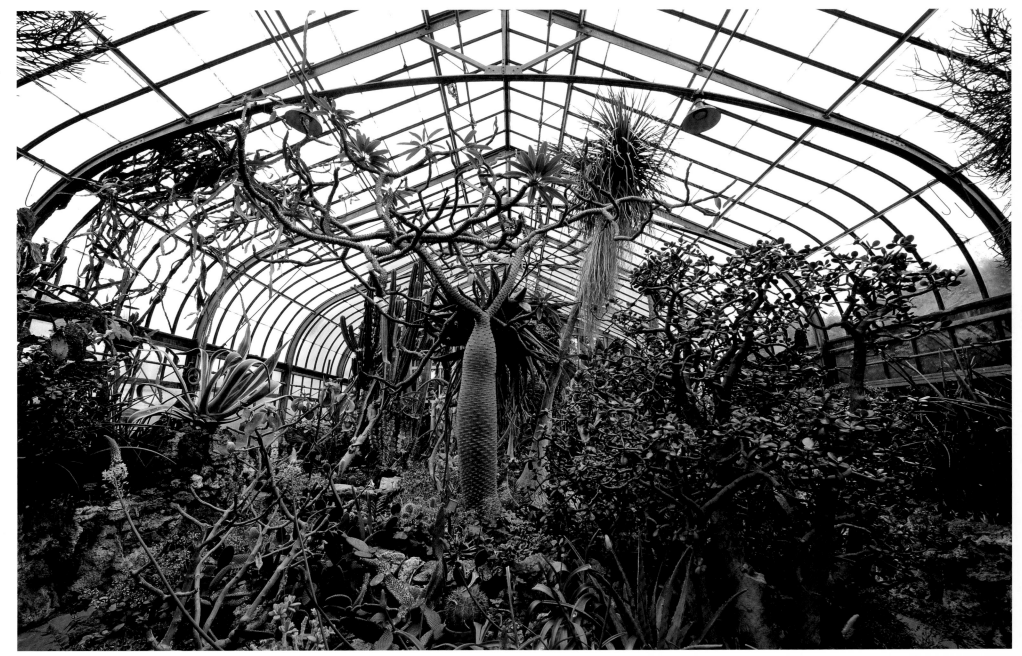

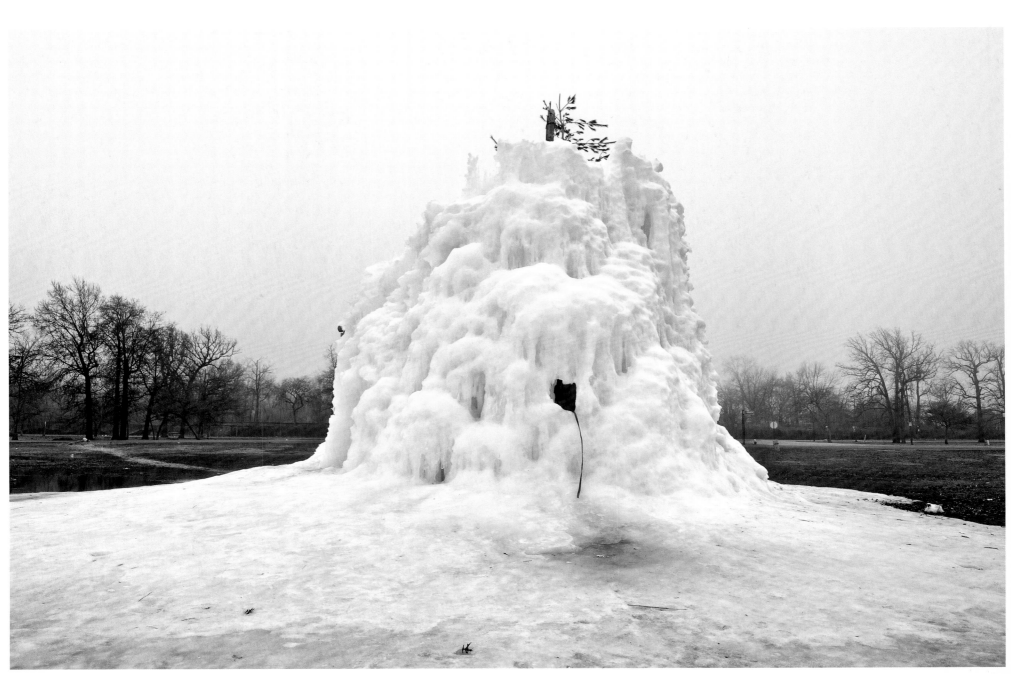

35

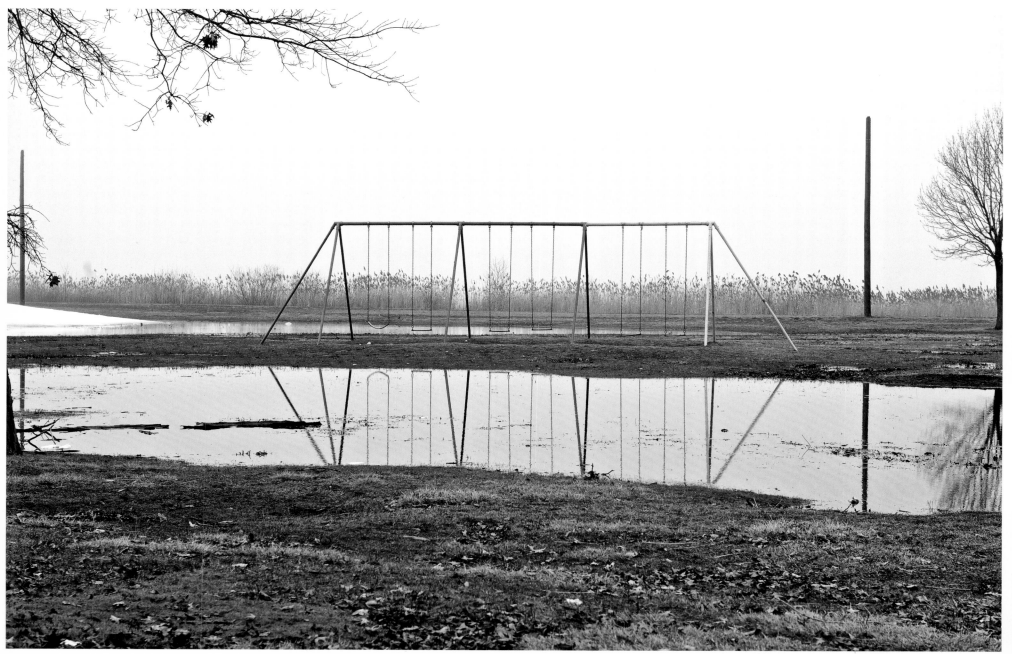

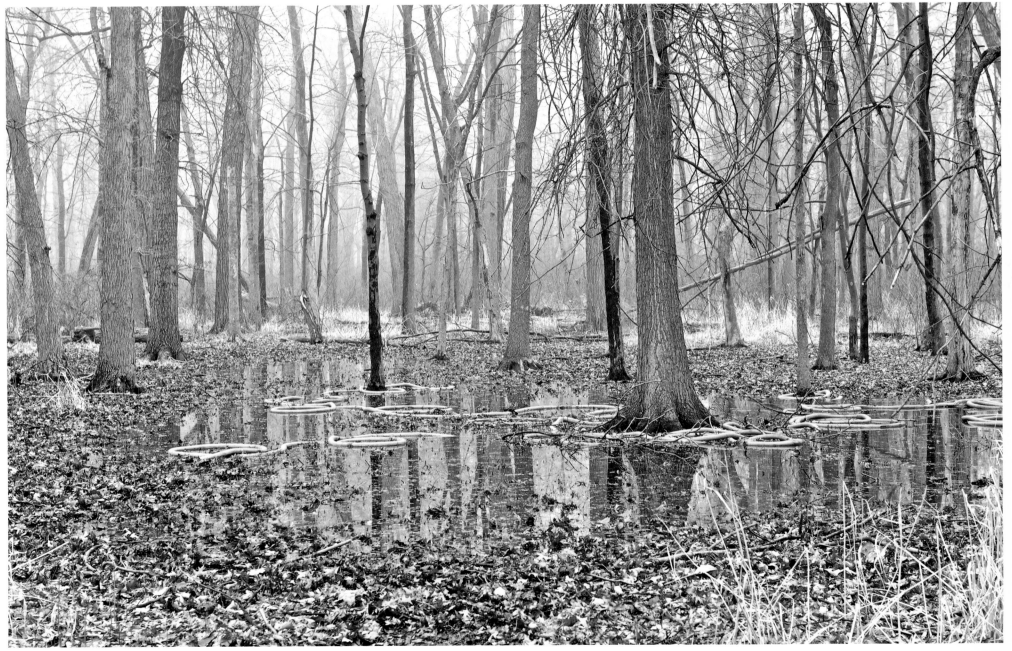

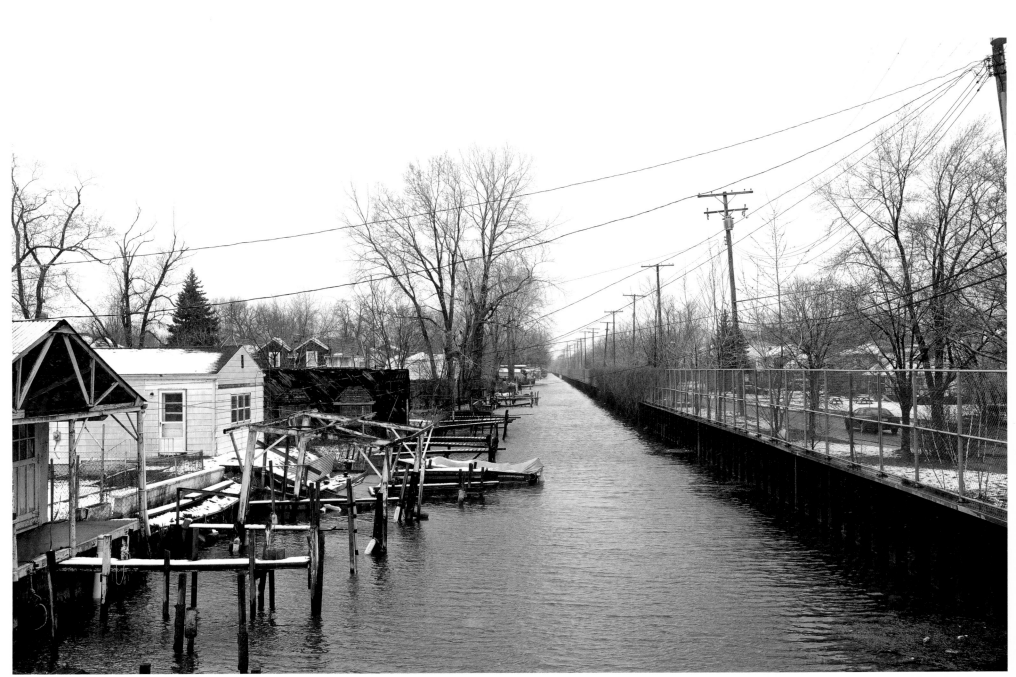

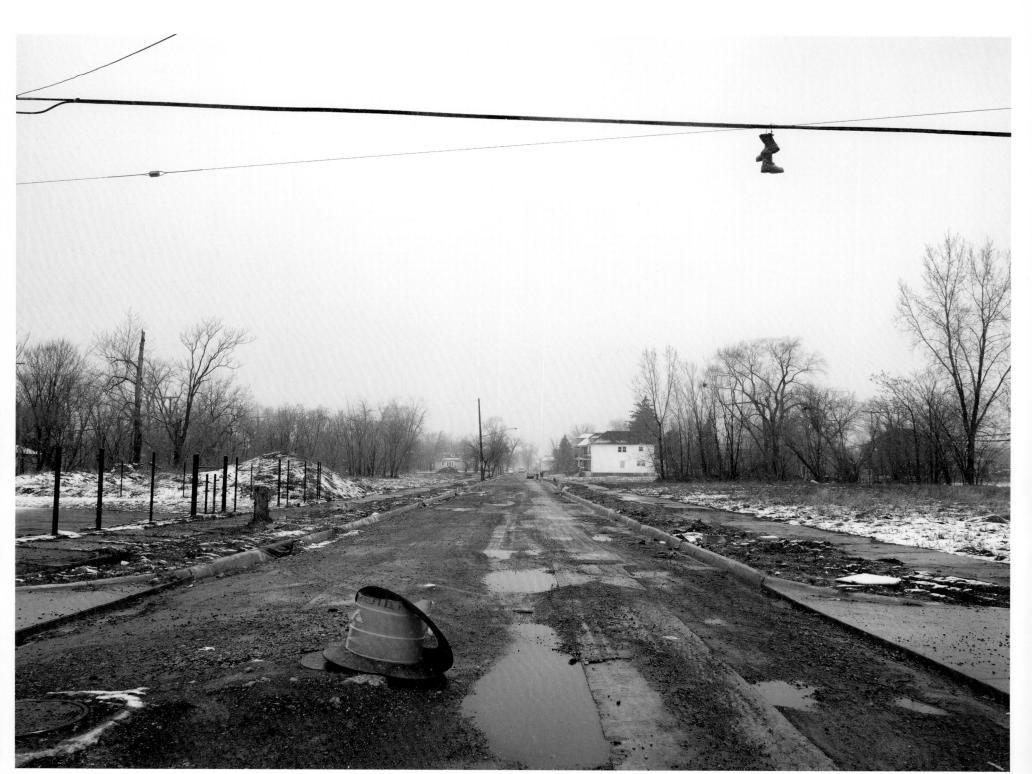

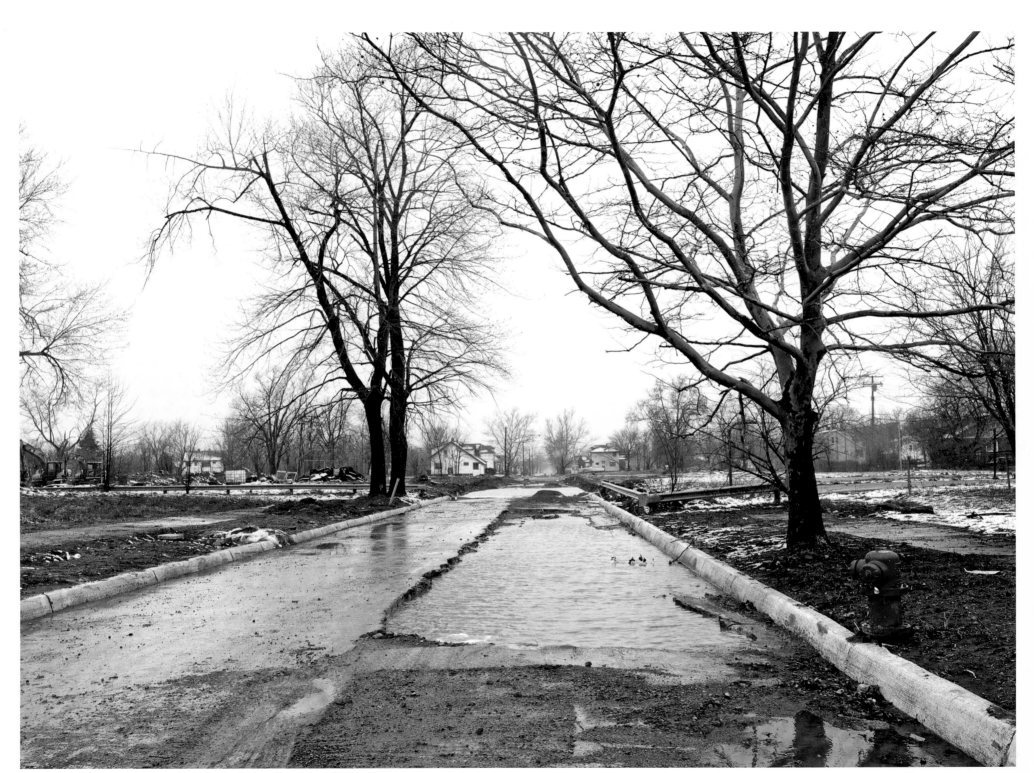

41

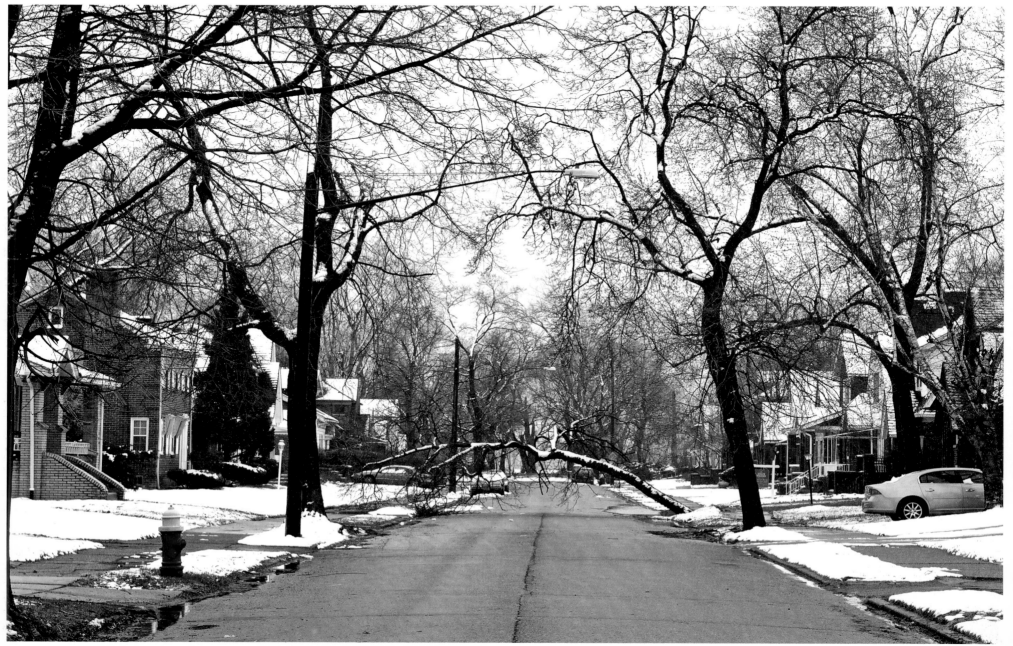

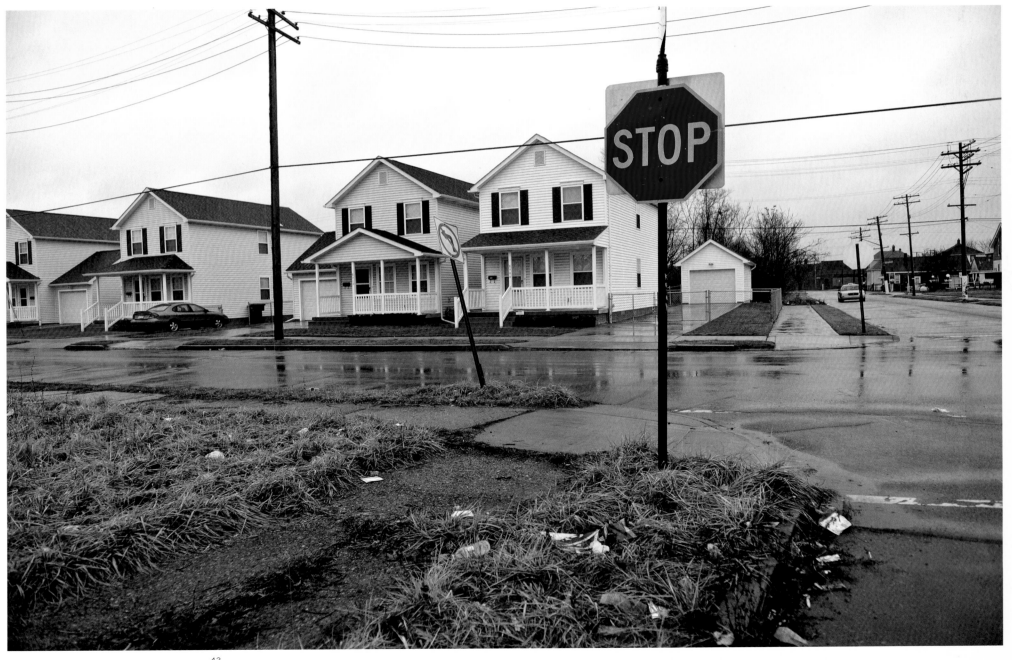

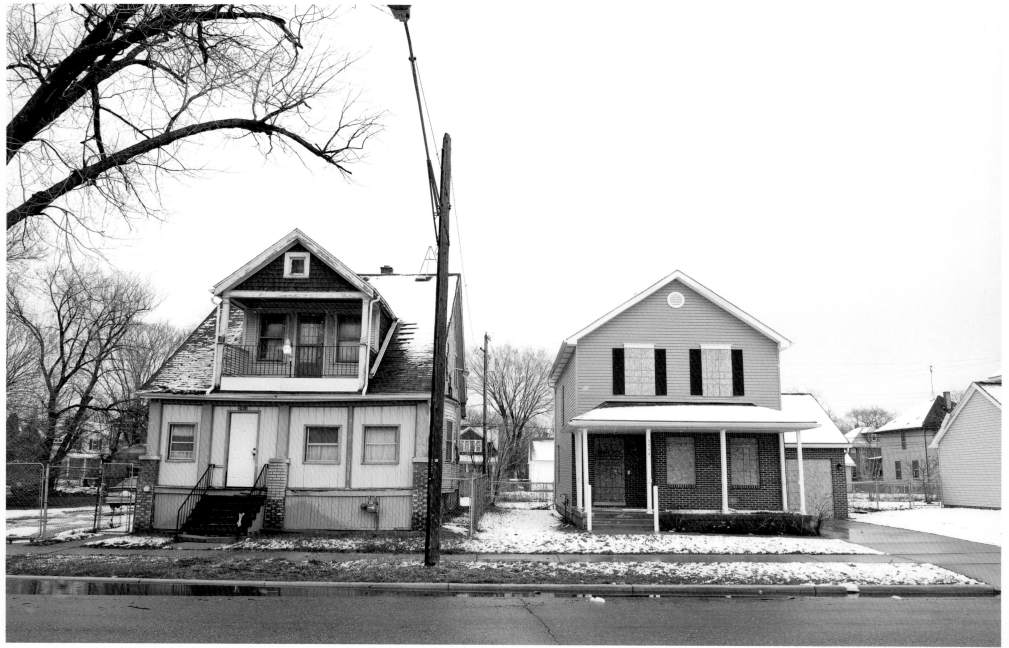

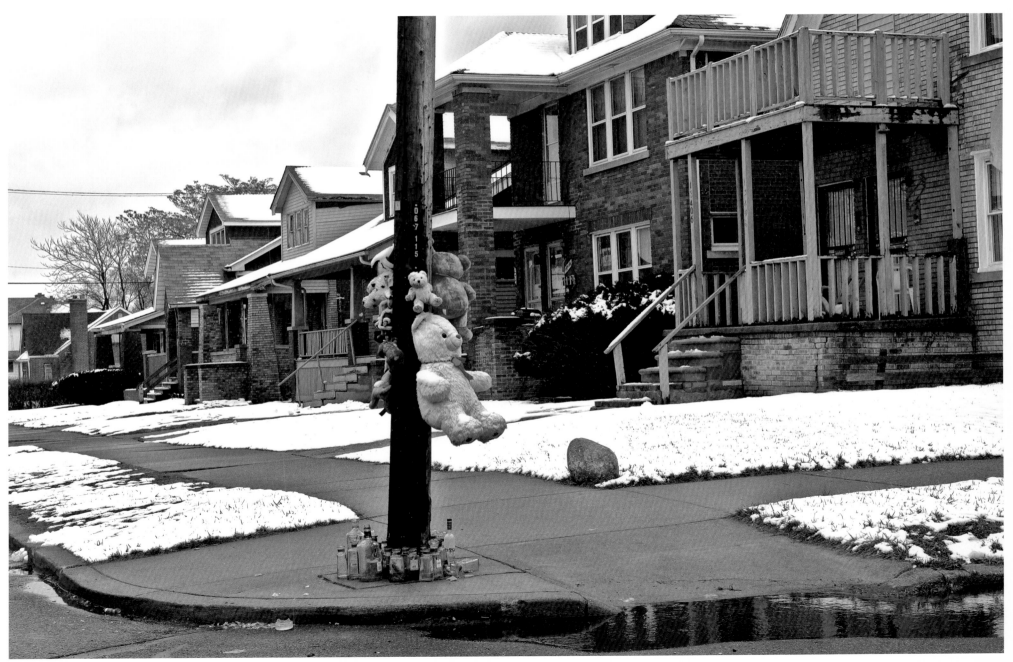

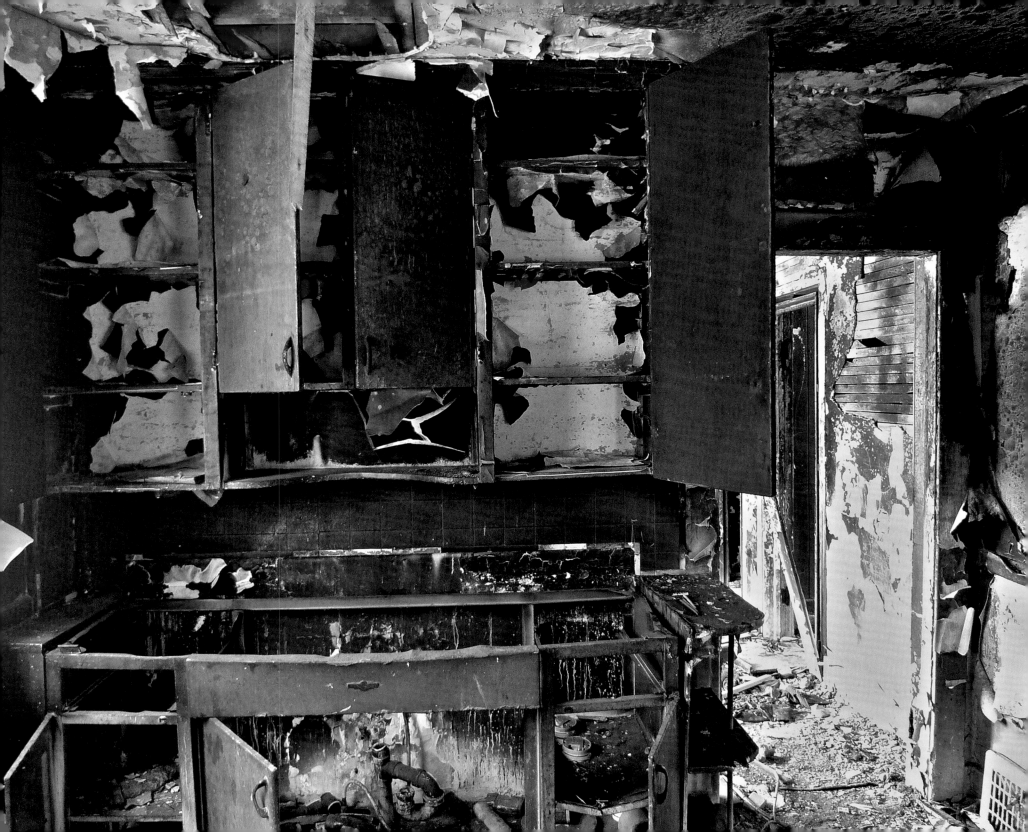

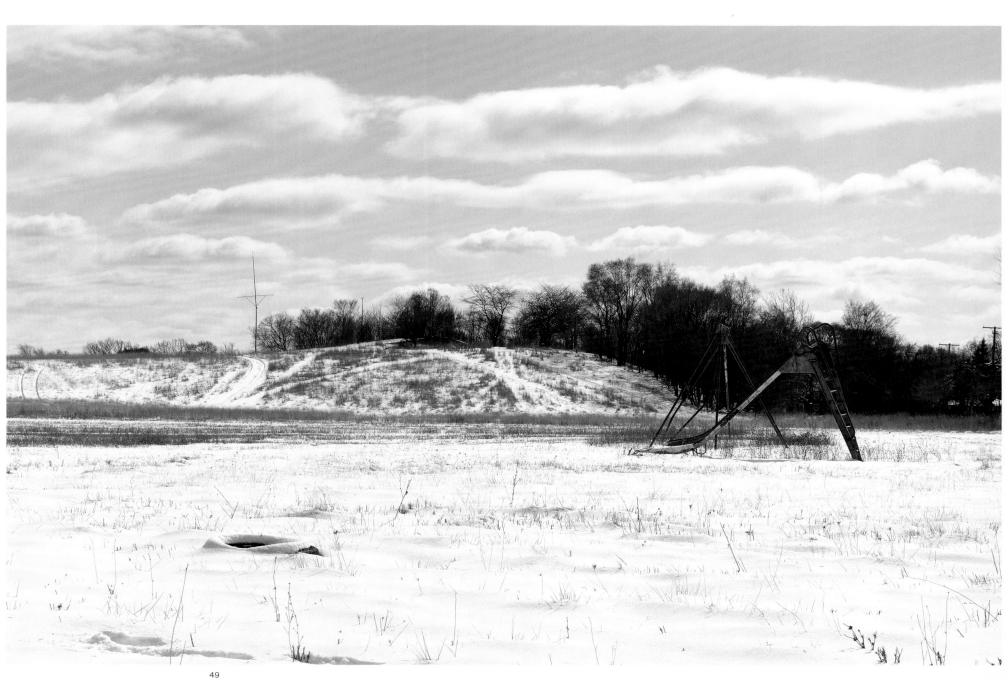

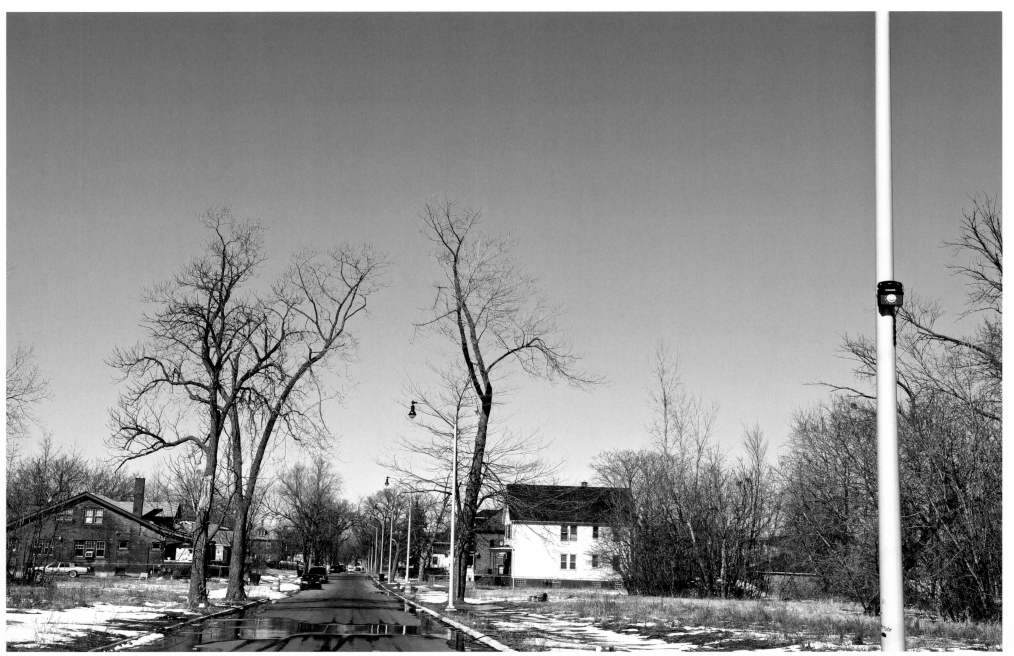

50

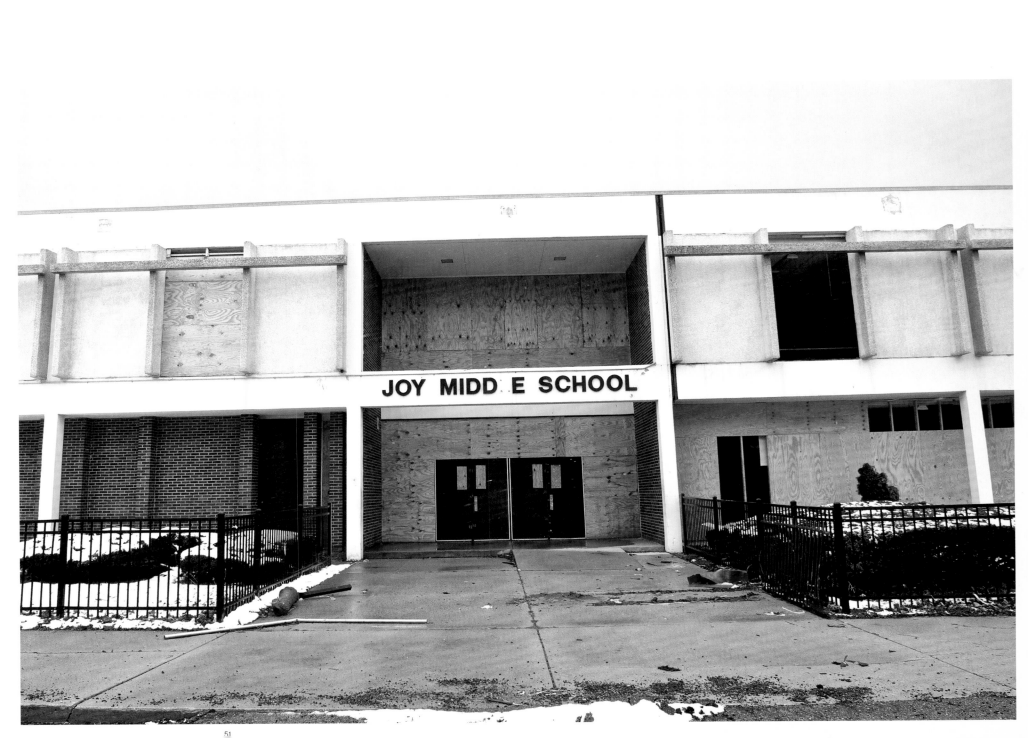

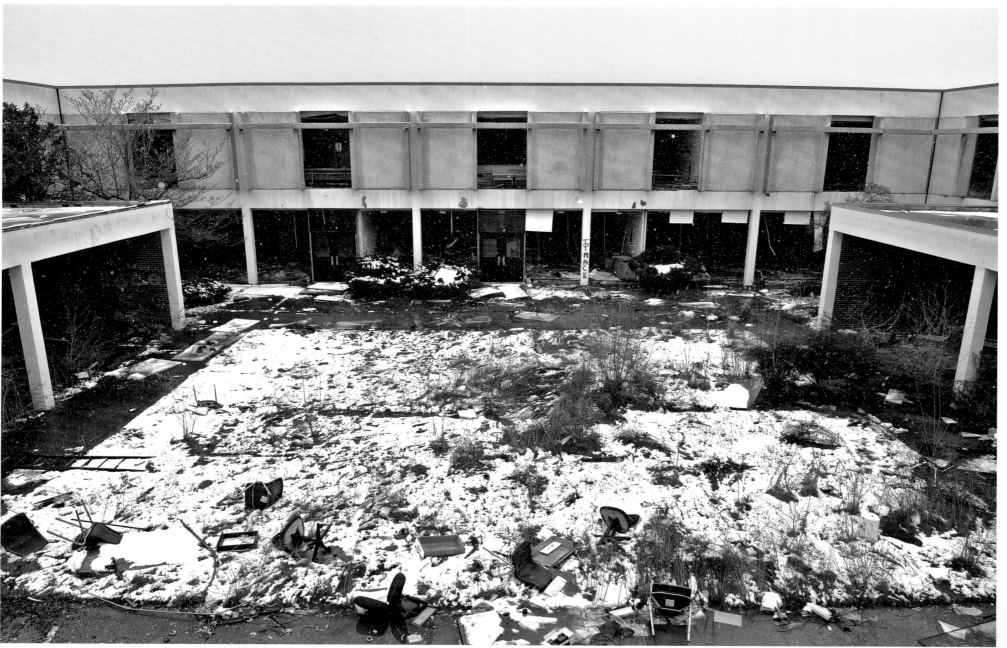

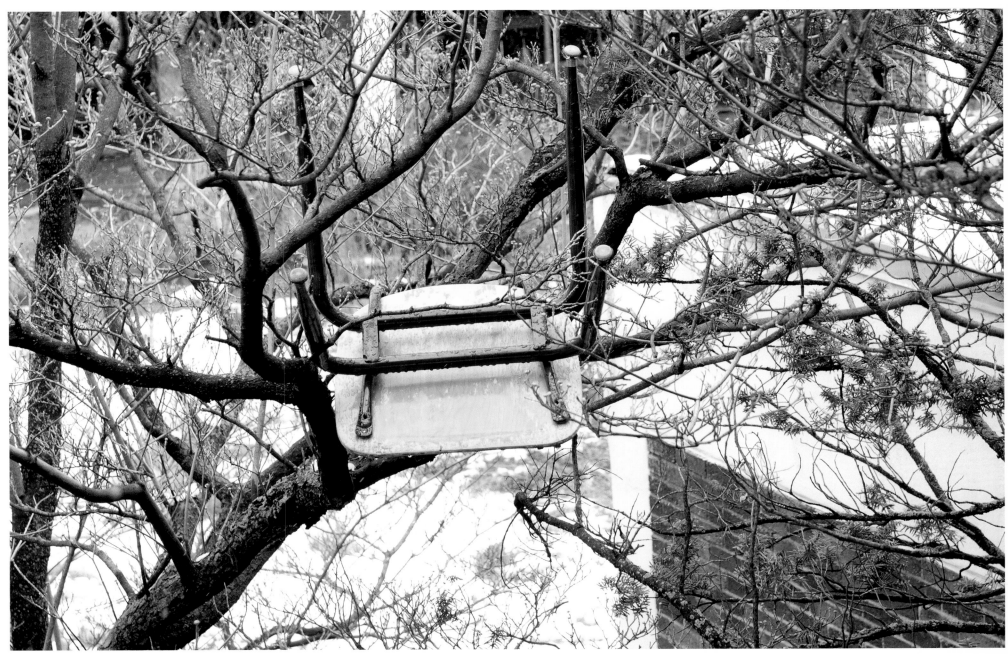

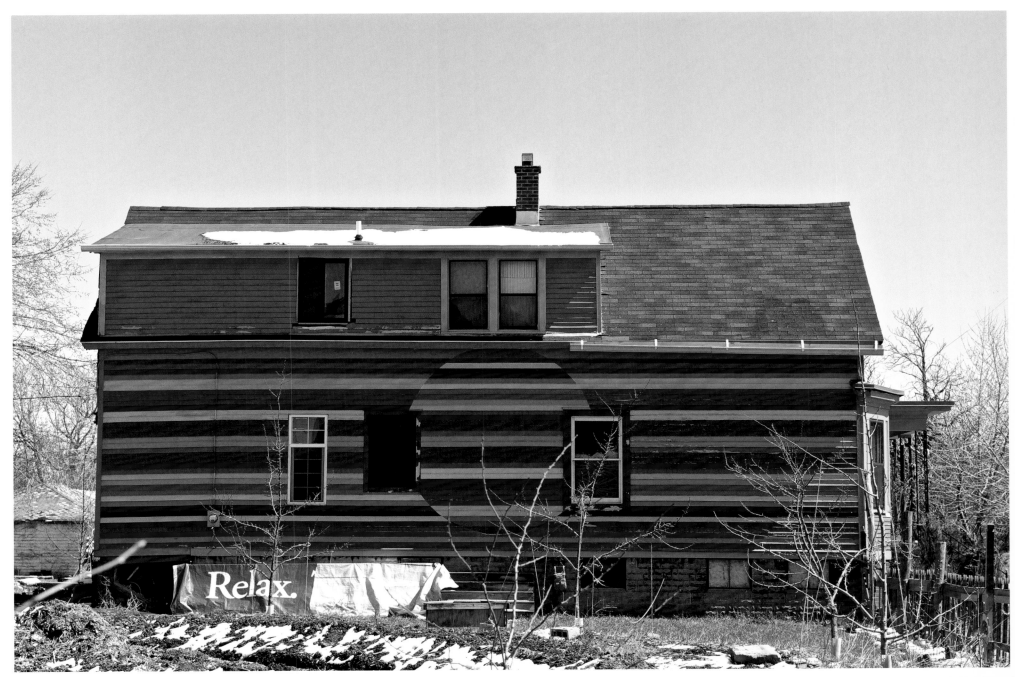

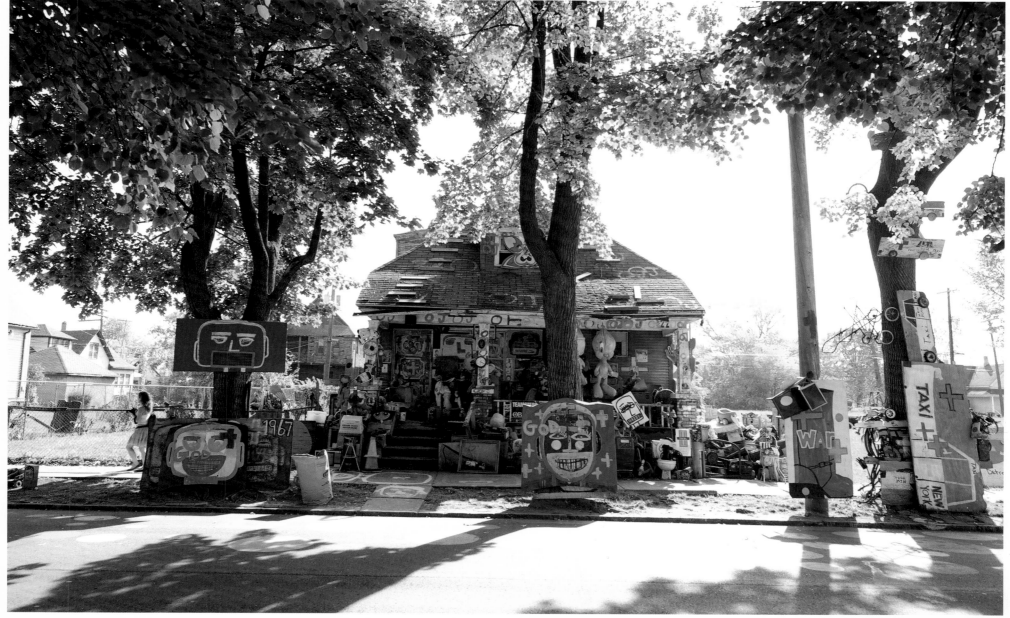

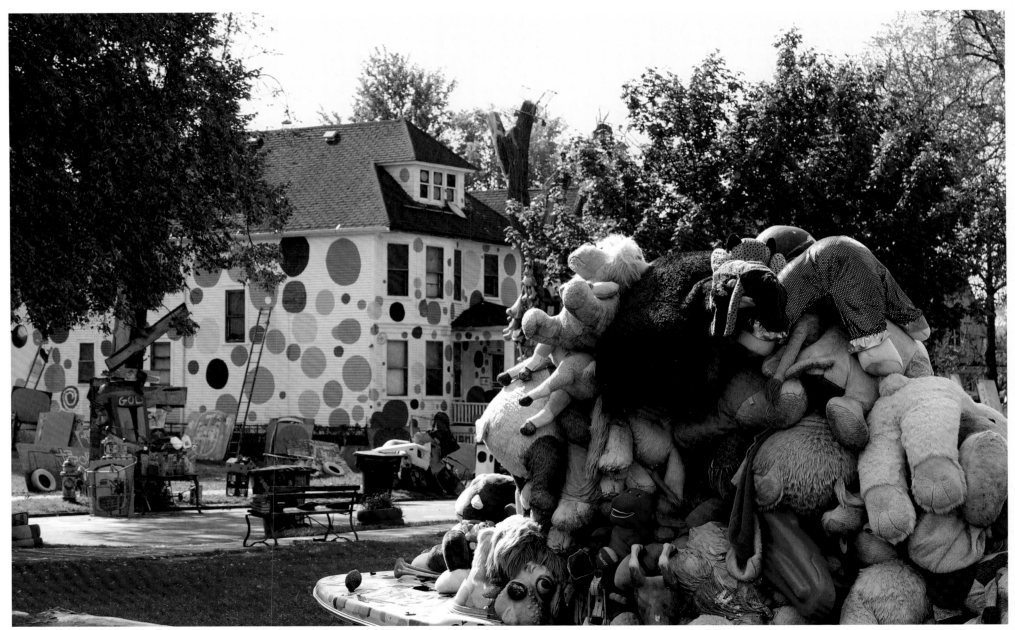

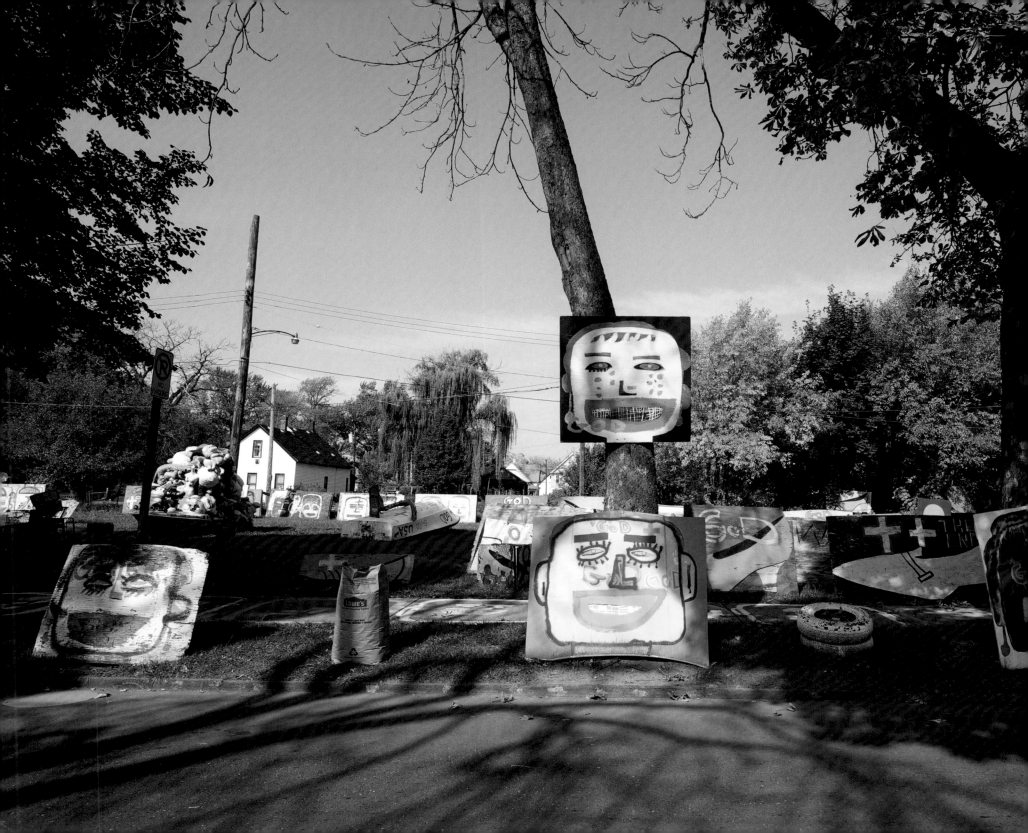

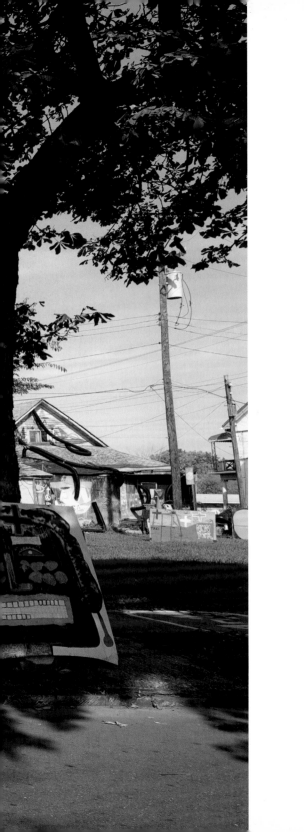

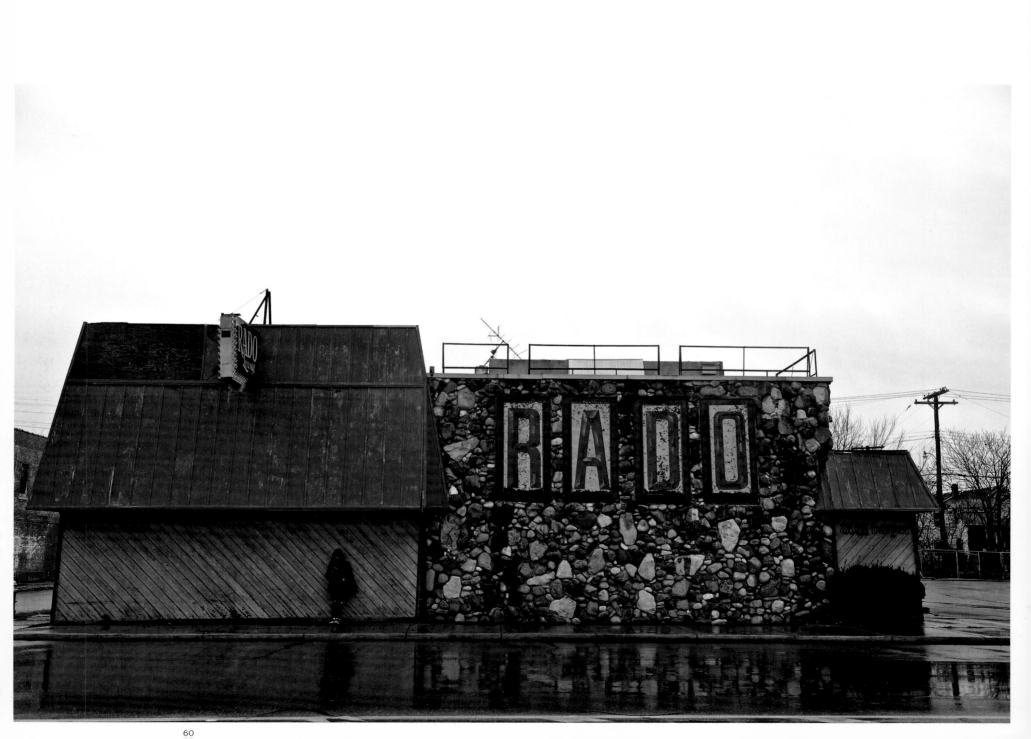

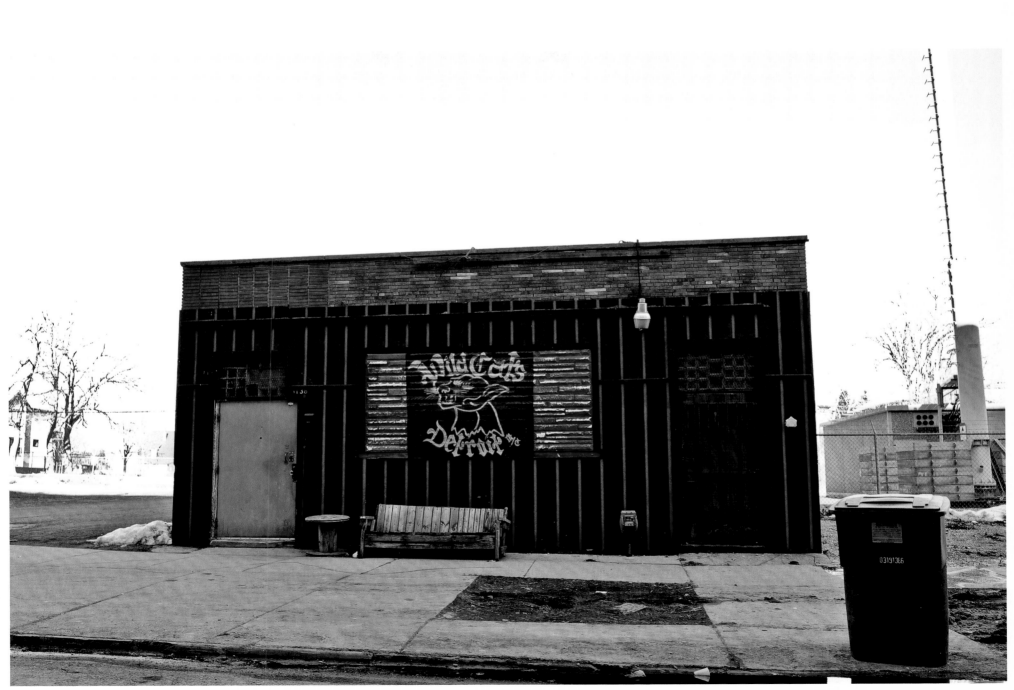

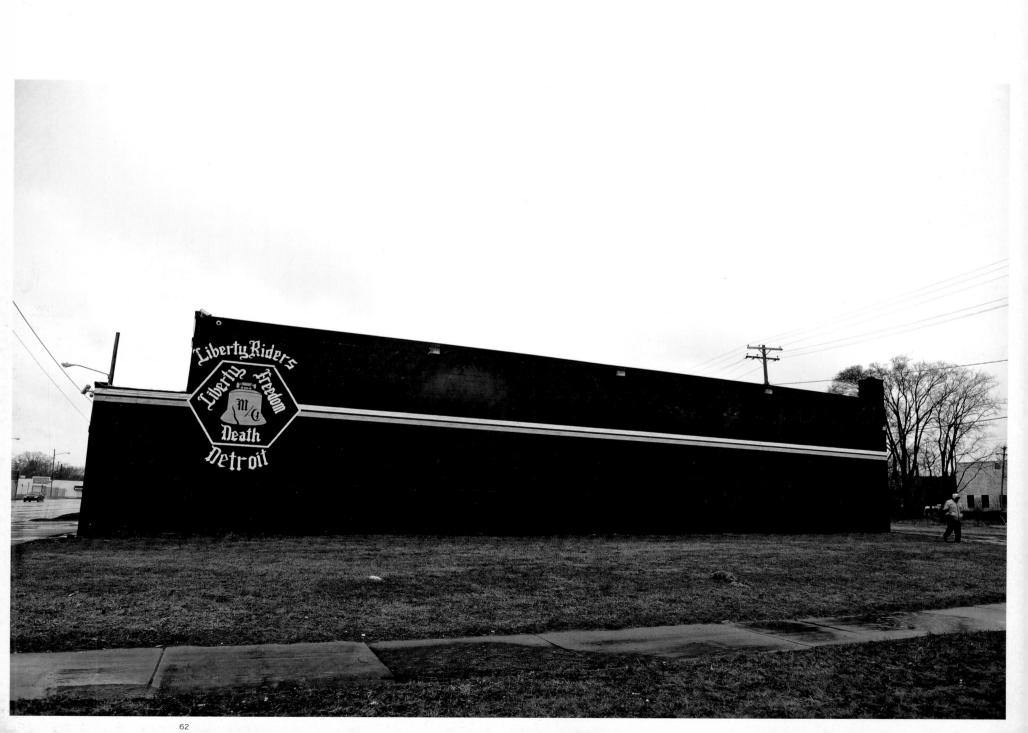

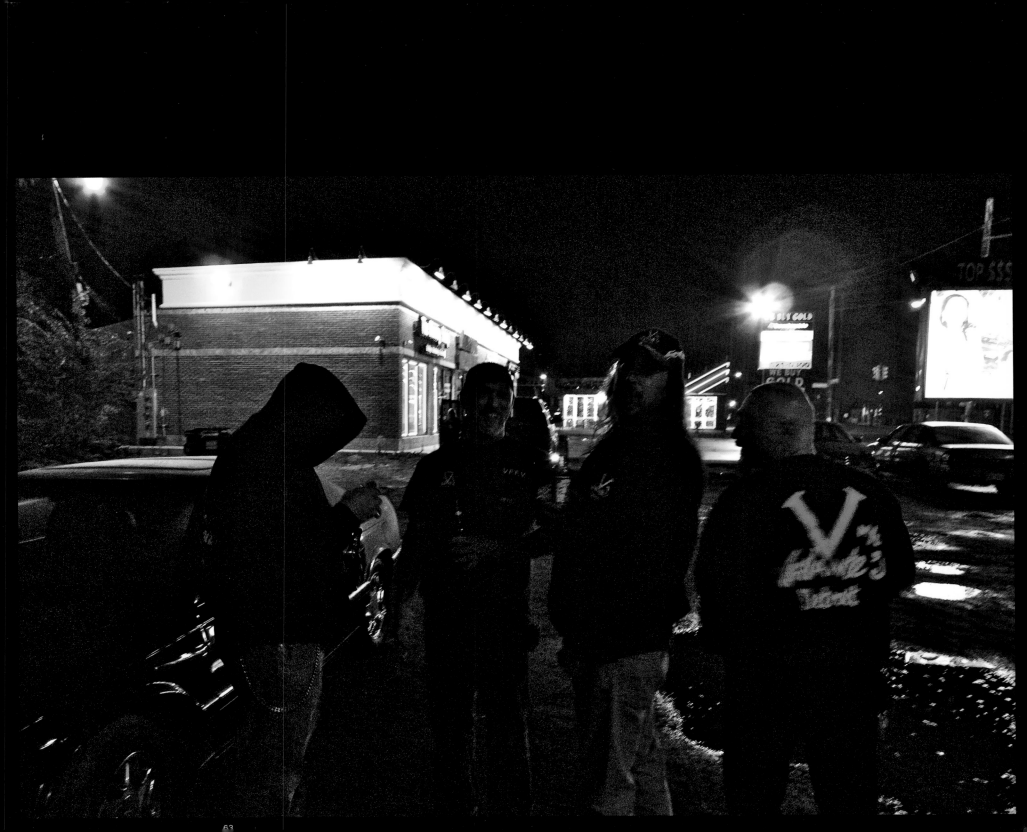

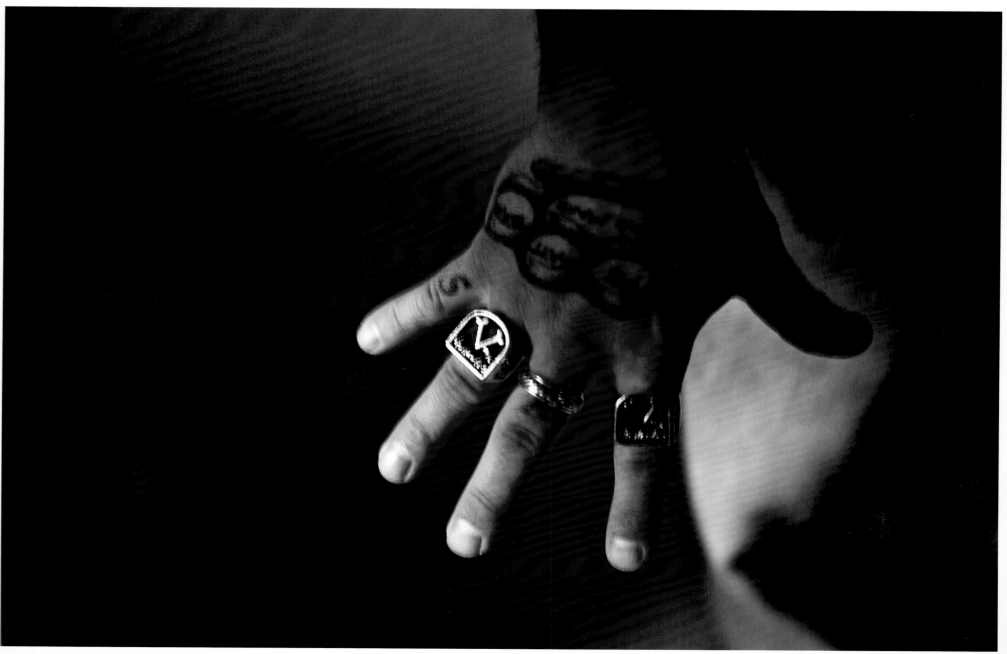

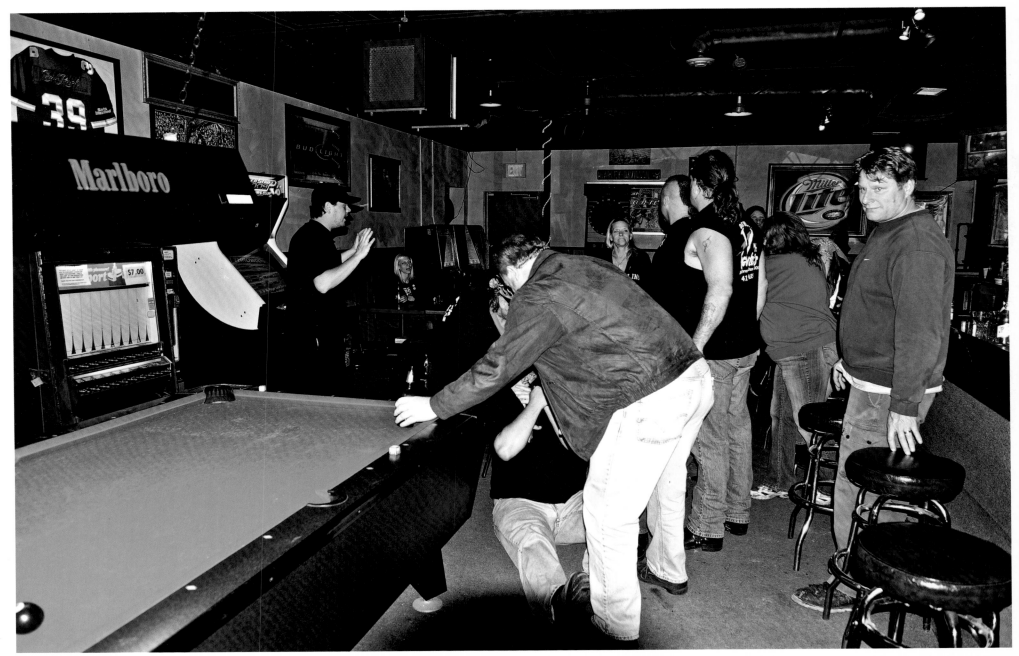

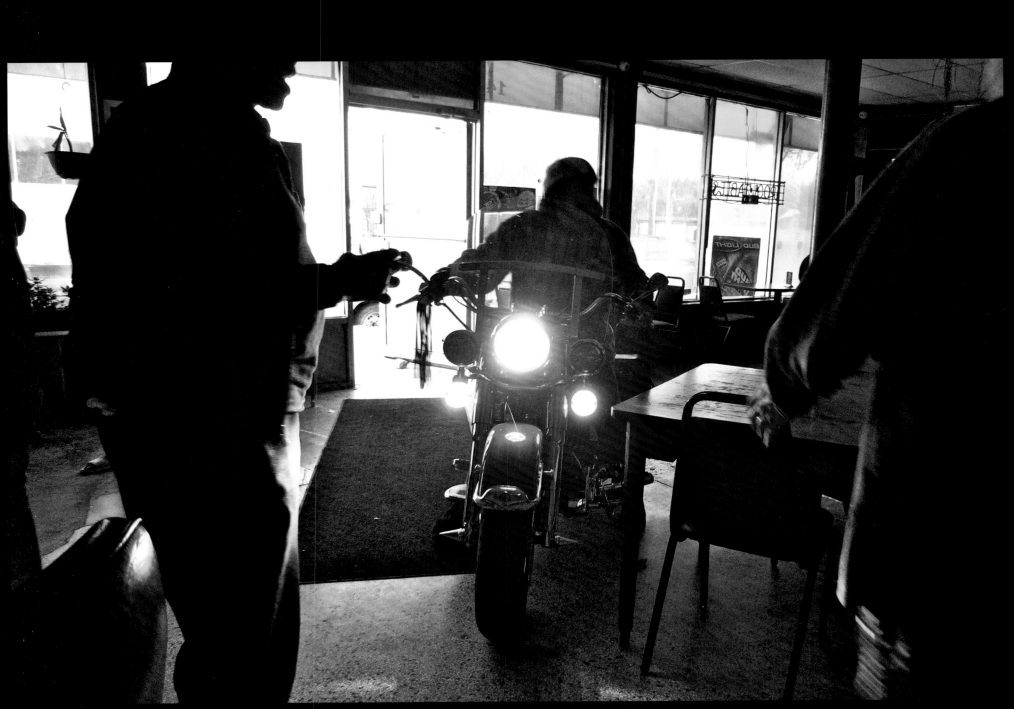

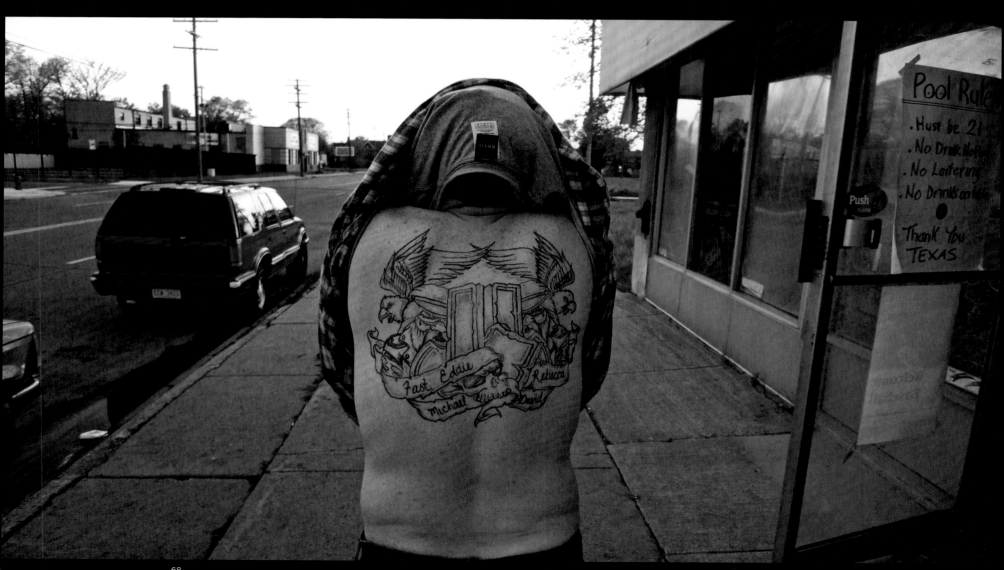

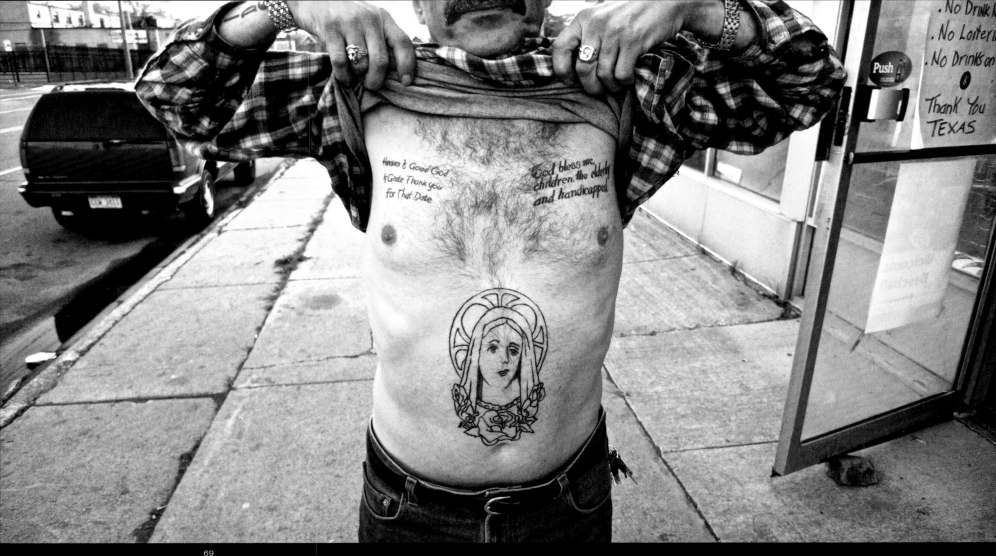

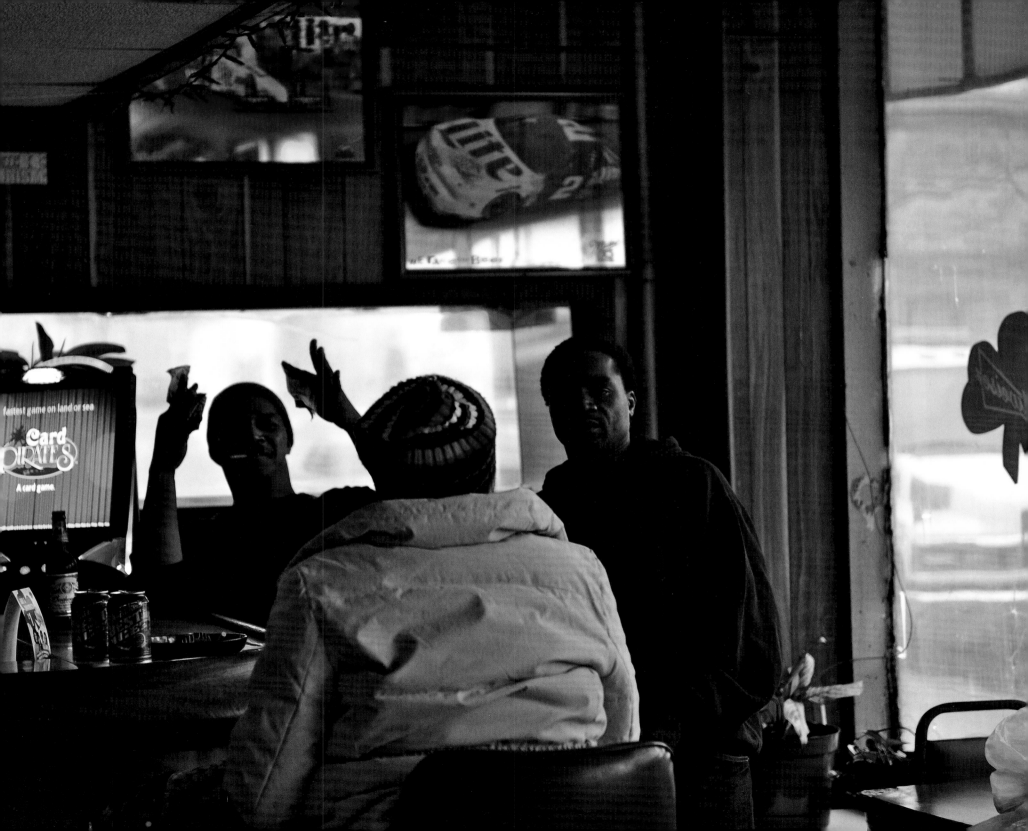

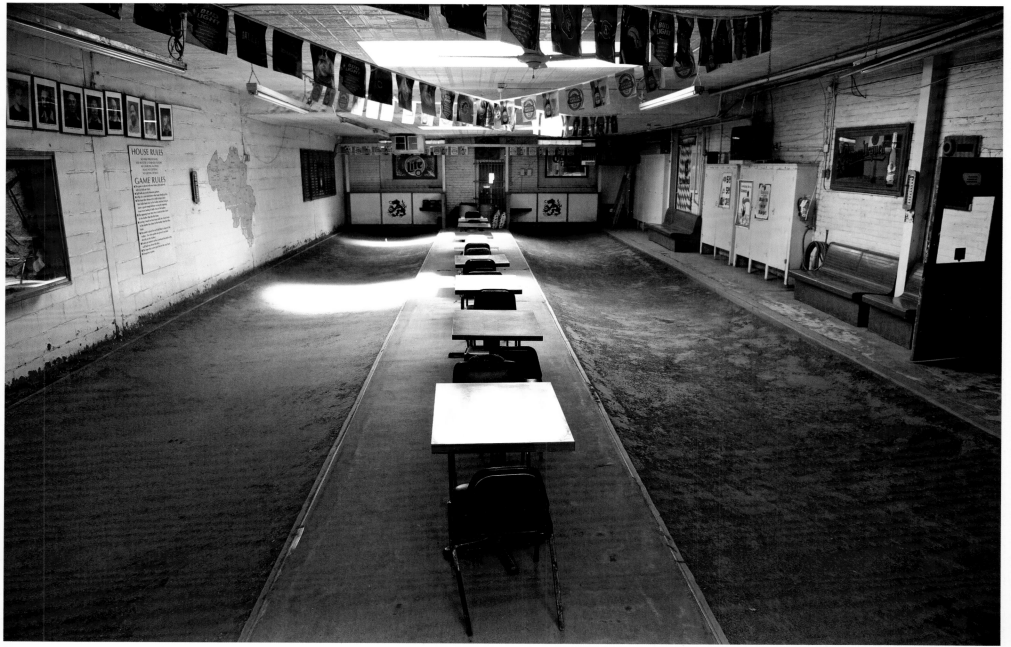

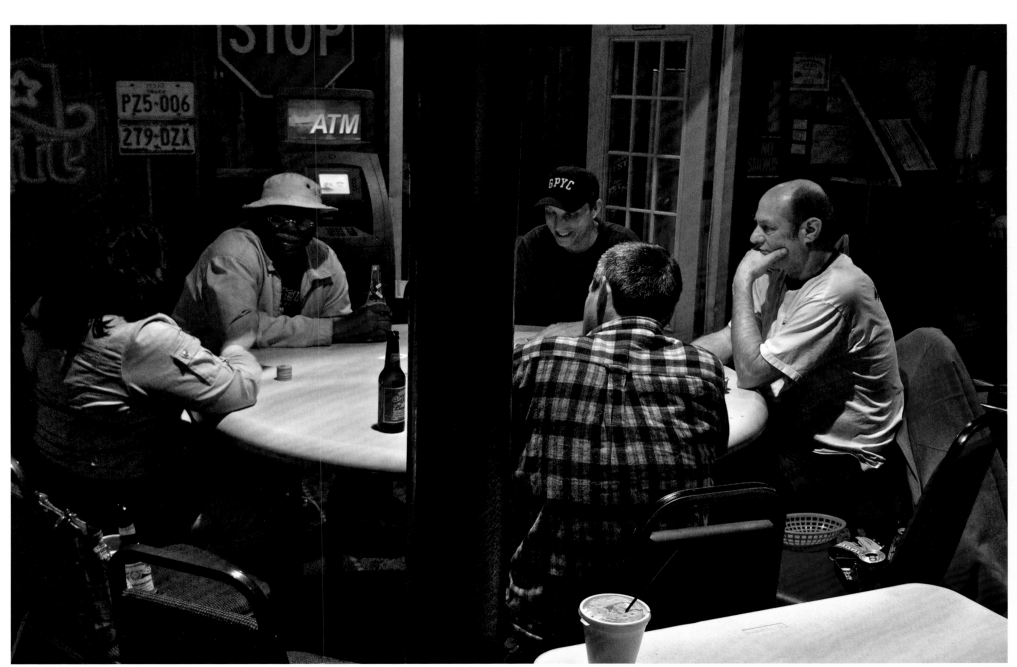

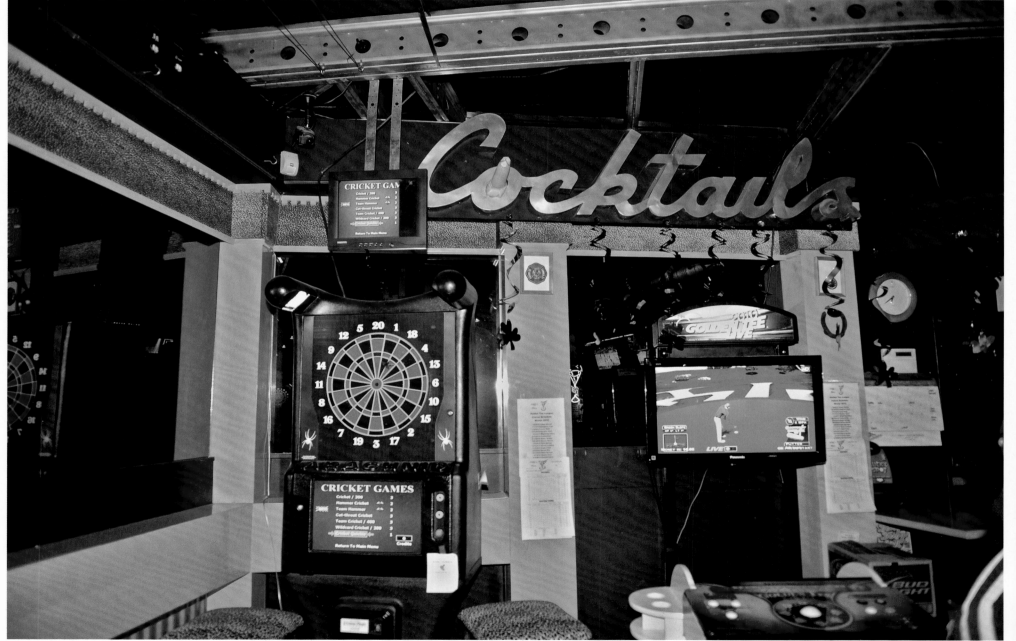

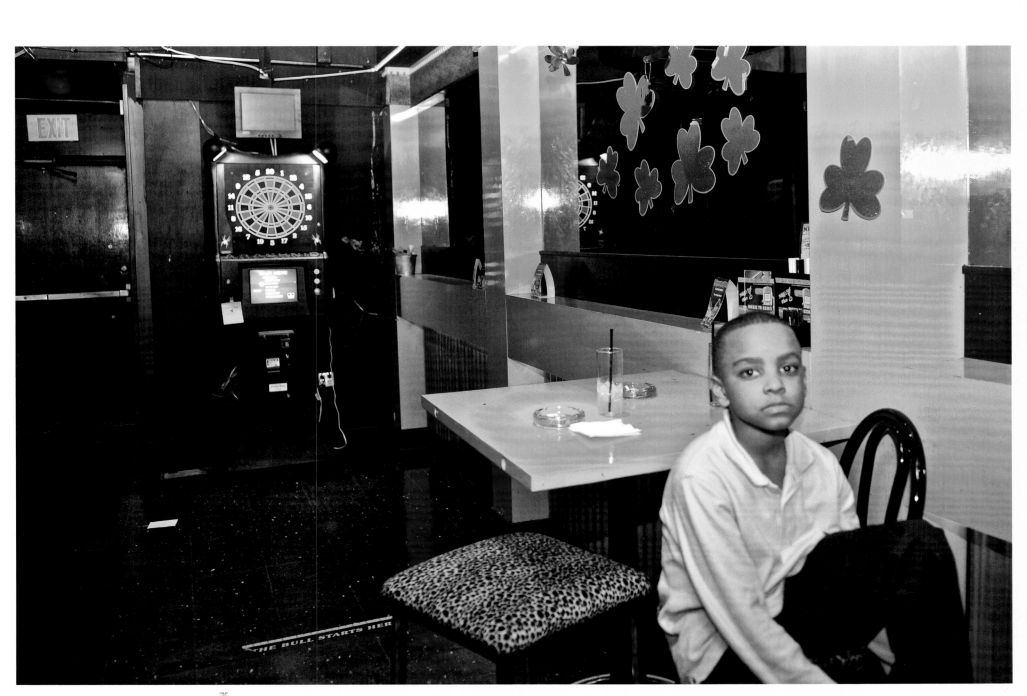

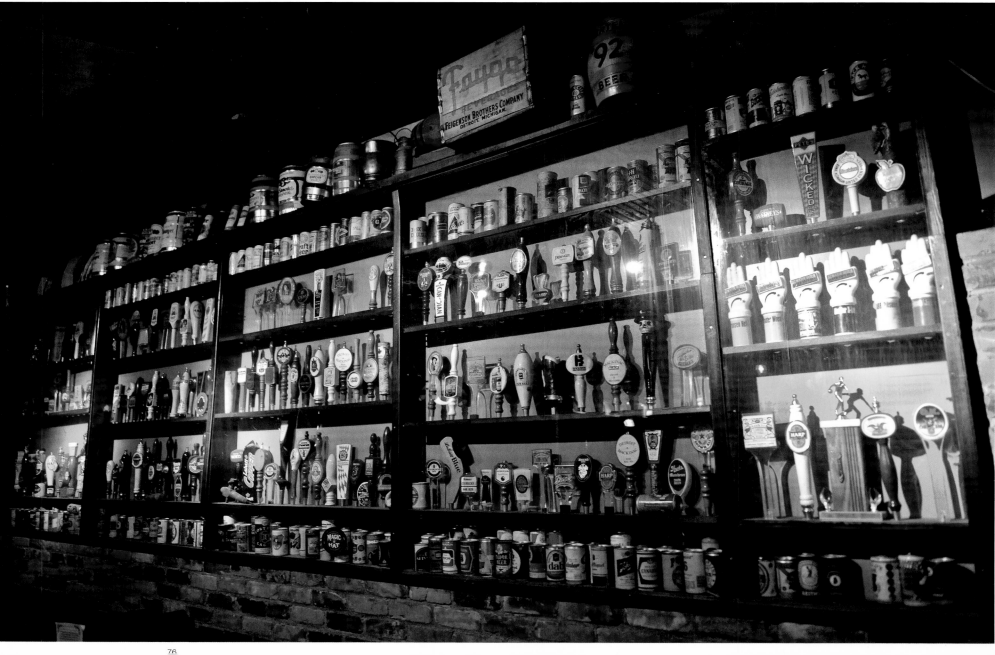

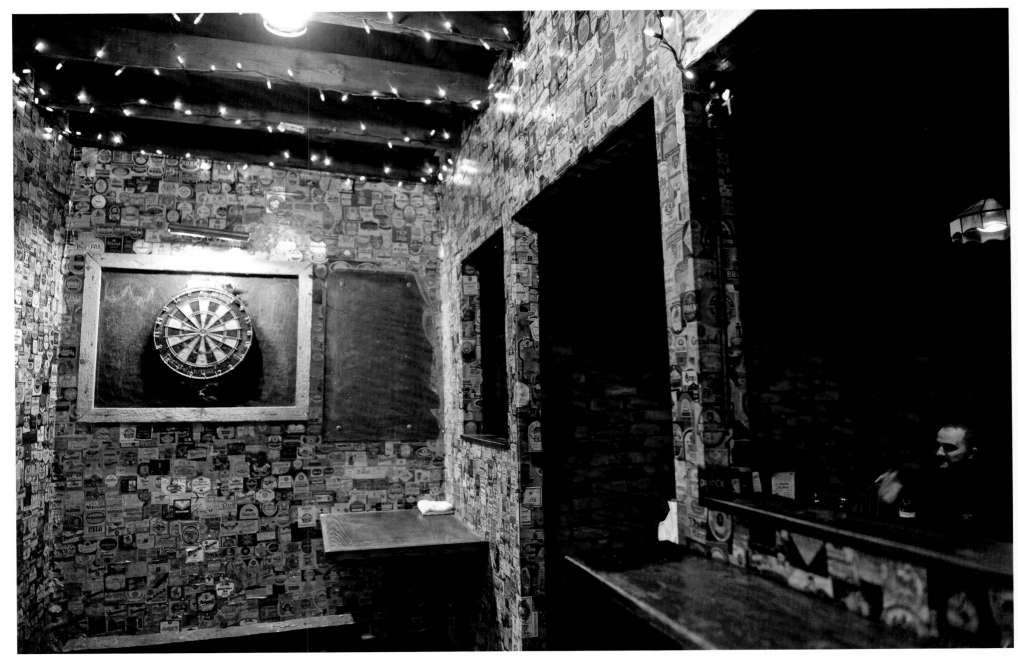

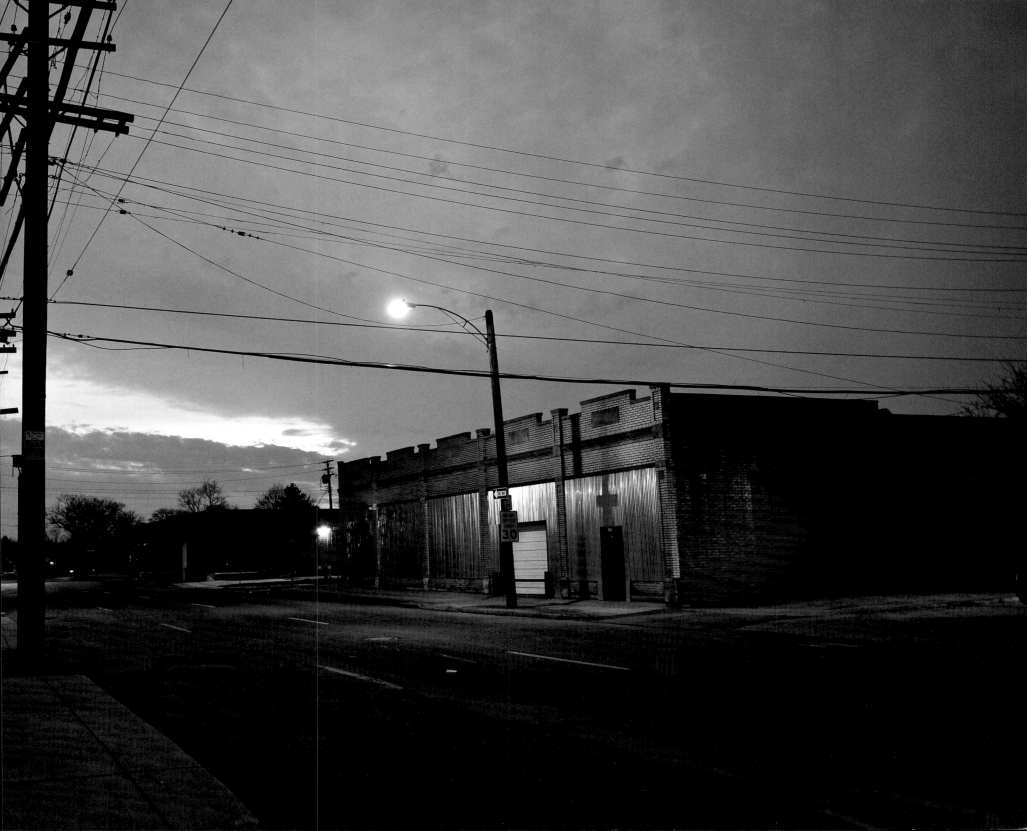

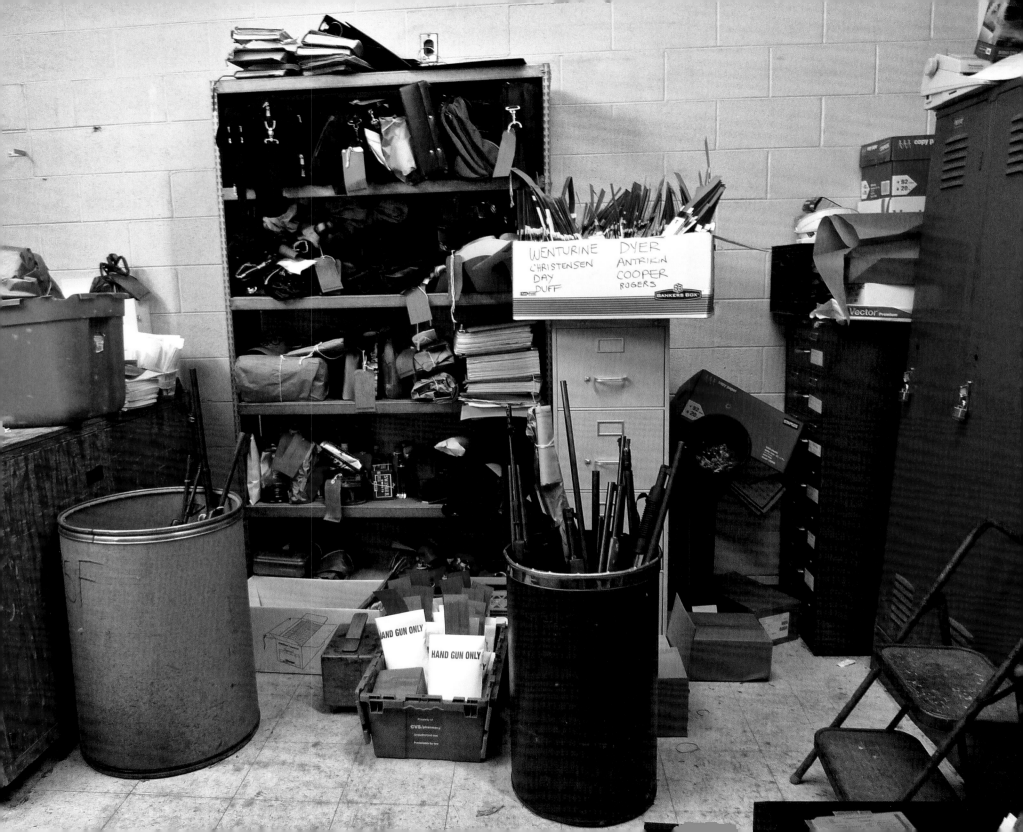

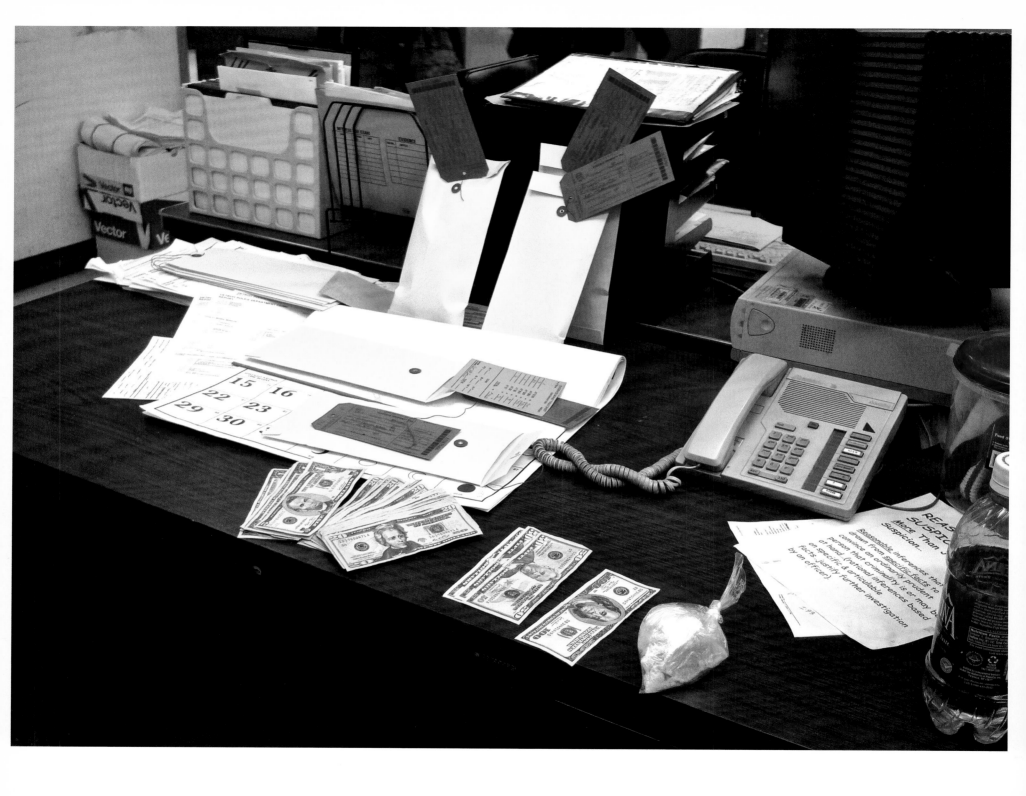

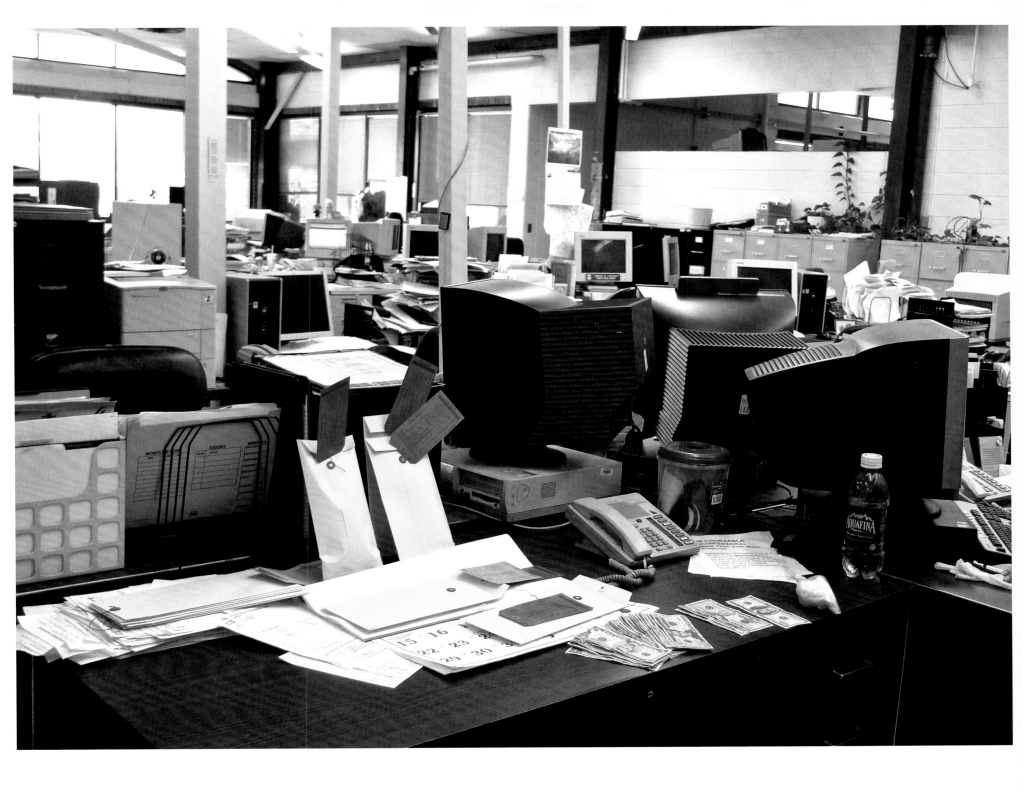

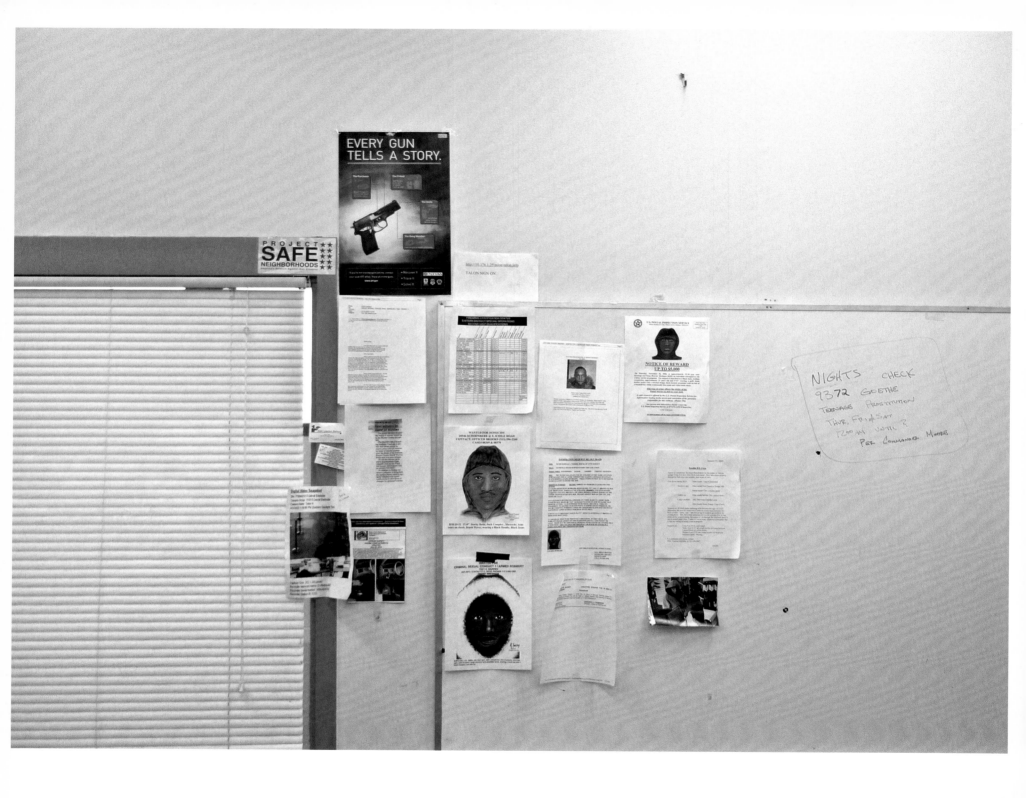

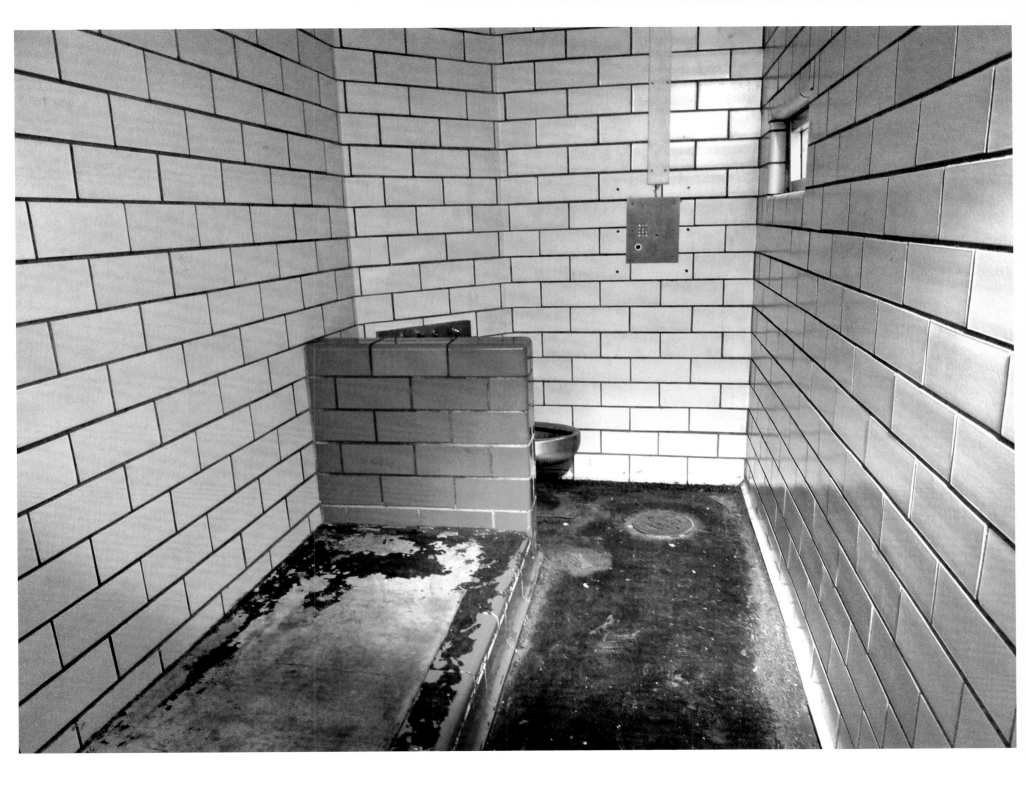

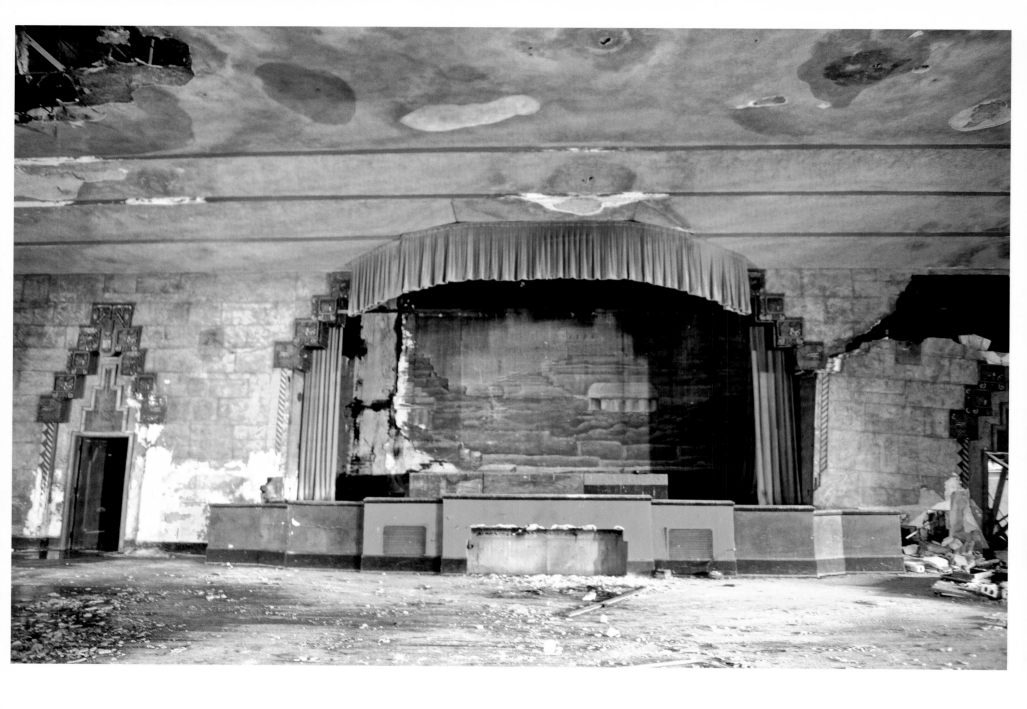

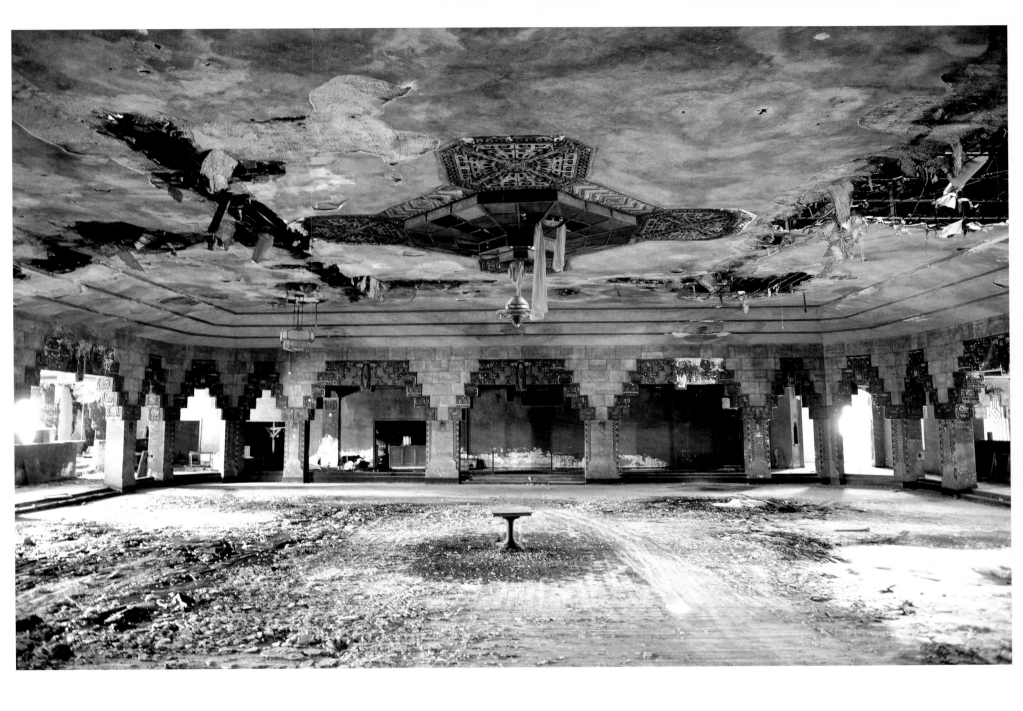

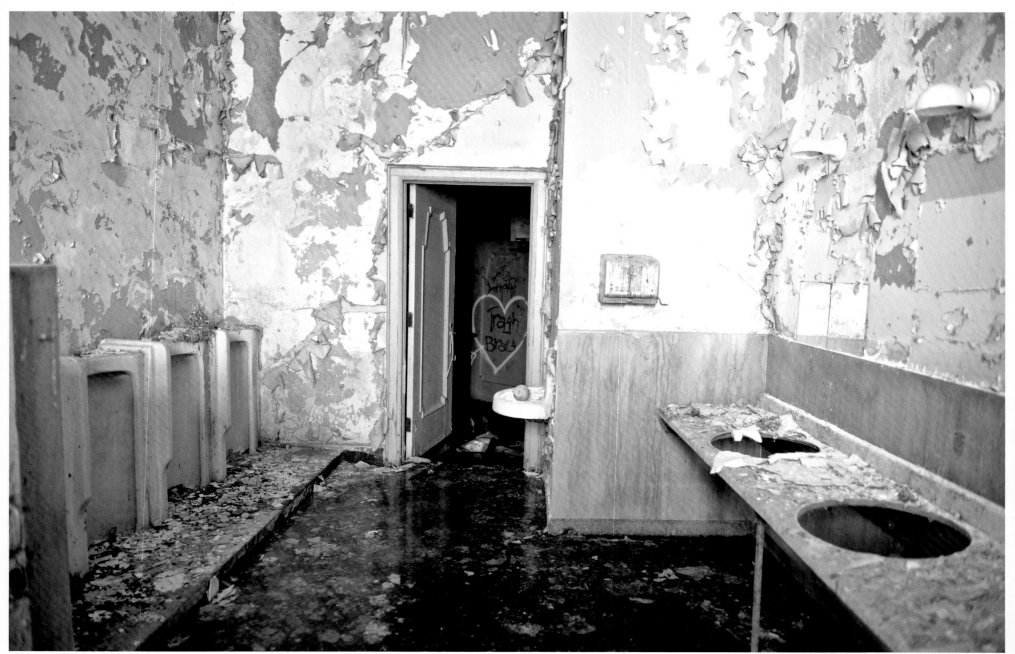

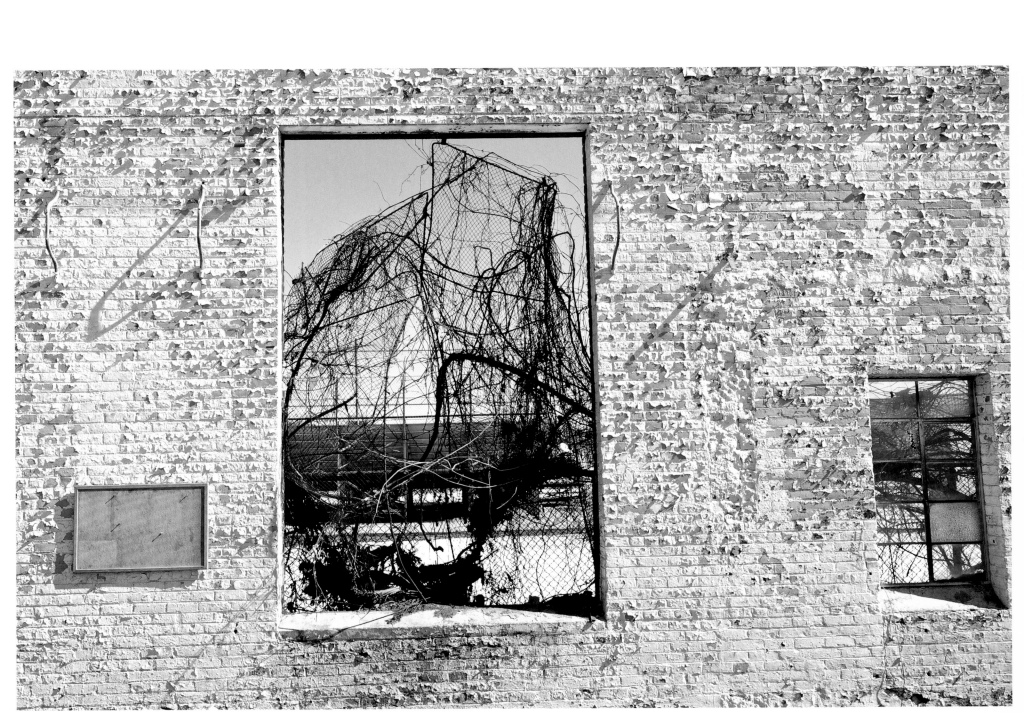

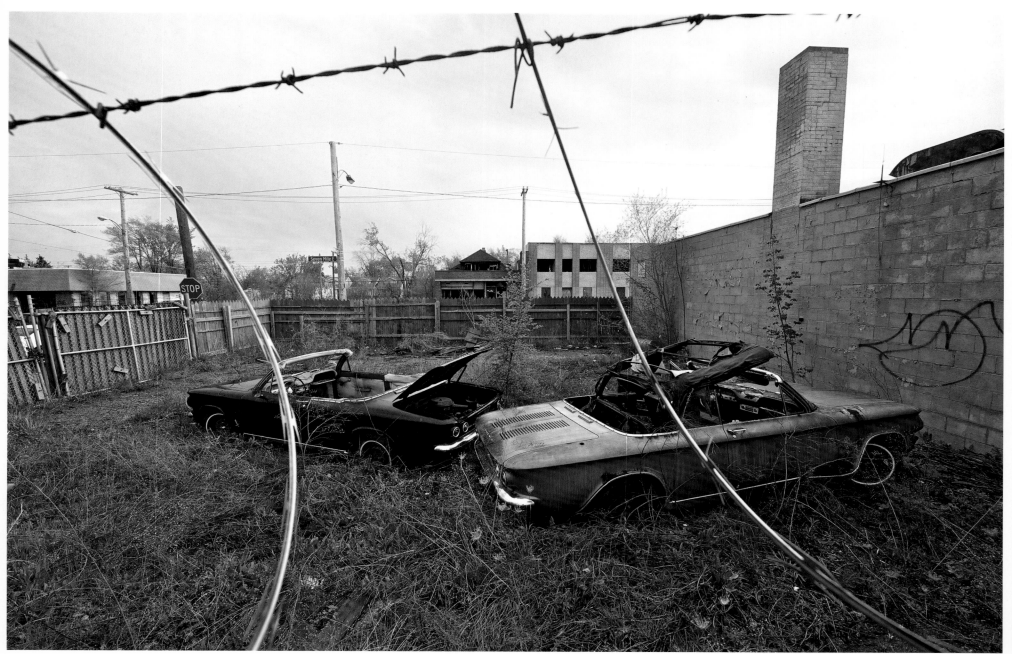

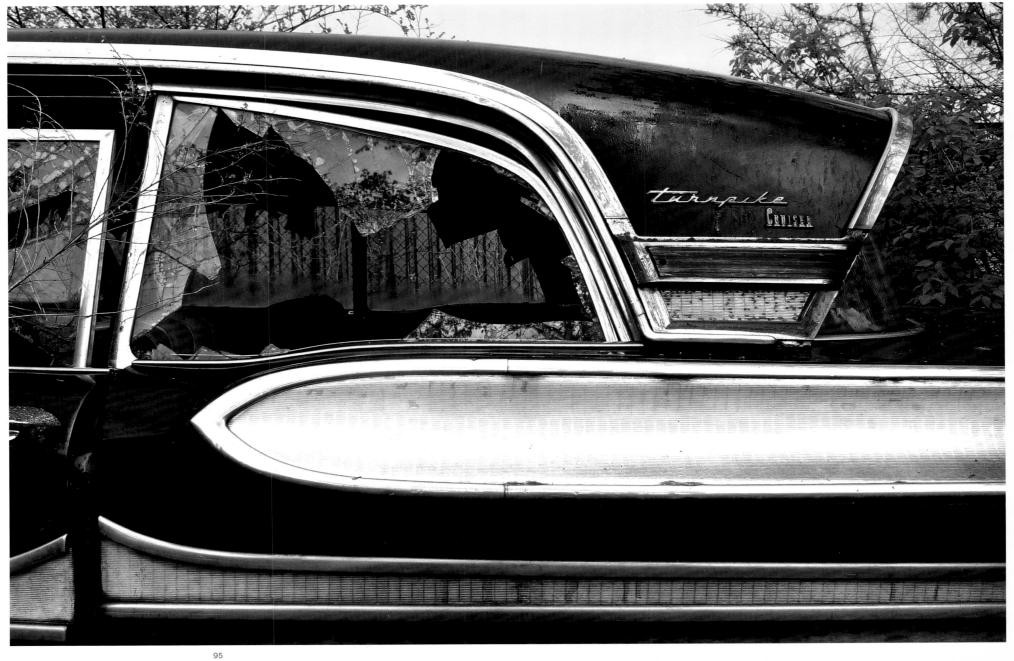

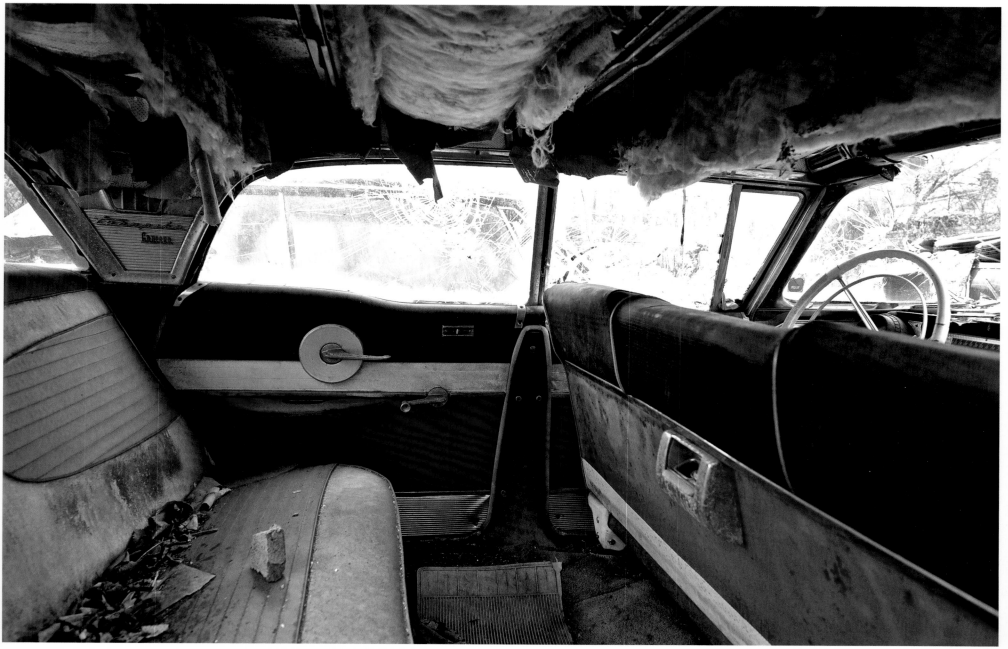

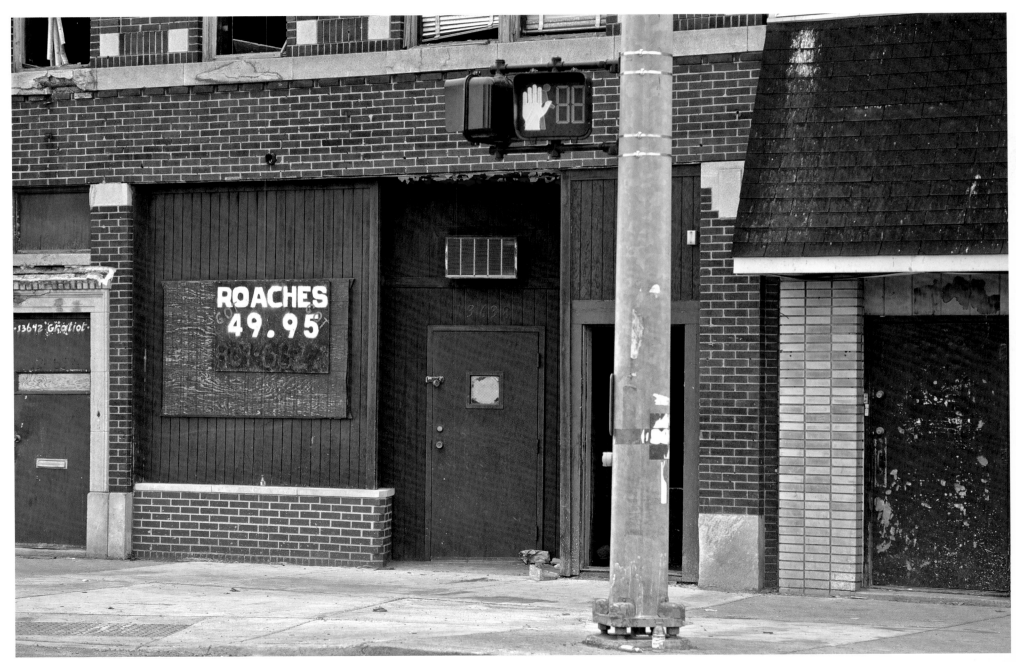

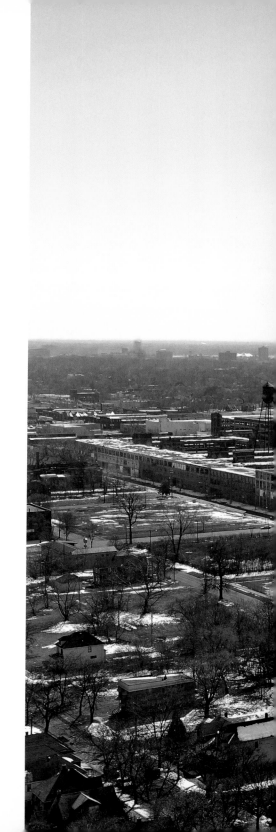

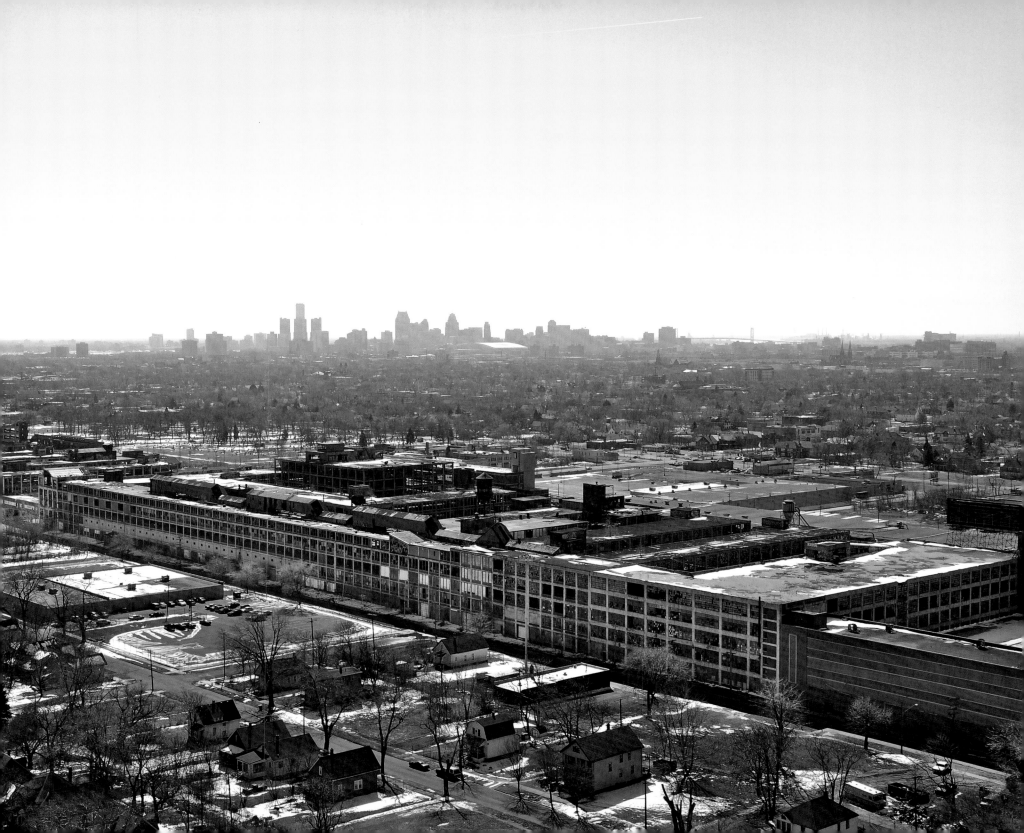

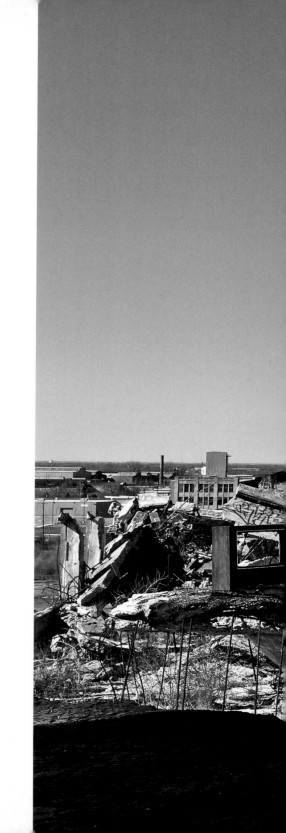

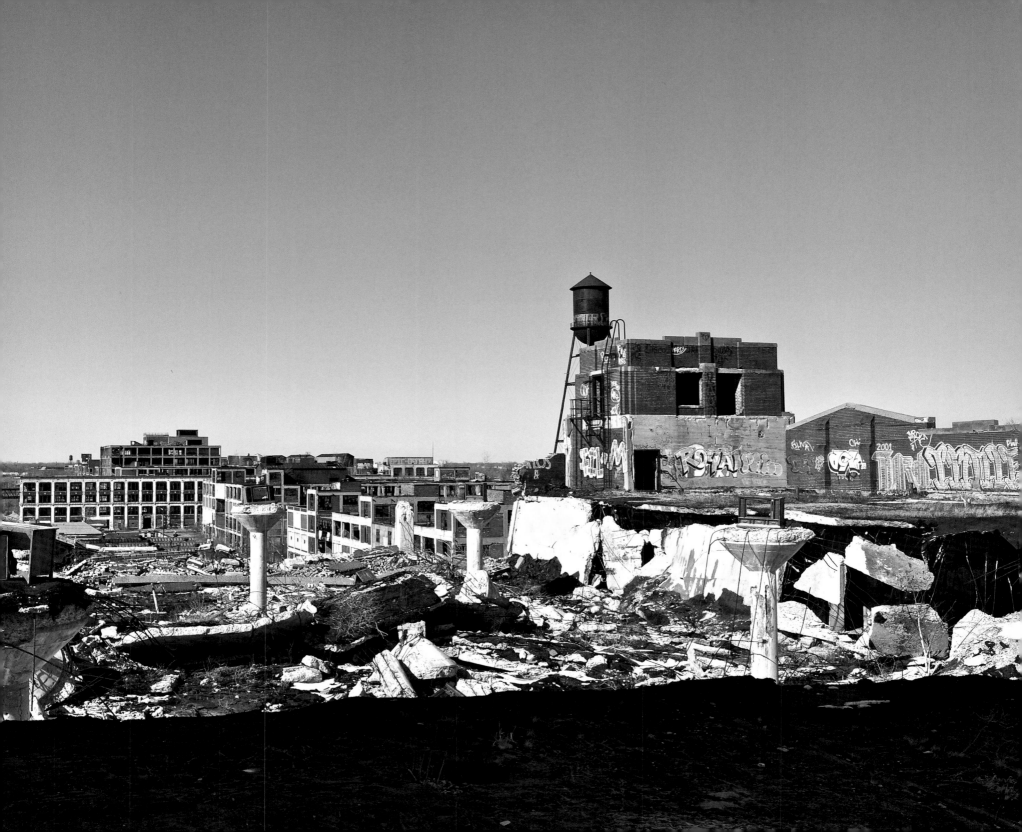

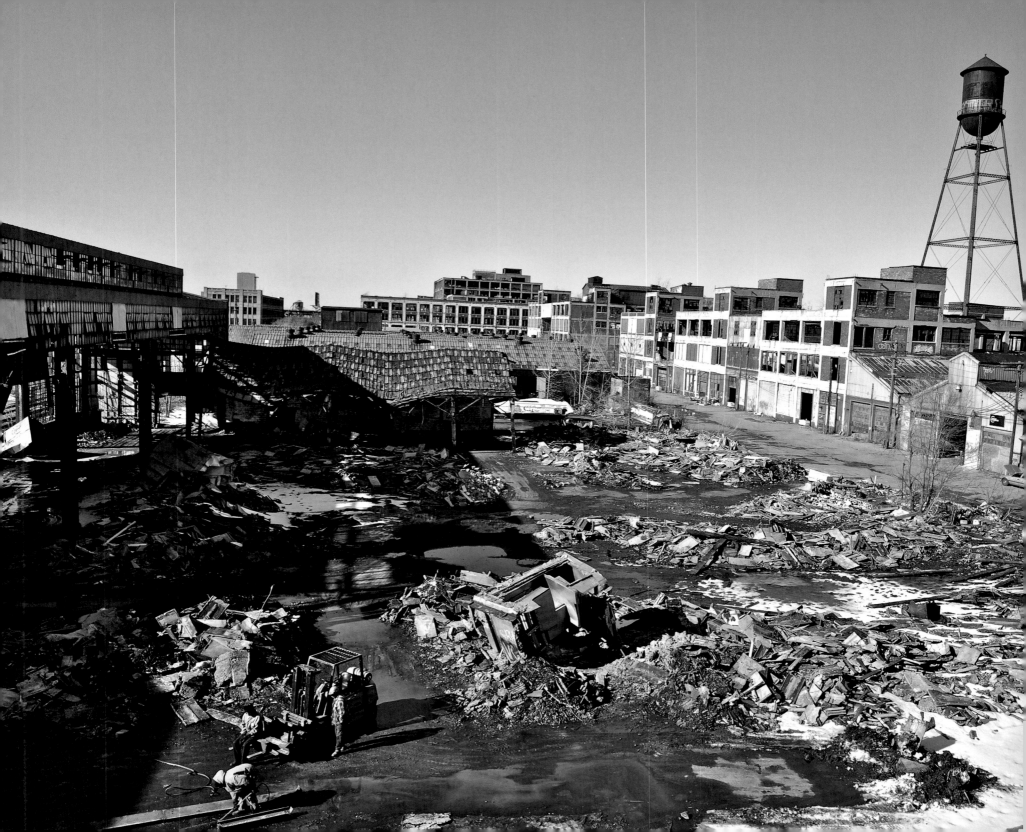

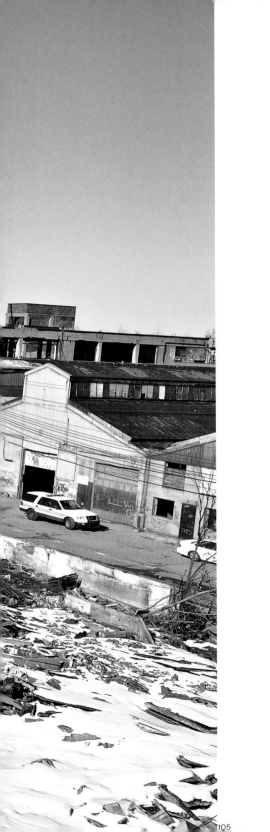

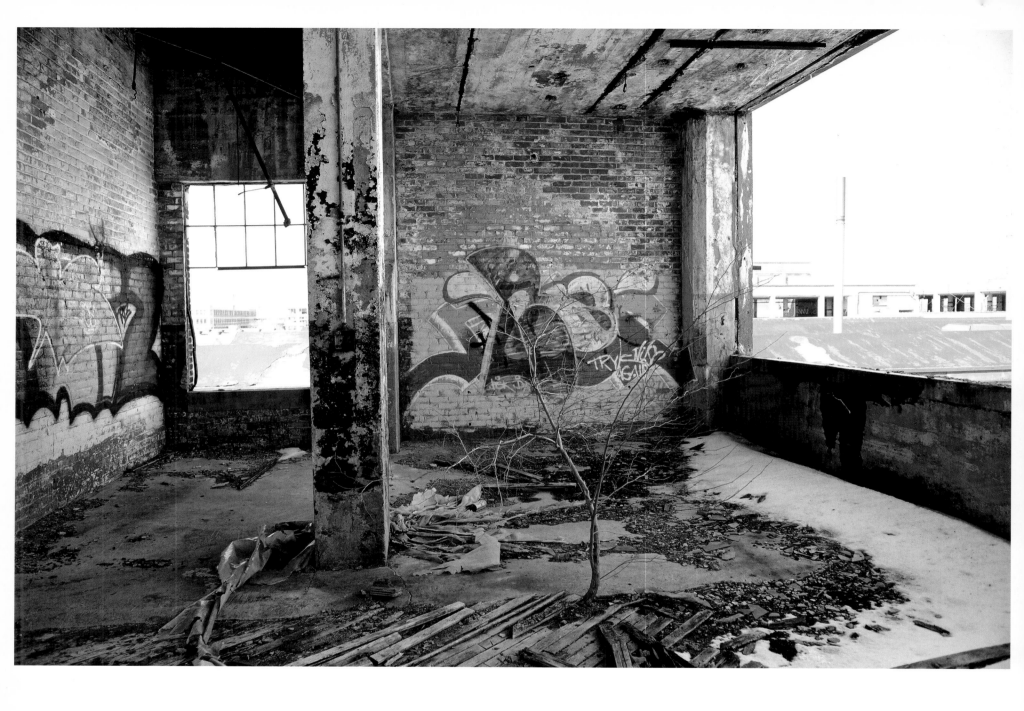

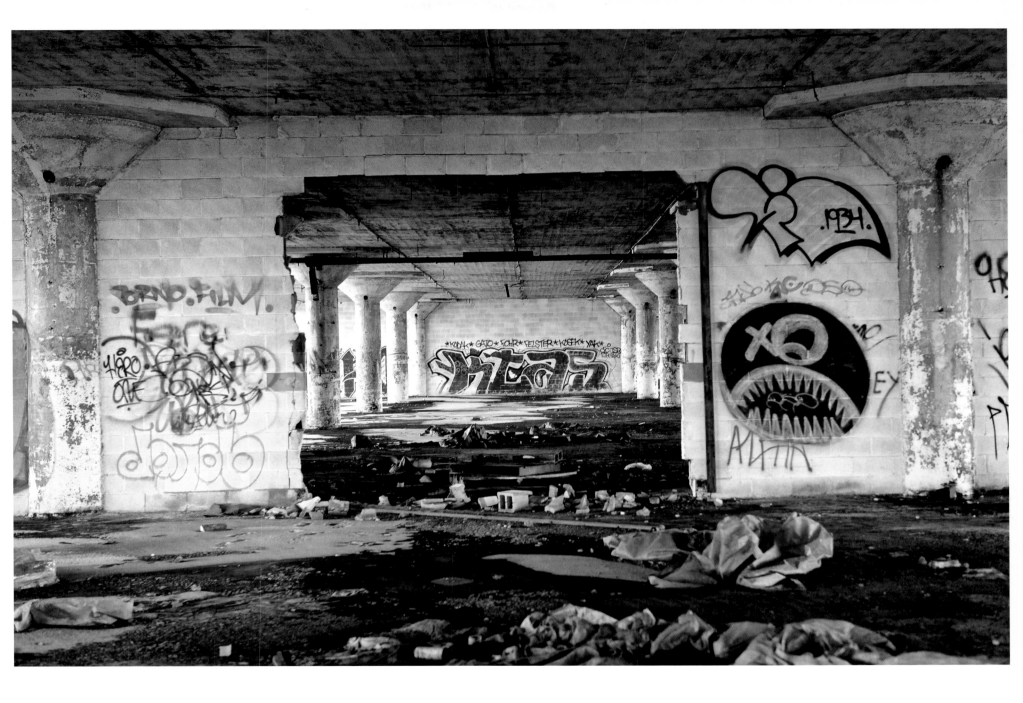

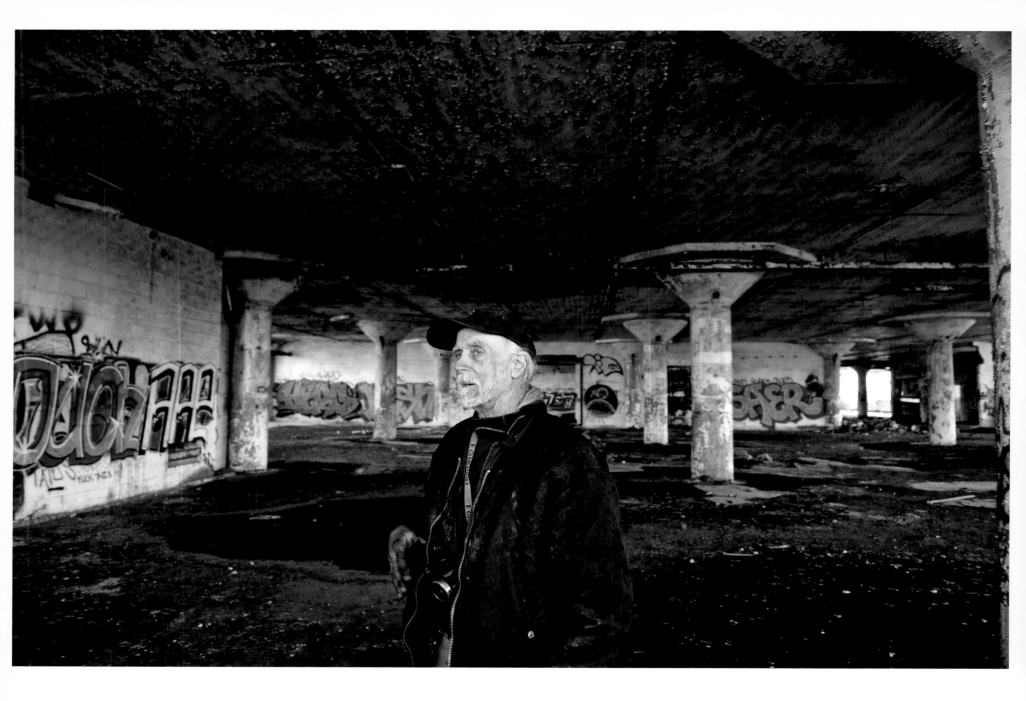

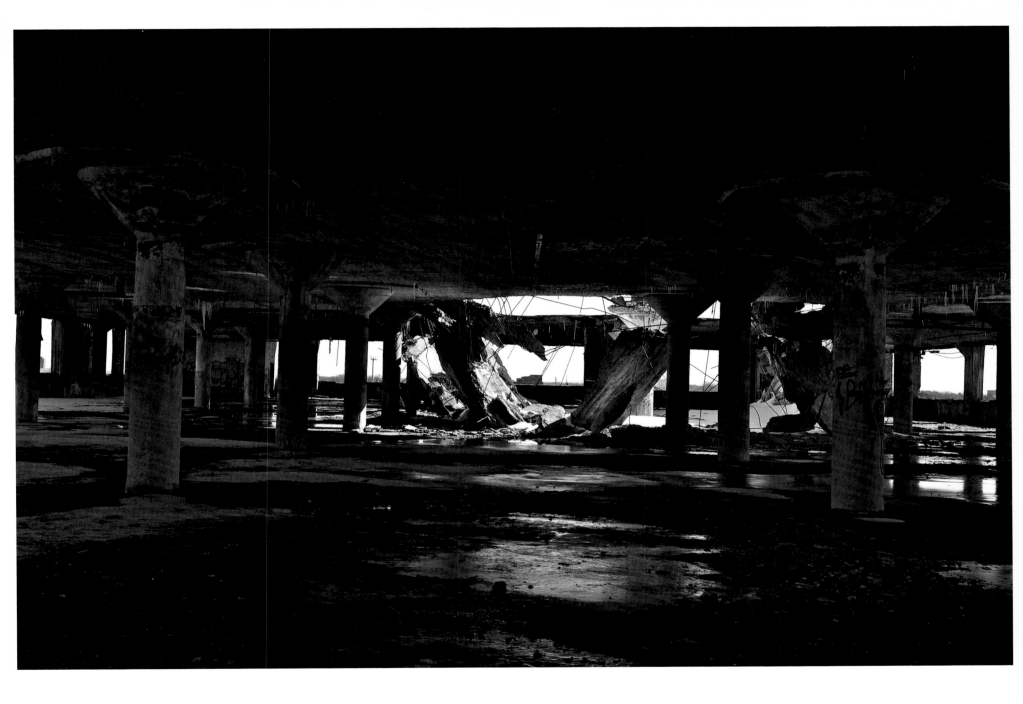

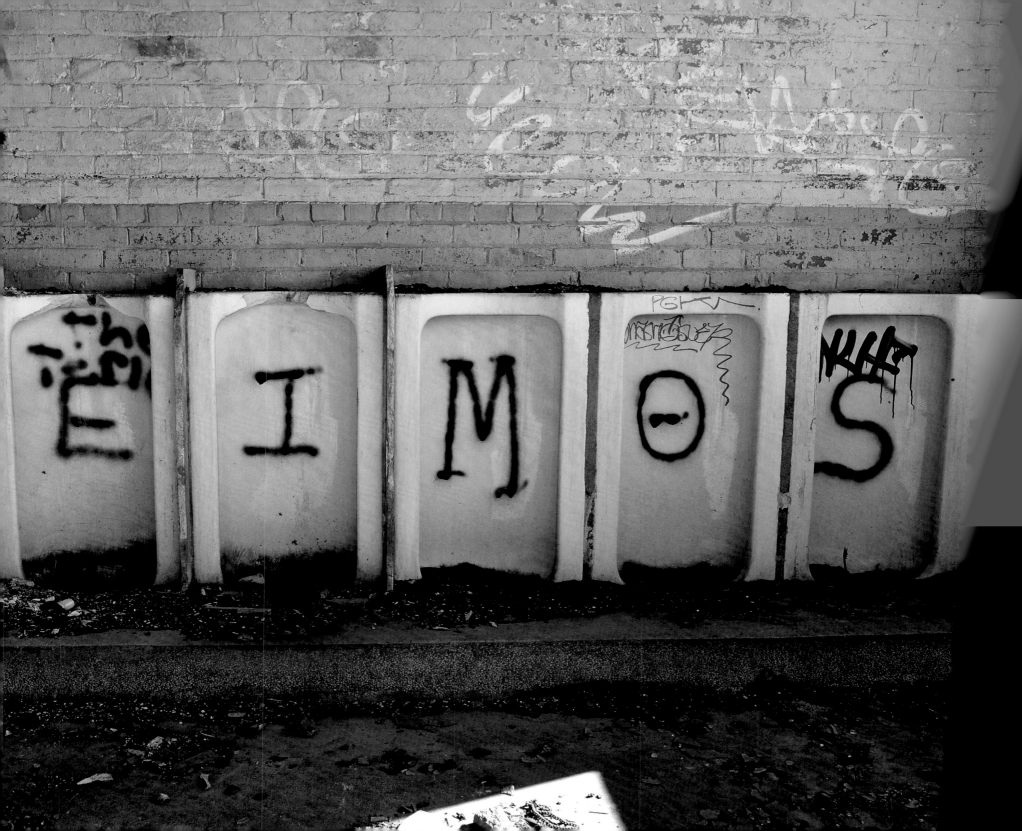

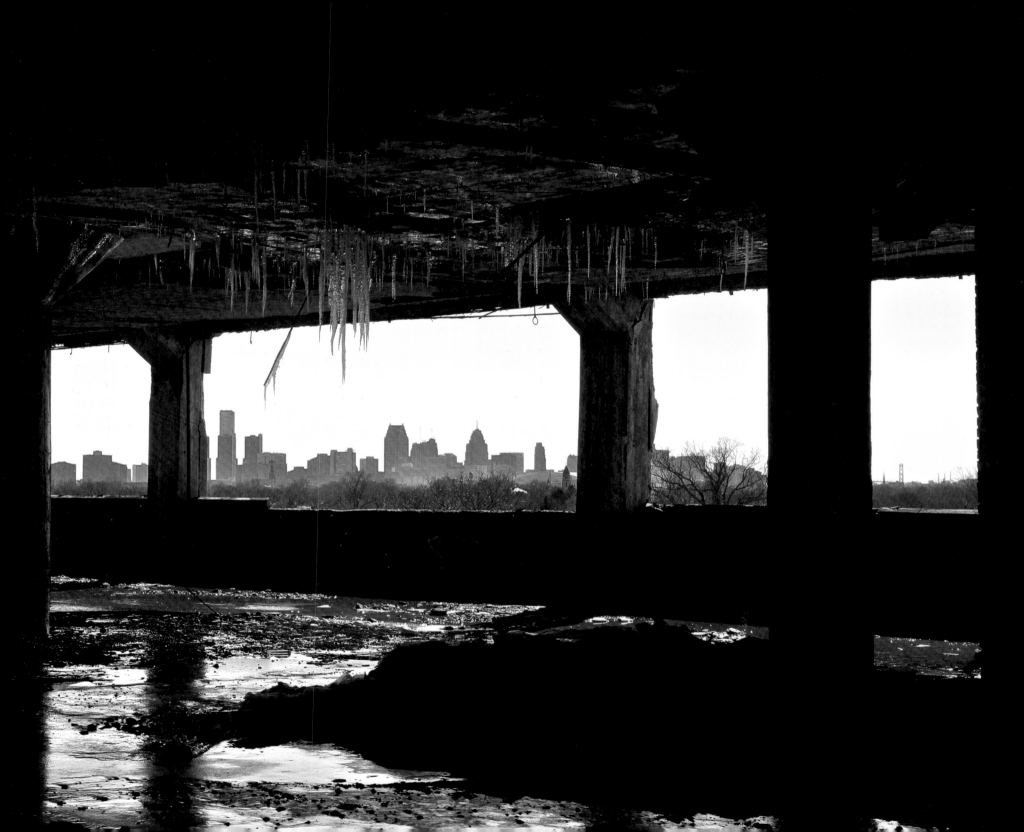

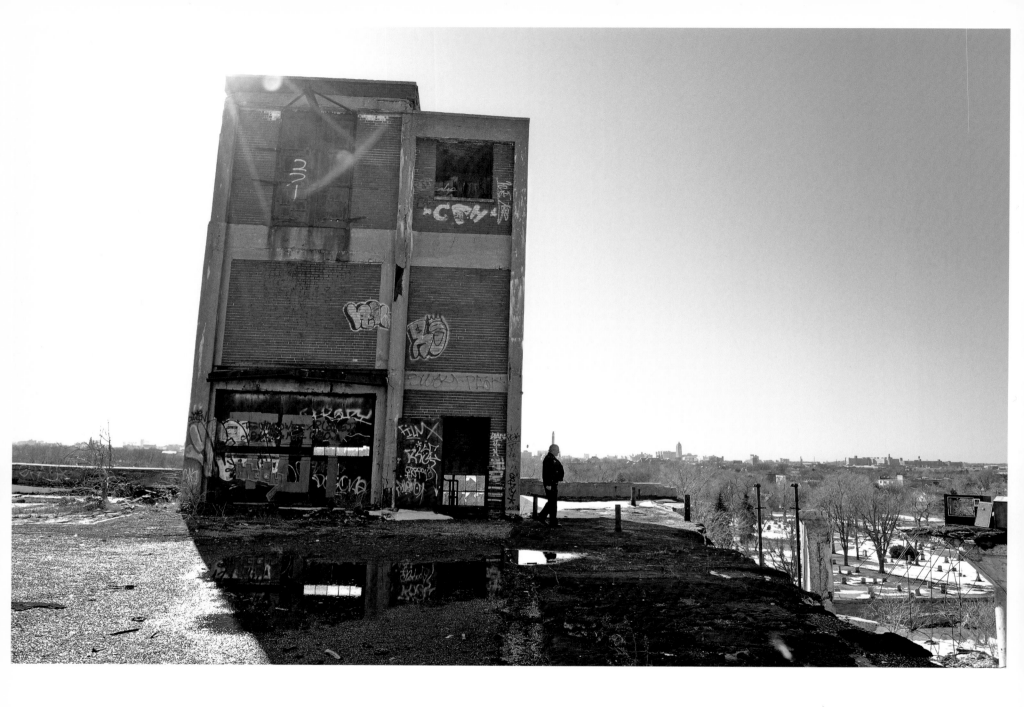

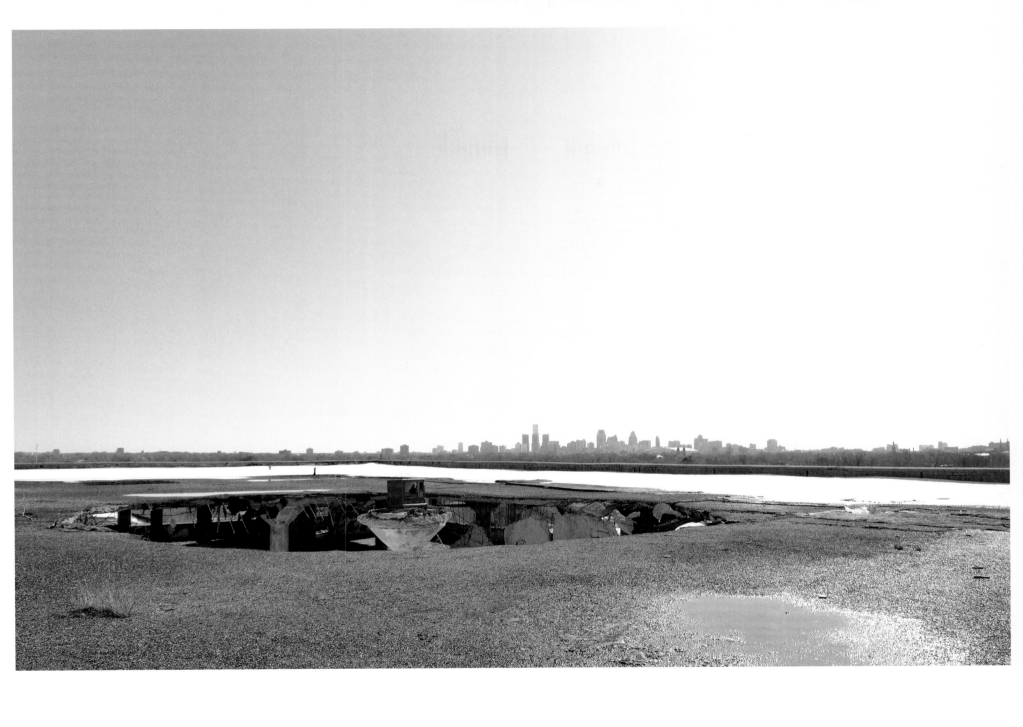

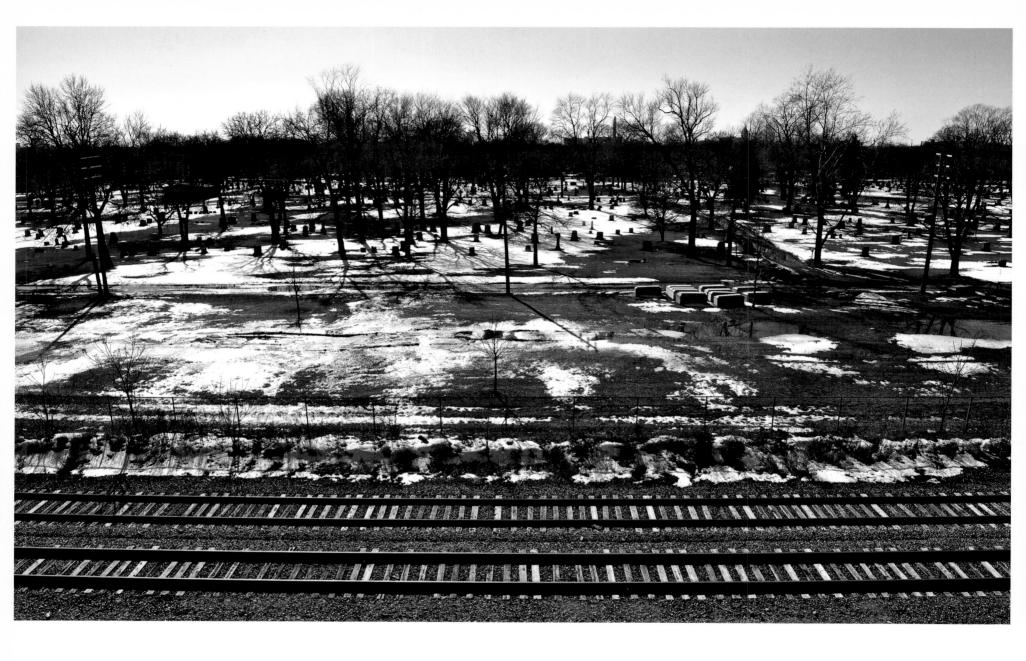

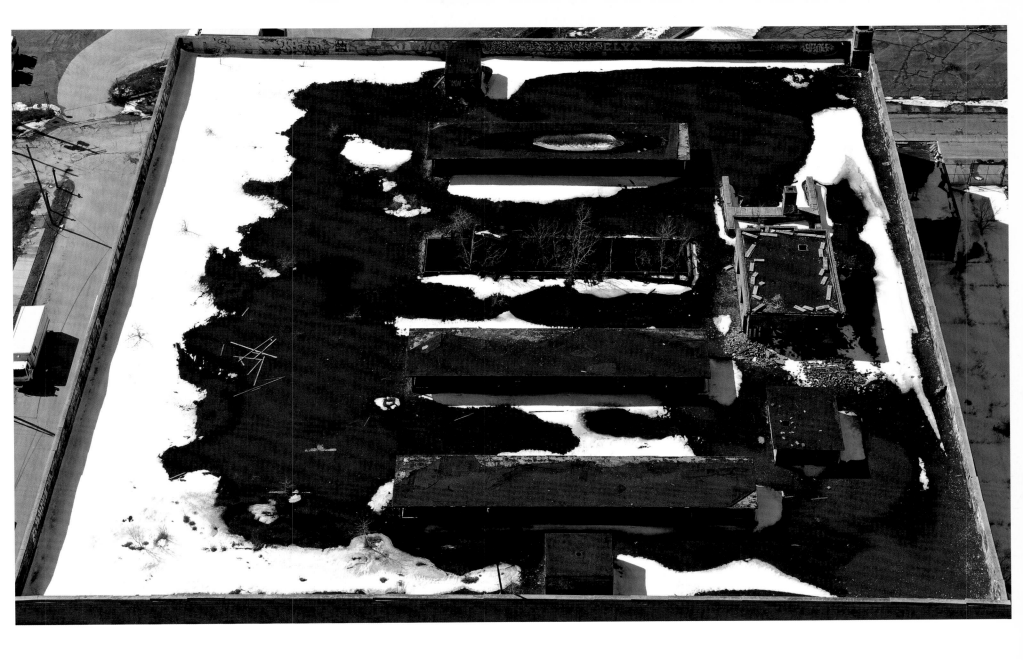

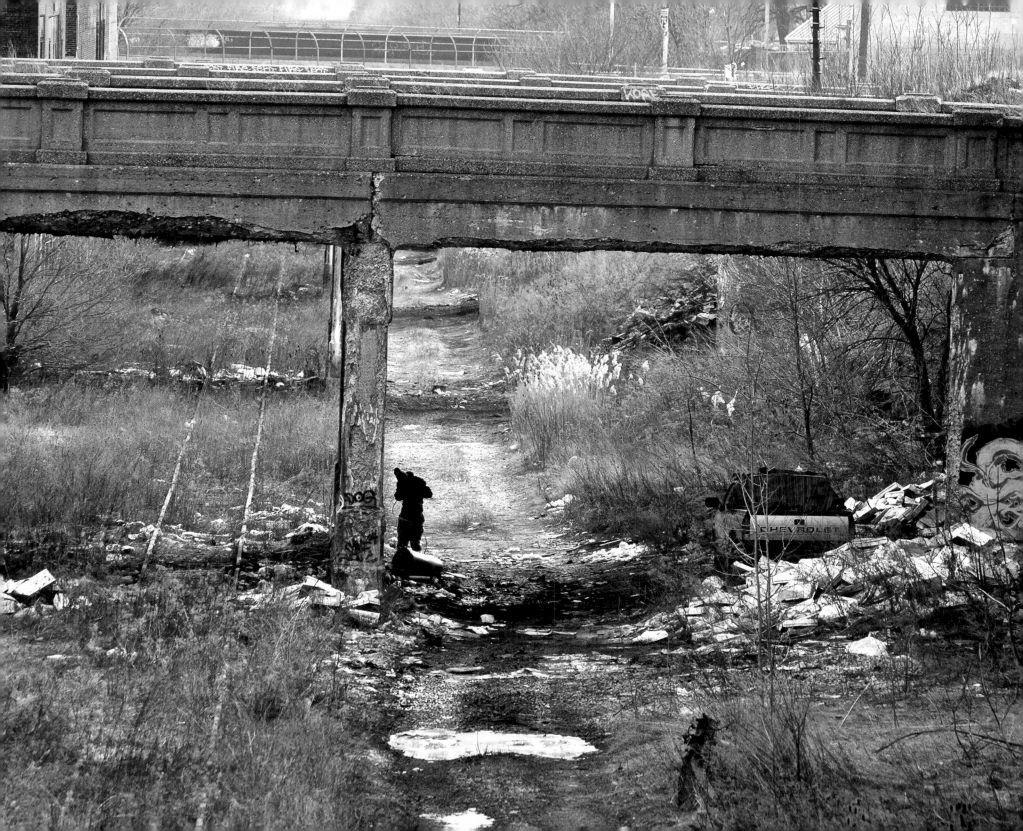

INJURED?
1-866-YOUR RIGHTS
Attorney
Joumana Kayrouz
◎CBS

40. Period!
Unlimited talk, text, and web.
Nationwide. metroPCS

EAST
🛡️
94

EAST
🛡️
94

MOTOR
VEHICLES
ONLY

FedEx
Ground

SUNOCO

Regular Cash	2 6 5 ⁹
Regular Credit	2 7 5 ⁹
Diesel Self	

WE ACCEPT BRIDGE CARD
LOTTO · ATM · SANDWICHES
COFFEE · CAPPUCCINO · CLOTHING
DISCOUNT CIGARETTES · PHONE CARDS

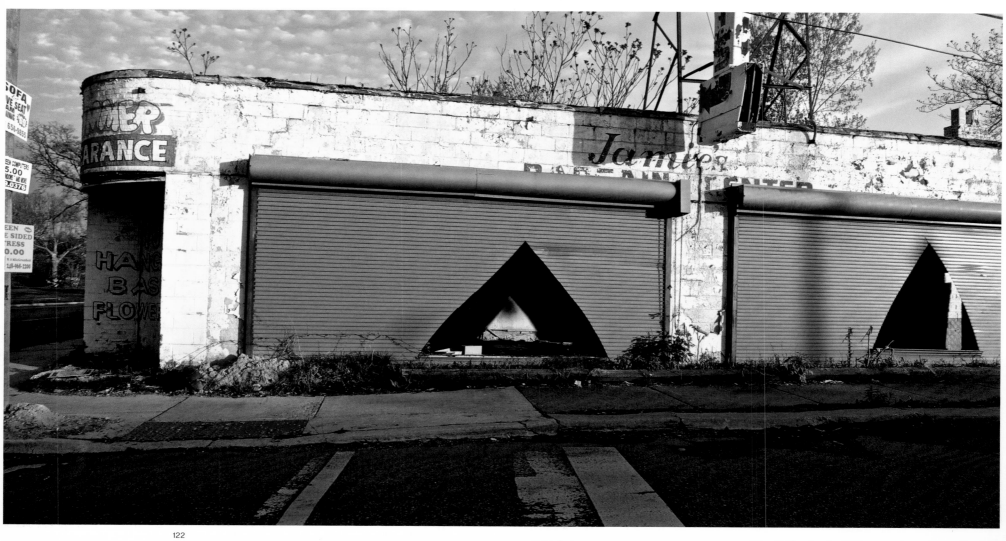

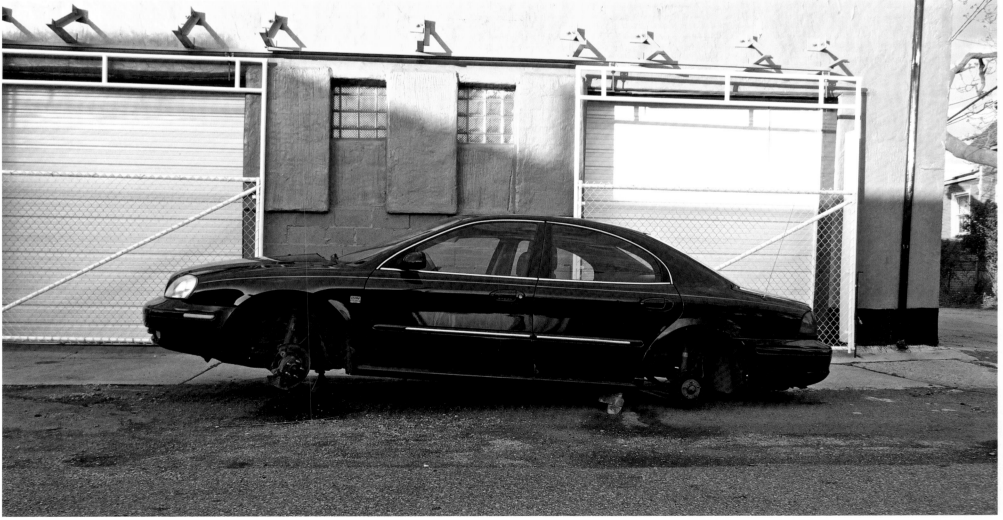

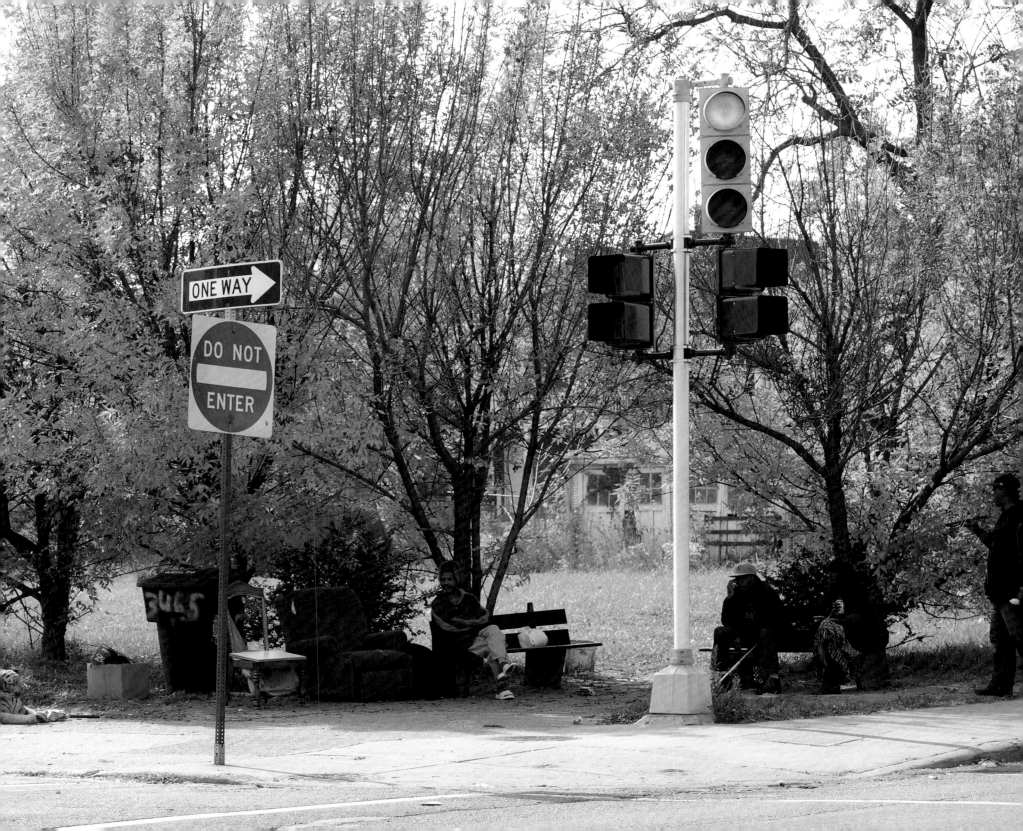

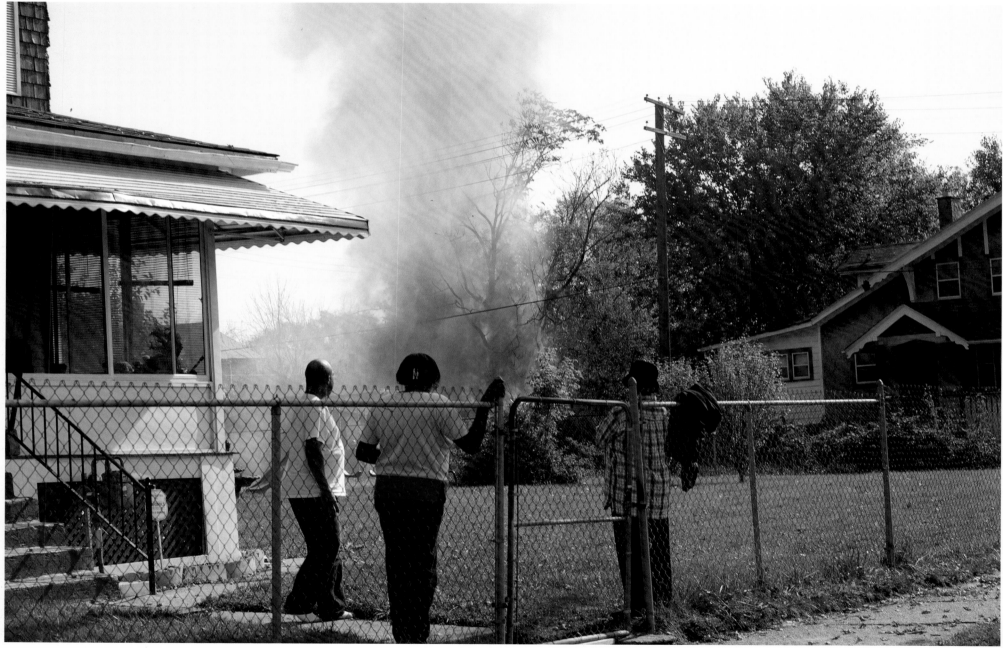

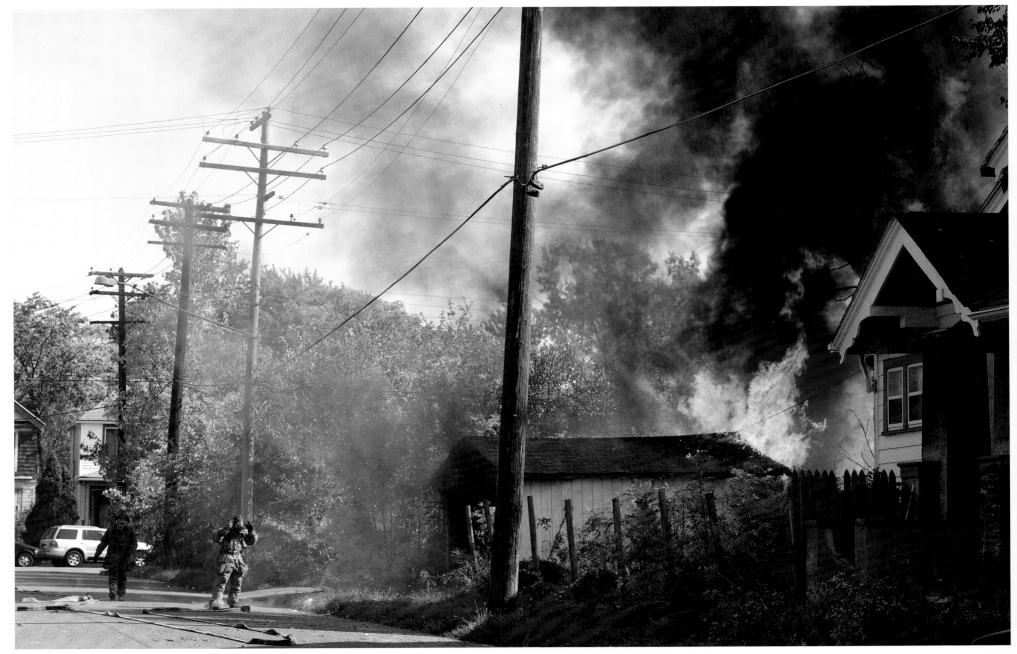

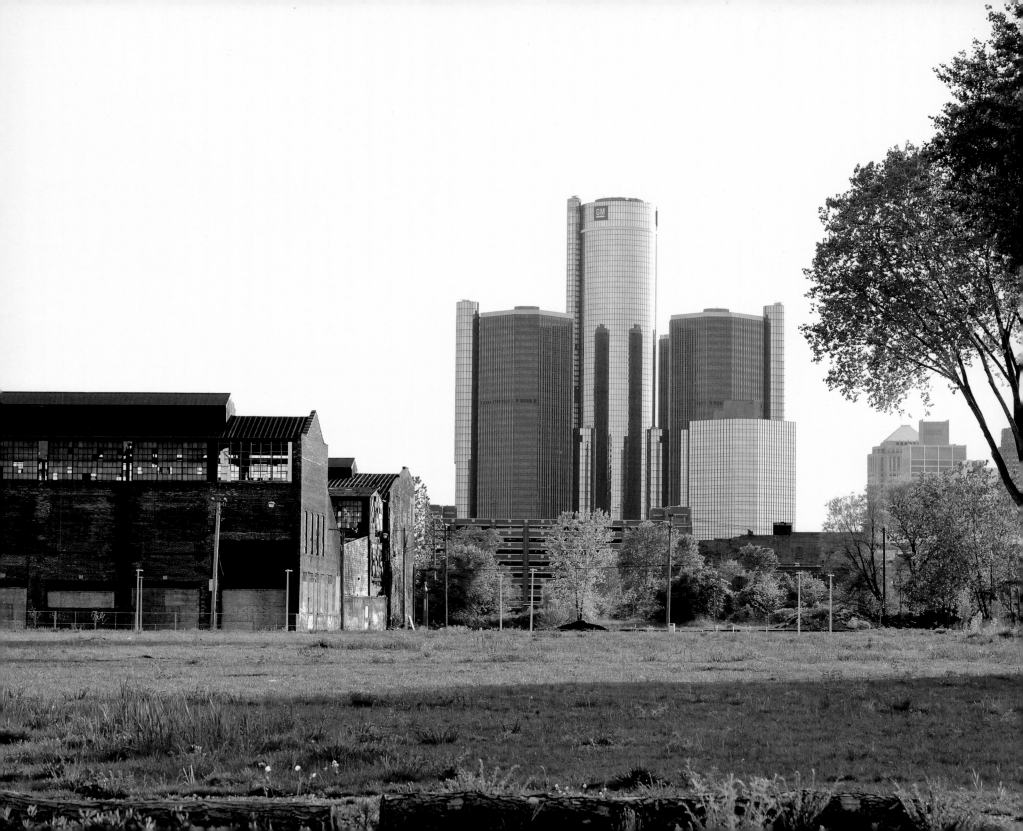

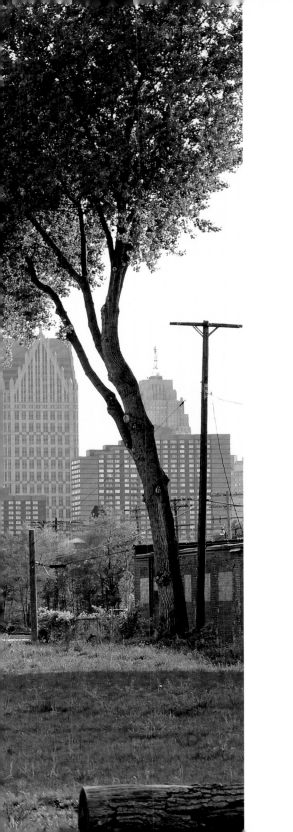

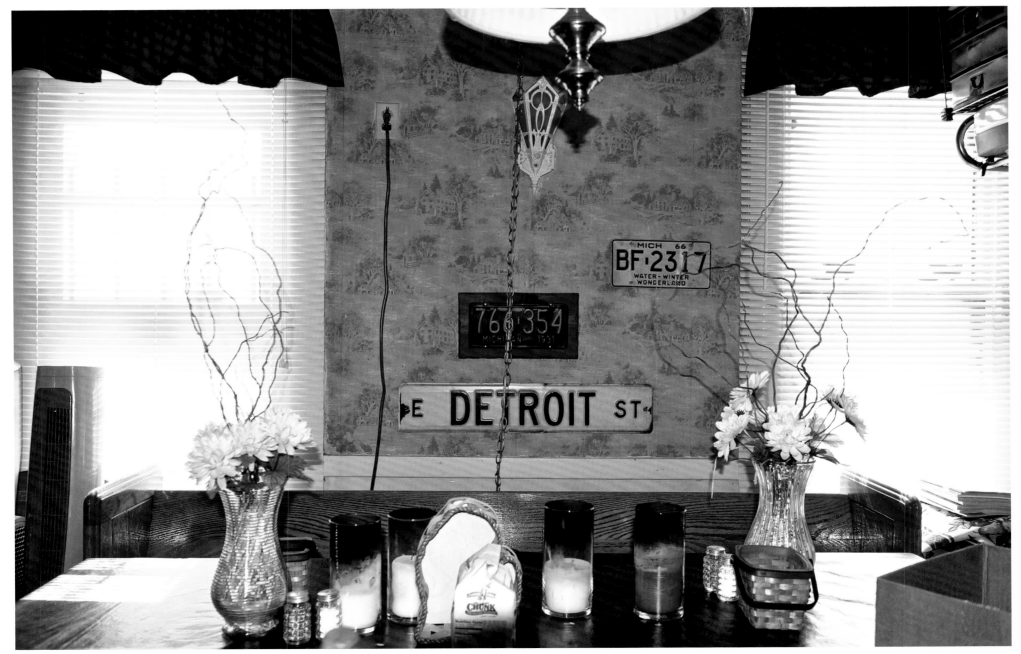

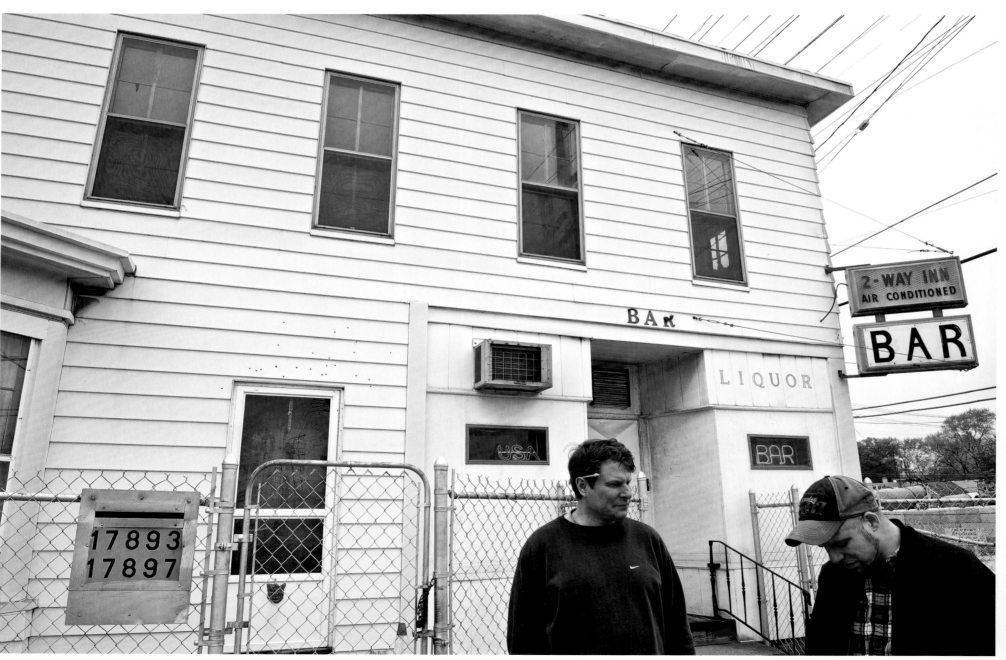

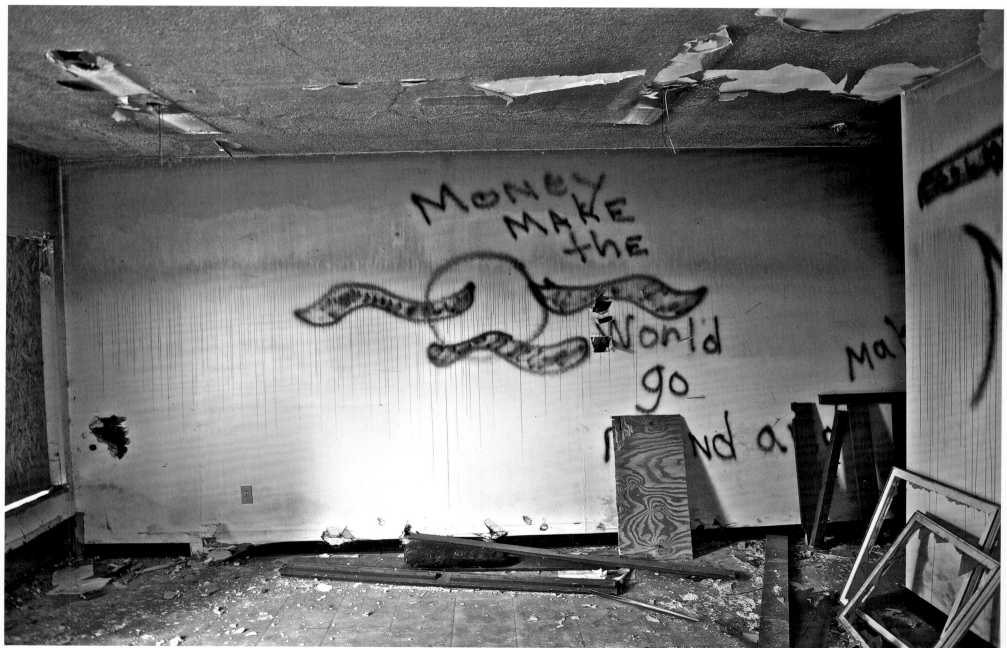

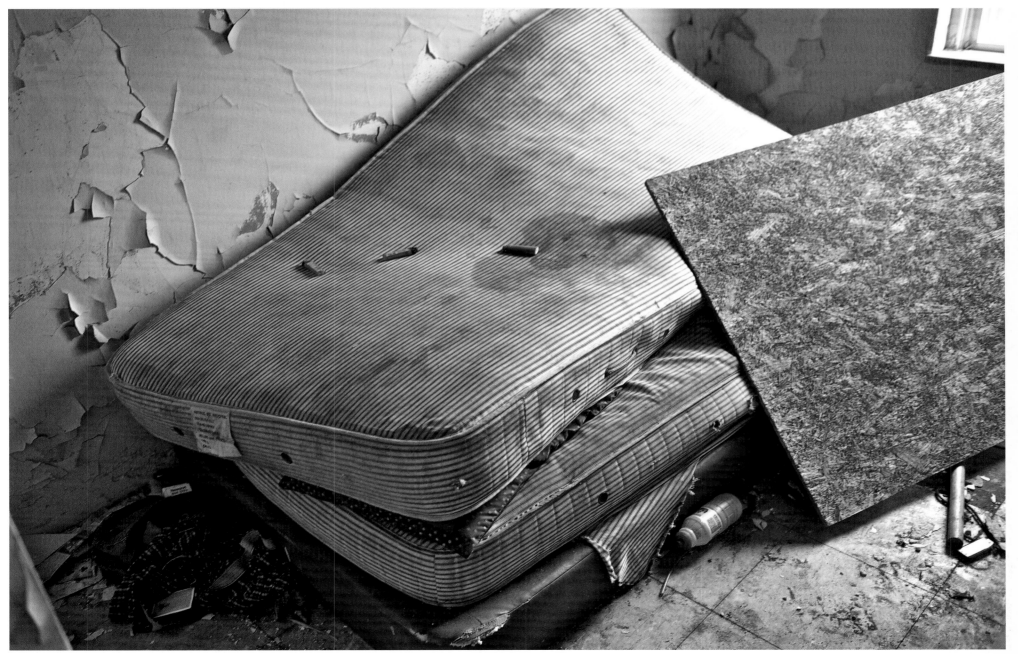

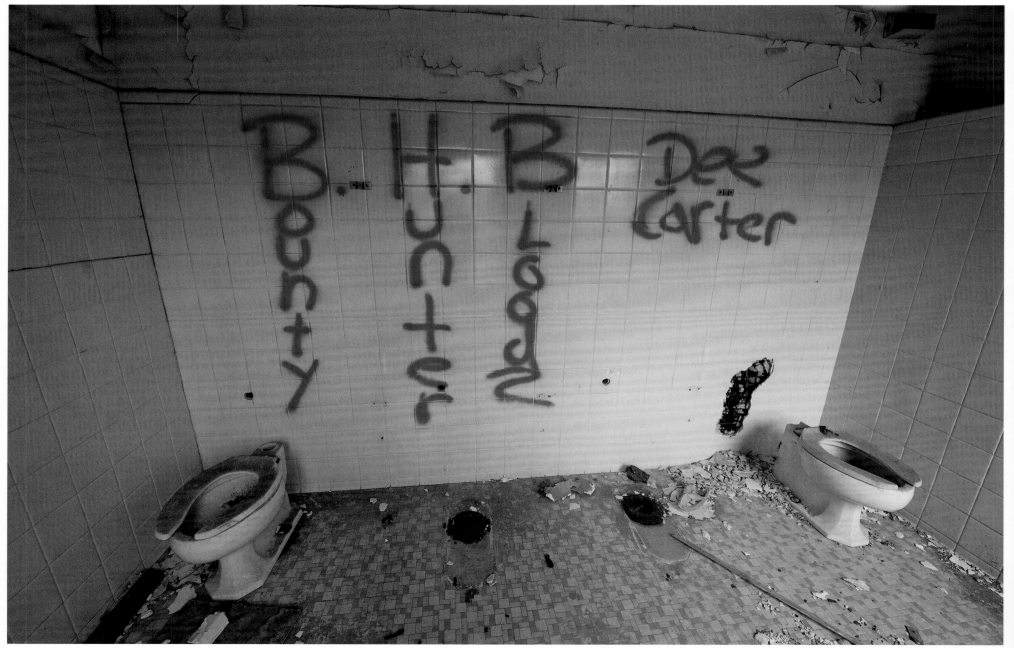

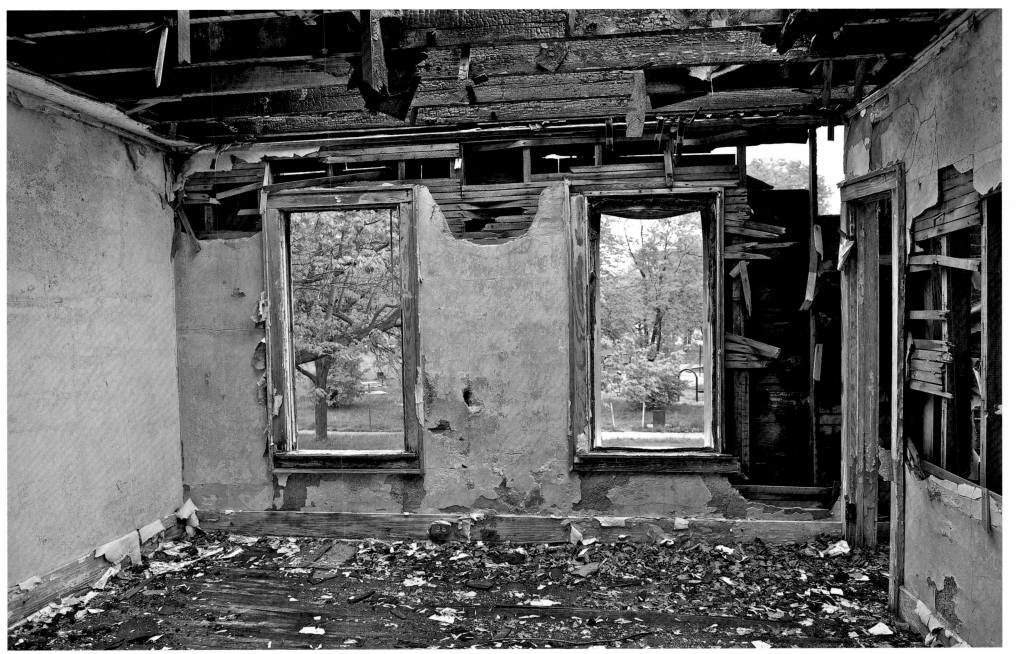

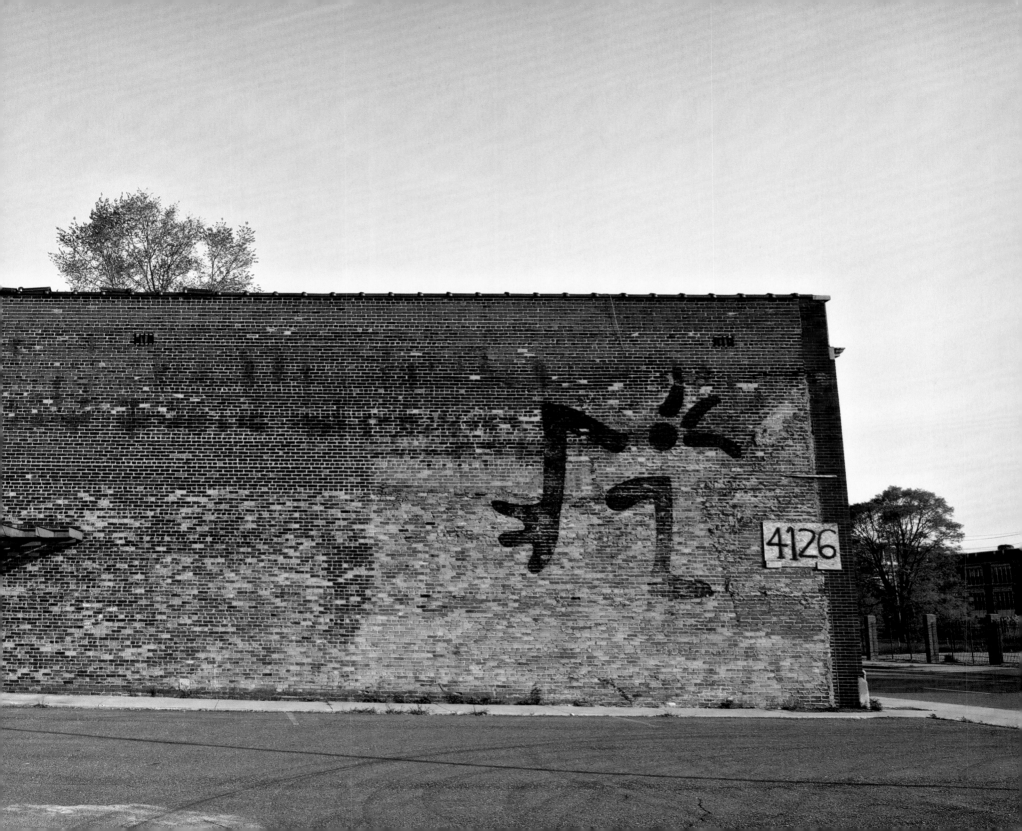

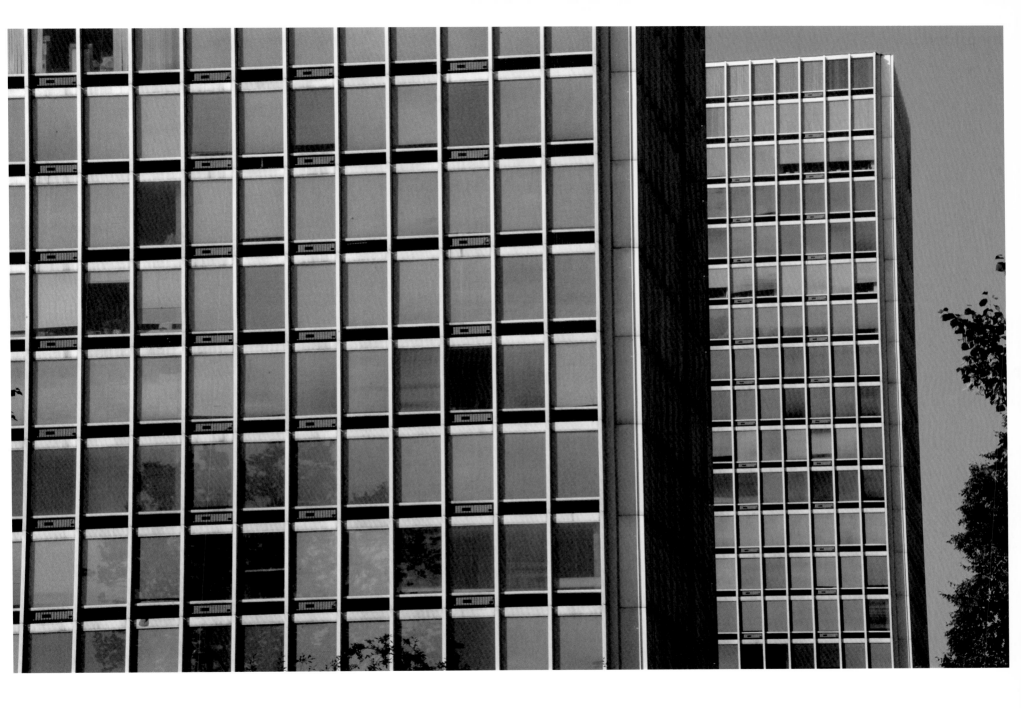

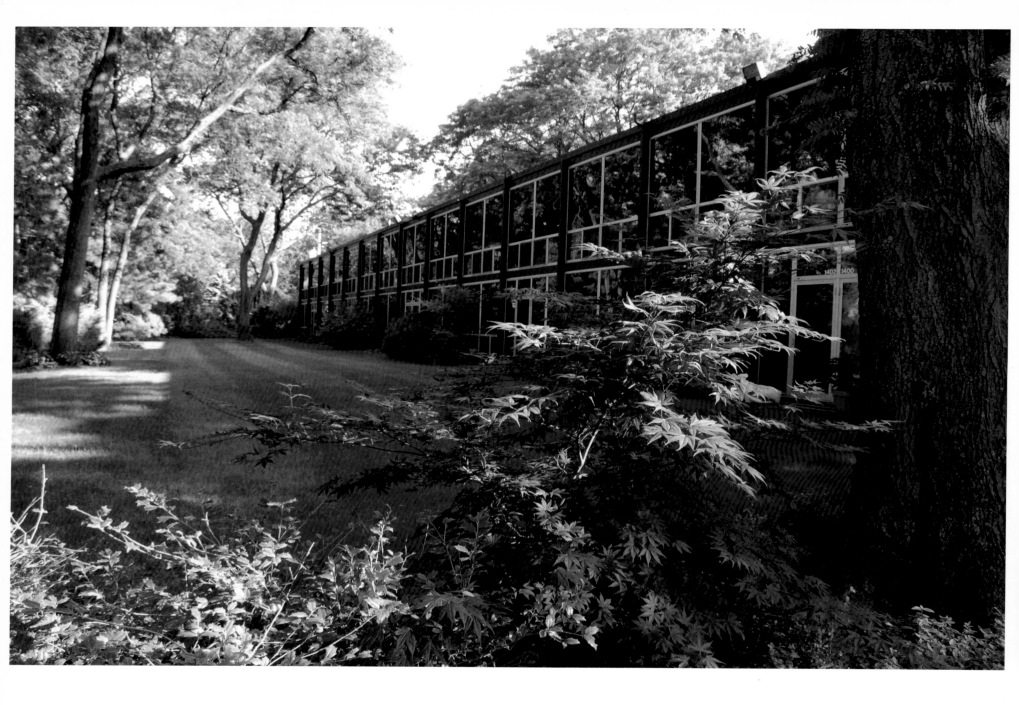

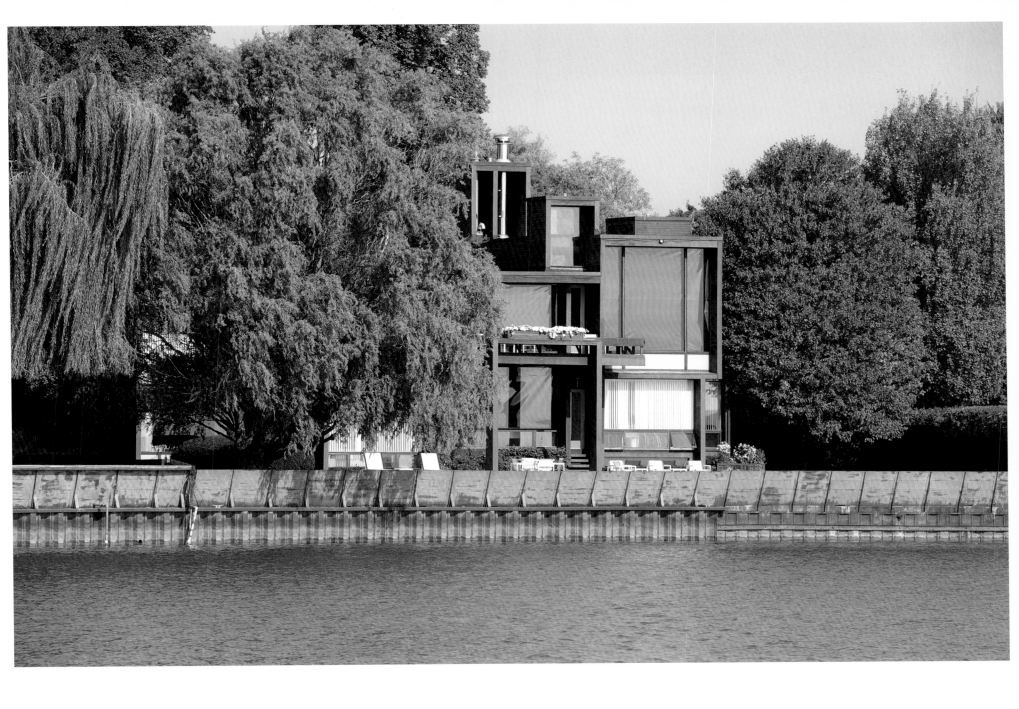

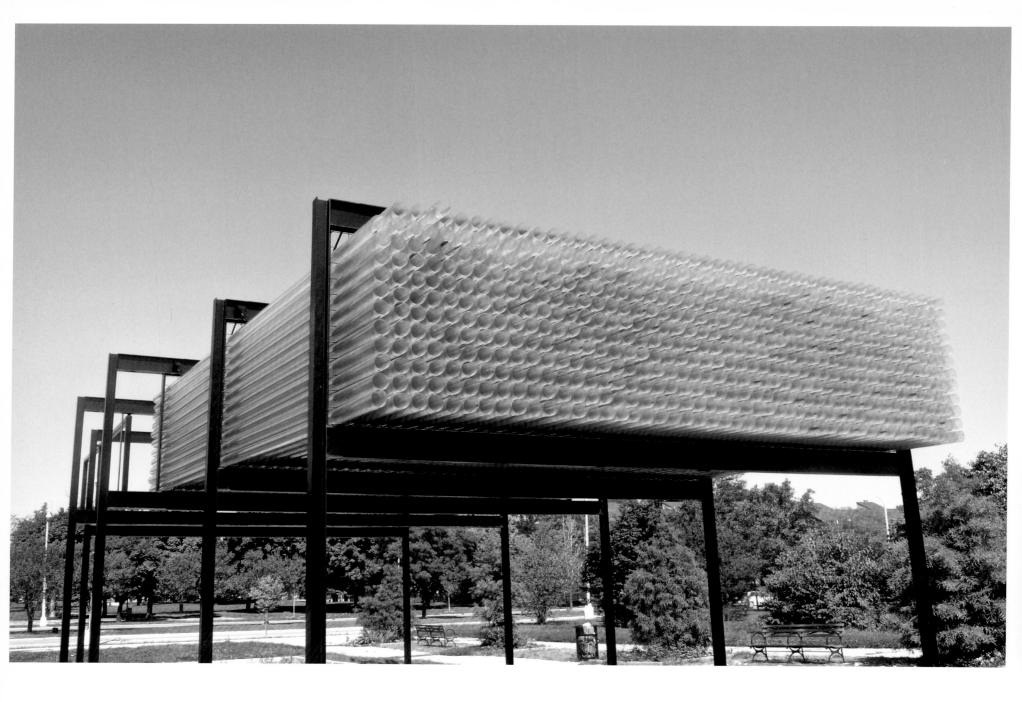

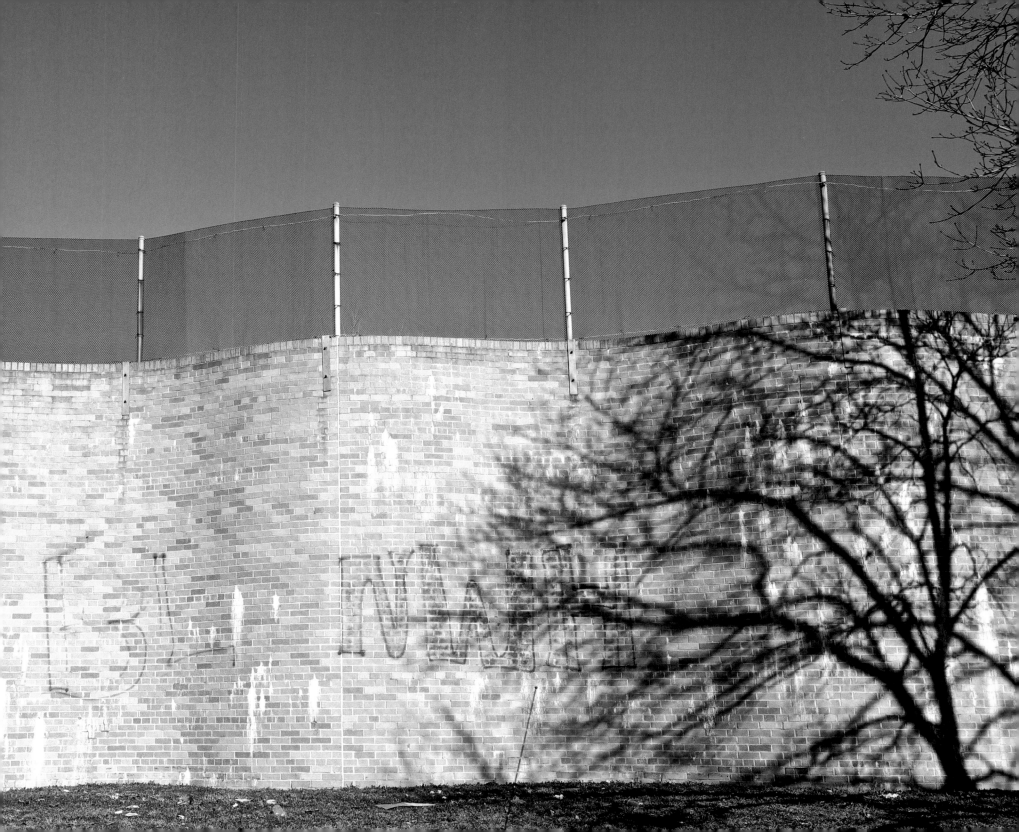

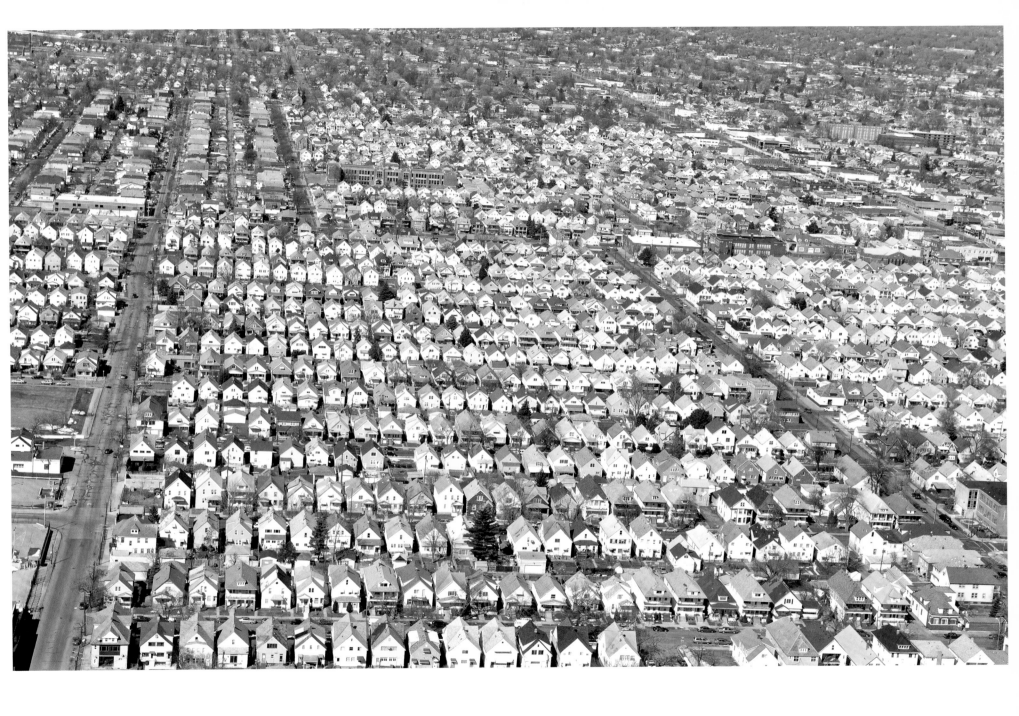

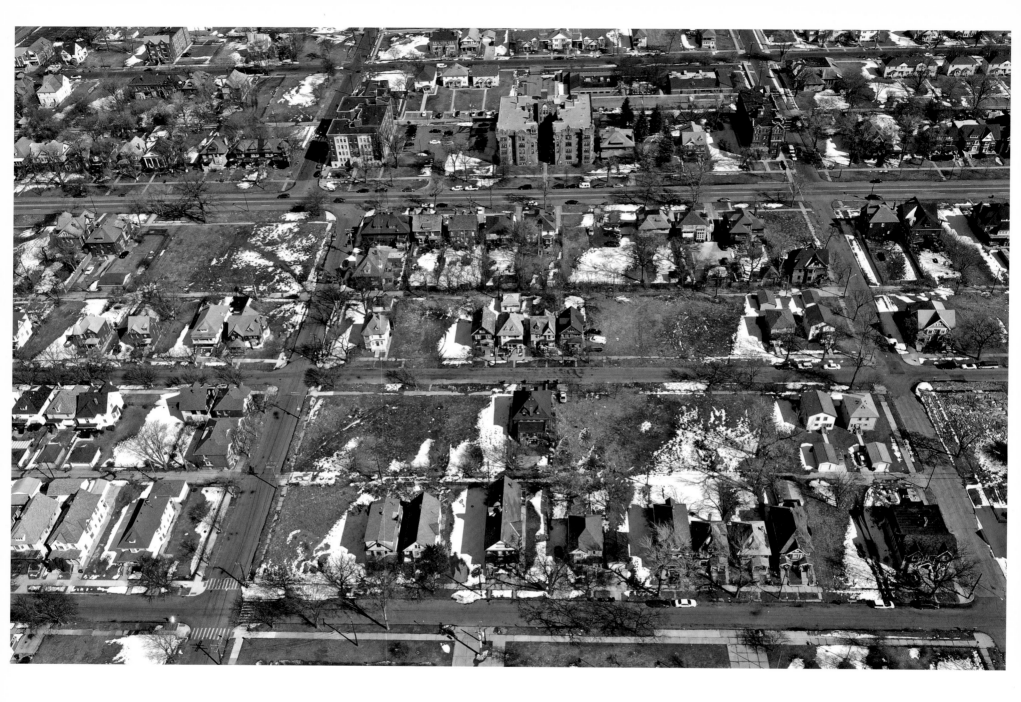

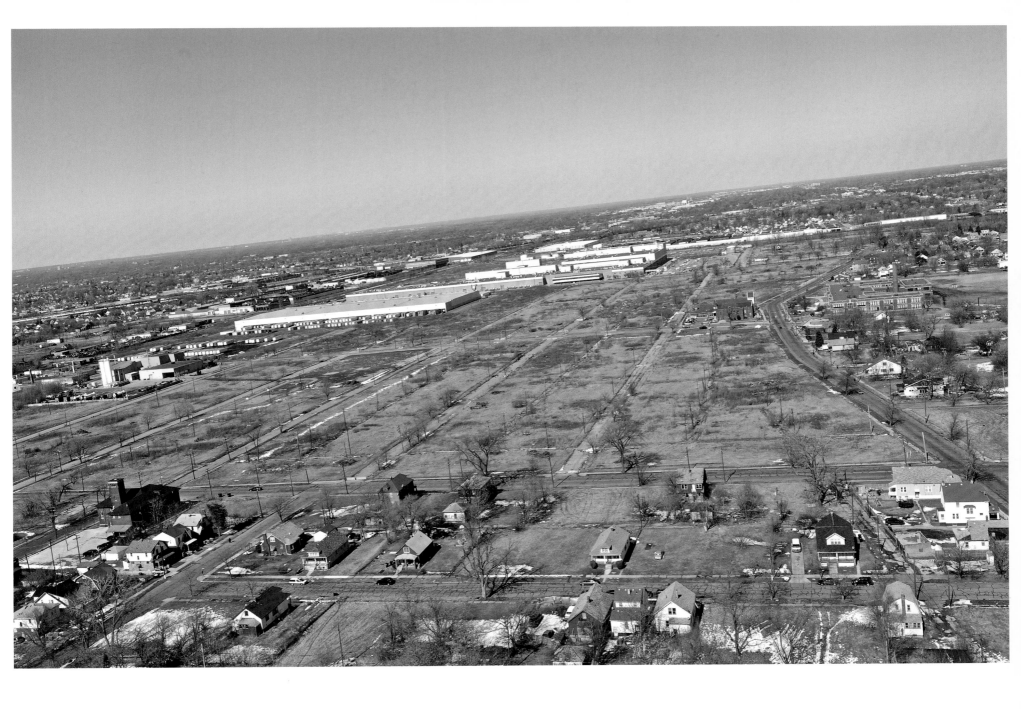

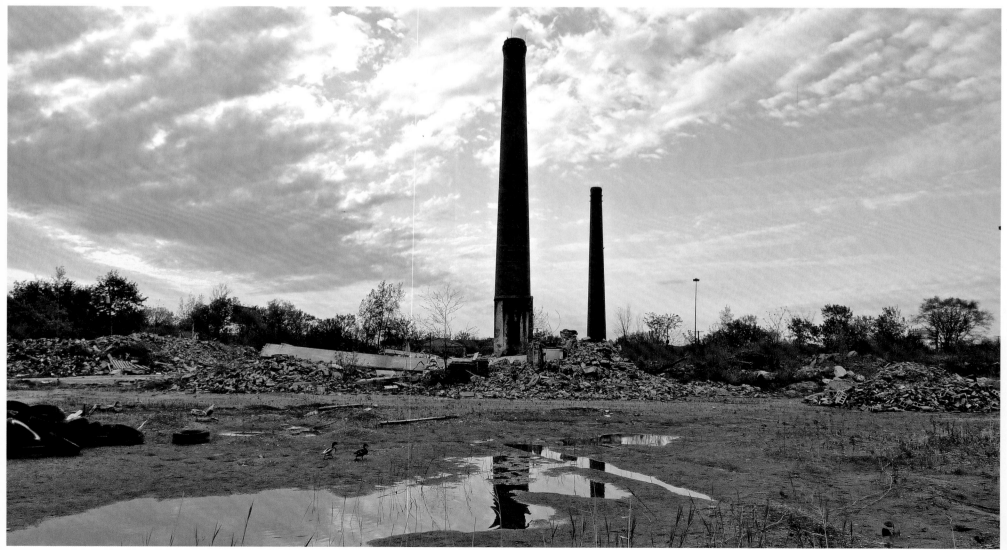

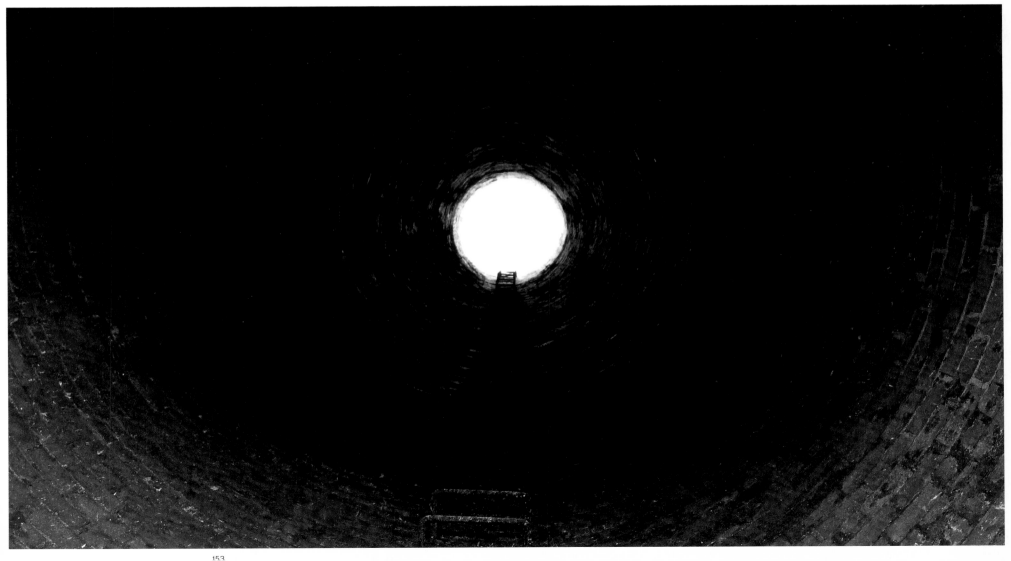

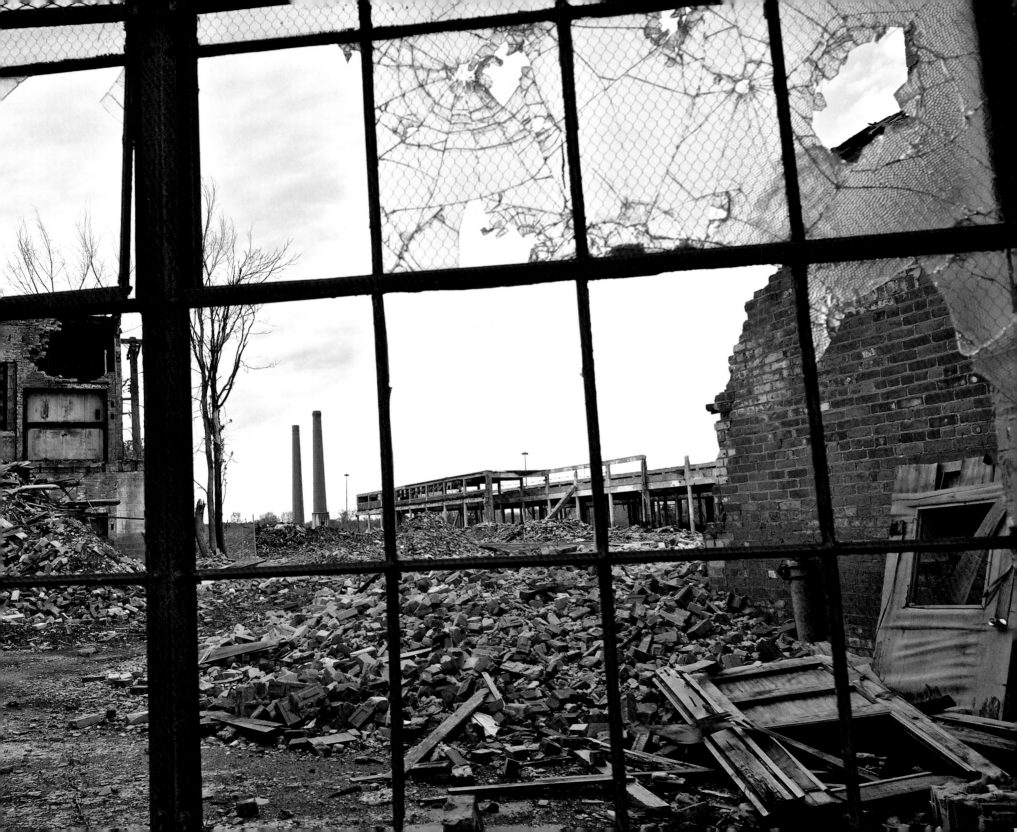

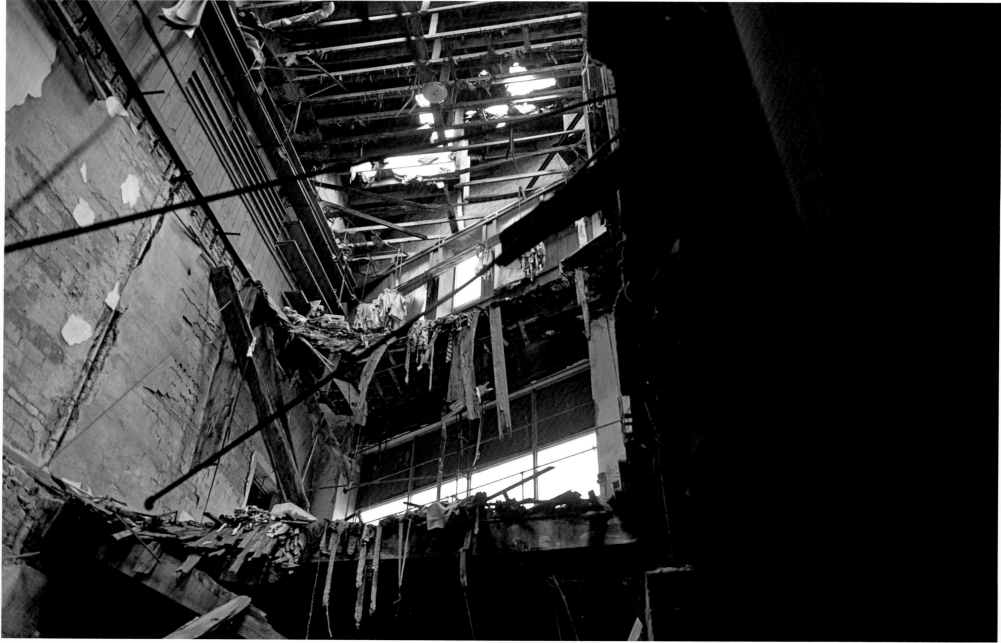

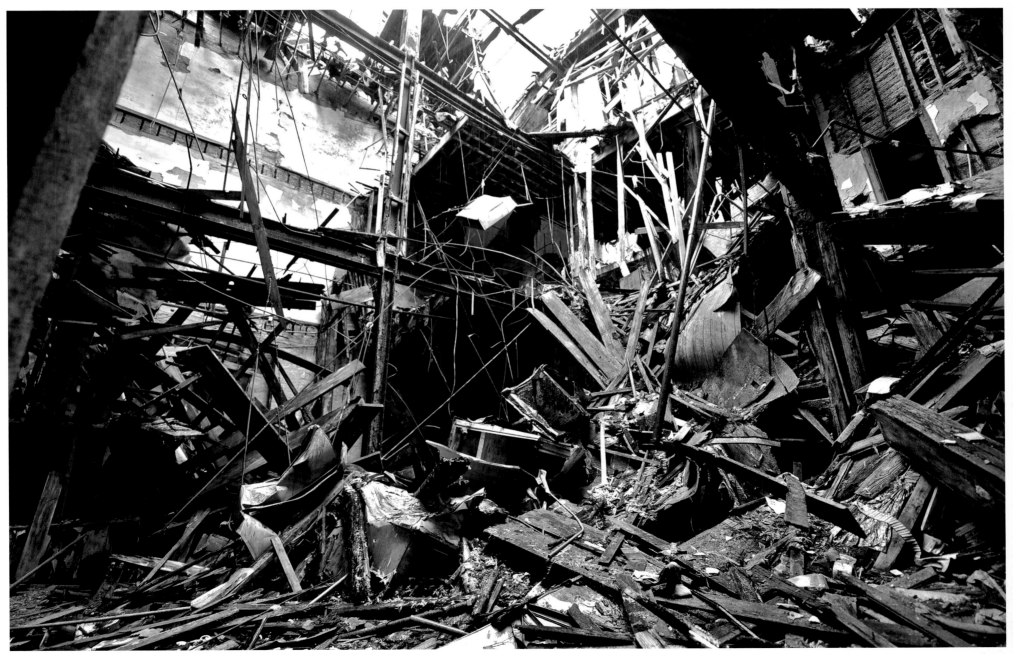

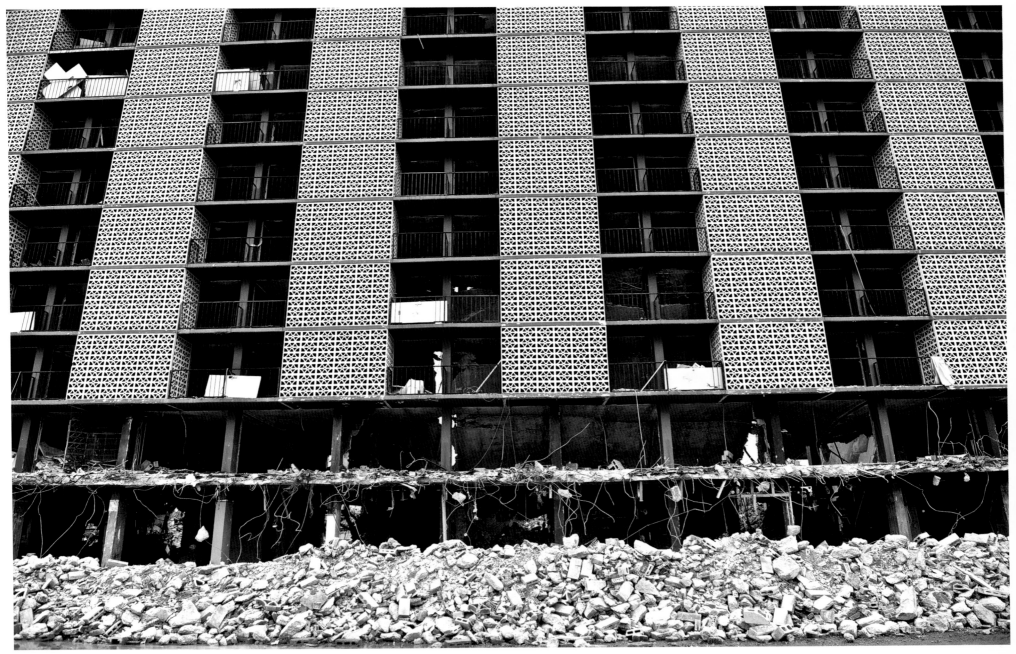

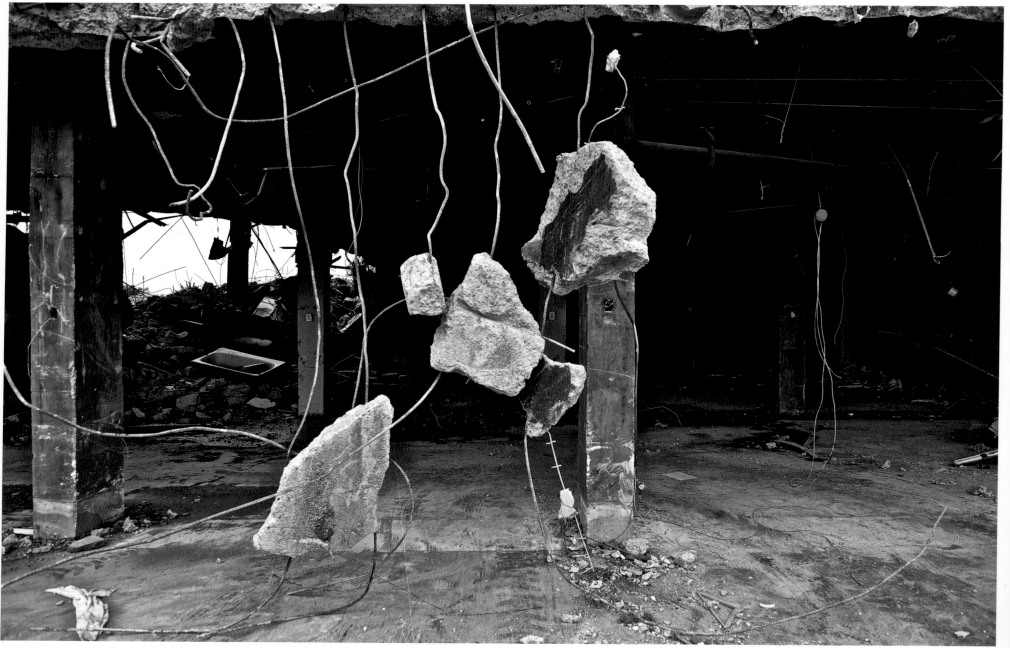

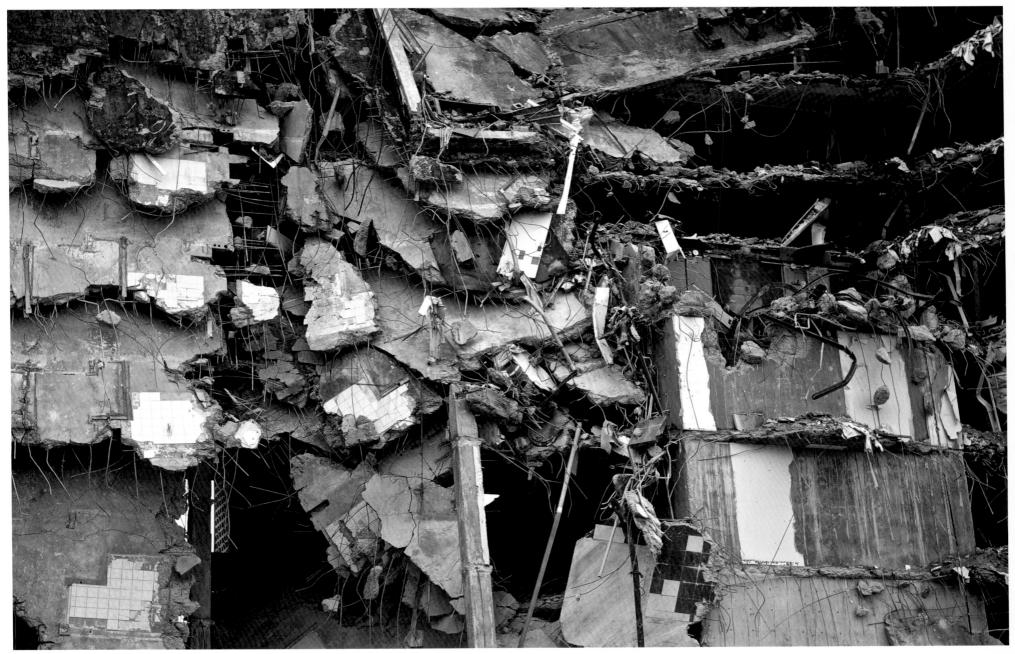

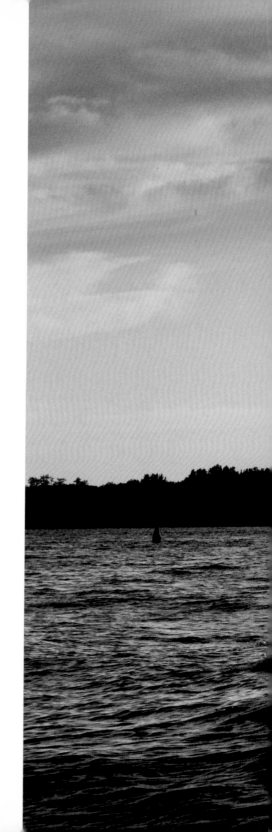

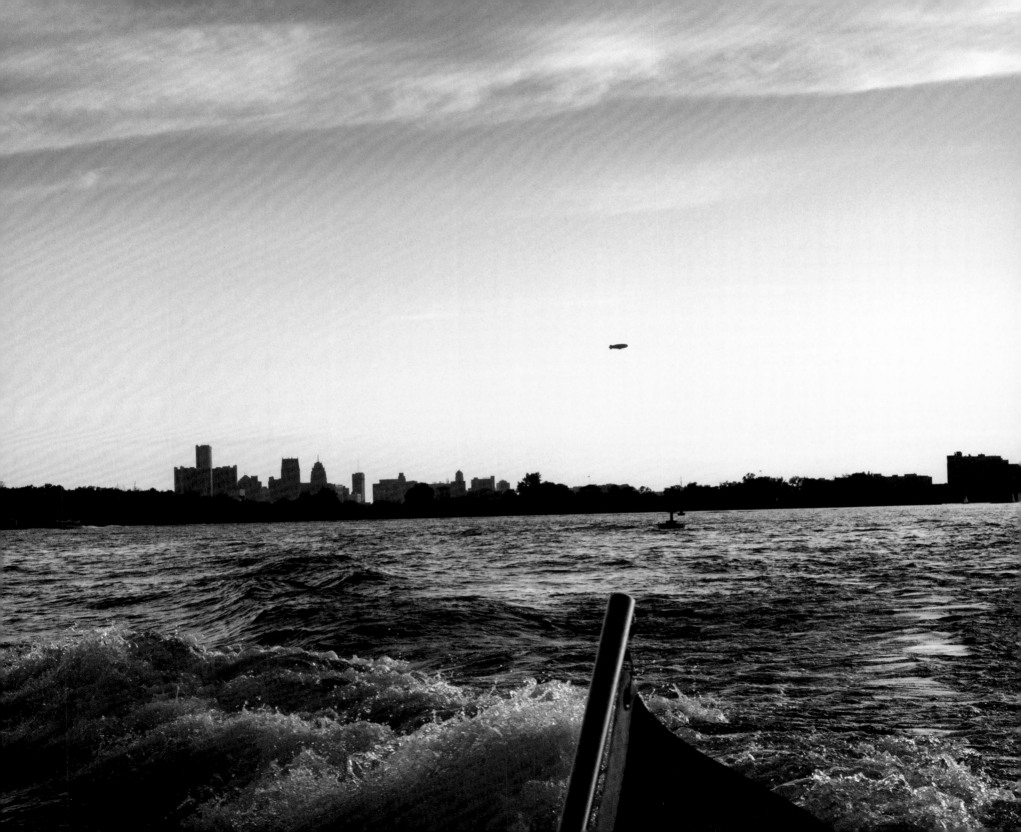

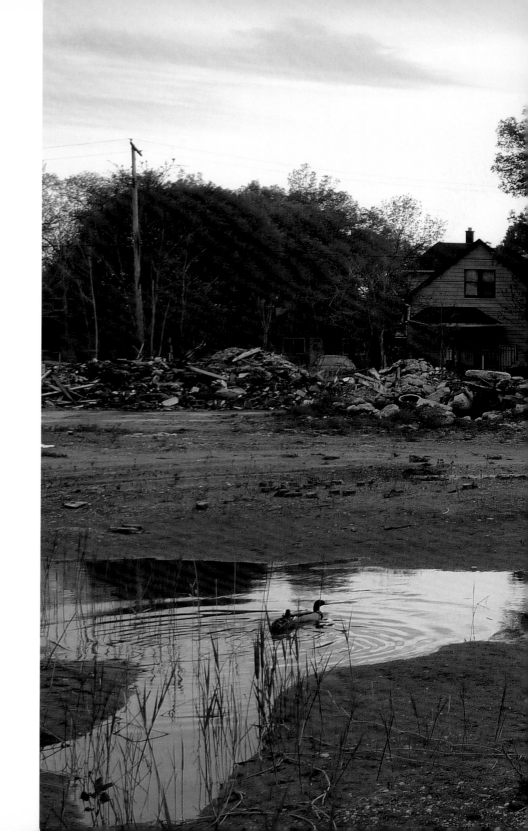

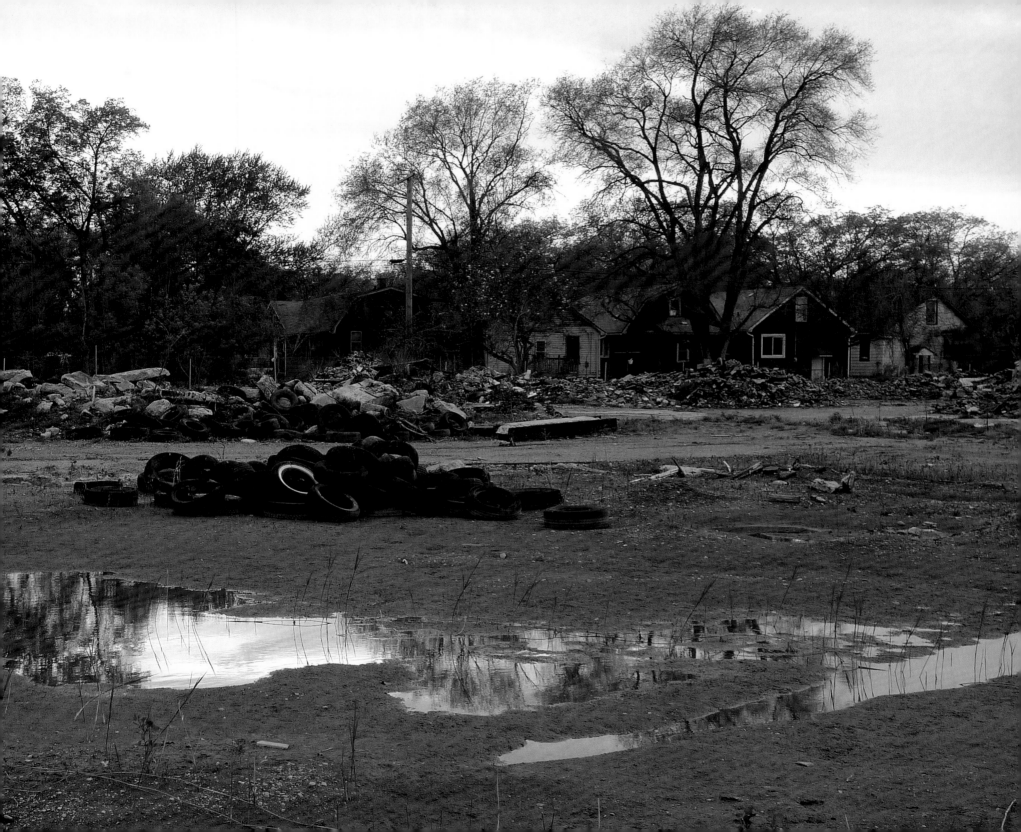

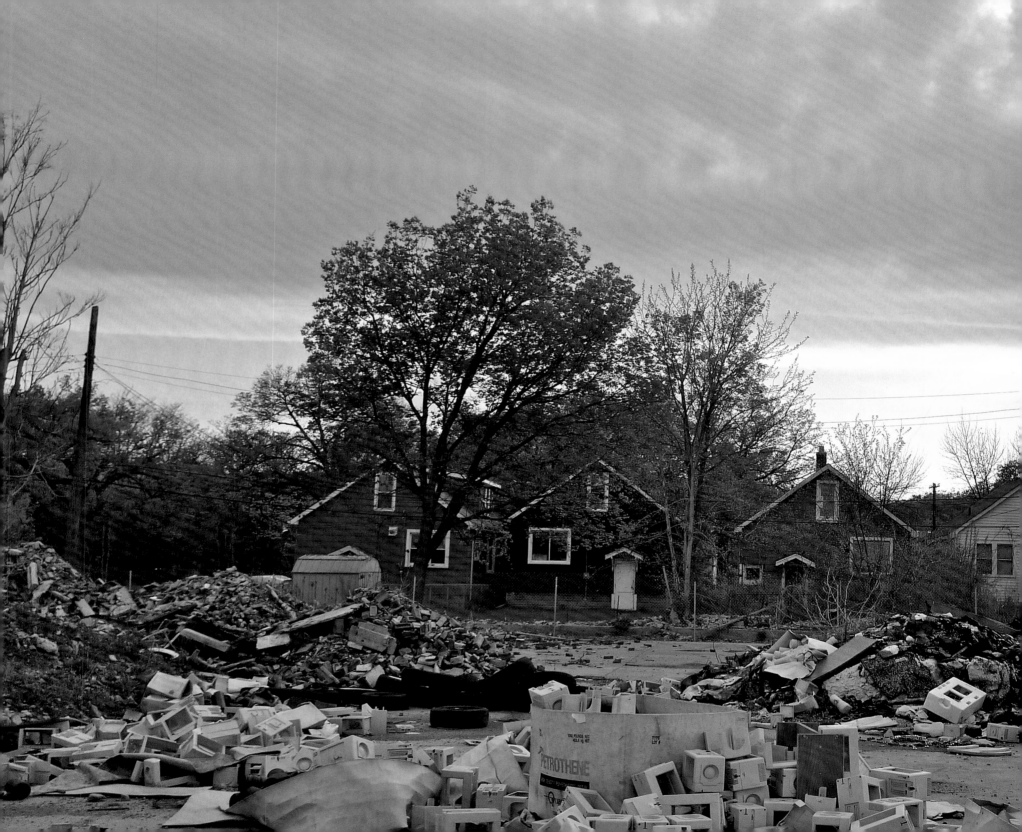

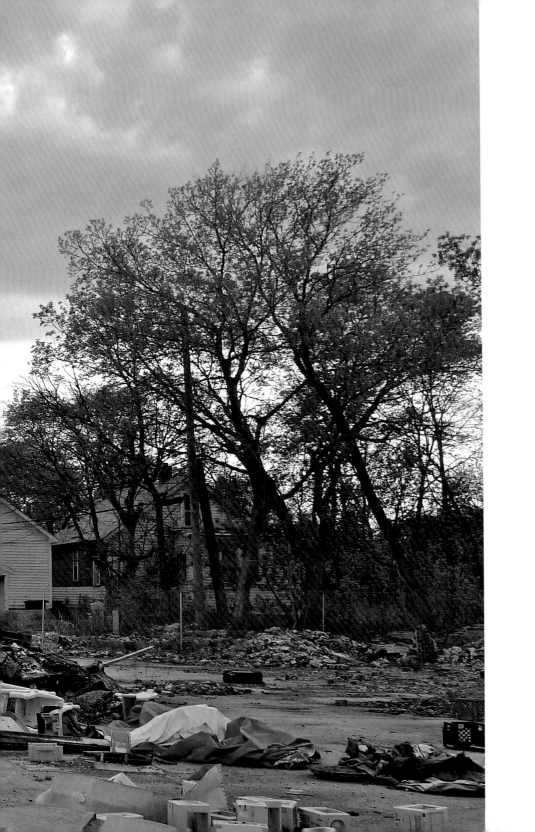

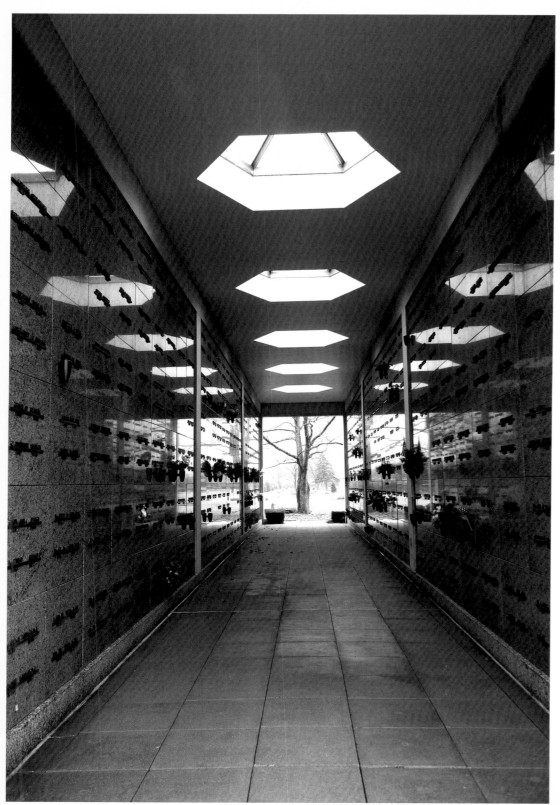

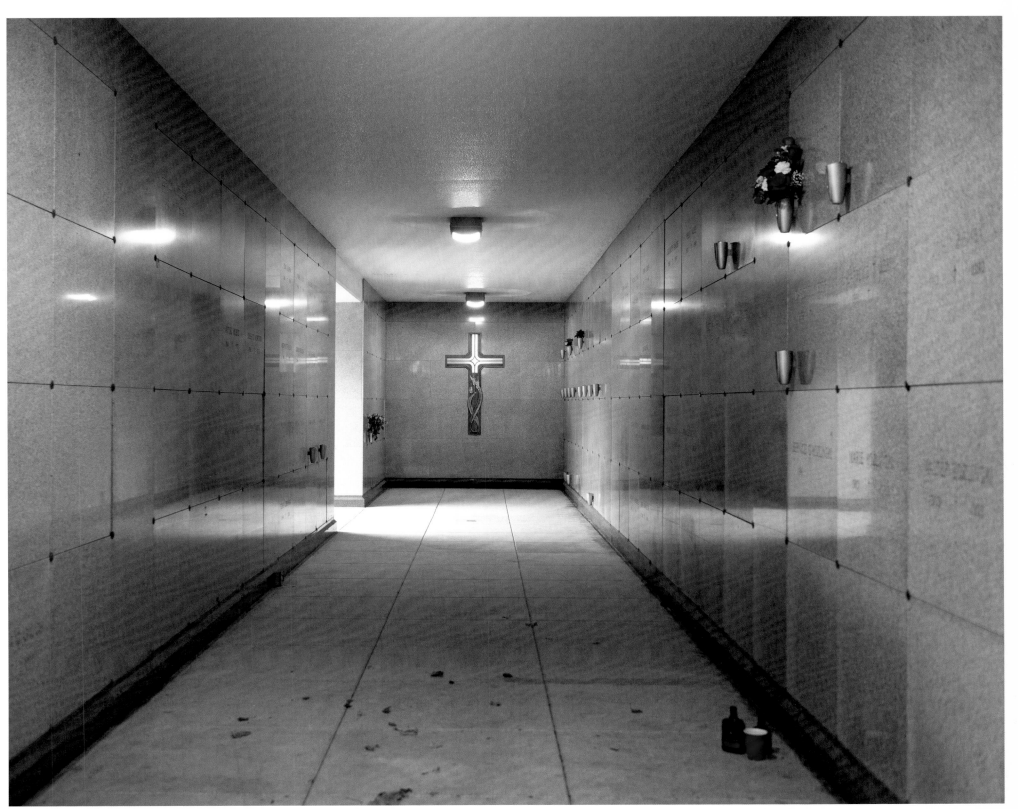

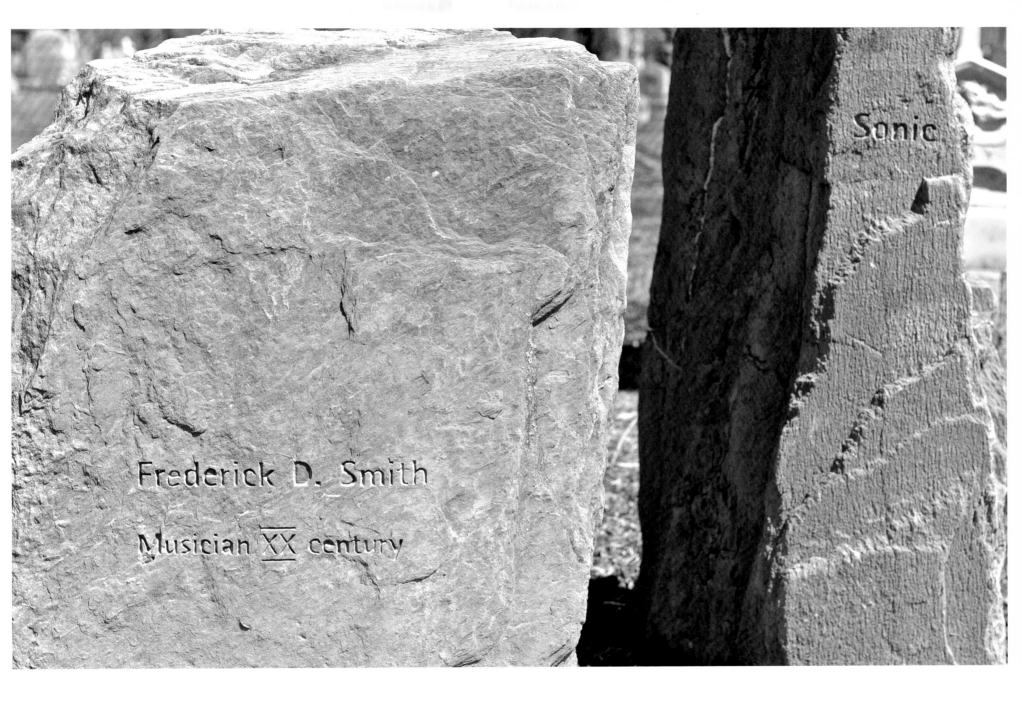

Frederick D. Smith

Musician XX century

Sonic

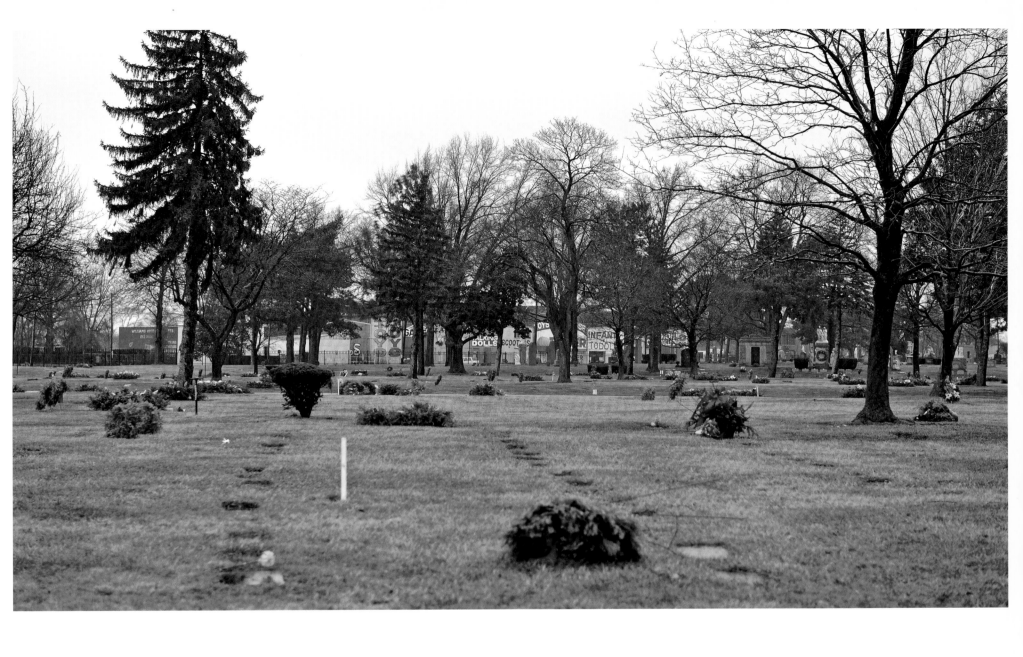

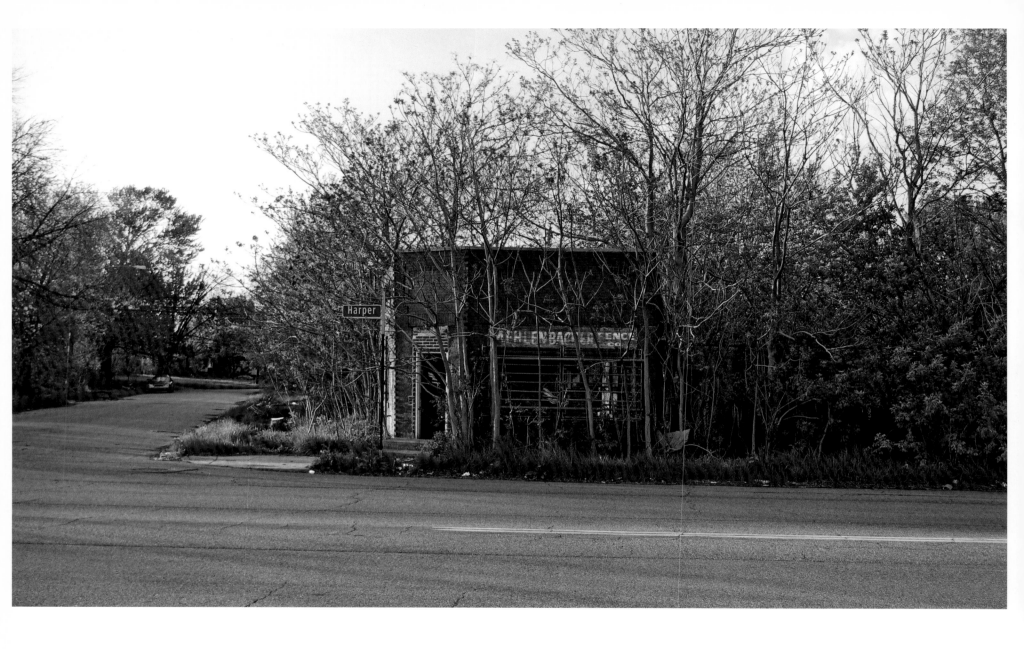

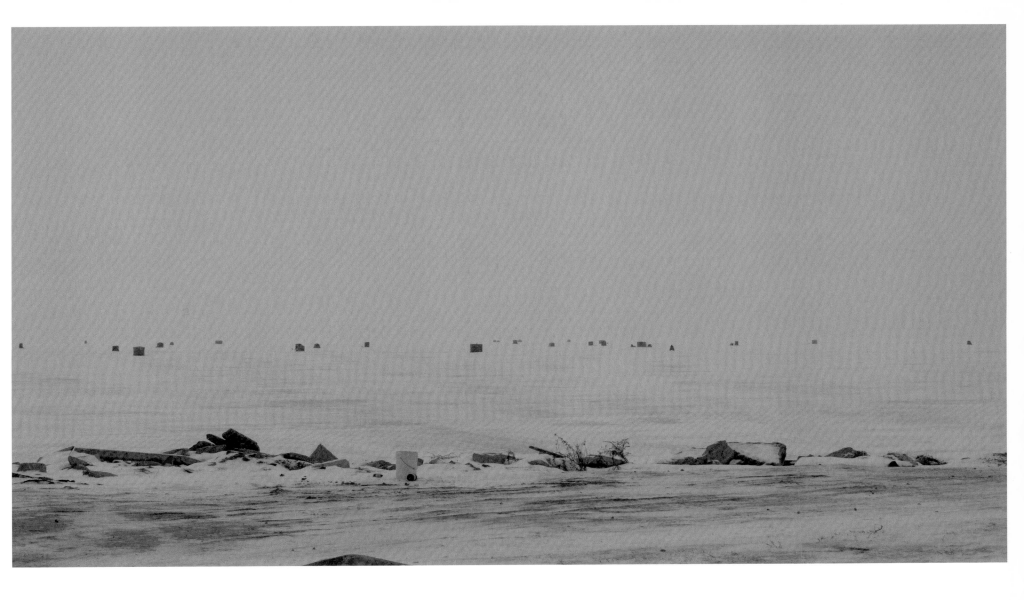

Central

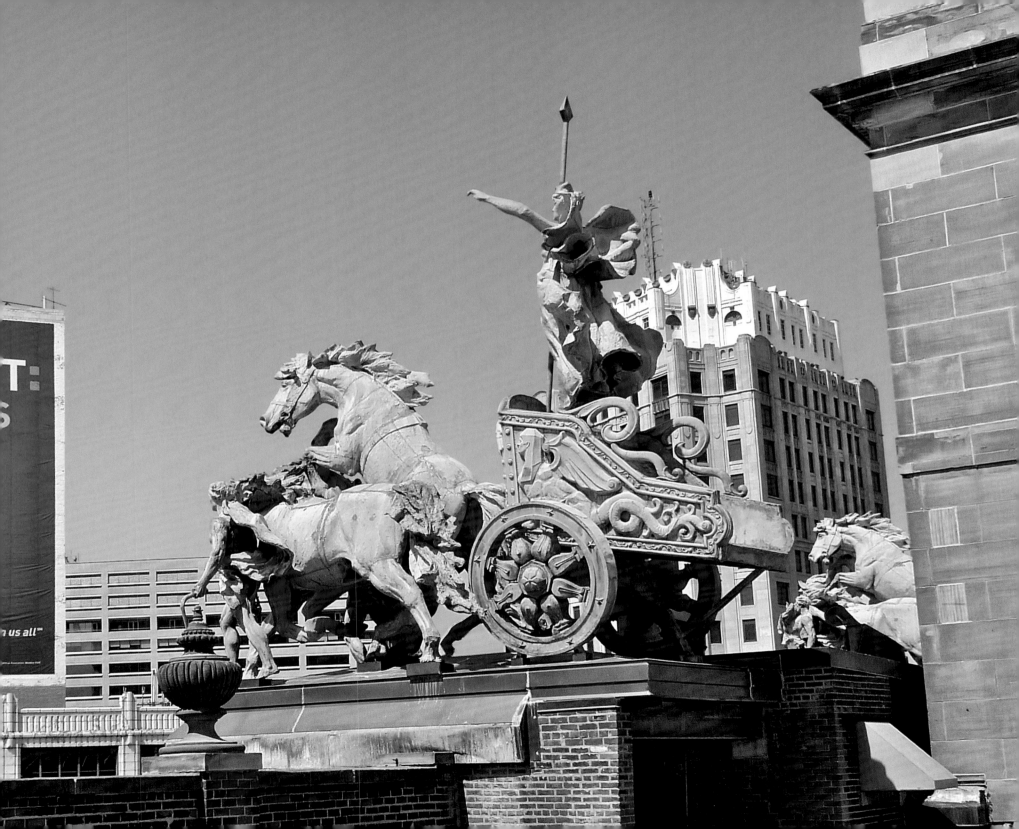

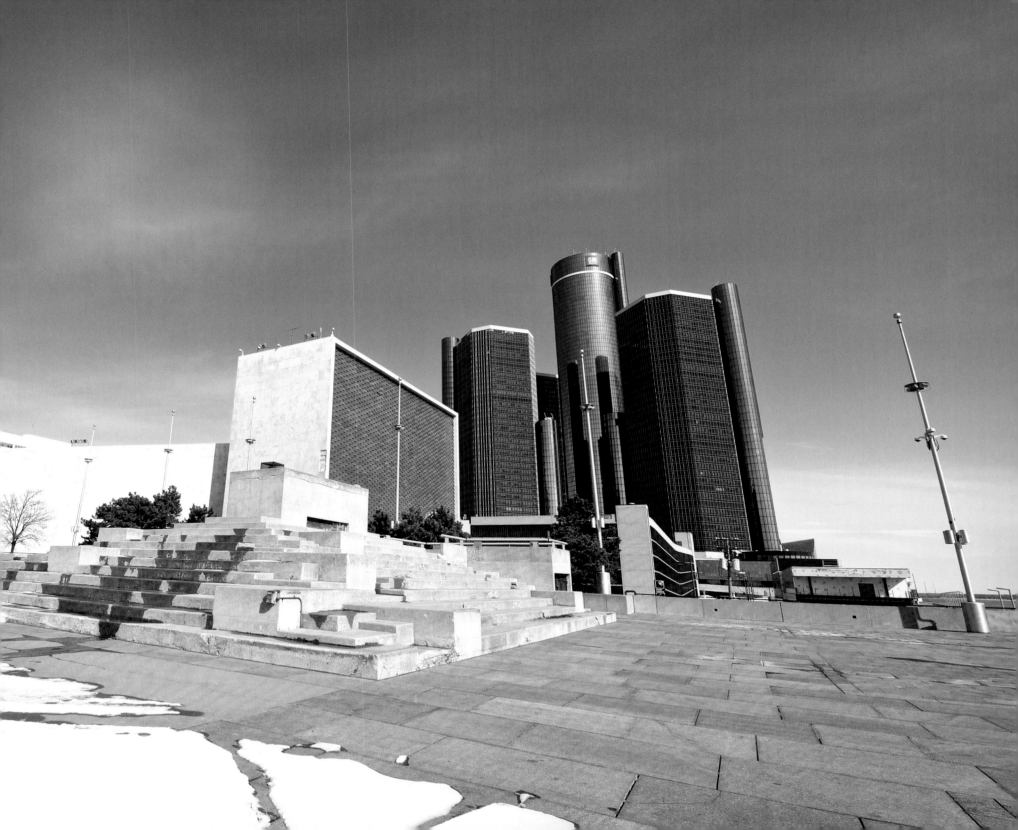

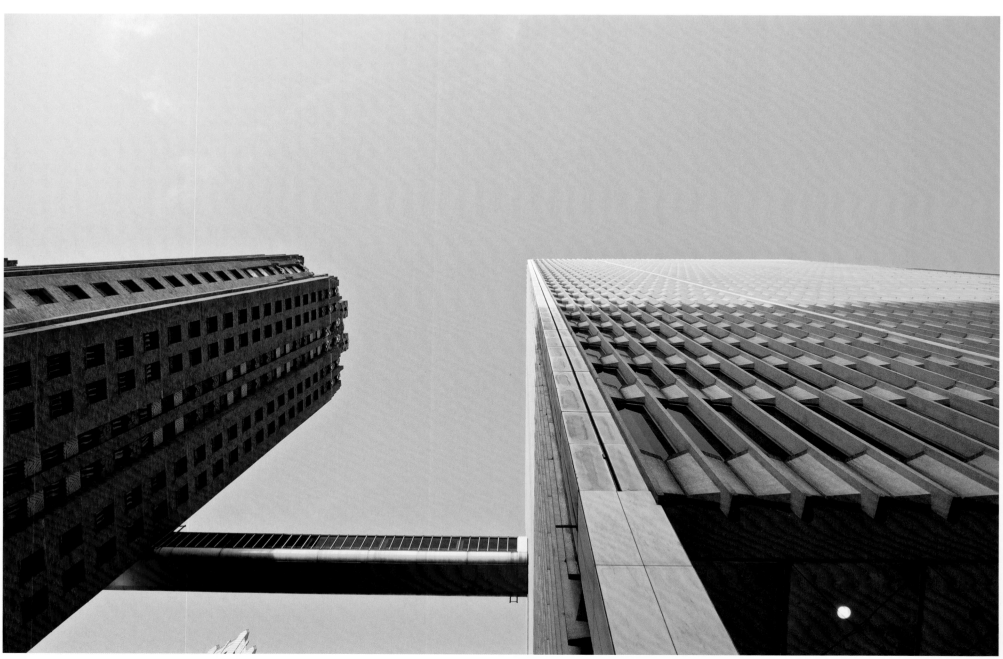

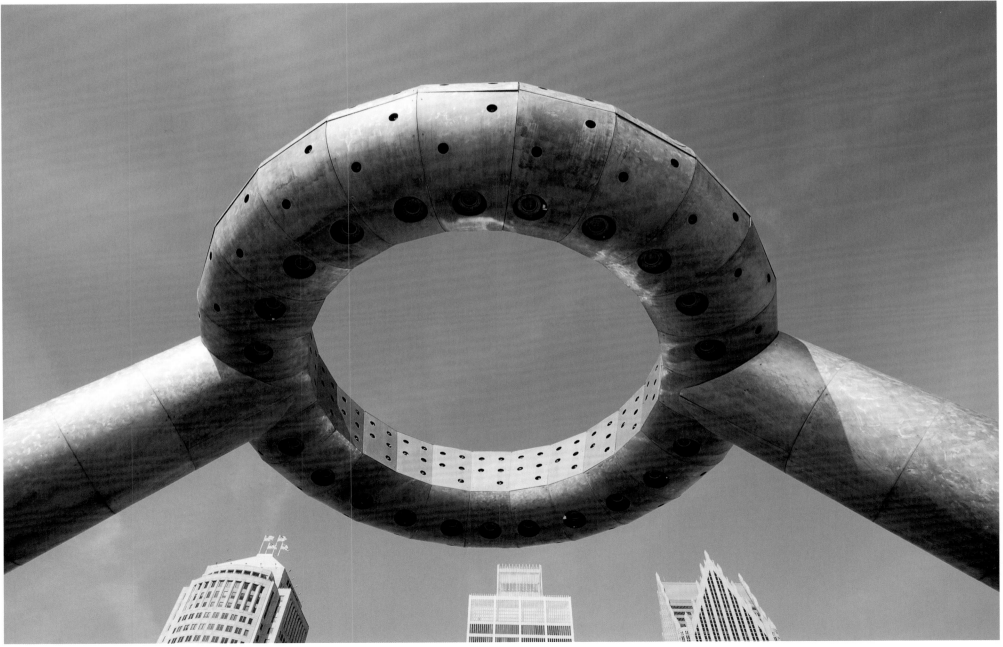

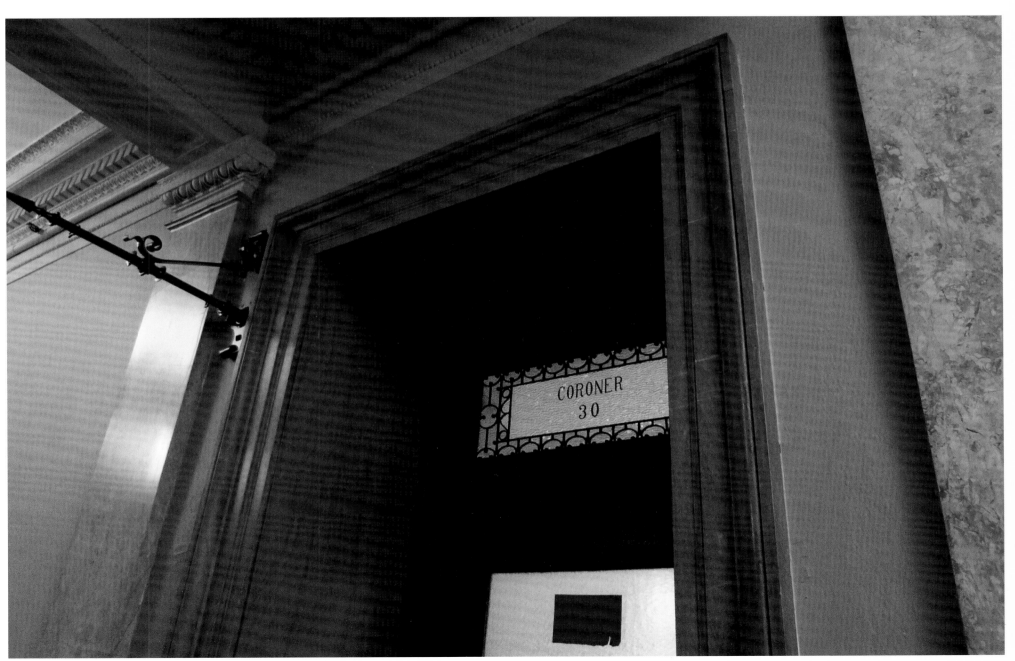

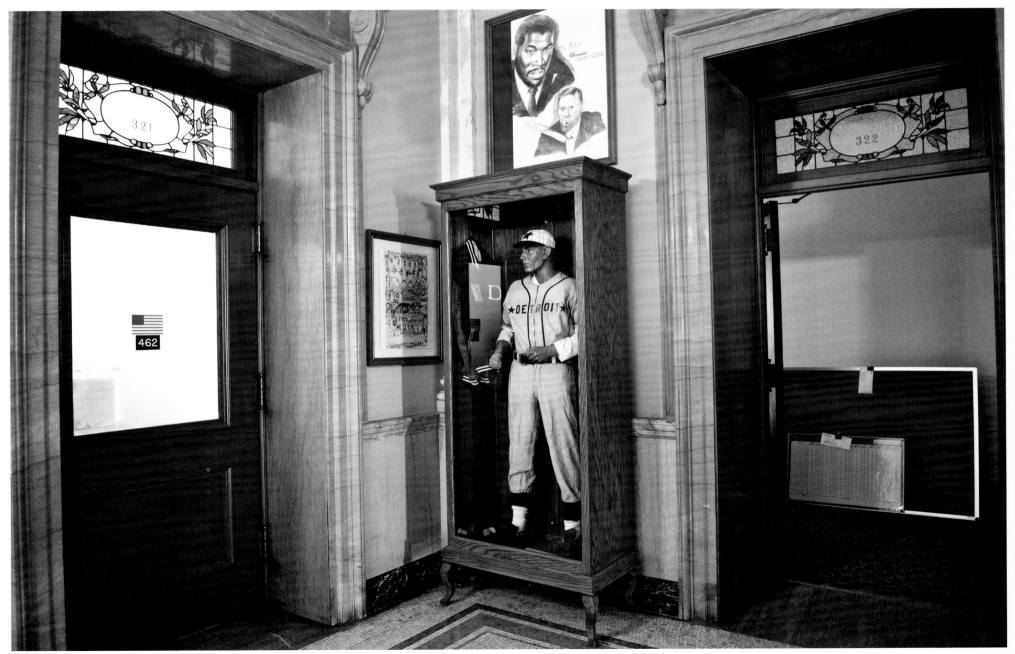

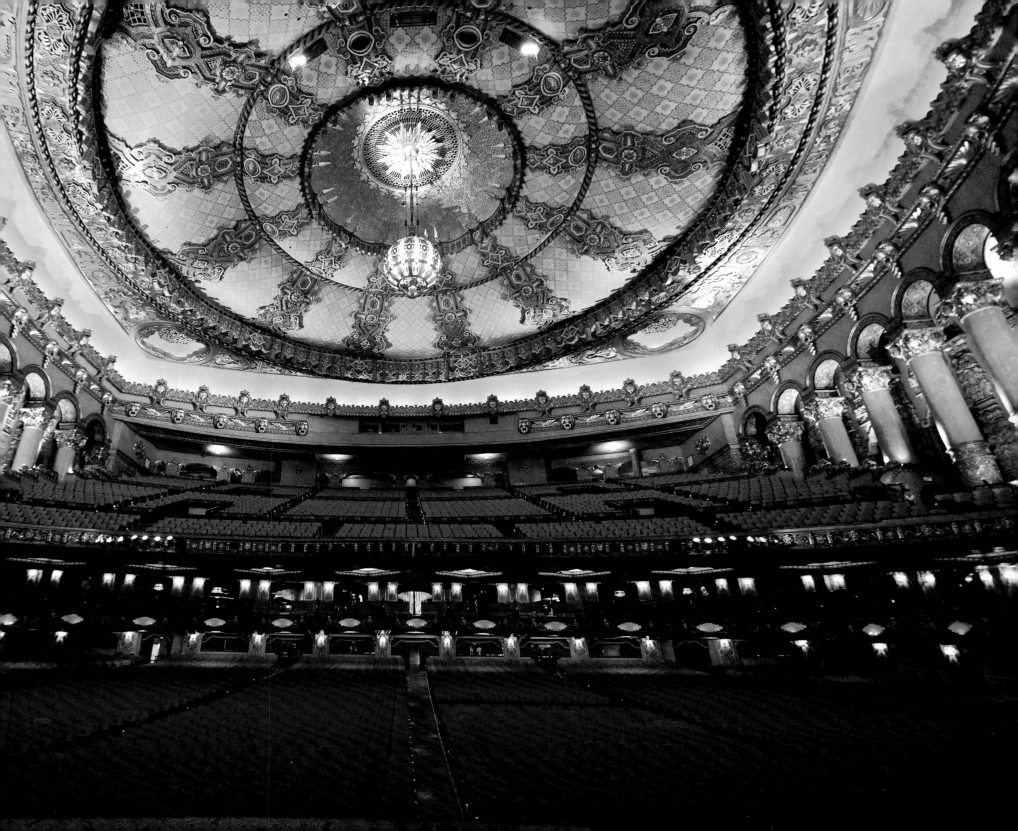

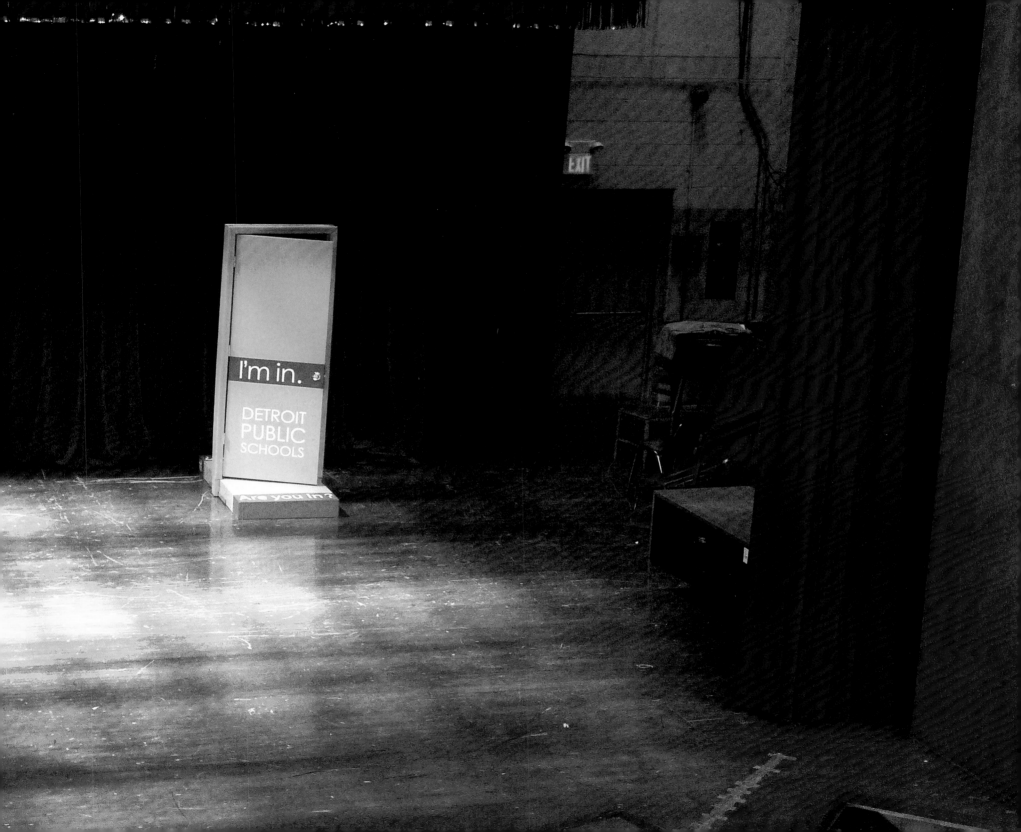

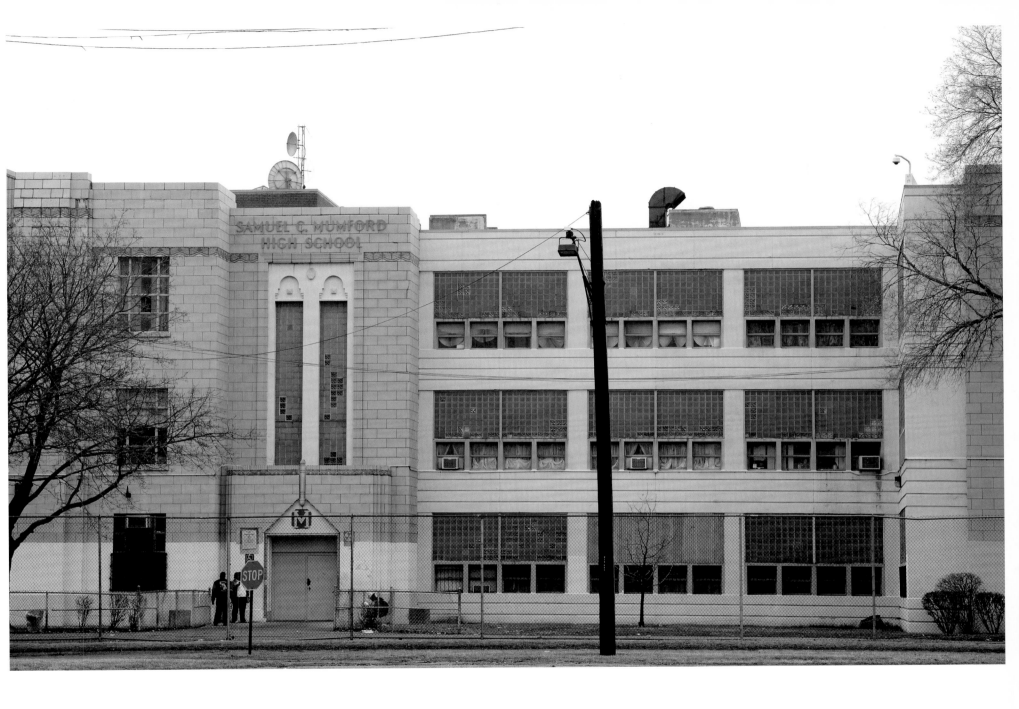

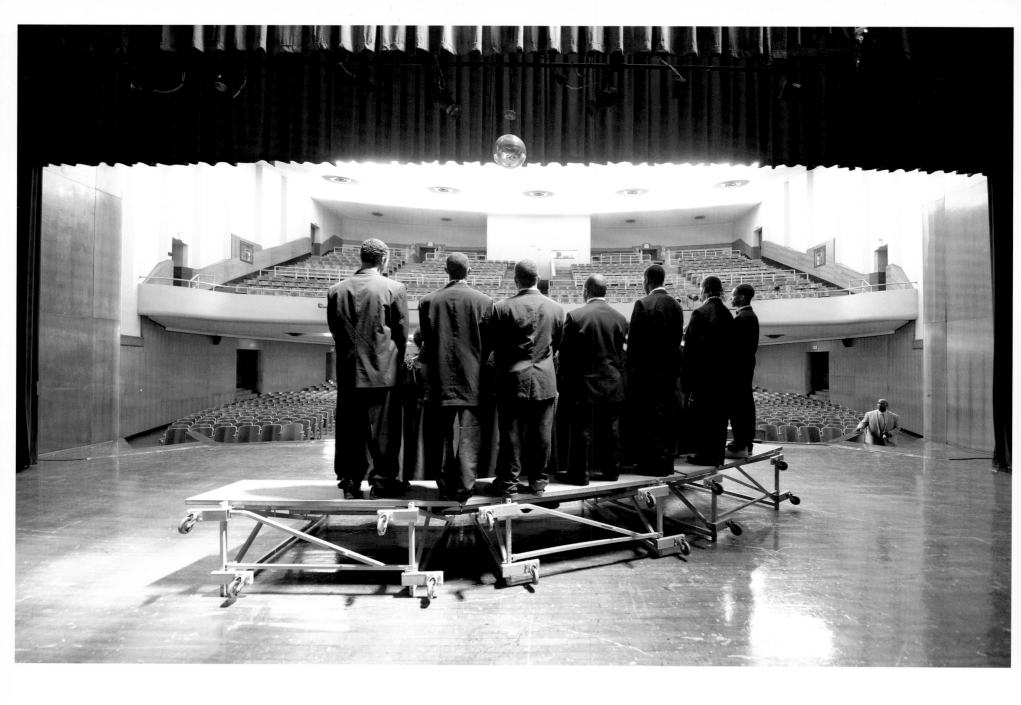

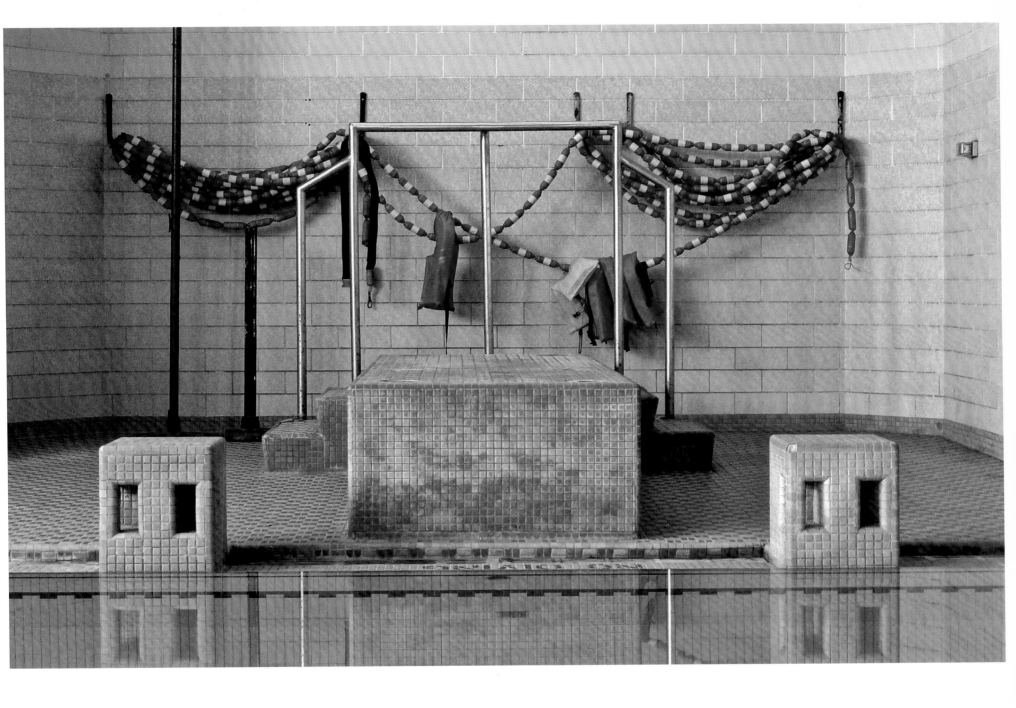

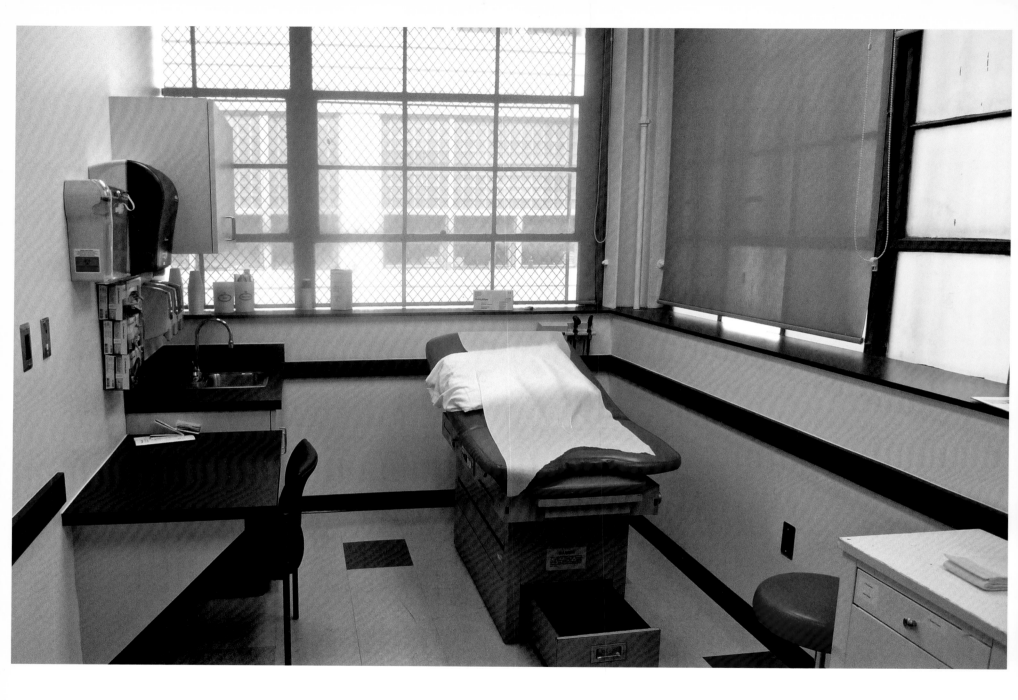

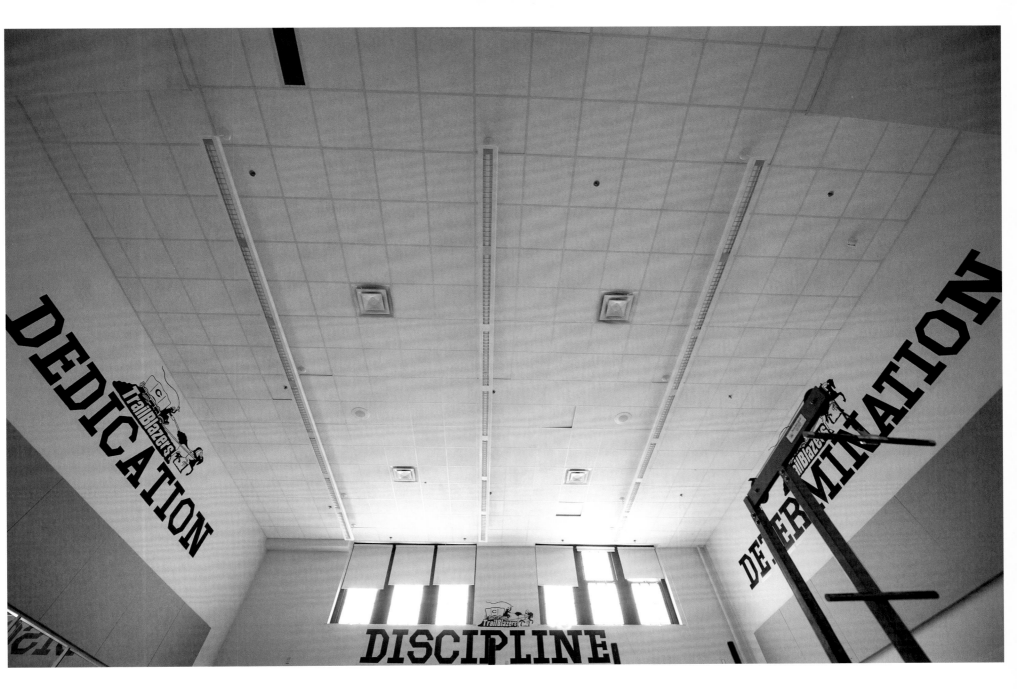

202

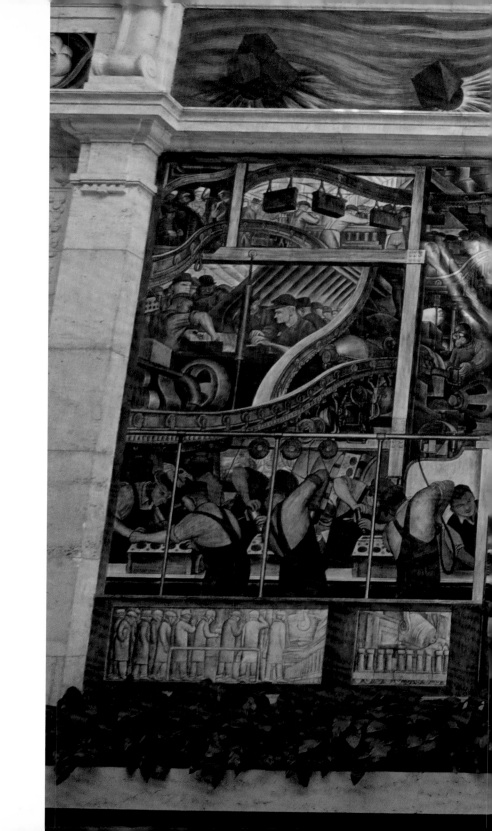

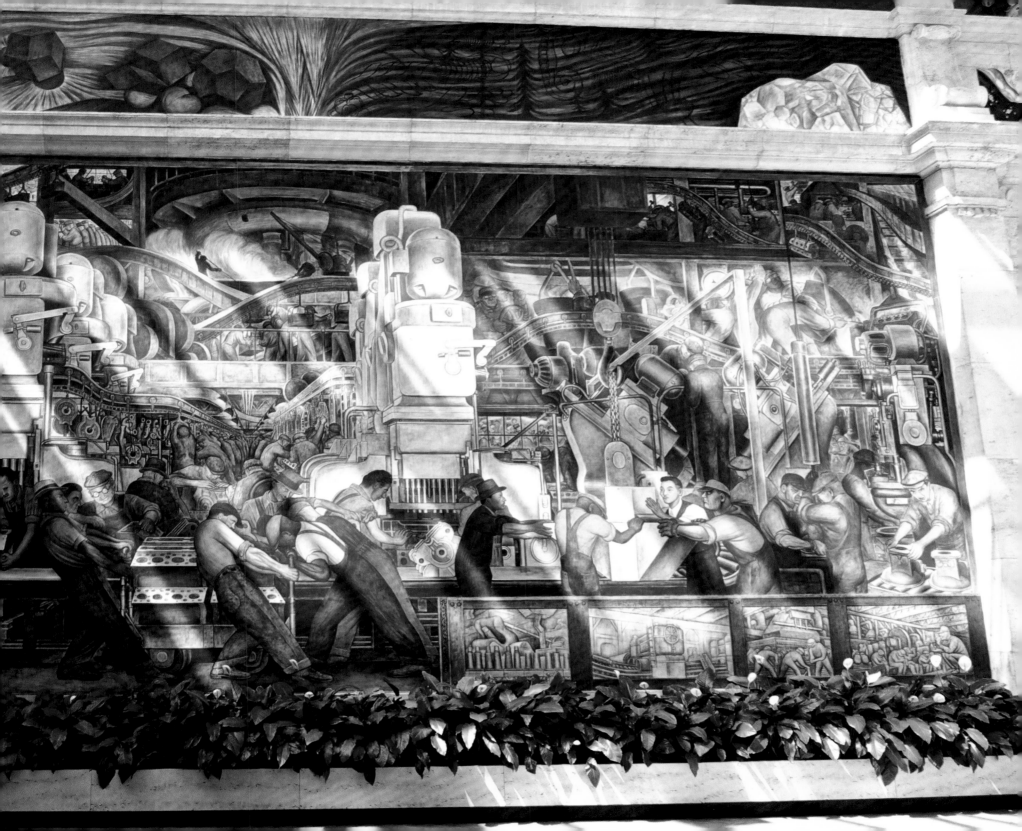

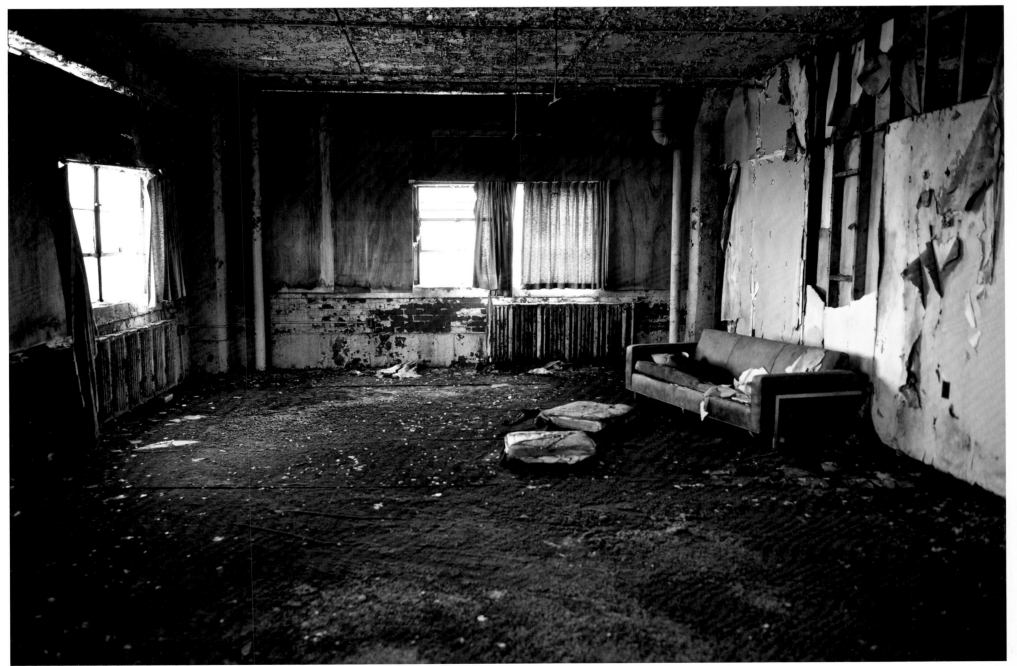

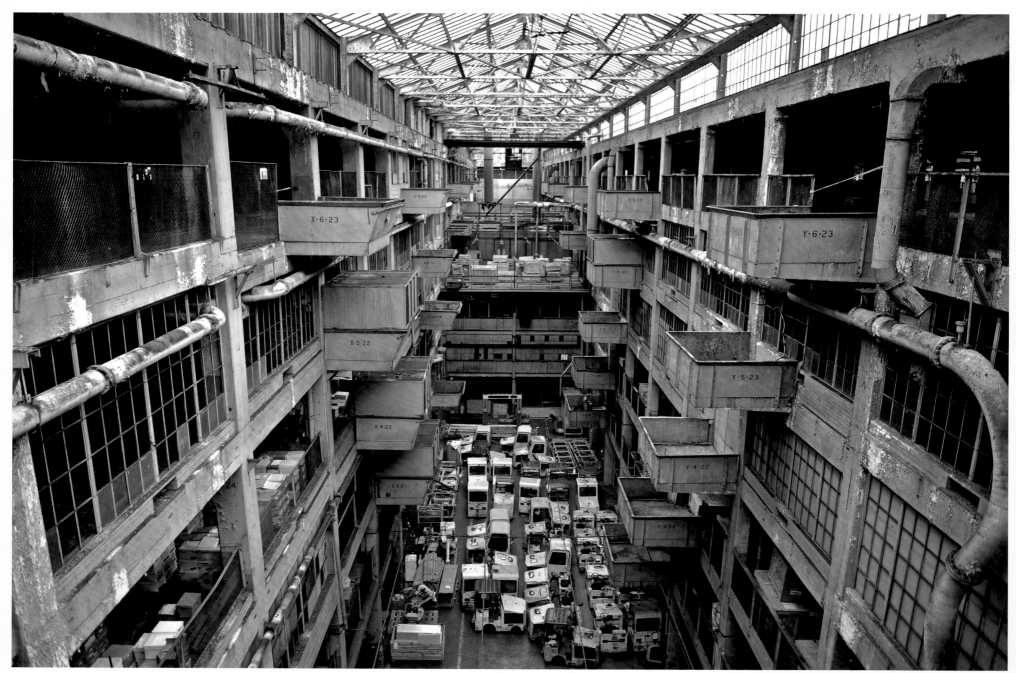

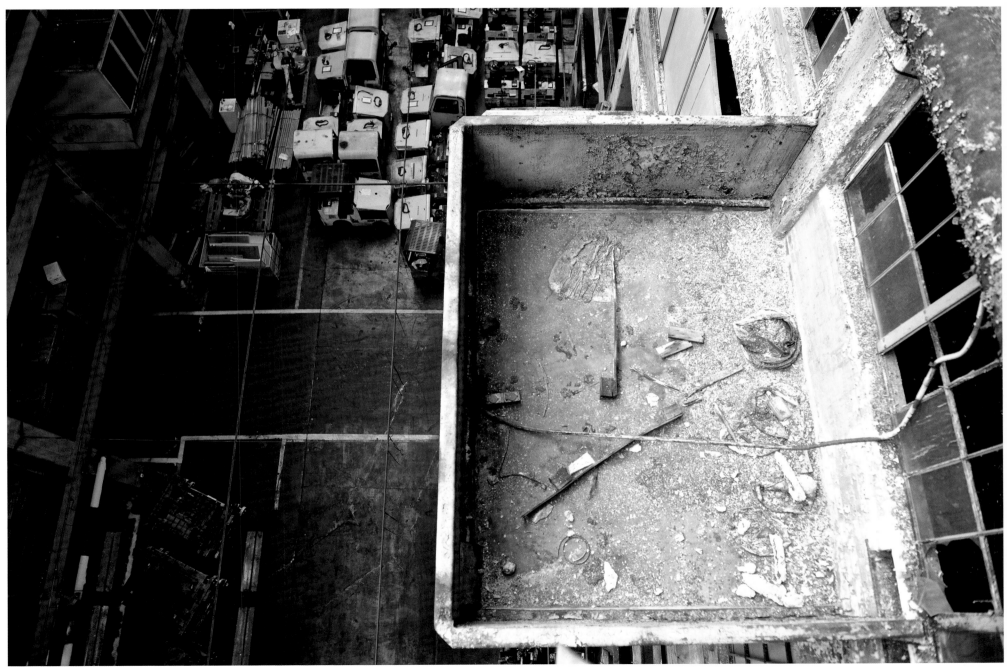

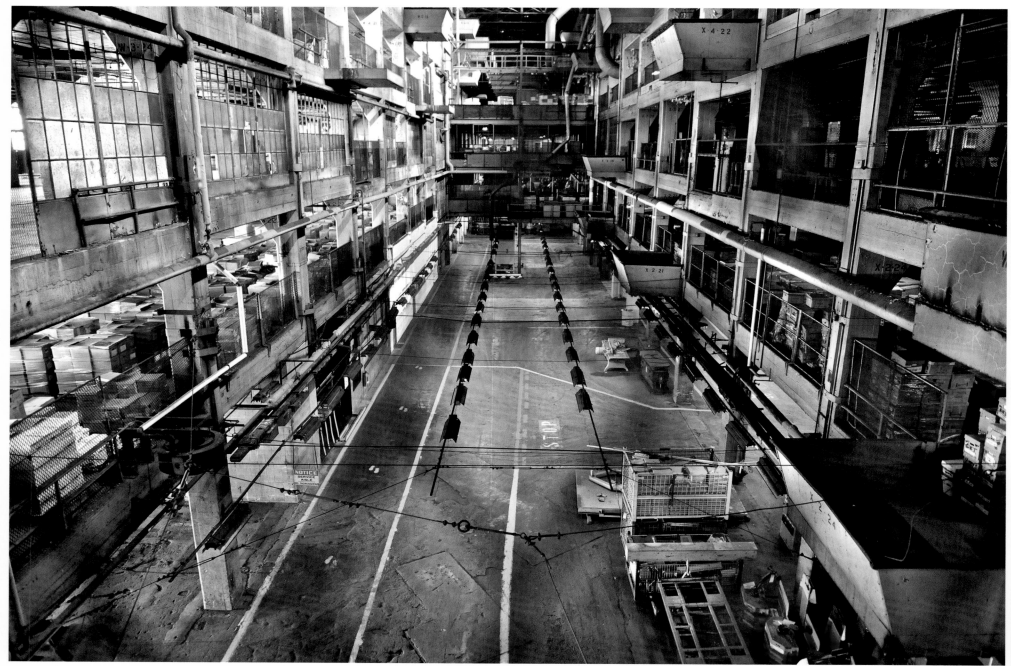

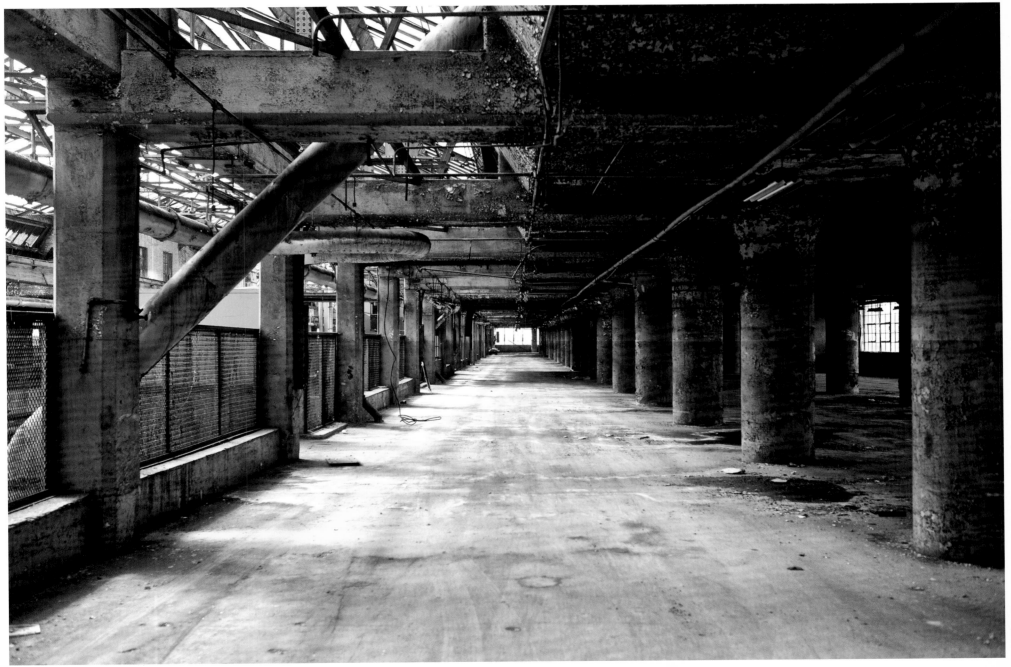

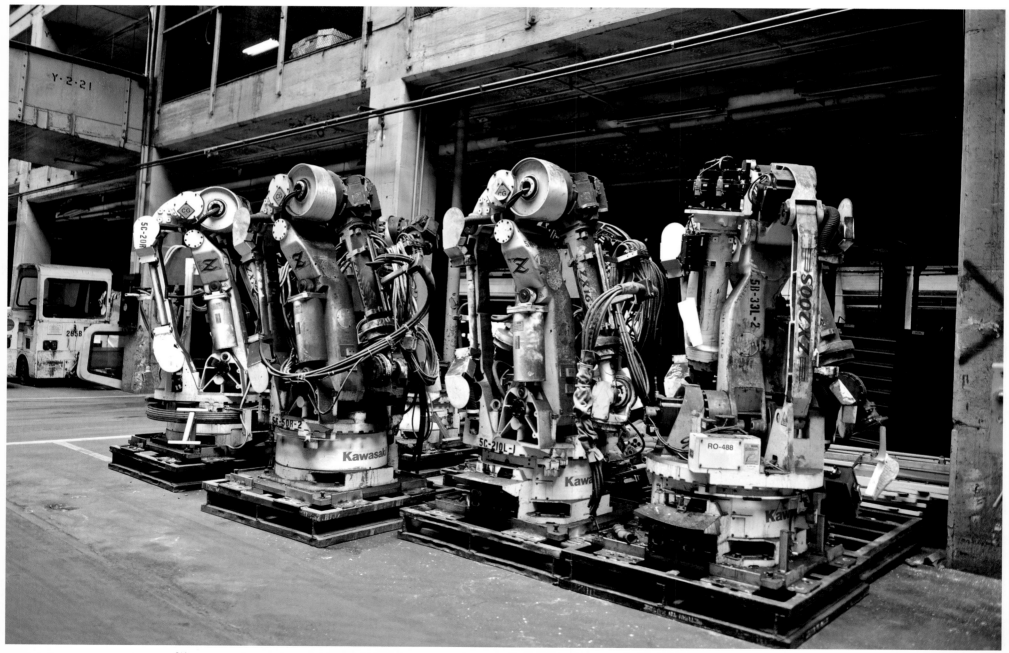

217

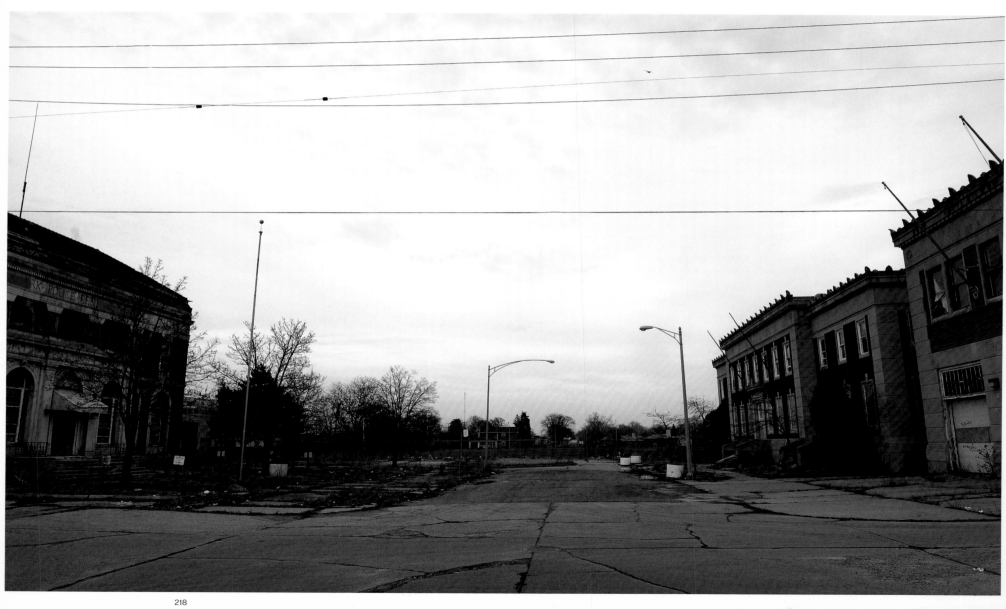

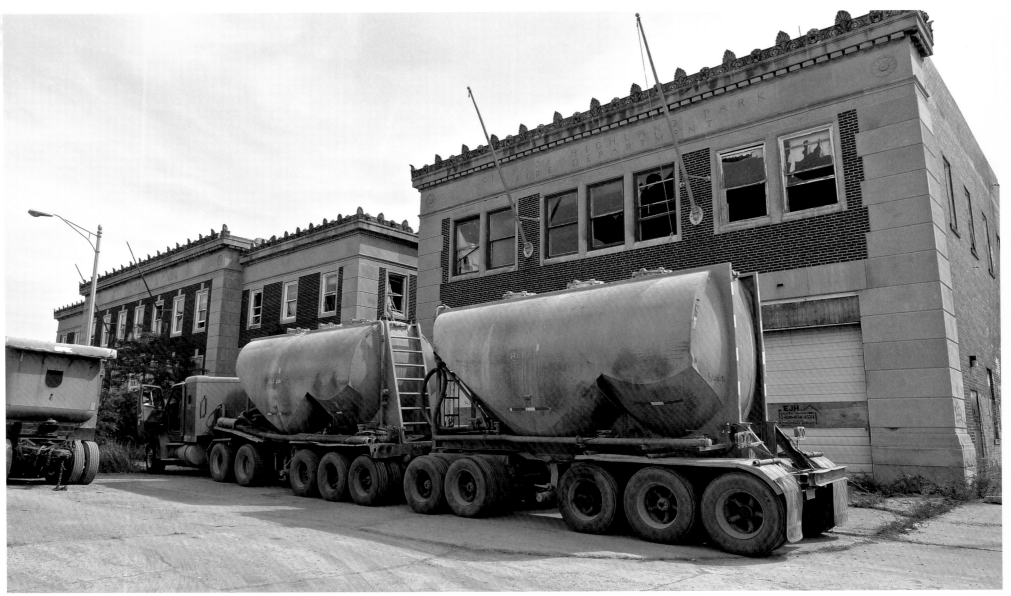

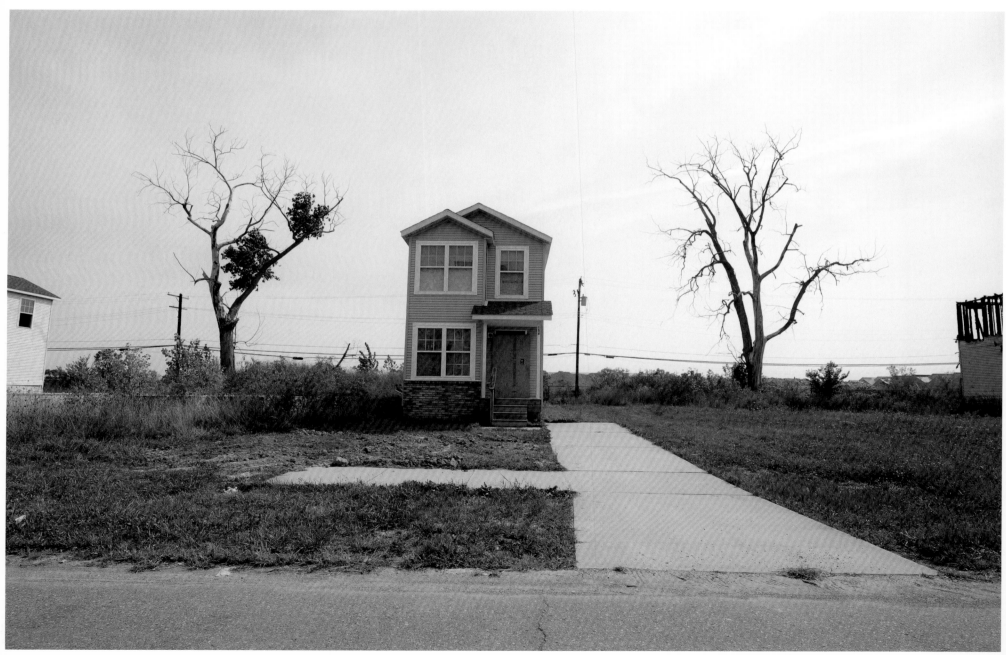

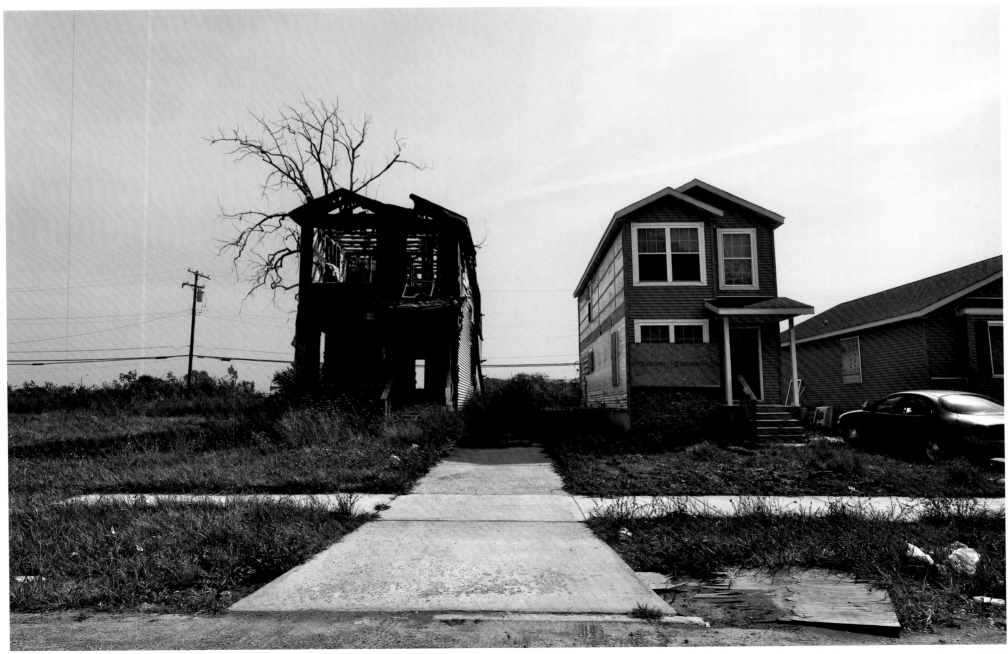

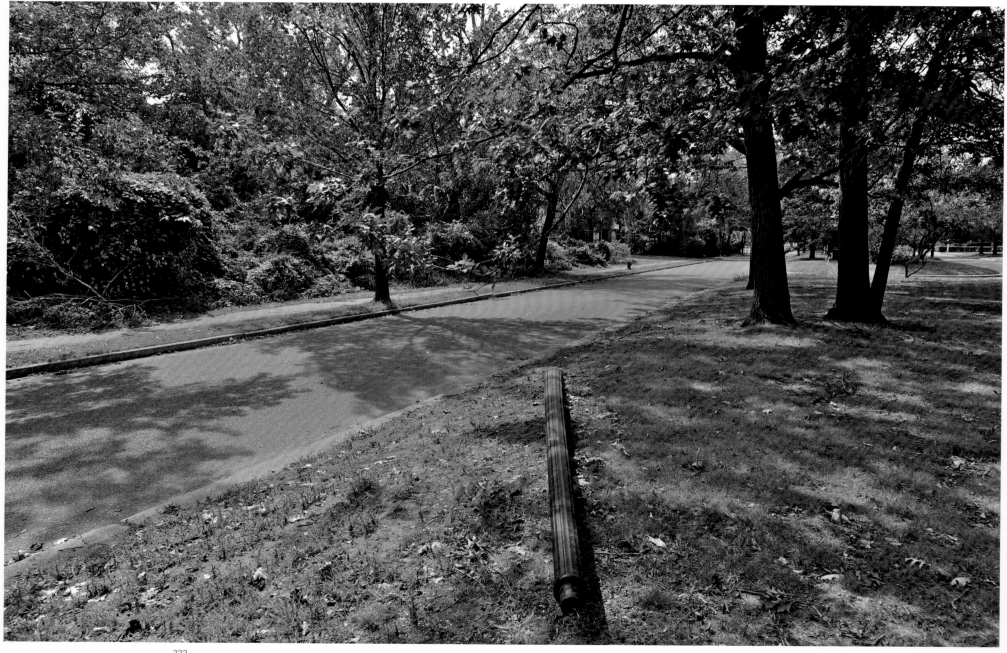

222

223

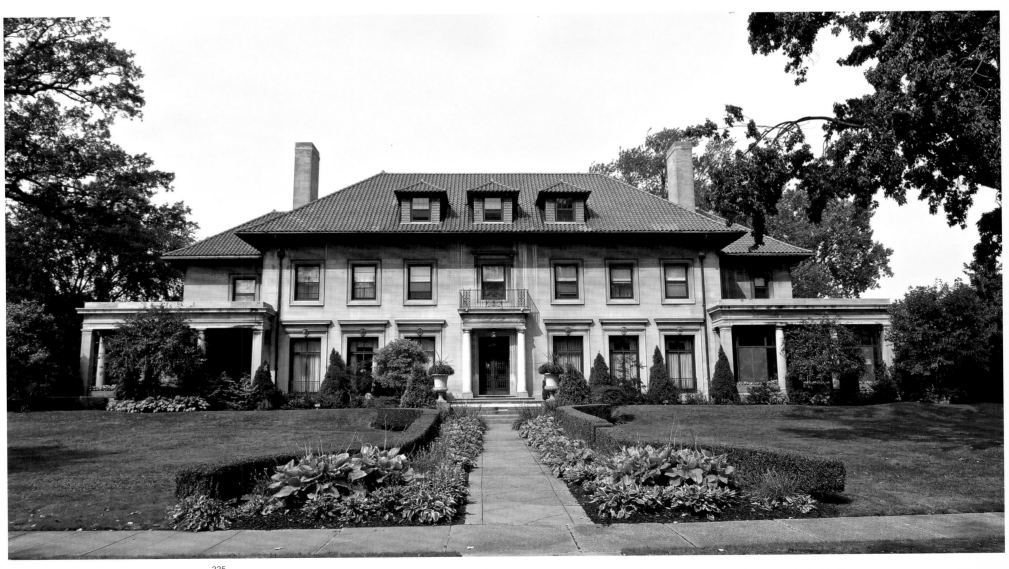

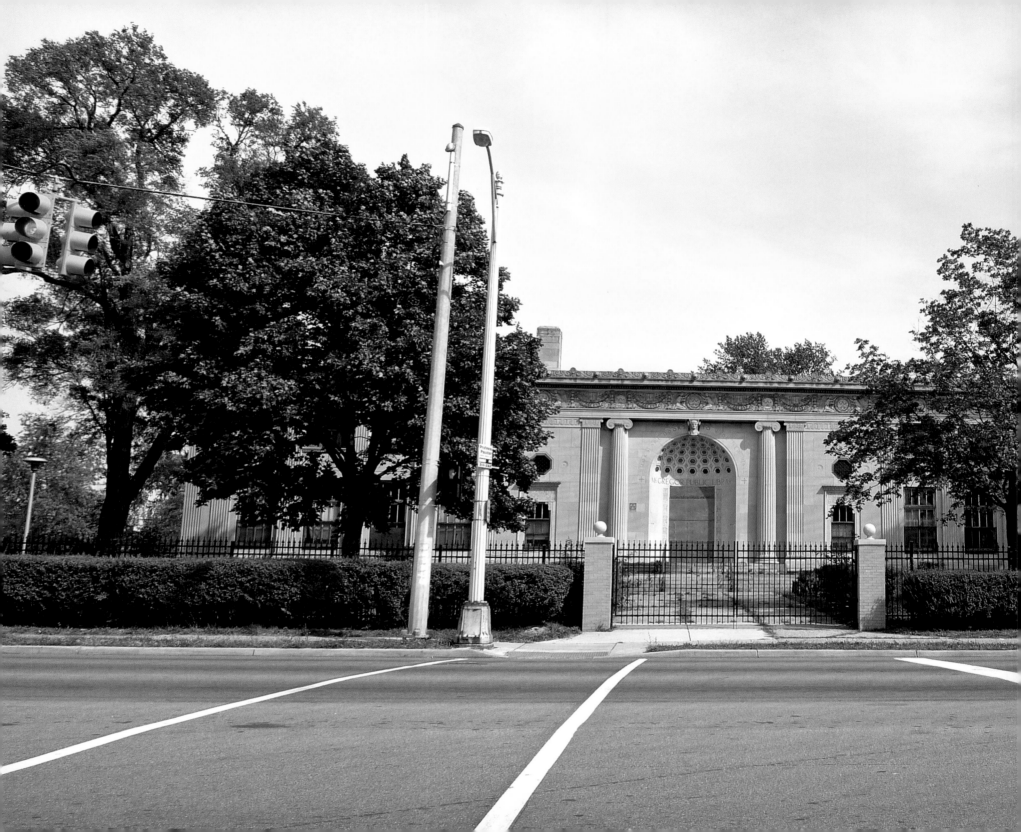

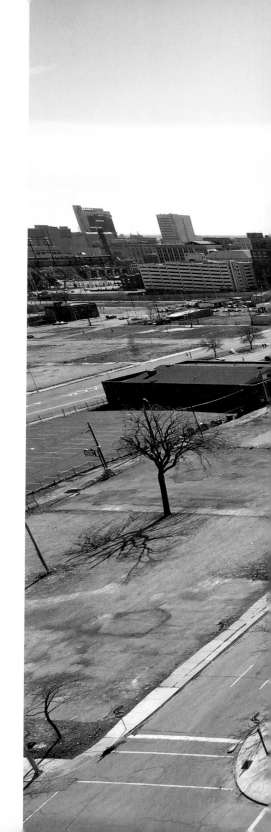

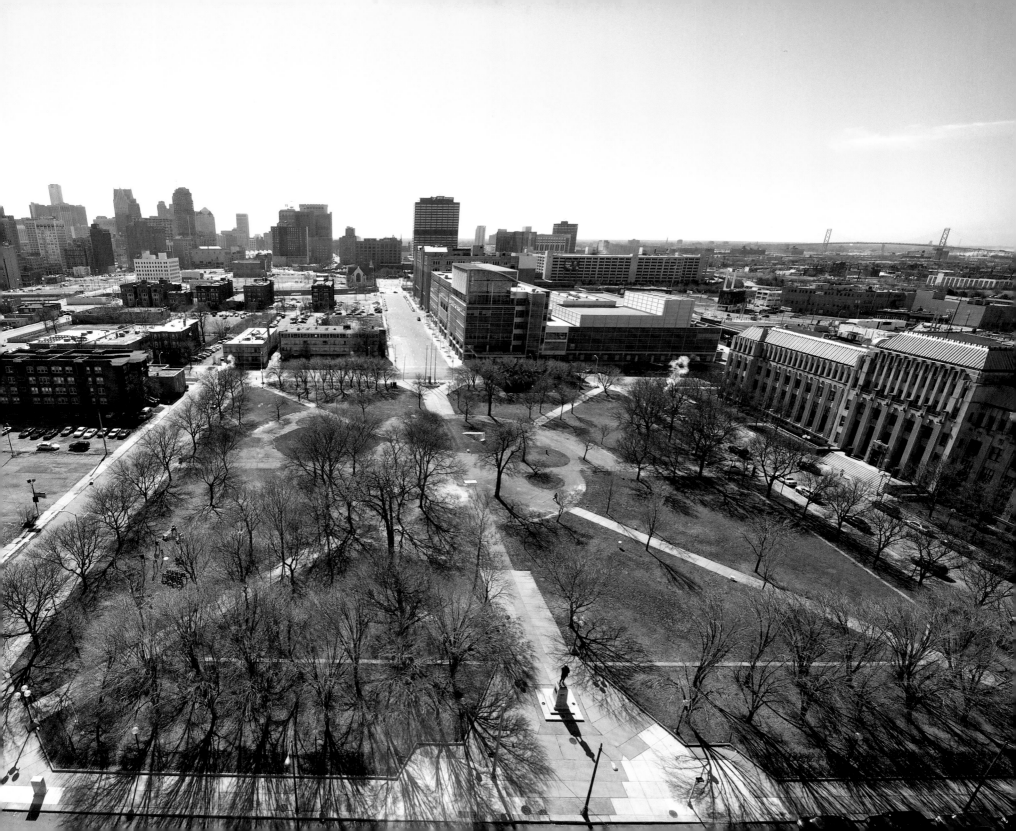

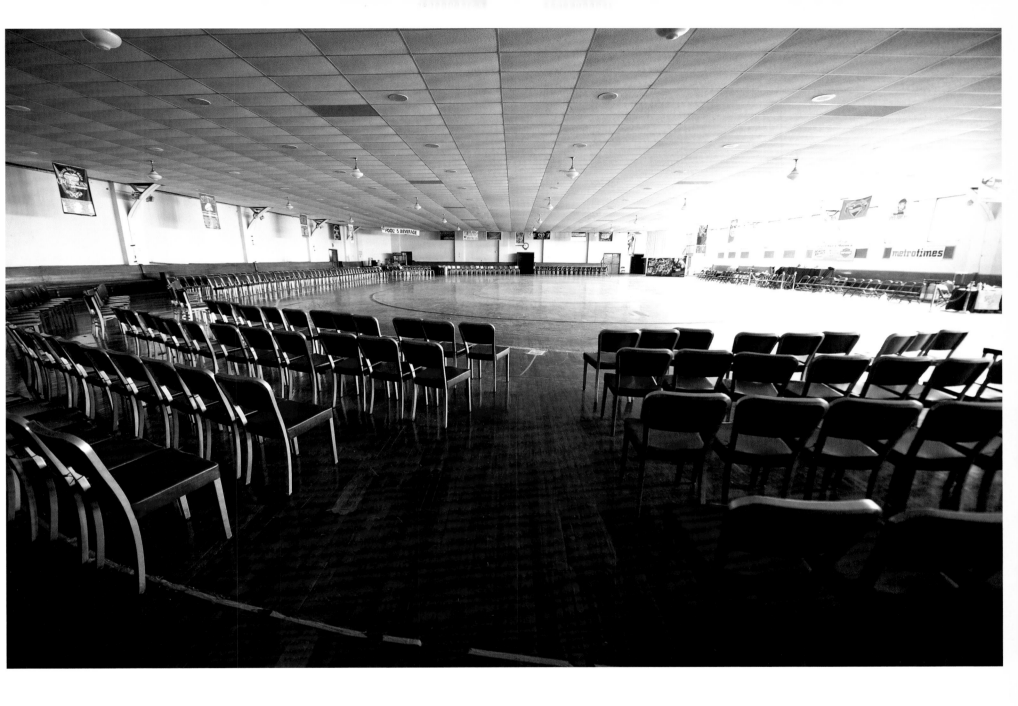

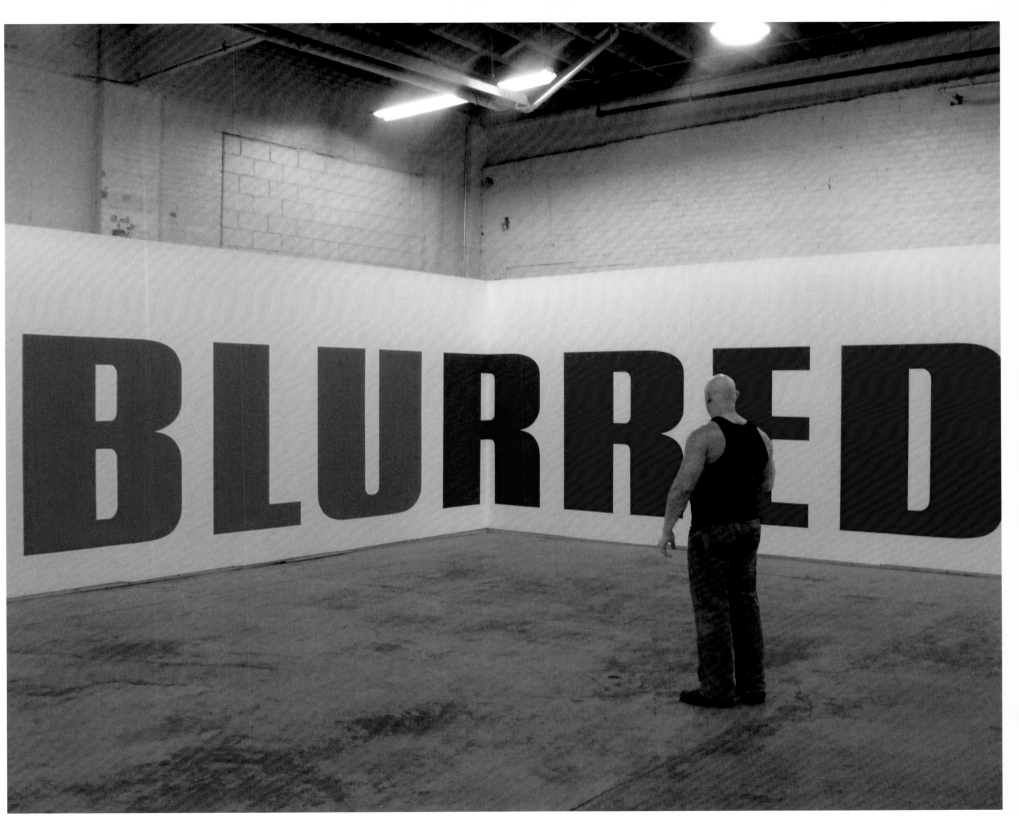

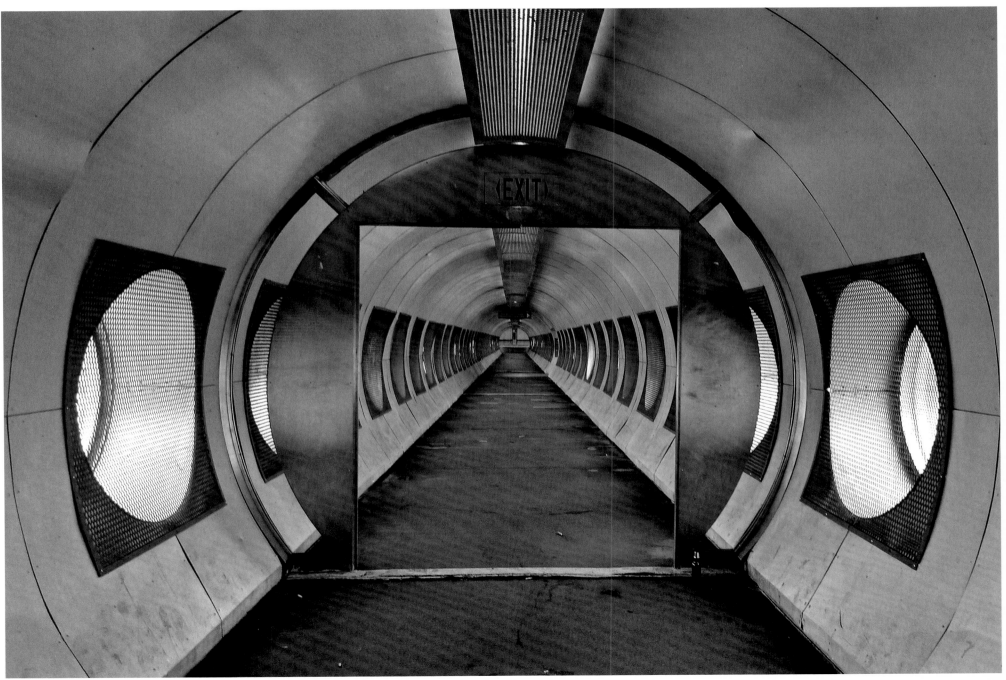

237

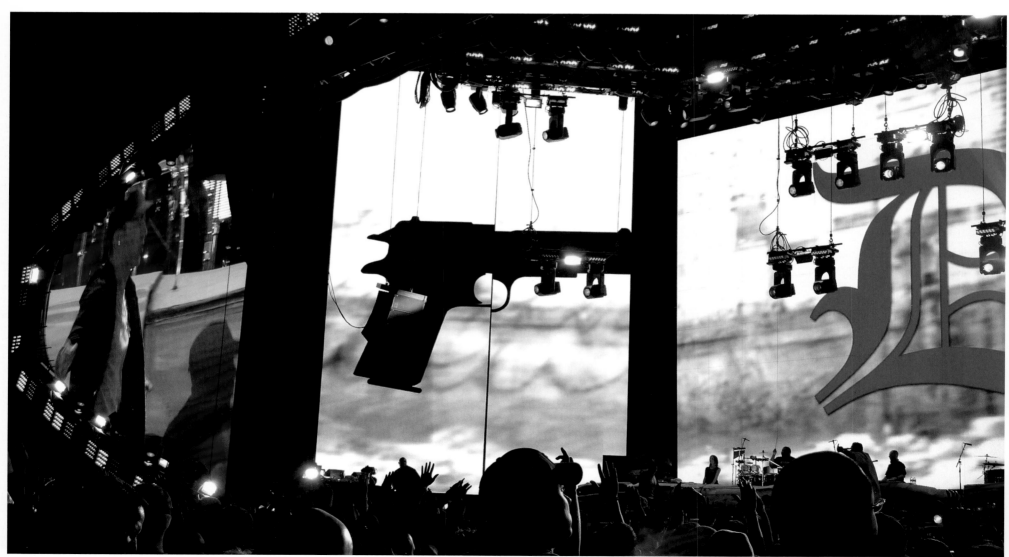

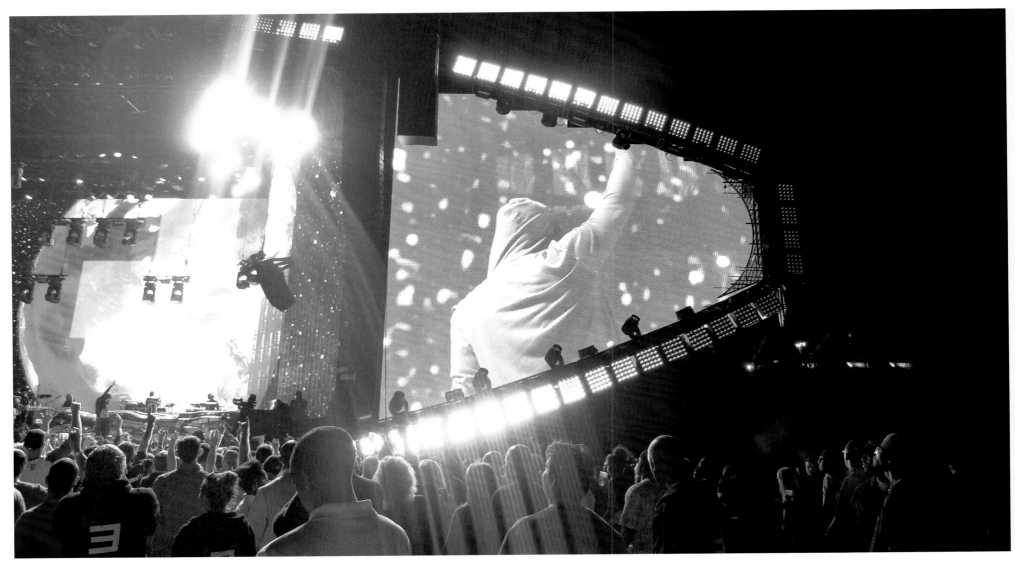

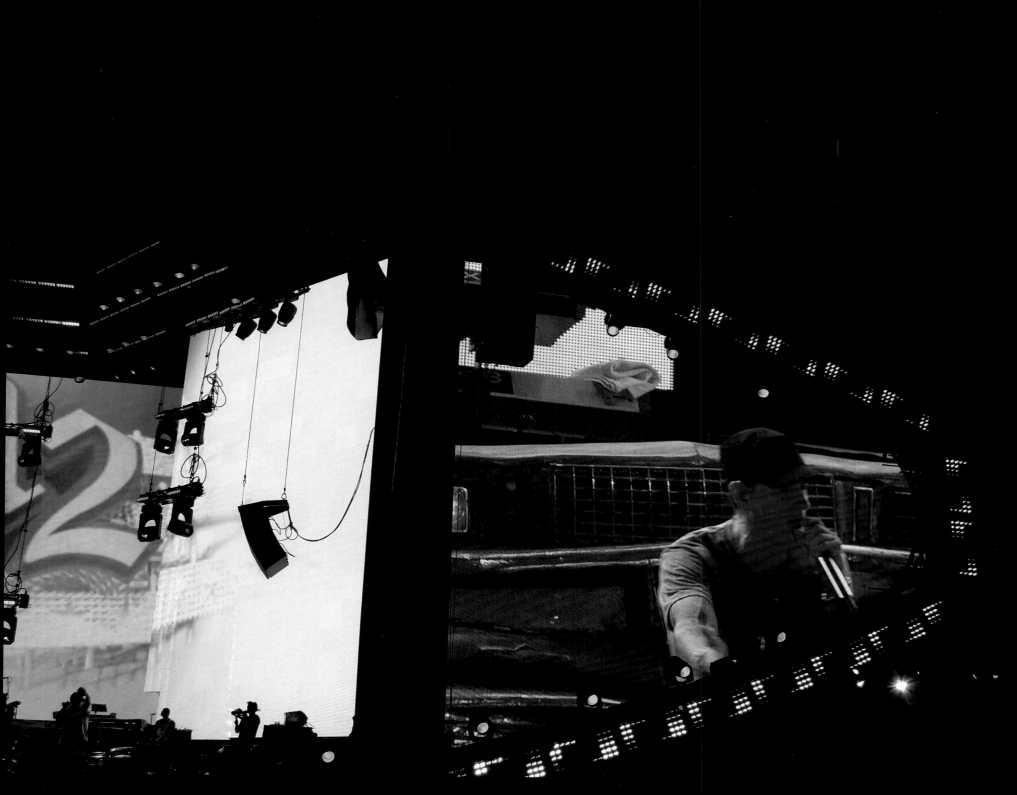

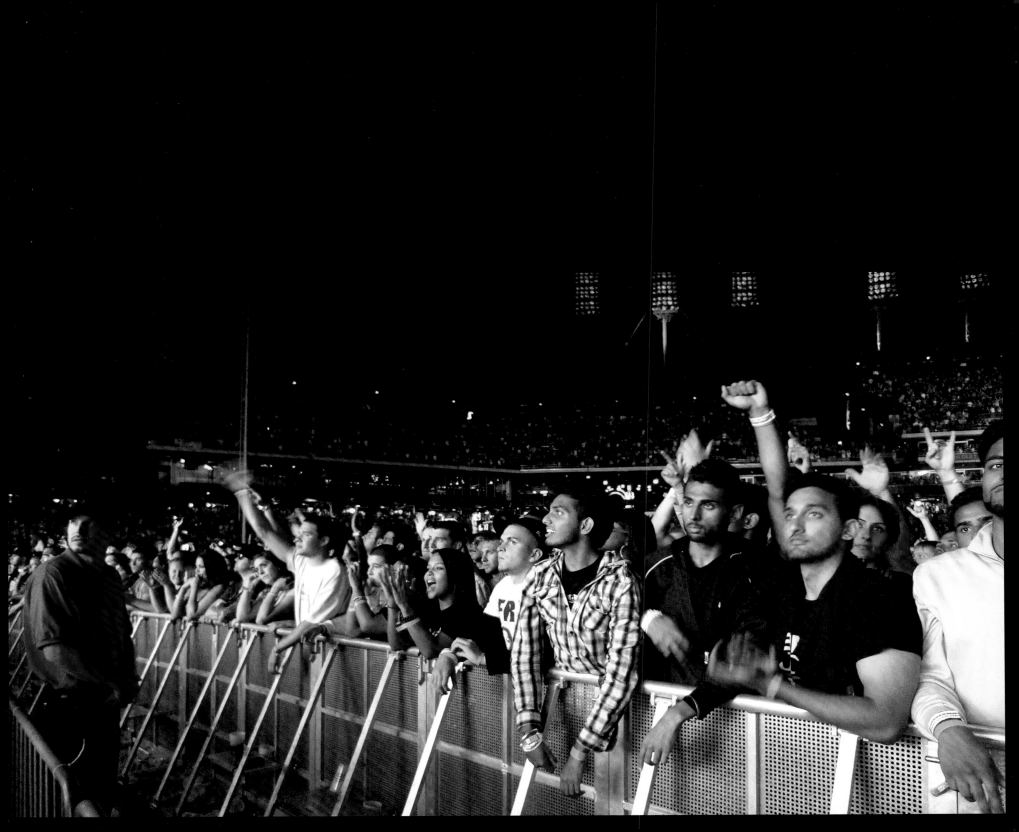

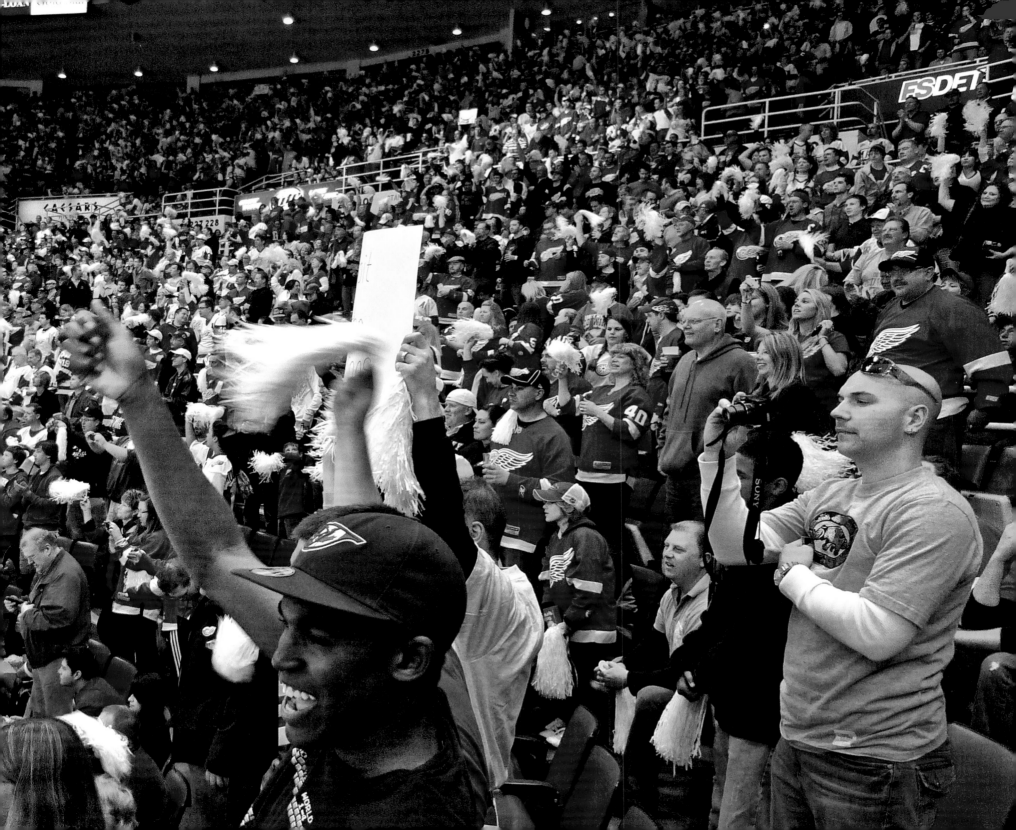

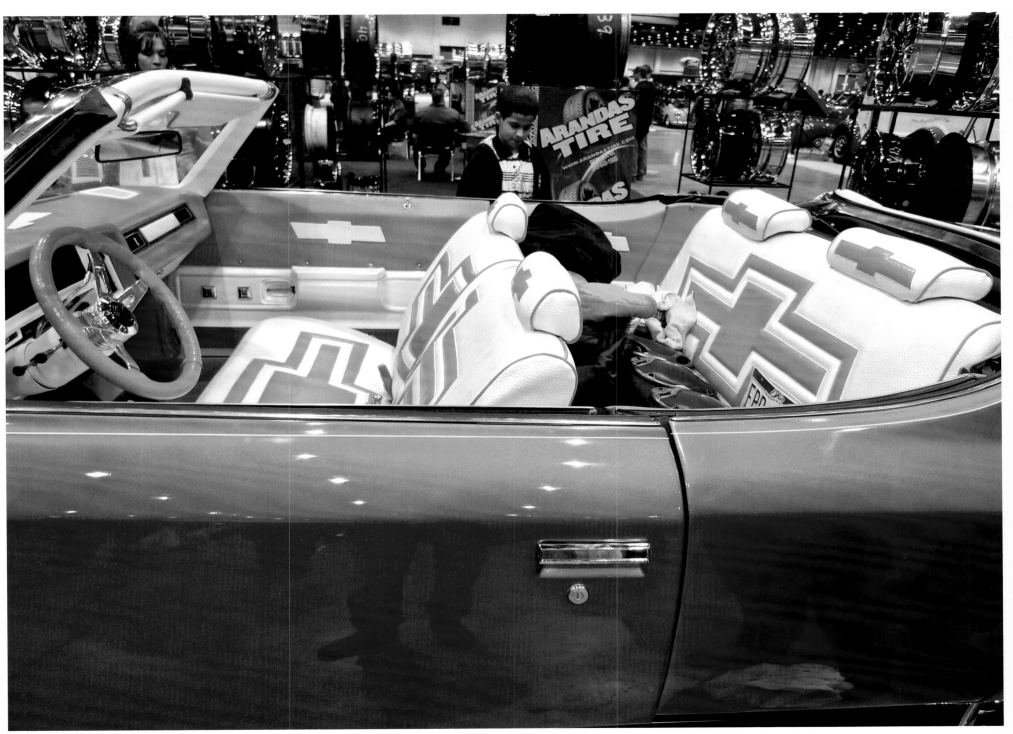

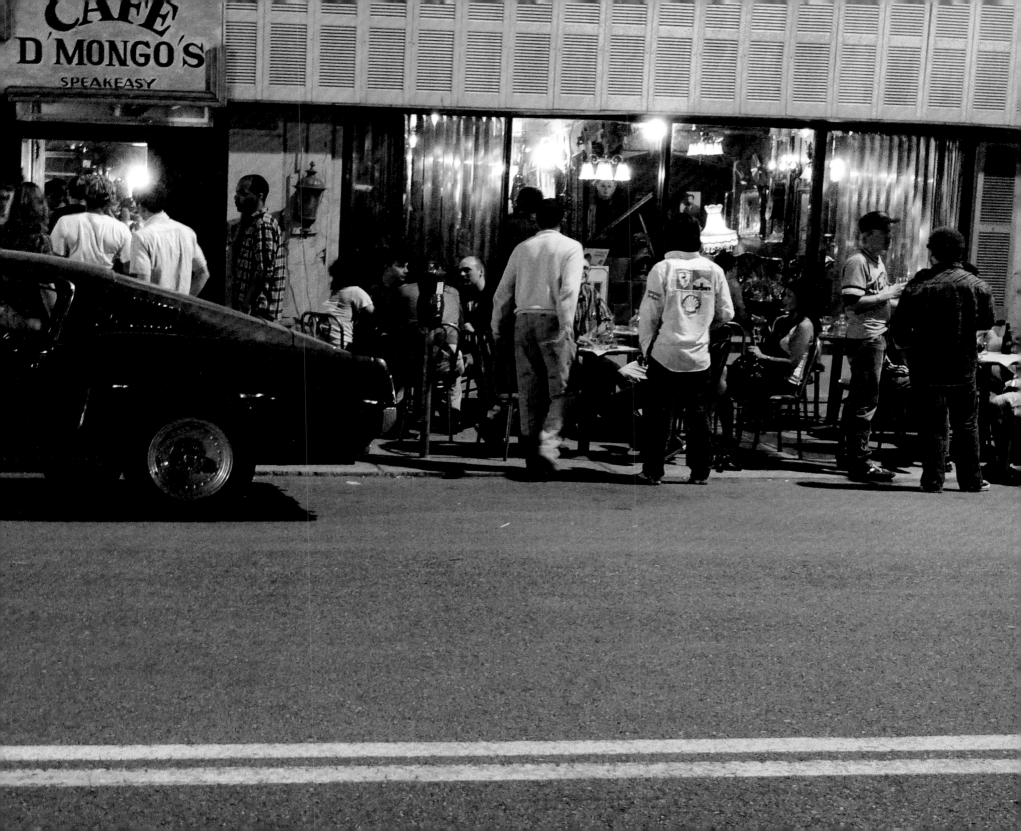

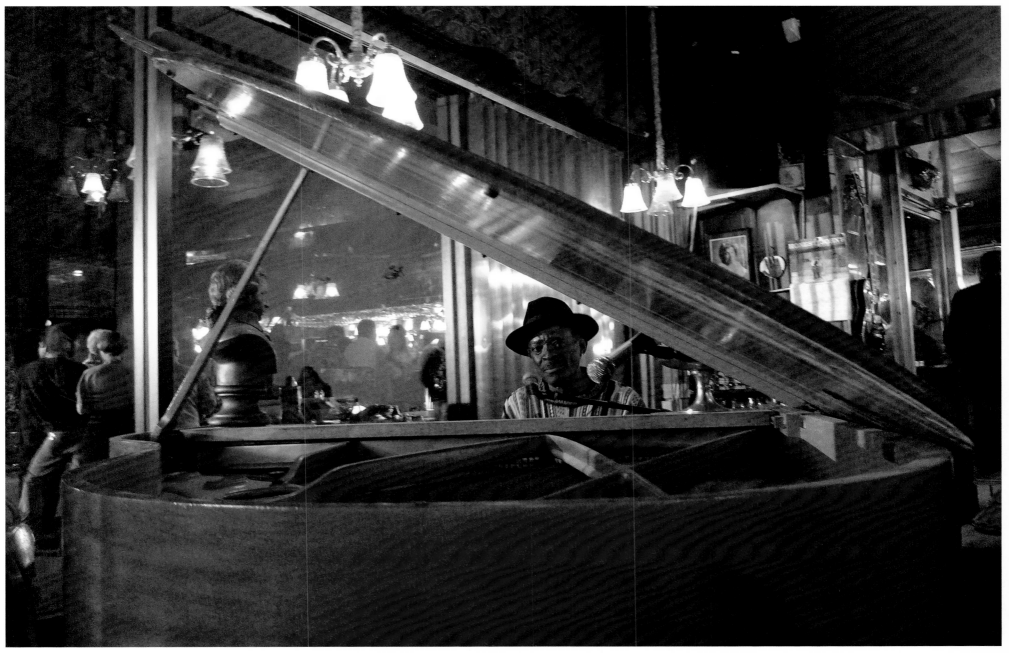

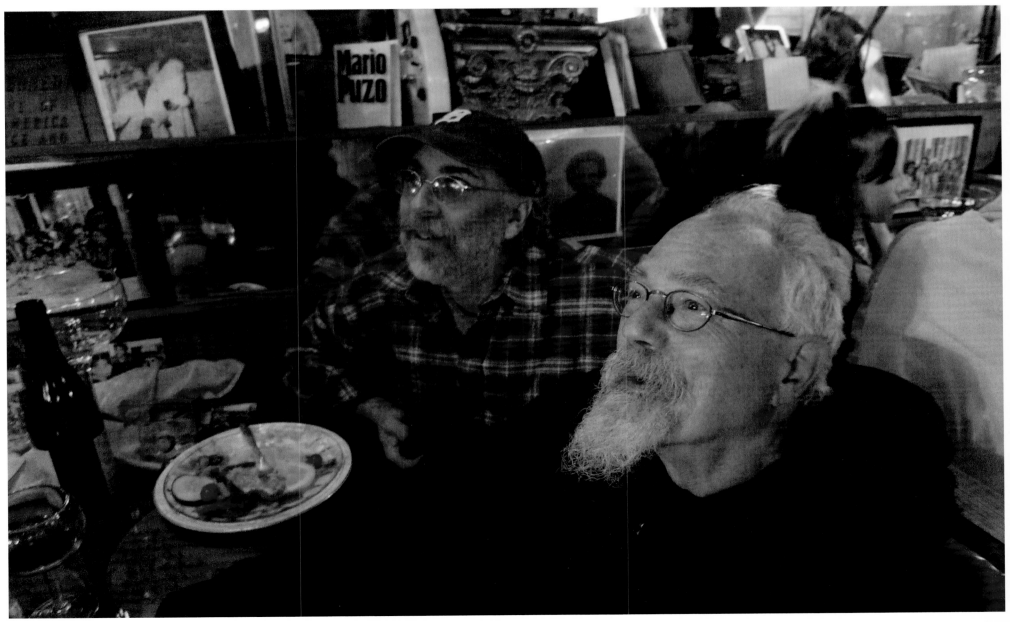

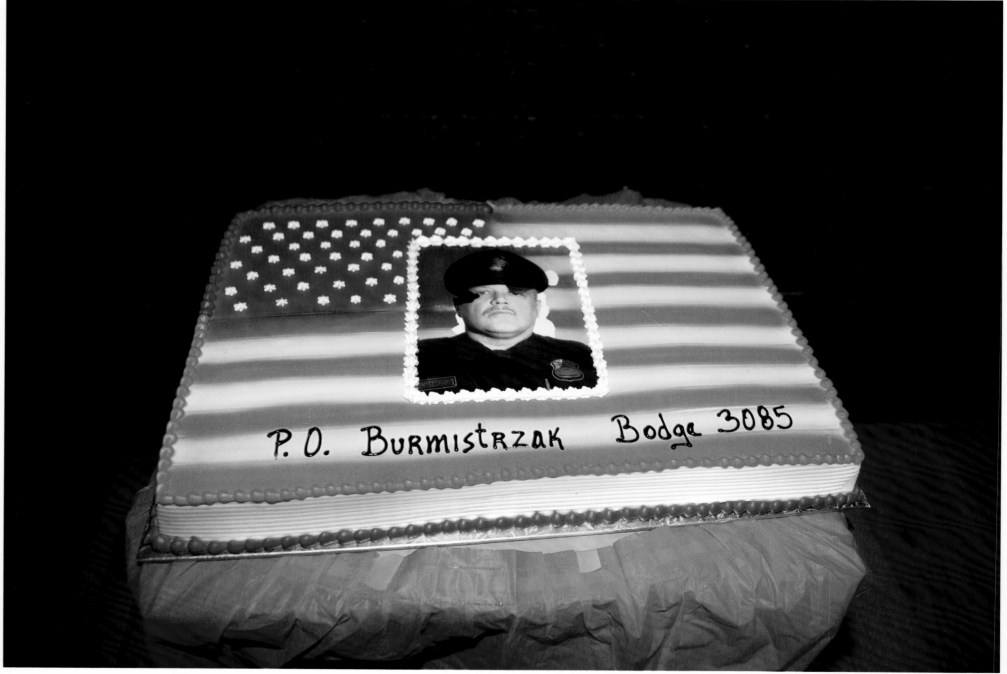

256

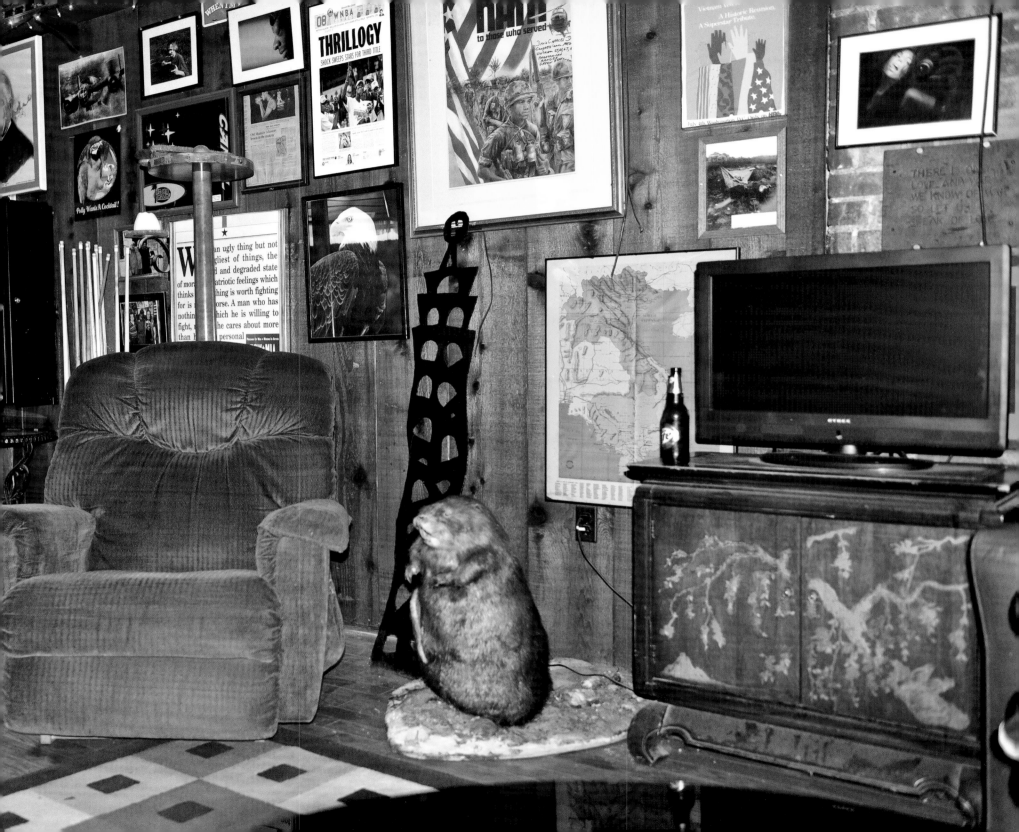

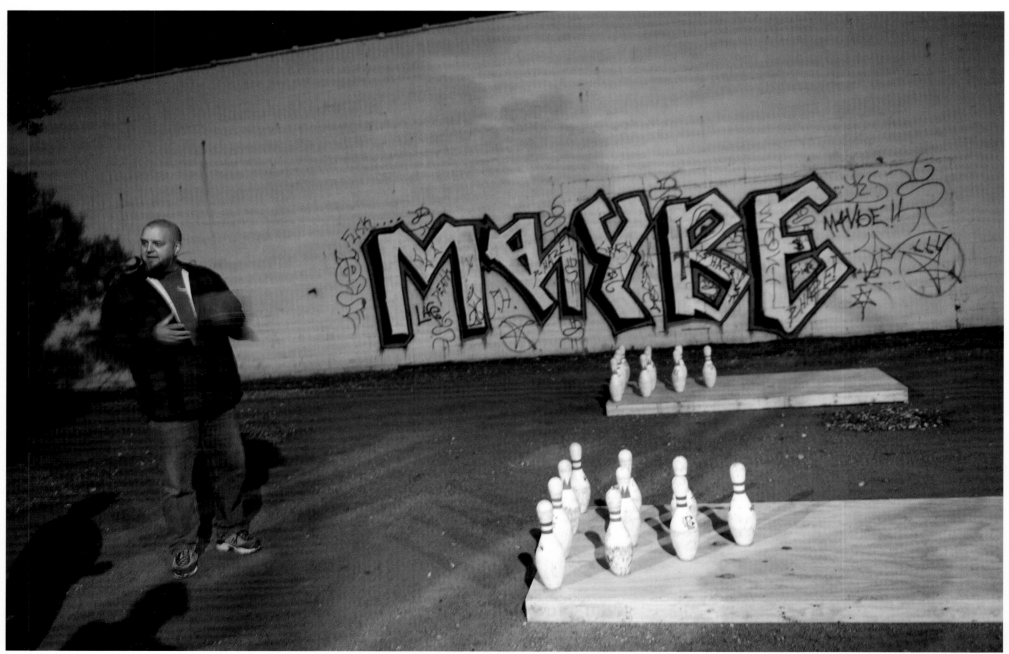

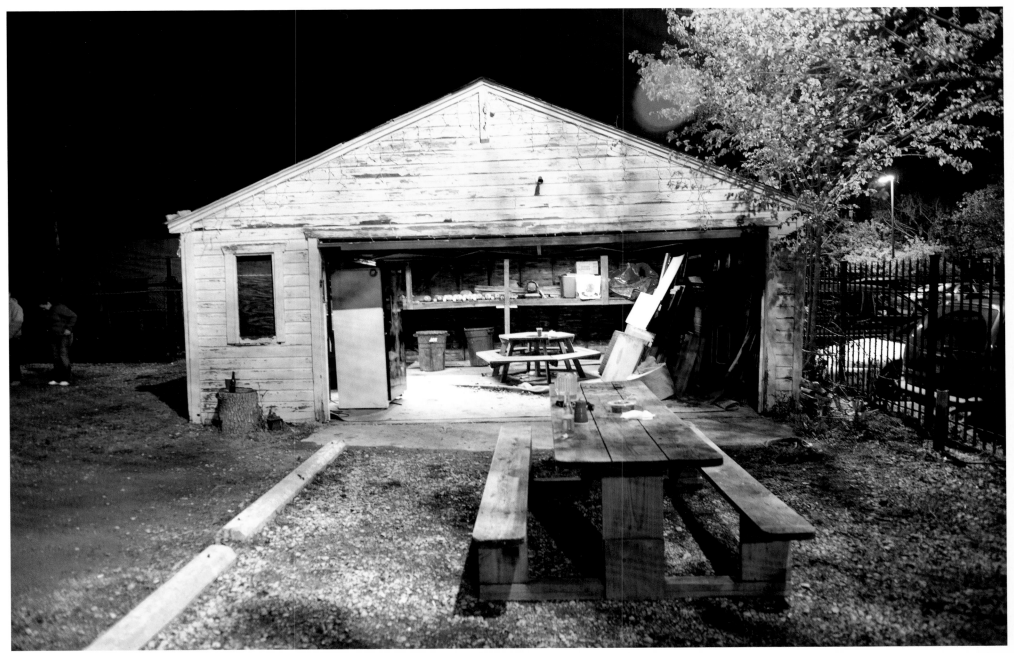

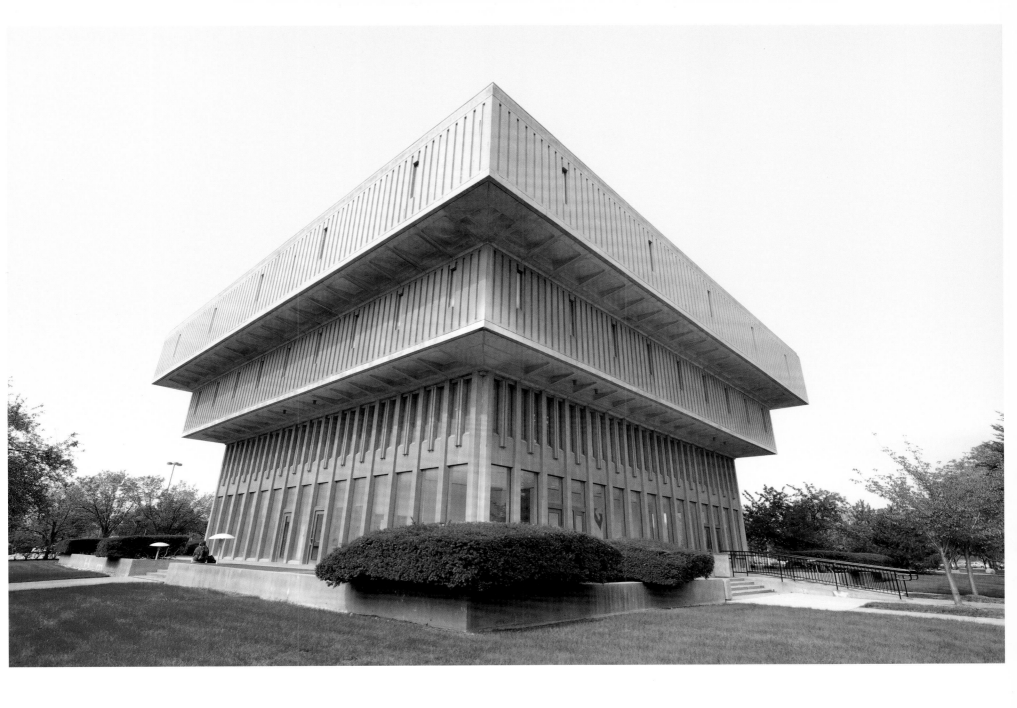

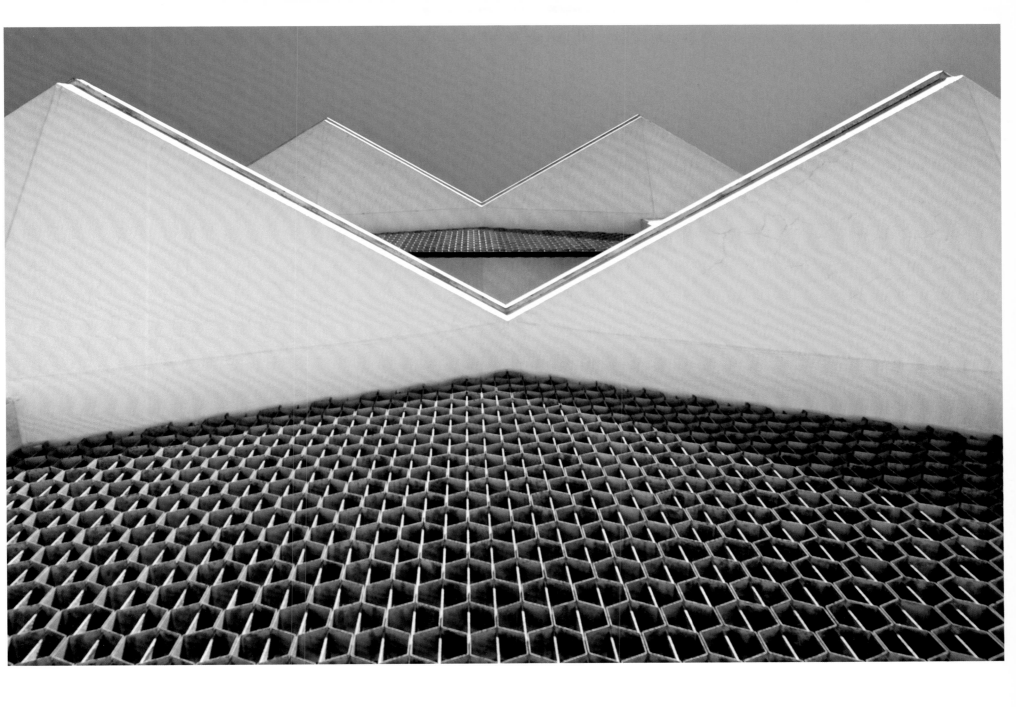

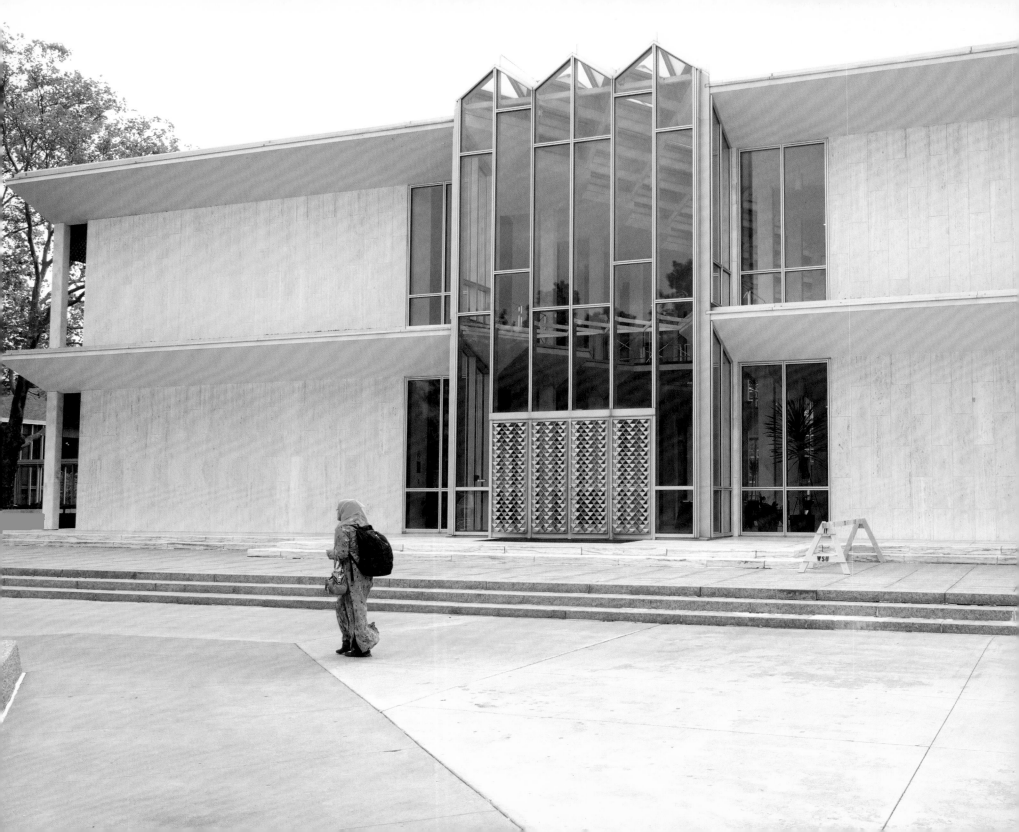

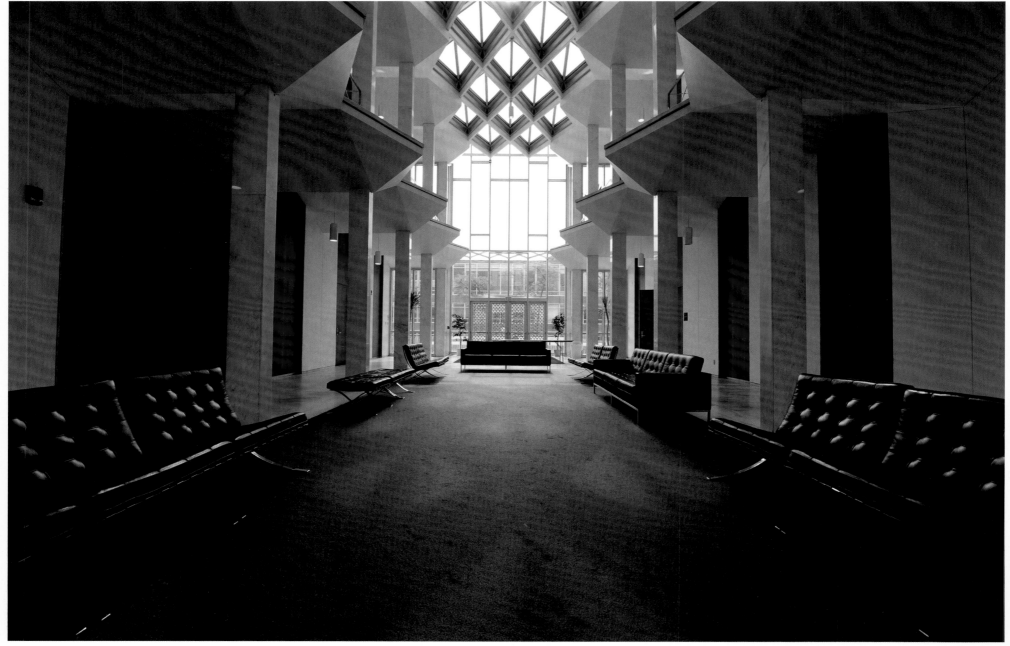

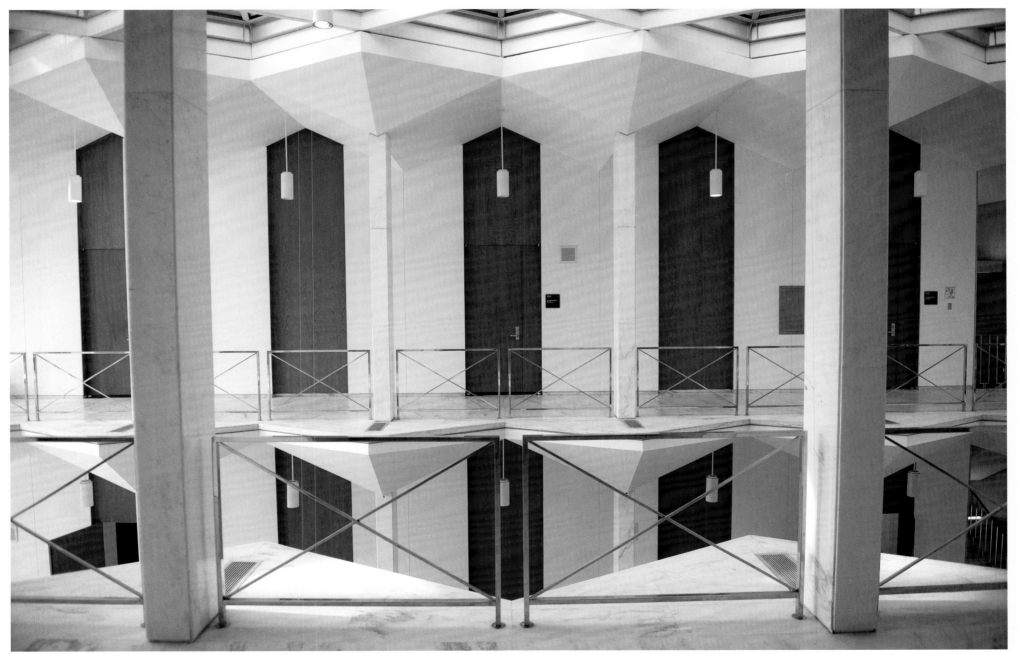

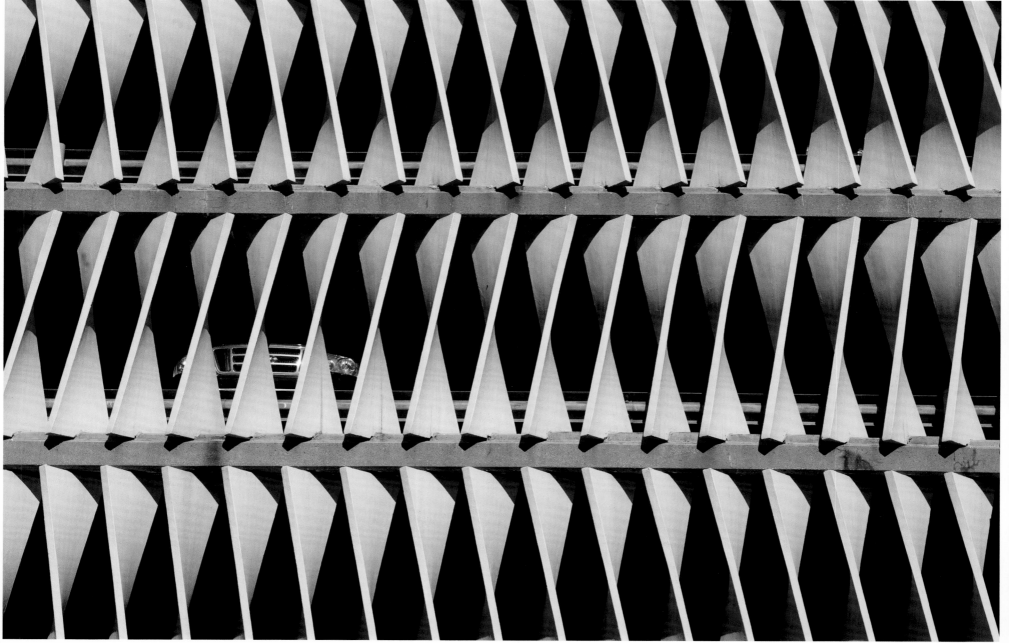

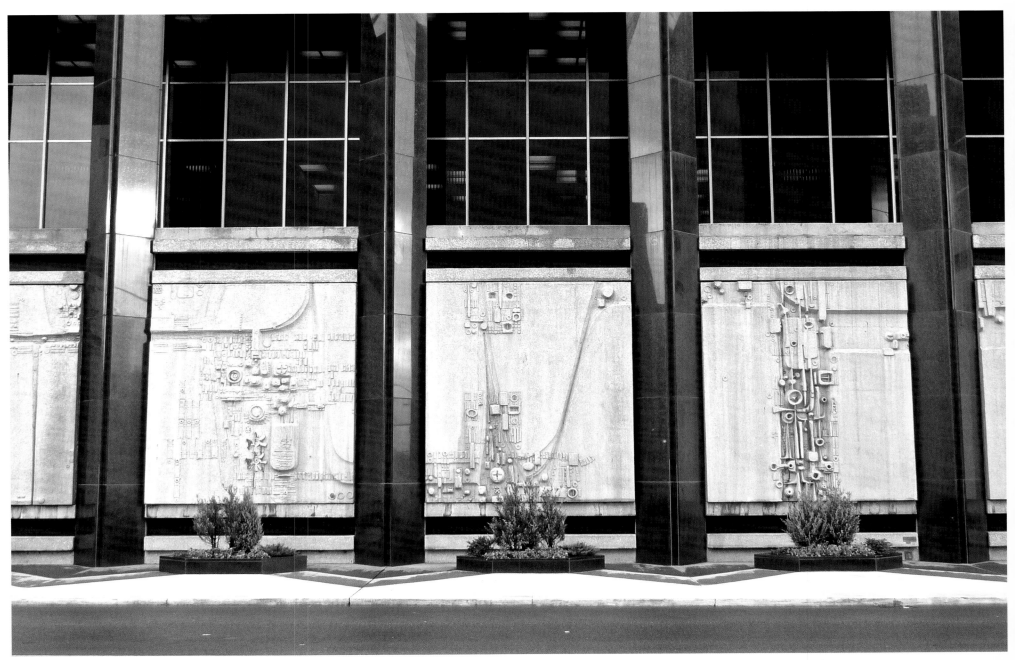

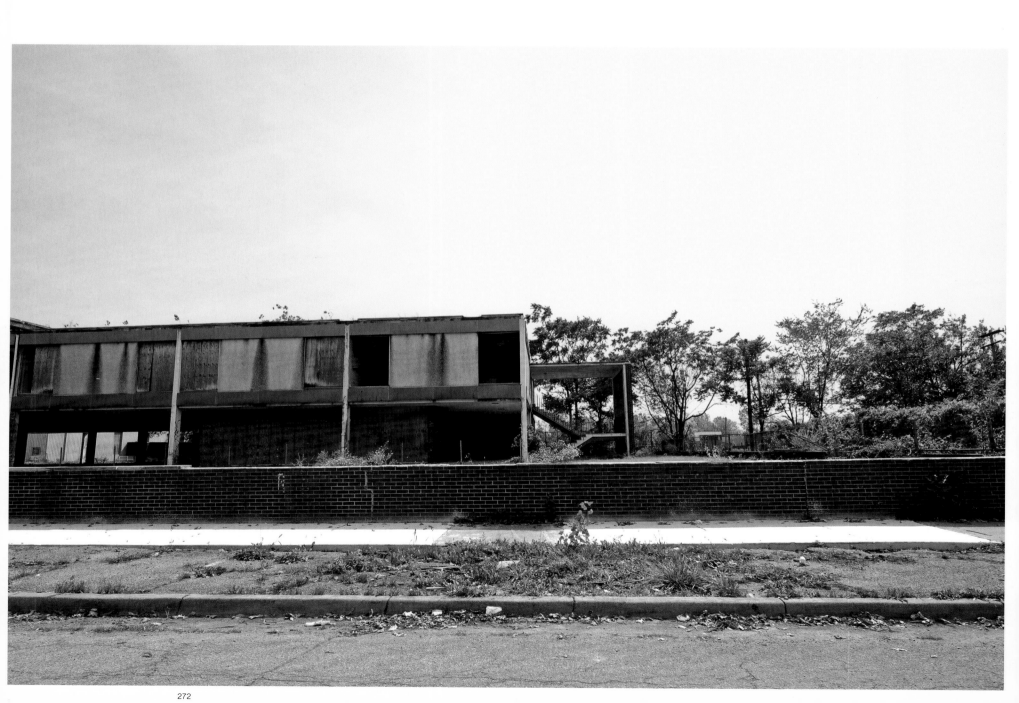

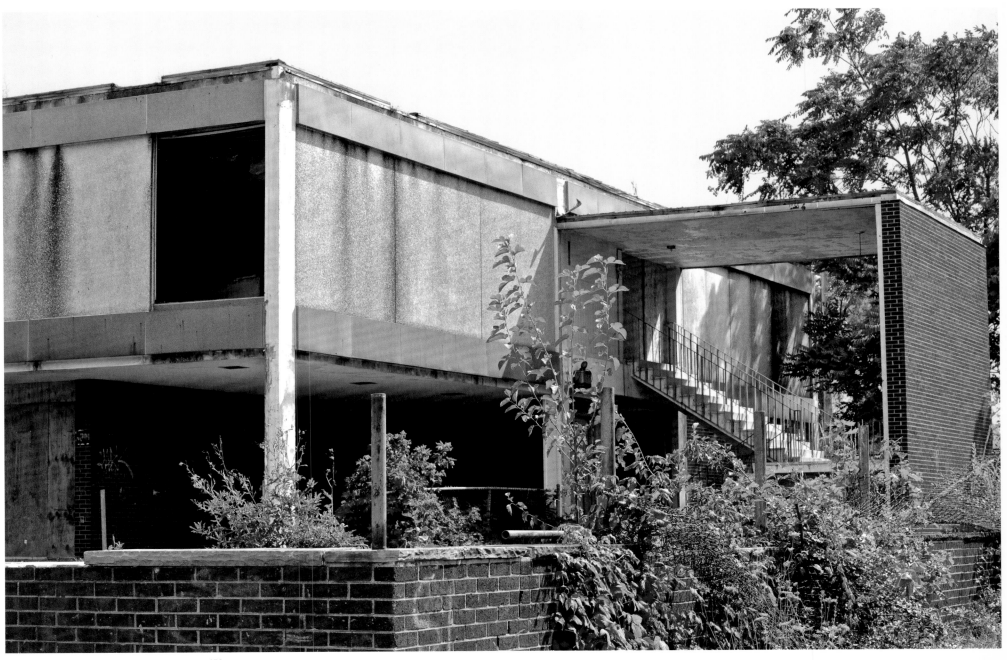

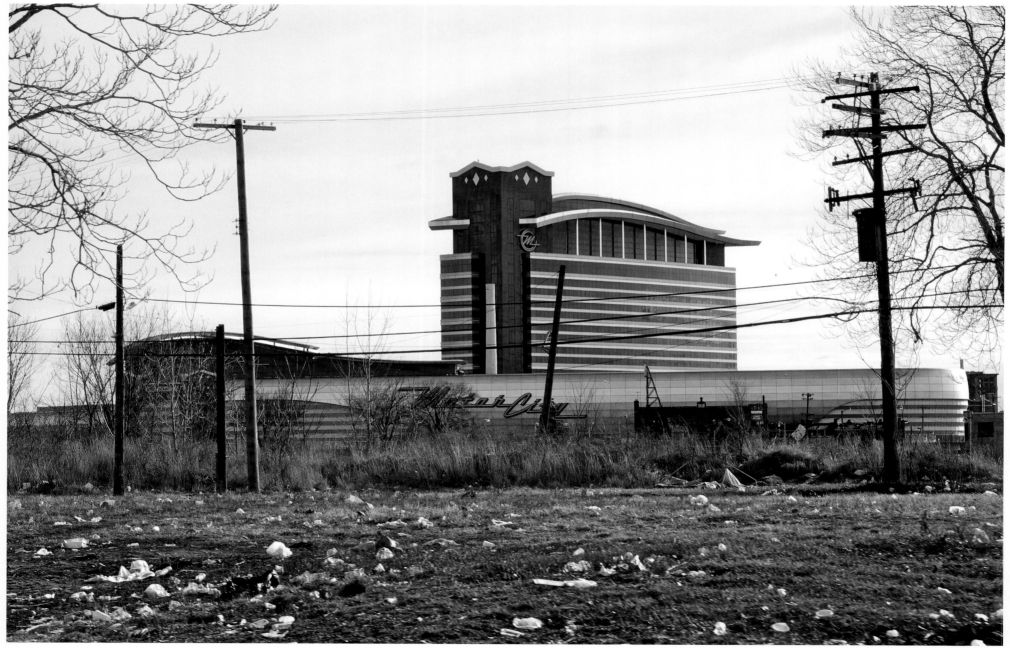

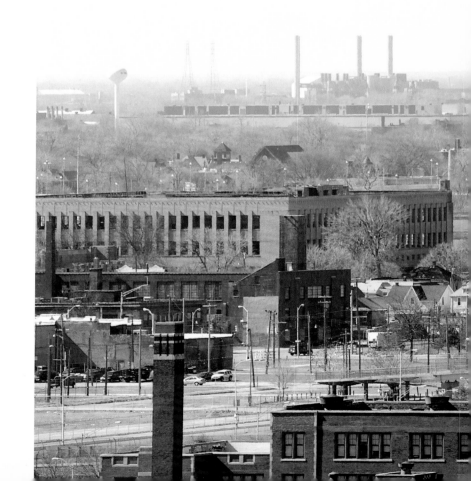

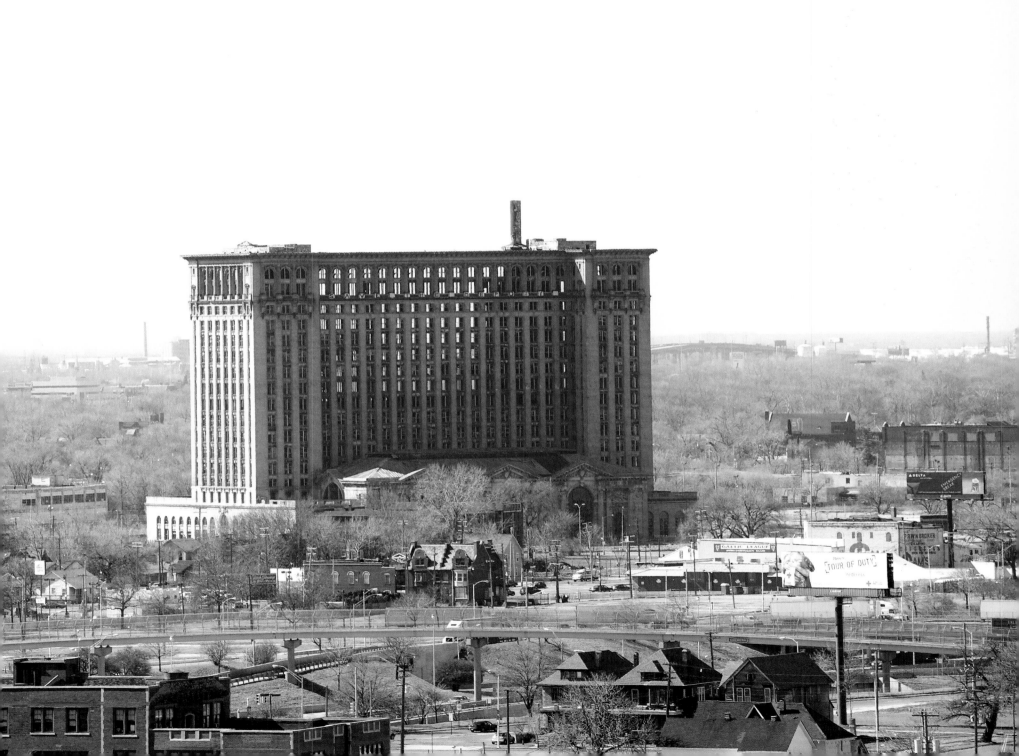

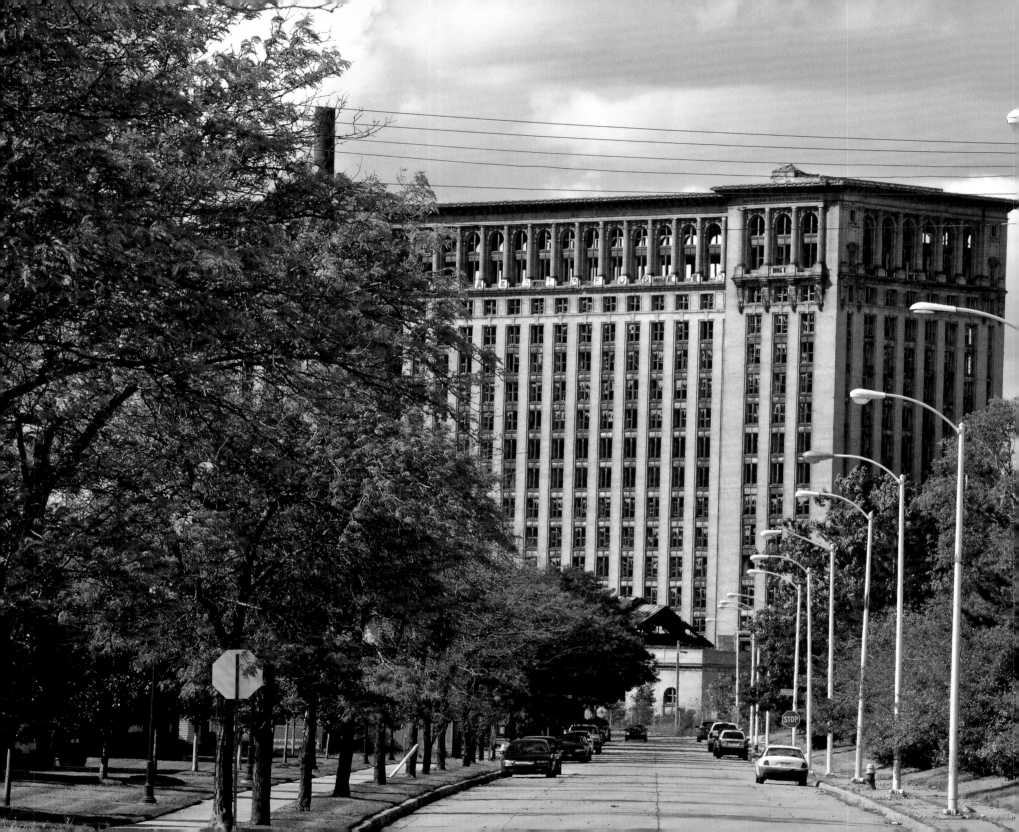

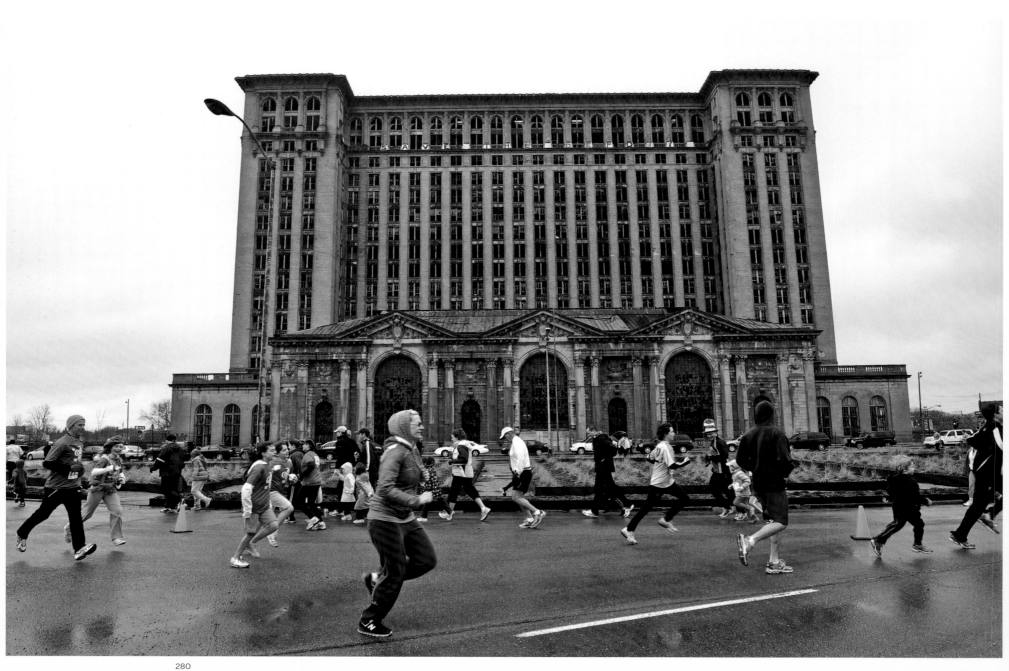

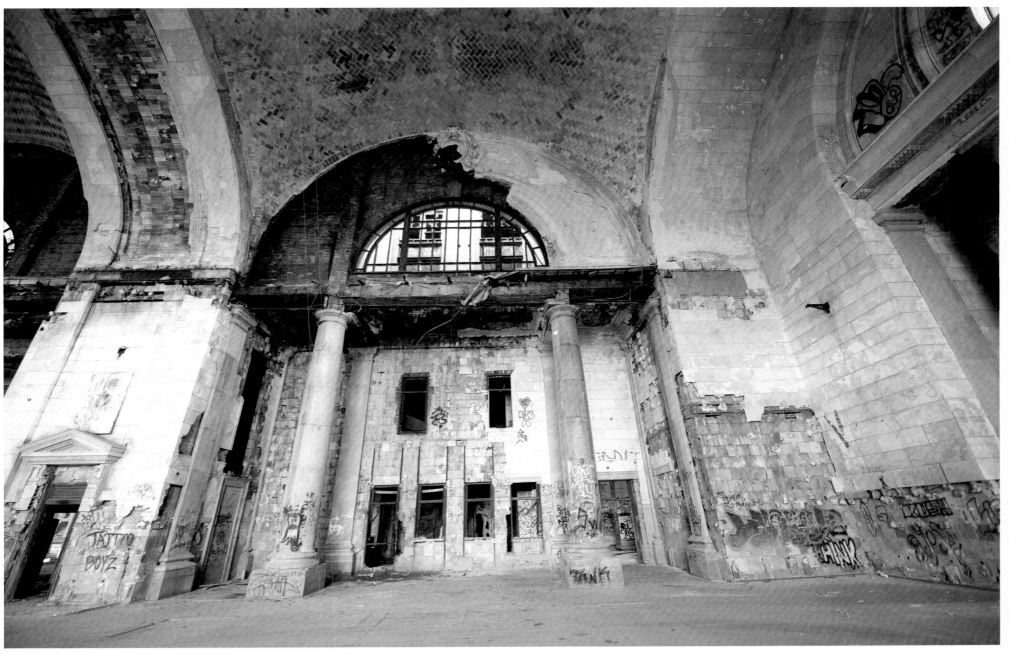

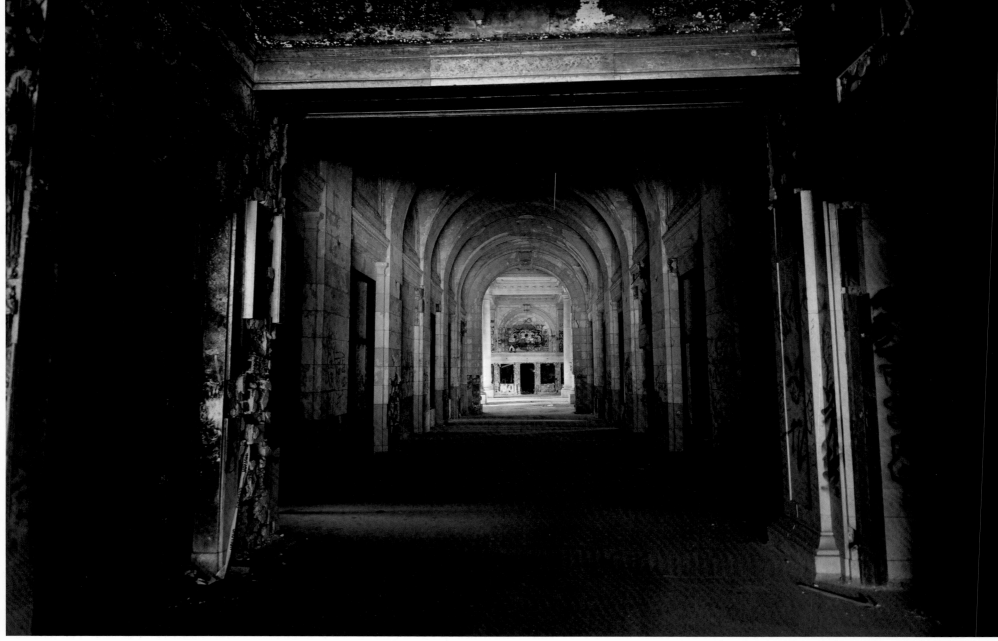

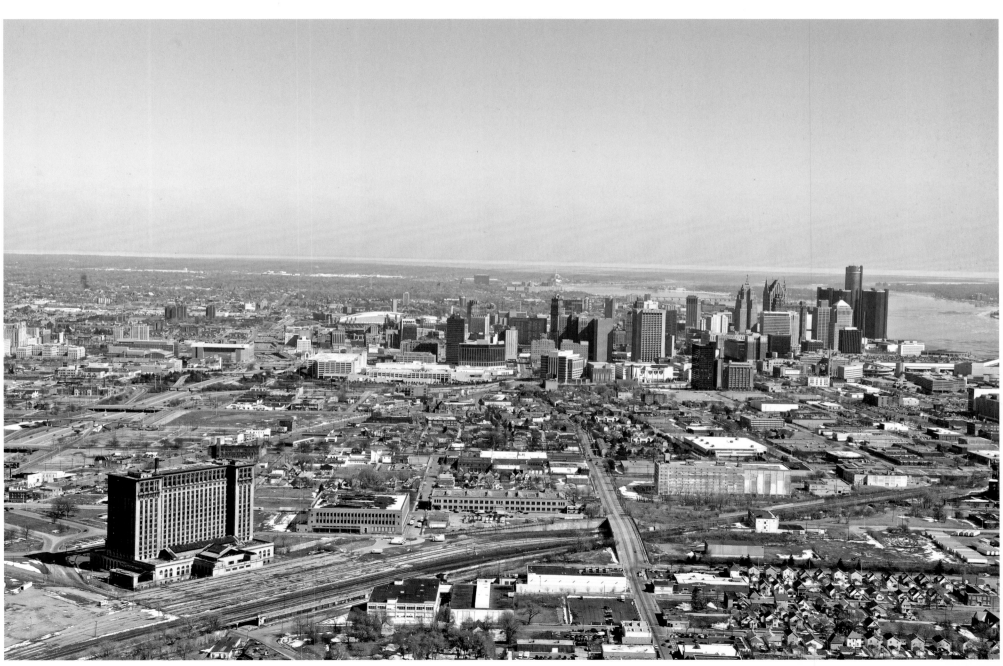

283

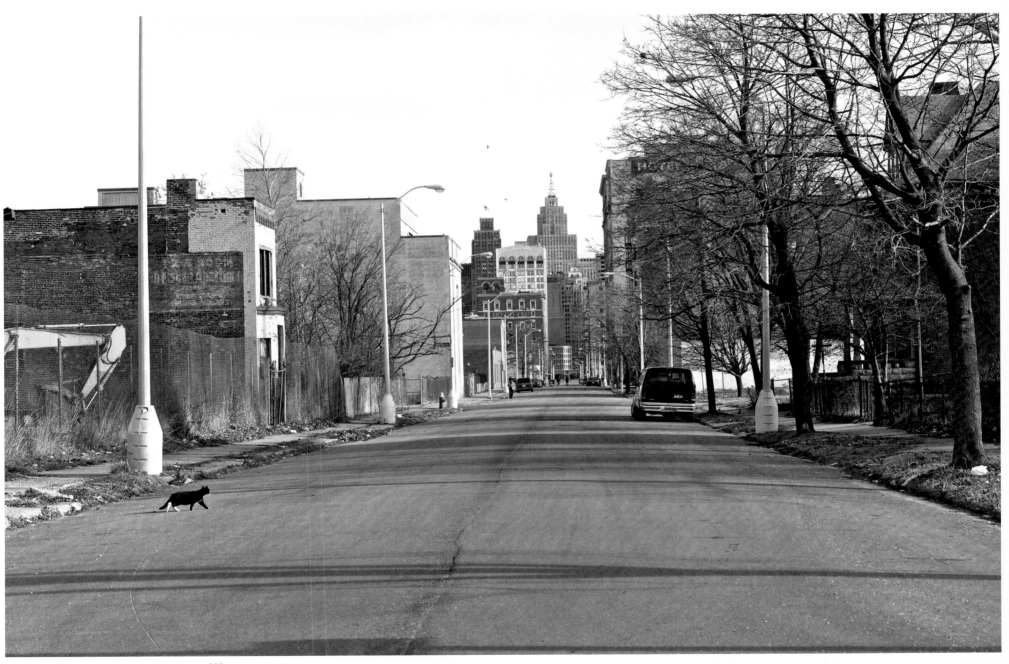

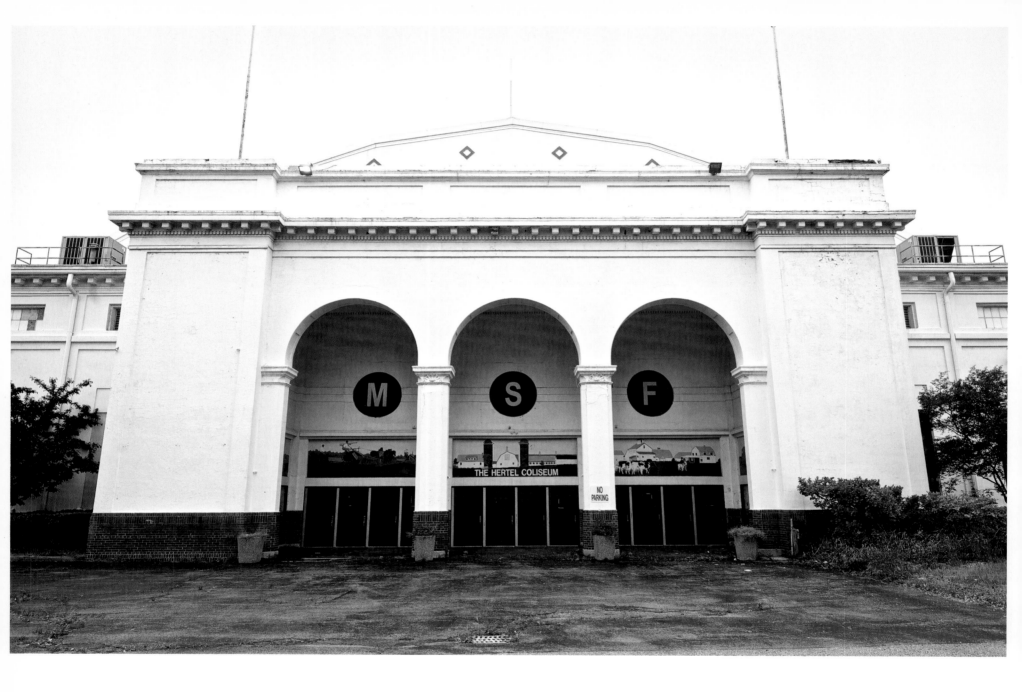

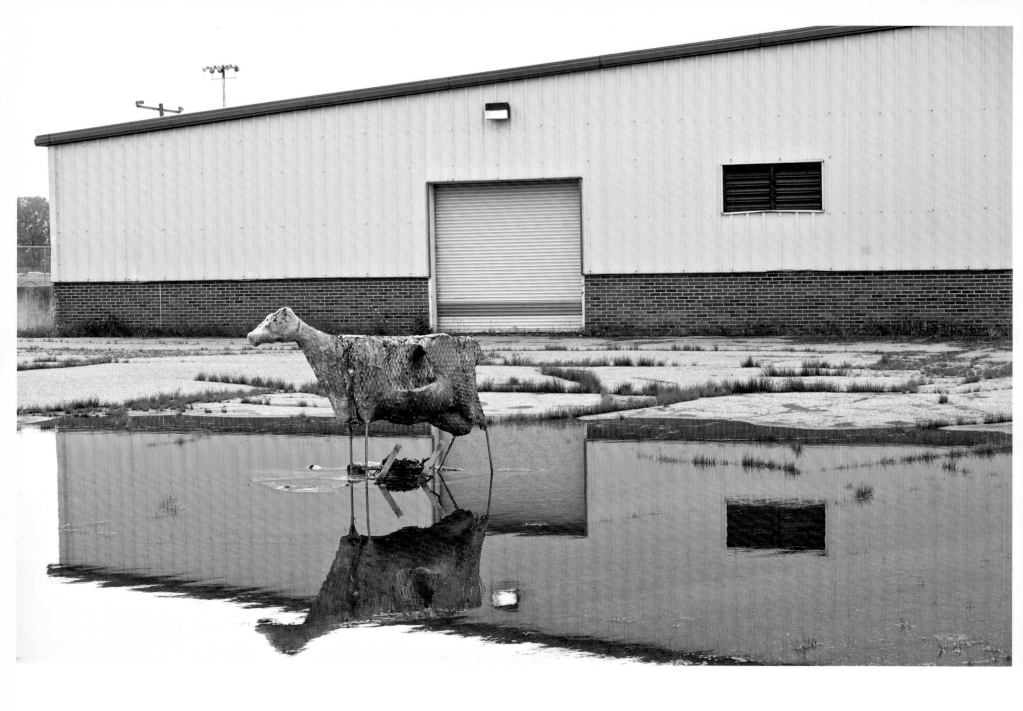

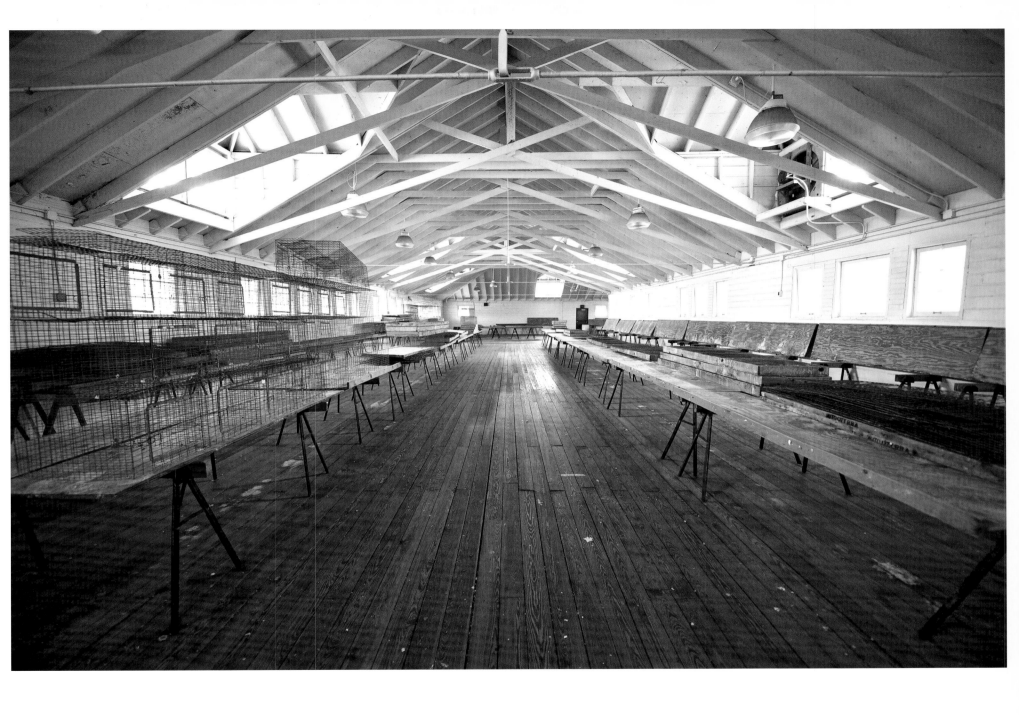

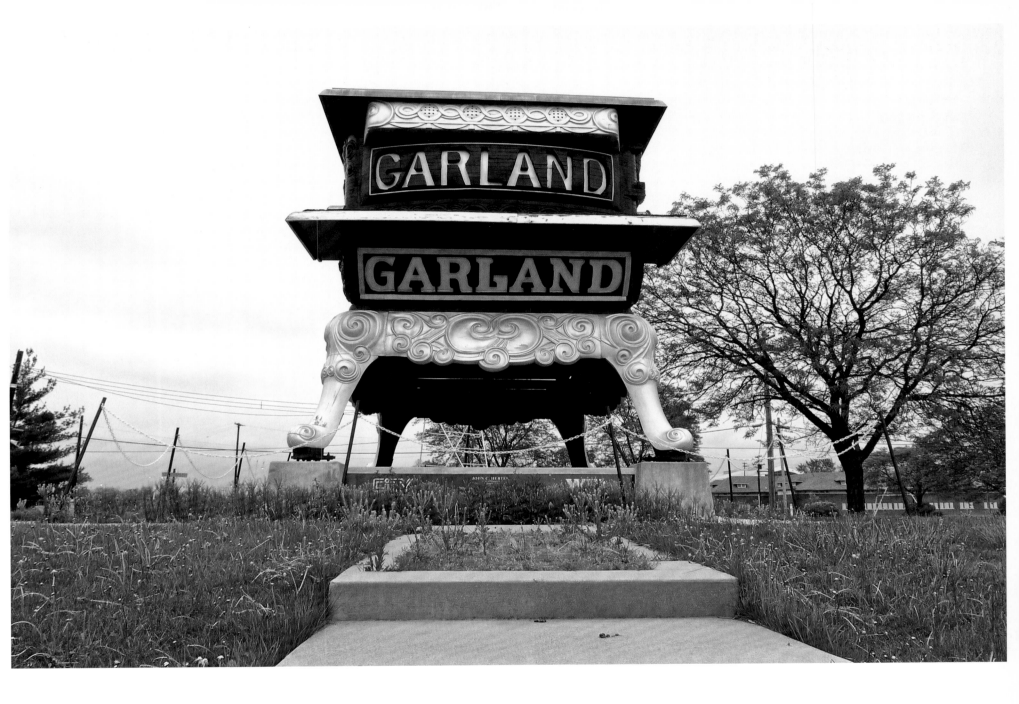

294

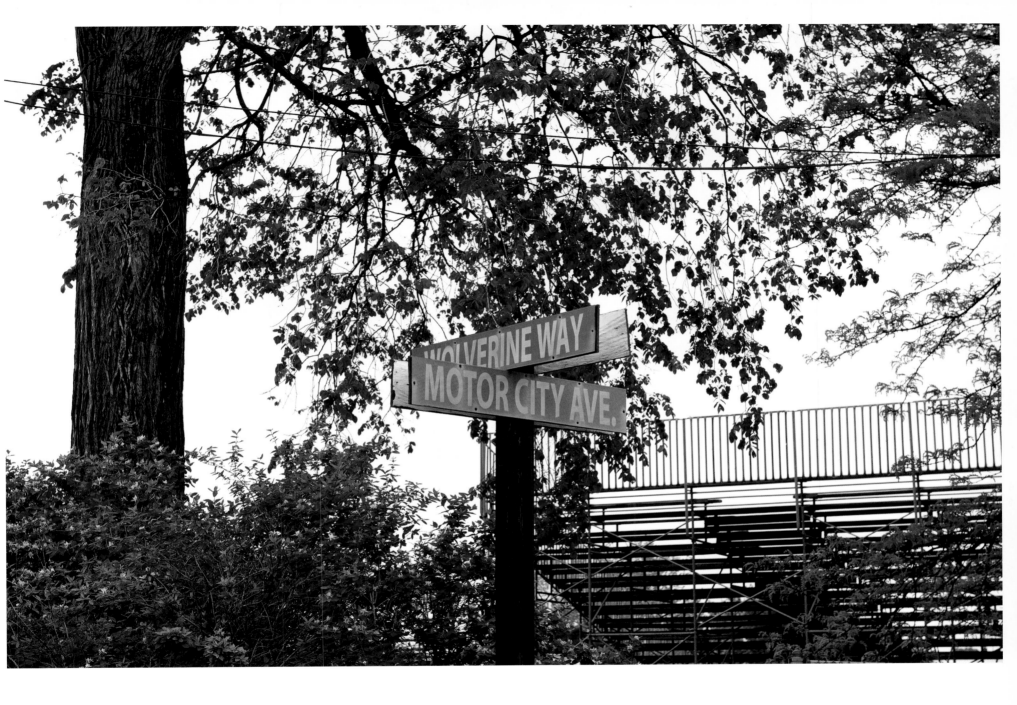

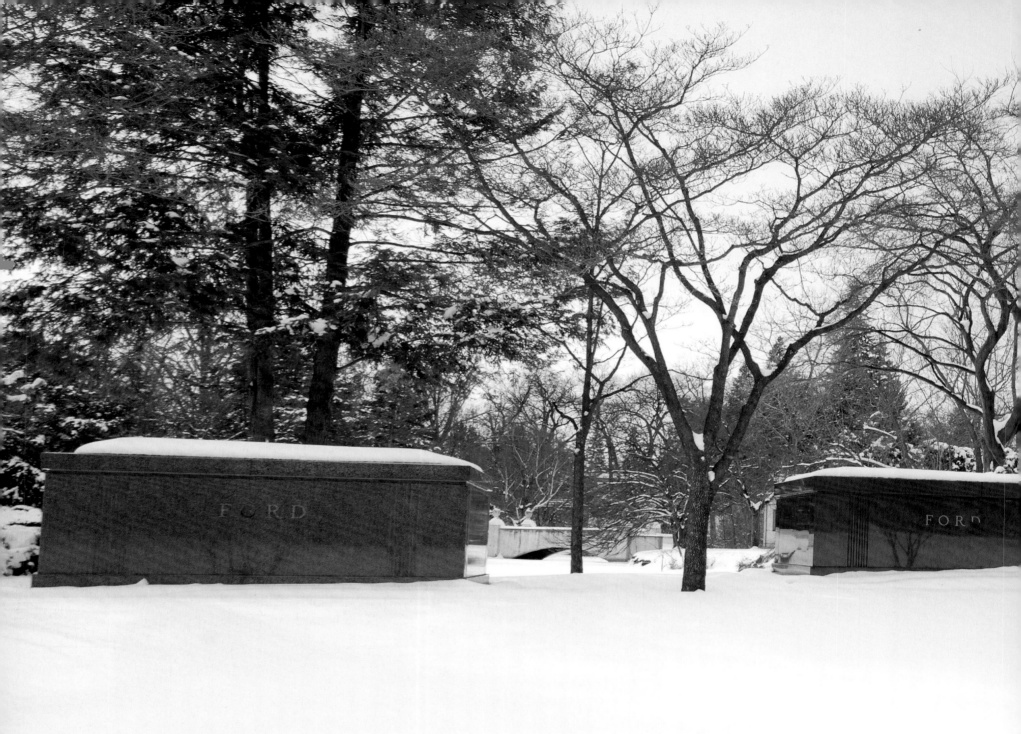

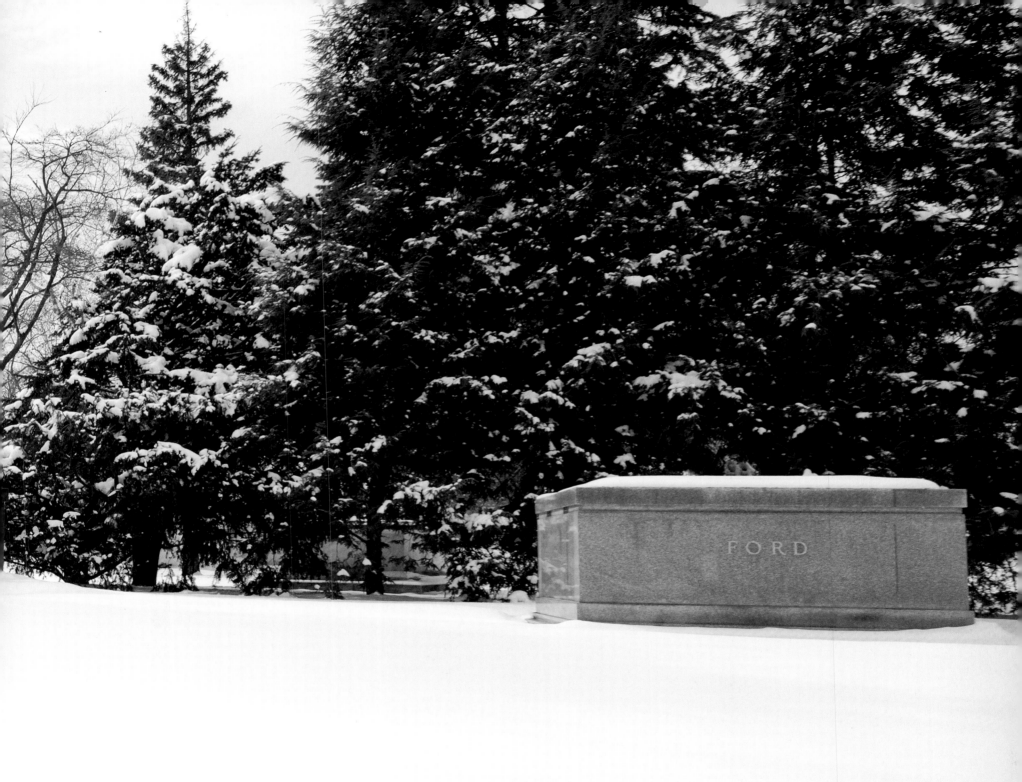

West

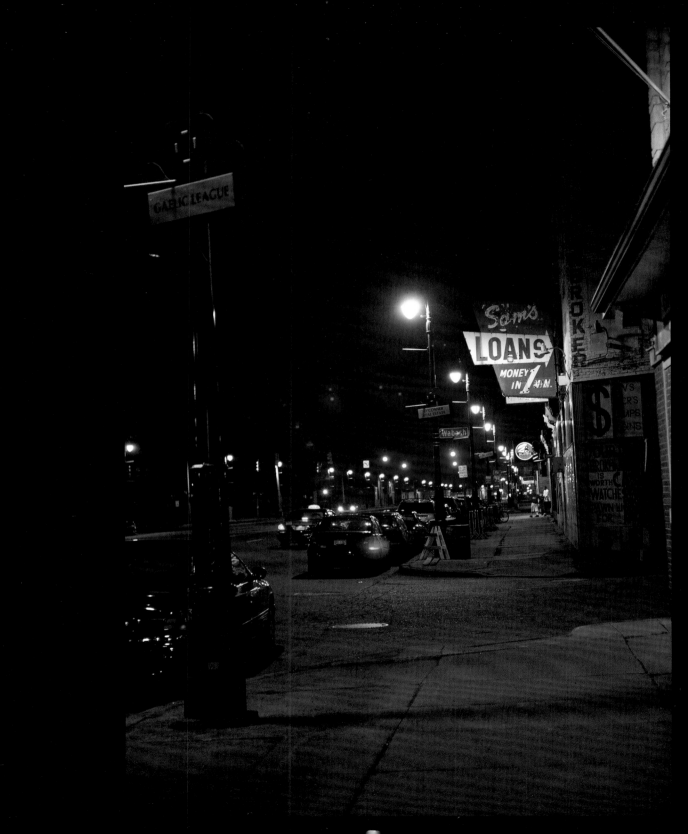

JUNE 5TH

RR

JUNE 5TH

MORE FUN
THAN YOU CAN
SHAKE A DICK AT

TK3

33RD

BEND OVER

ANNIVERSARY
BASH

THE GREATER MOTOWN
INTERNATIONAL
RODEO
JUNE 25-27, 2010
WAYNE COUNTY
FAIRGROUNDS
BELLEVILLE MI

RODEO
TICKETS
ON SALE HERE

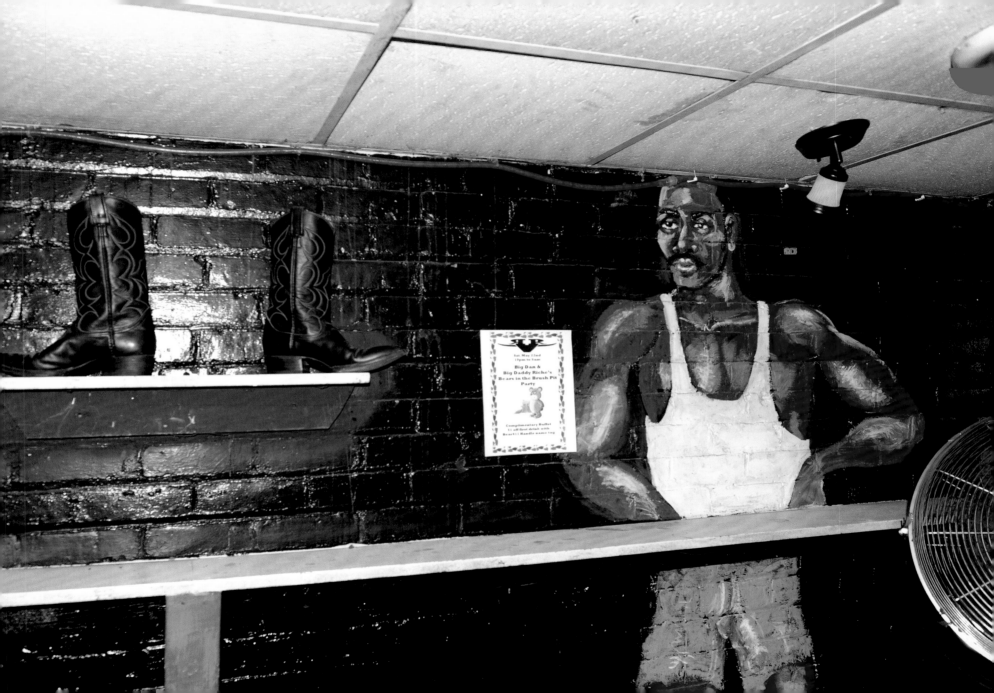

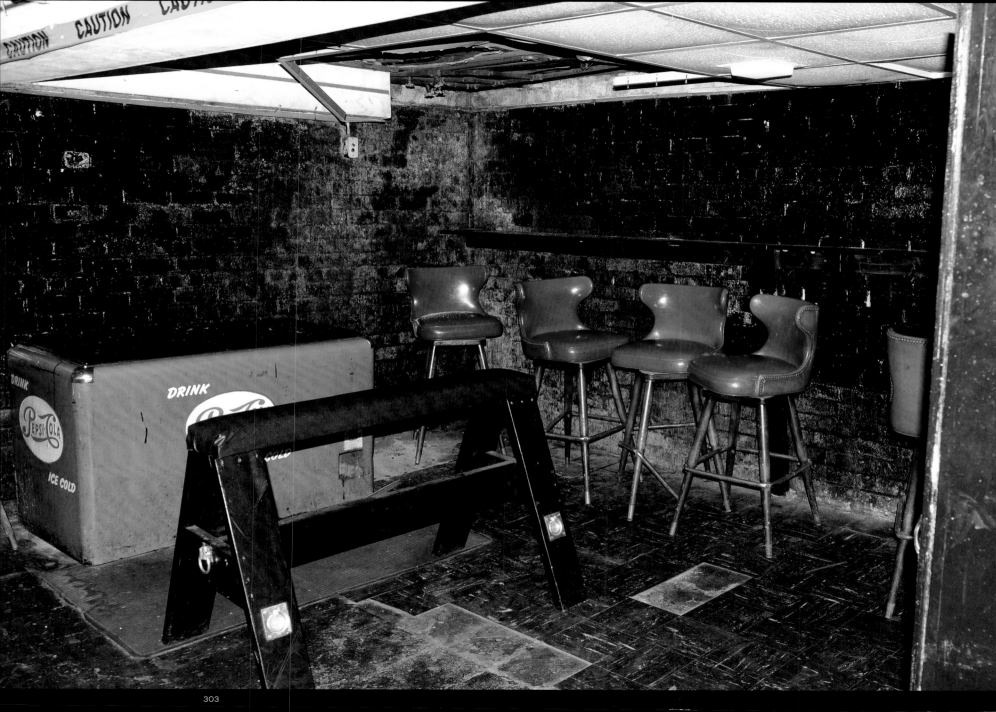

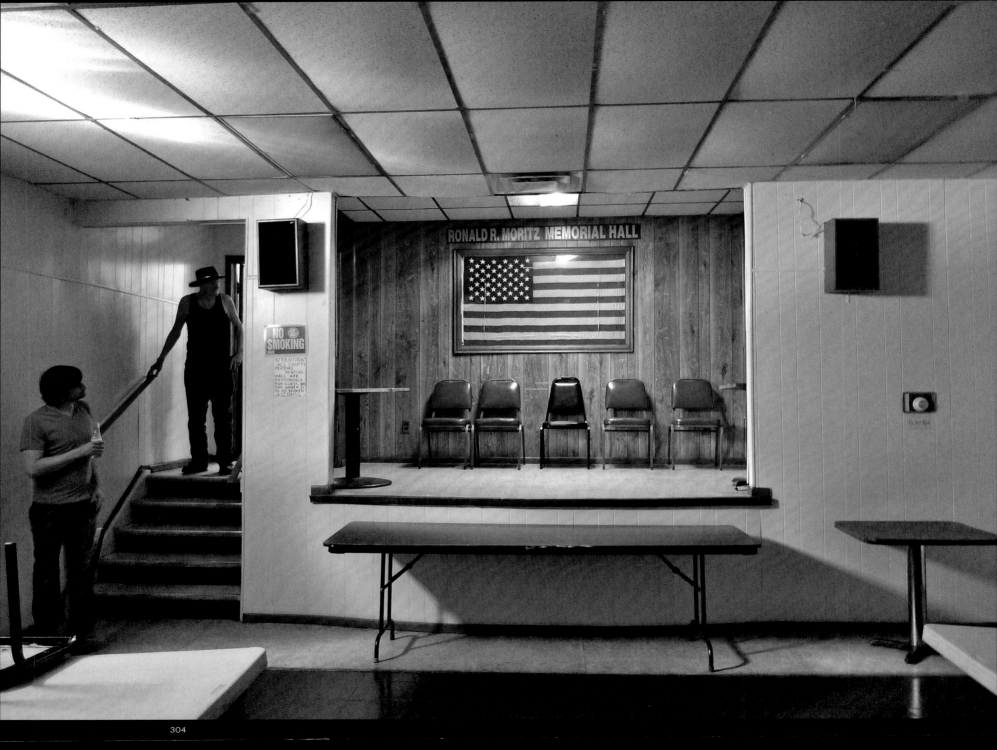

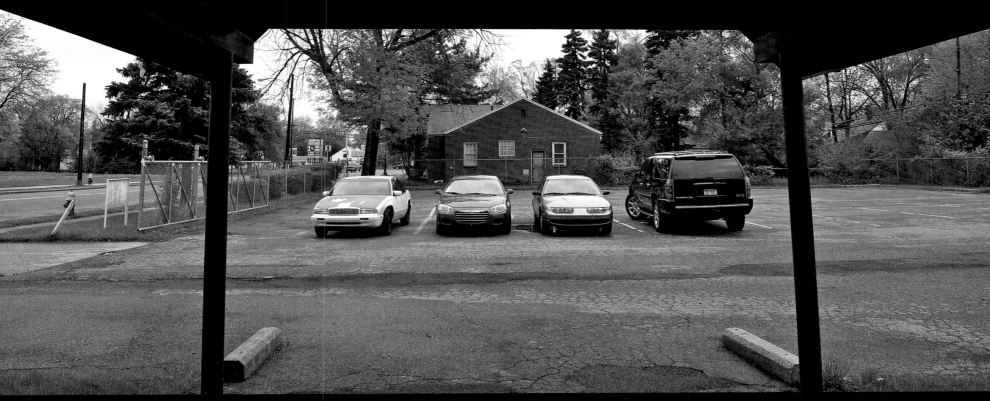

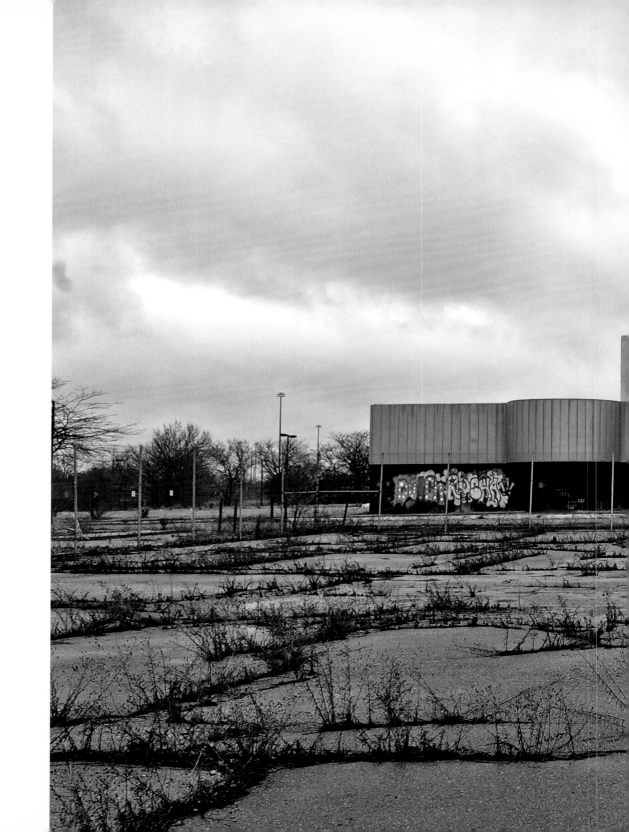

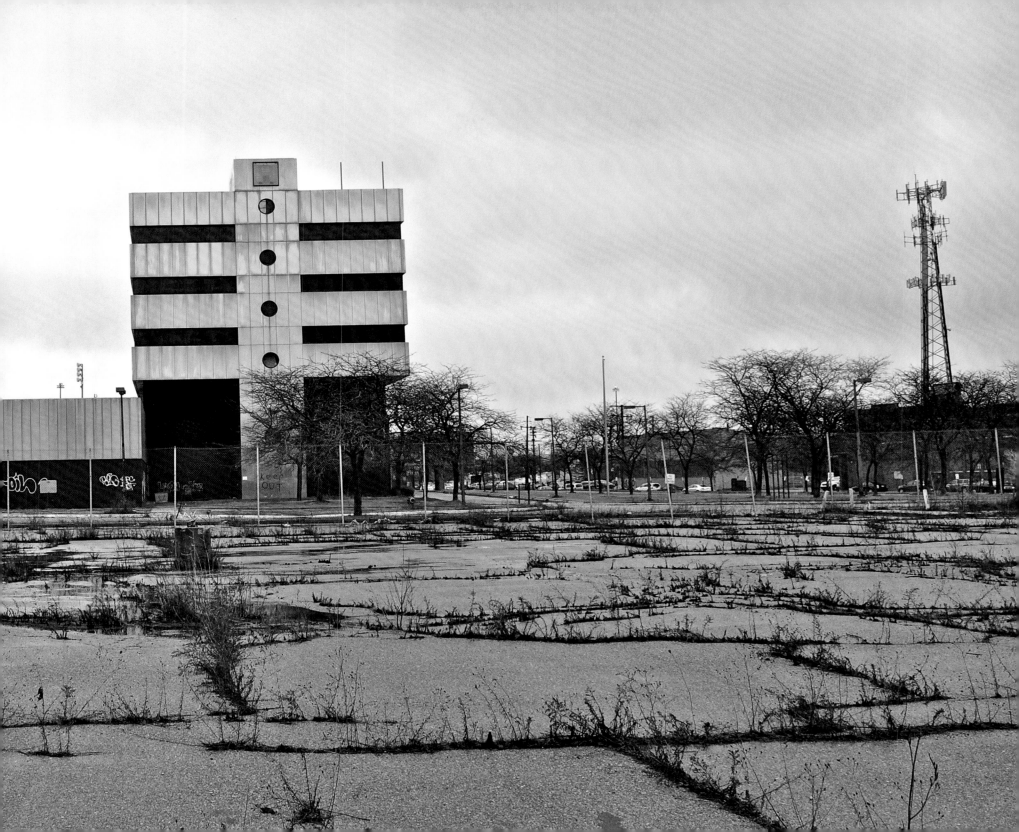

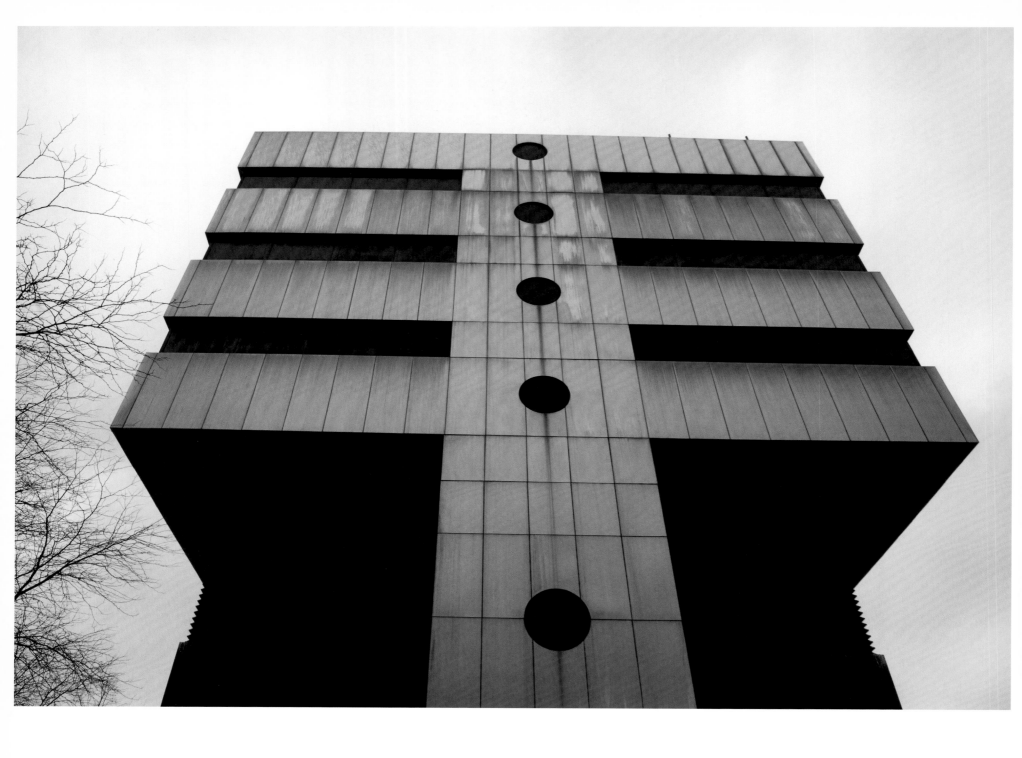

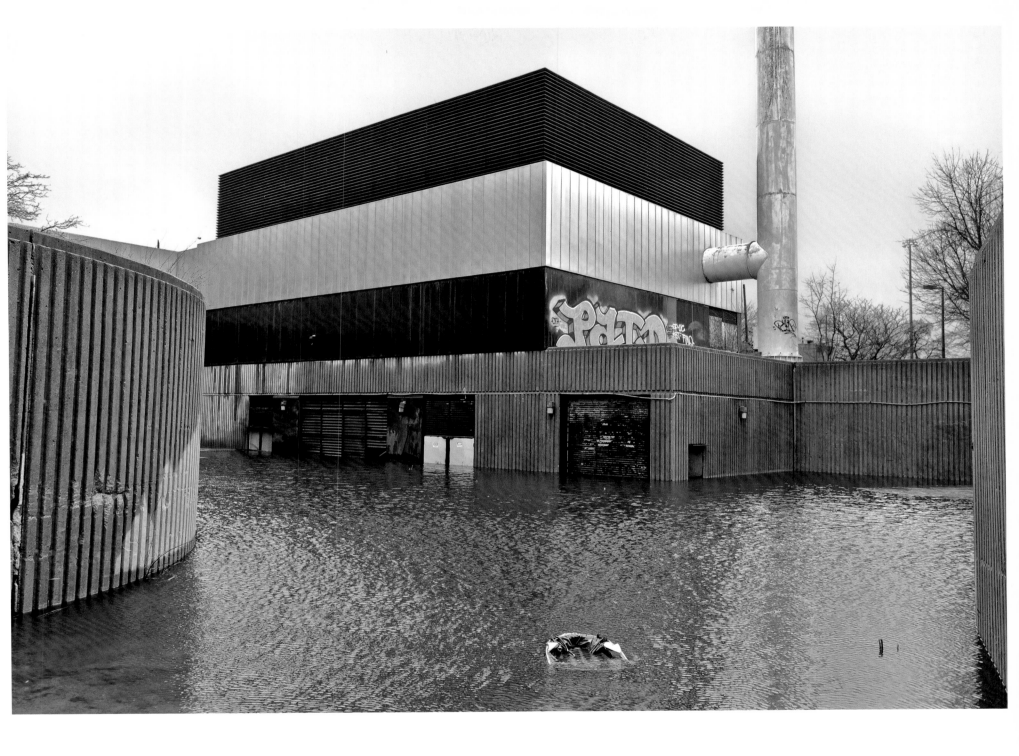

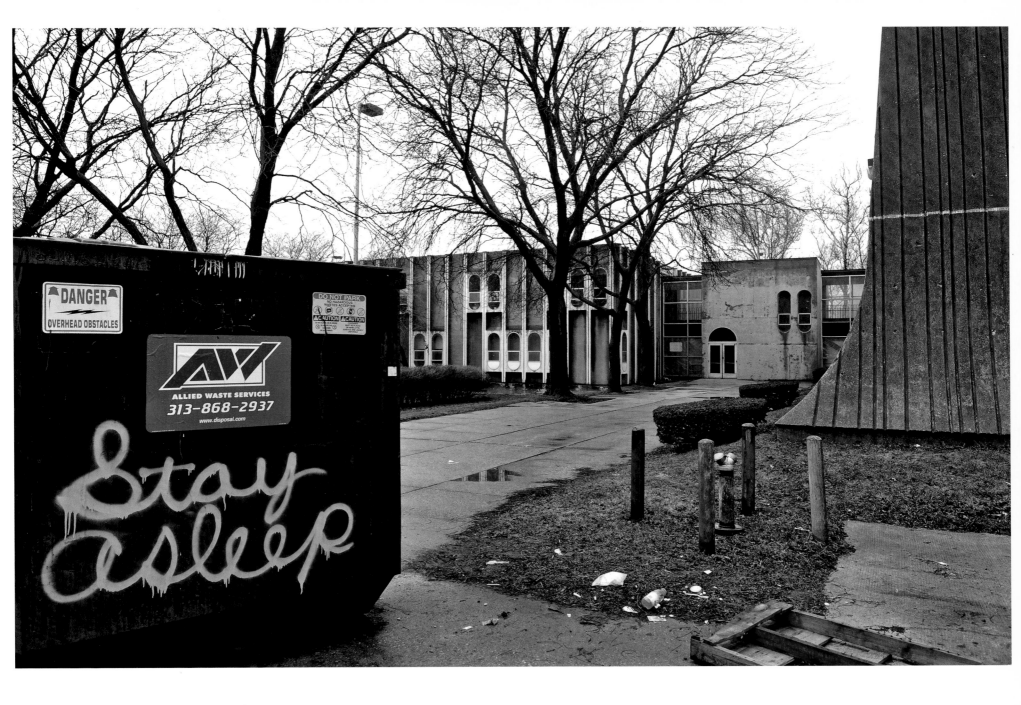

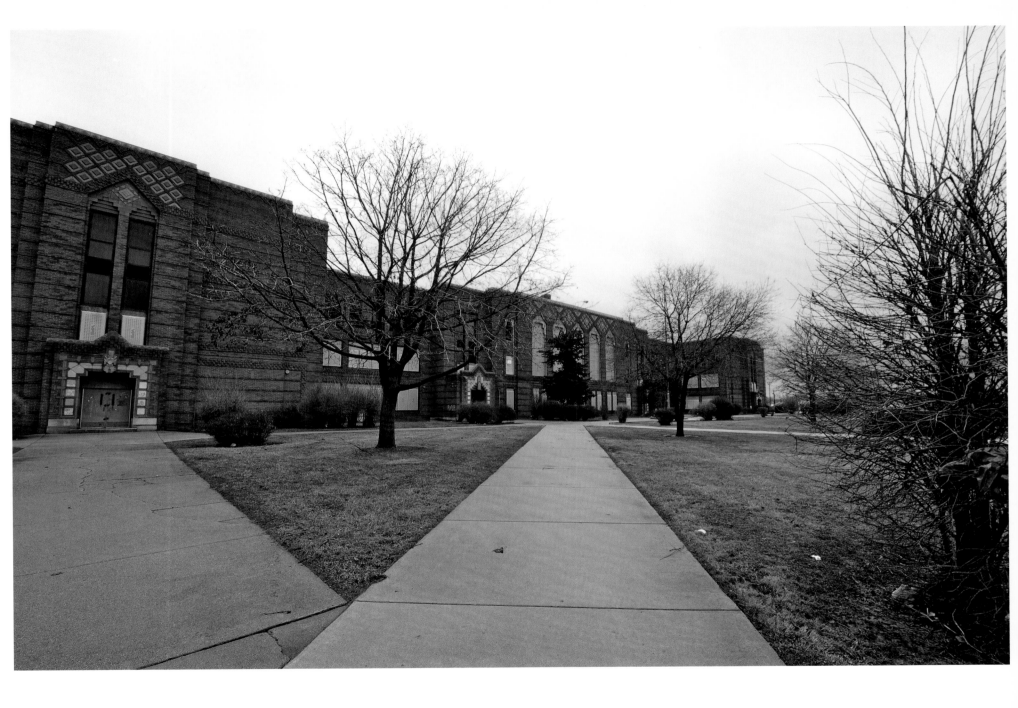

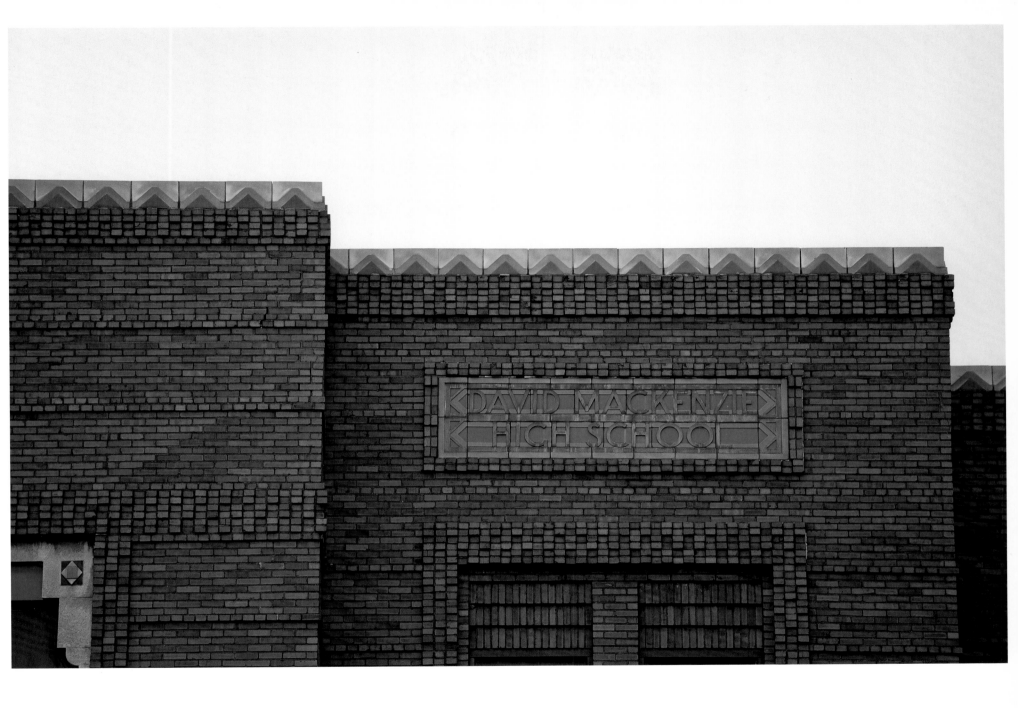

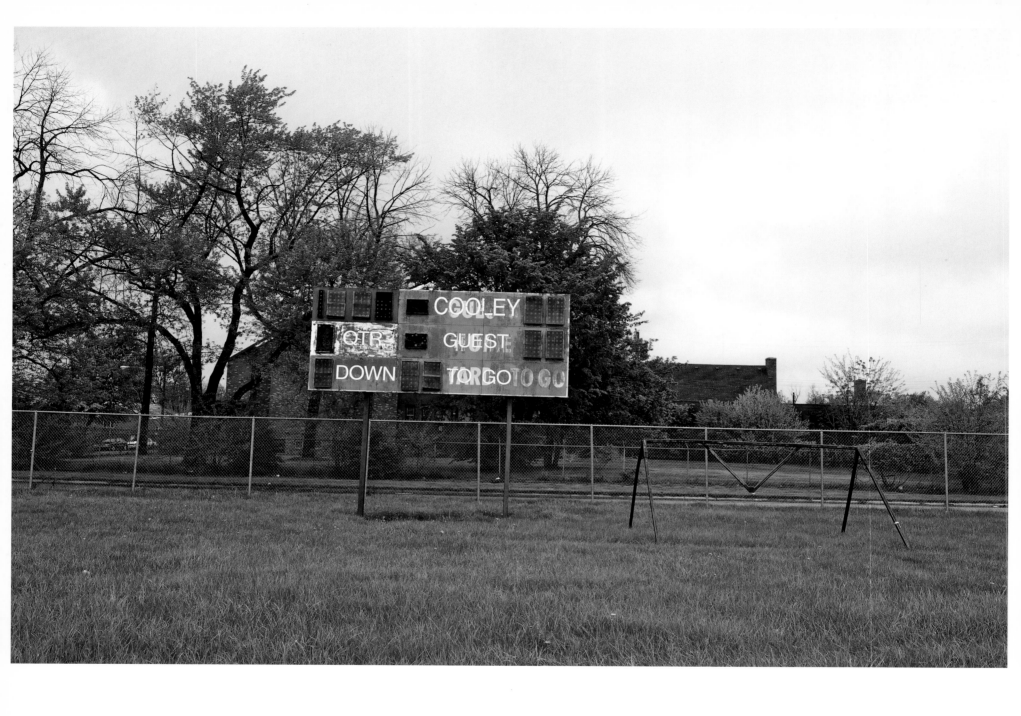

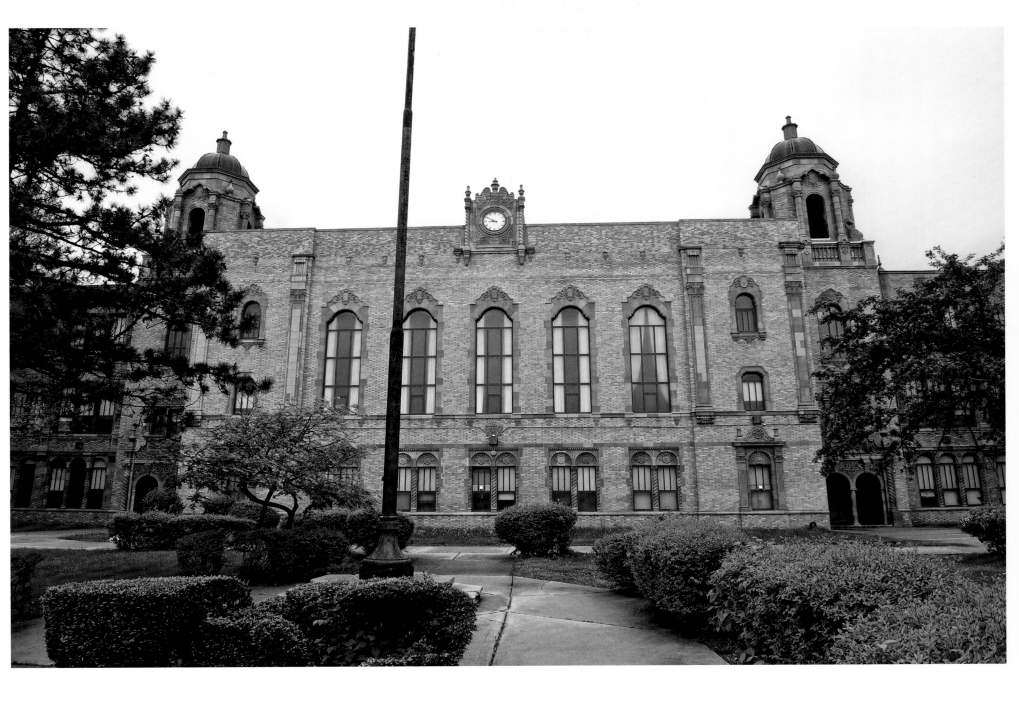

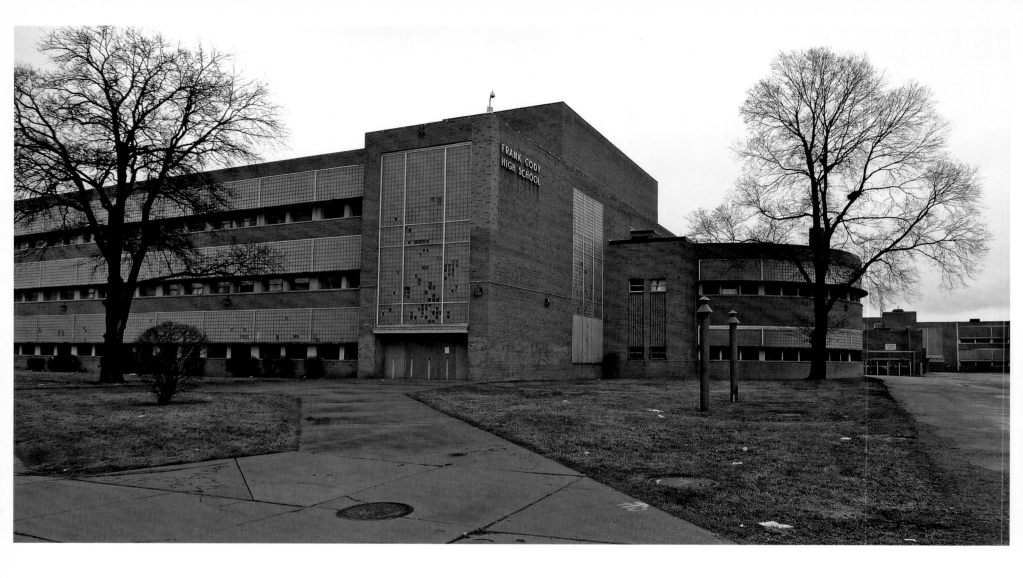

328

329

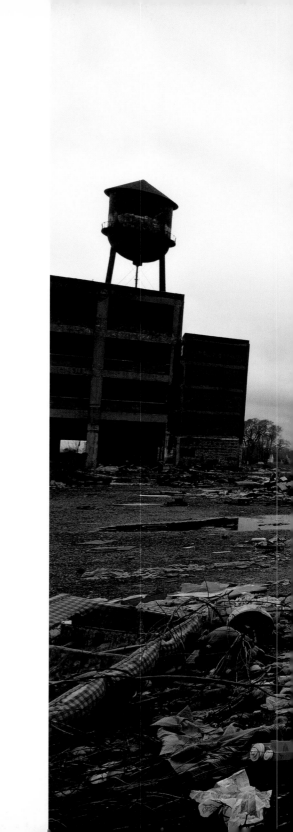

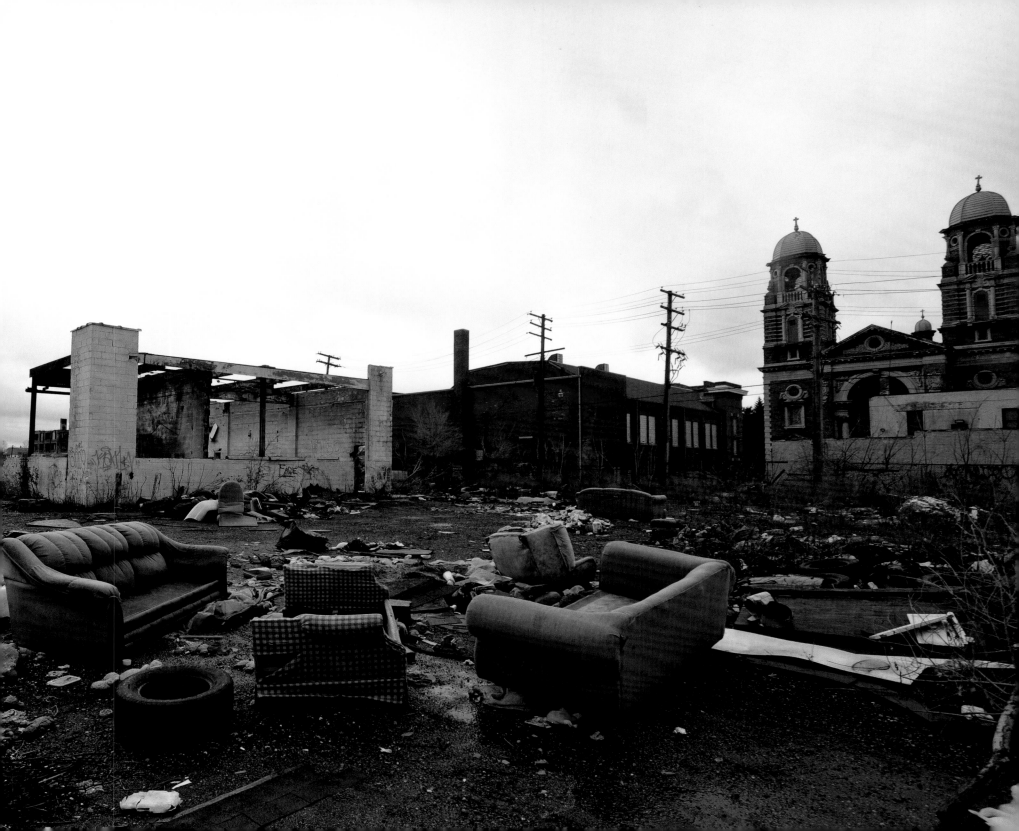

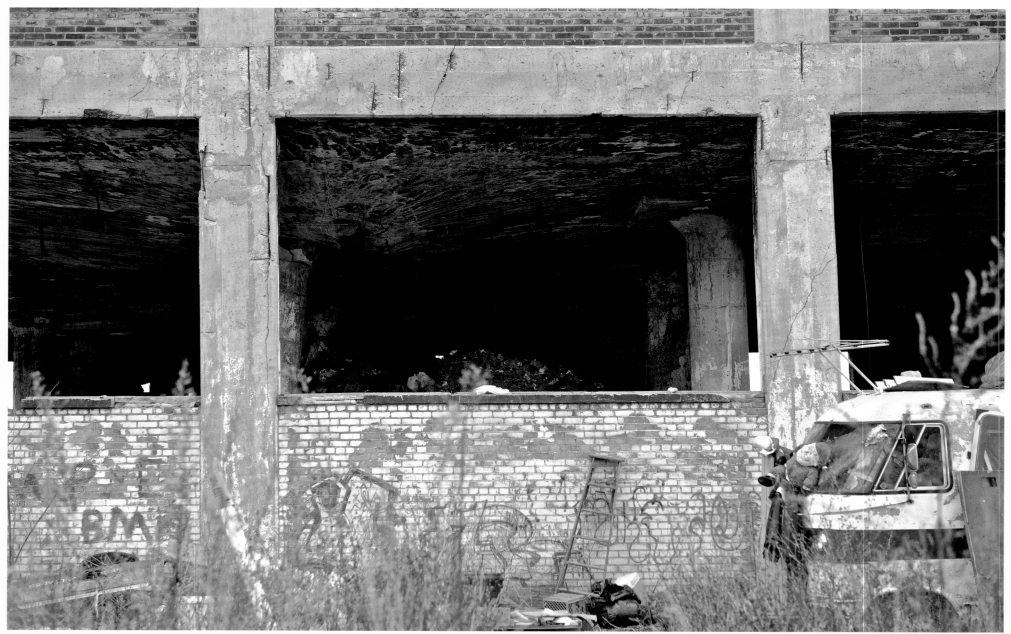

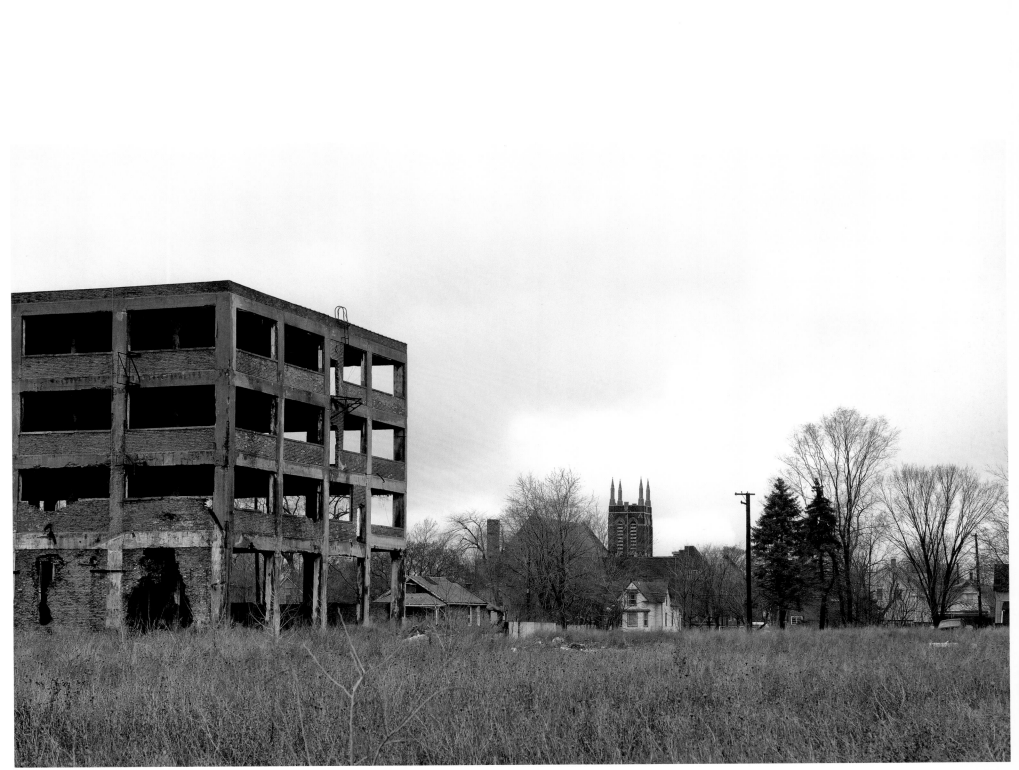

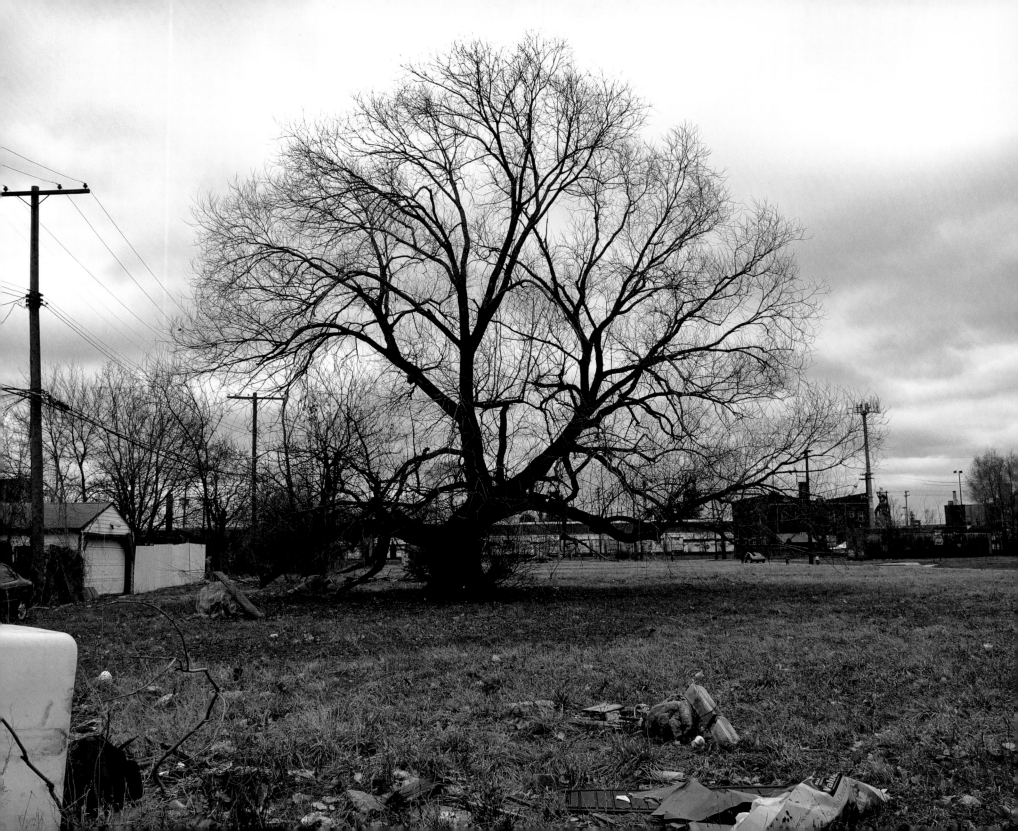

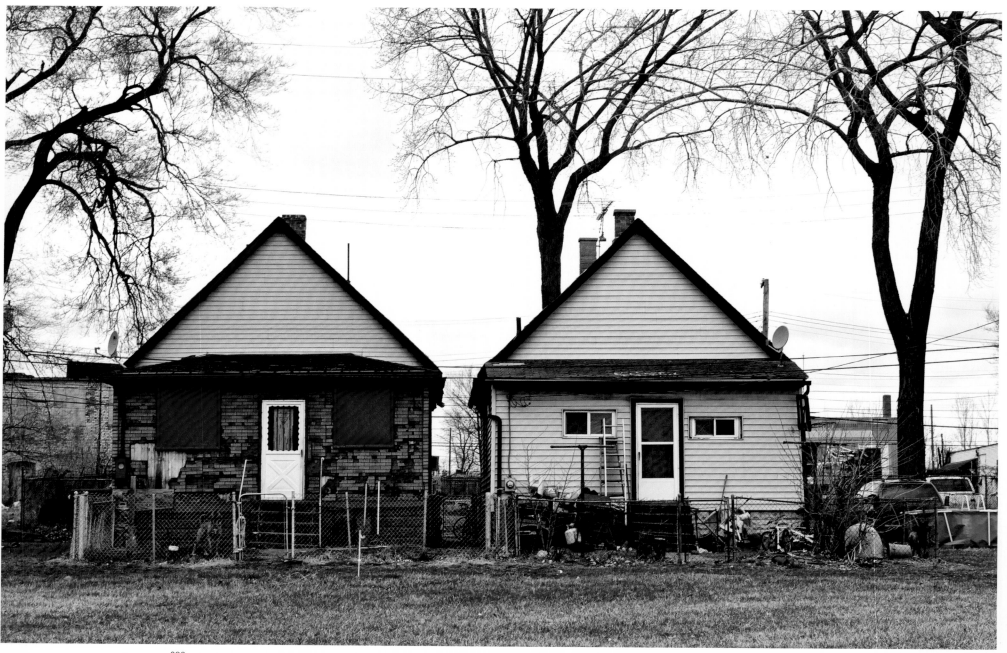

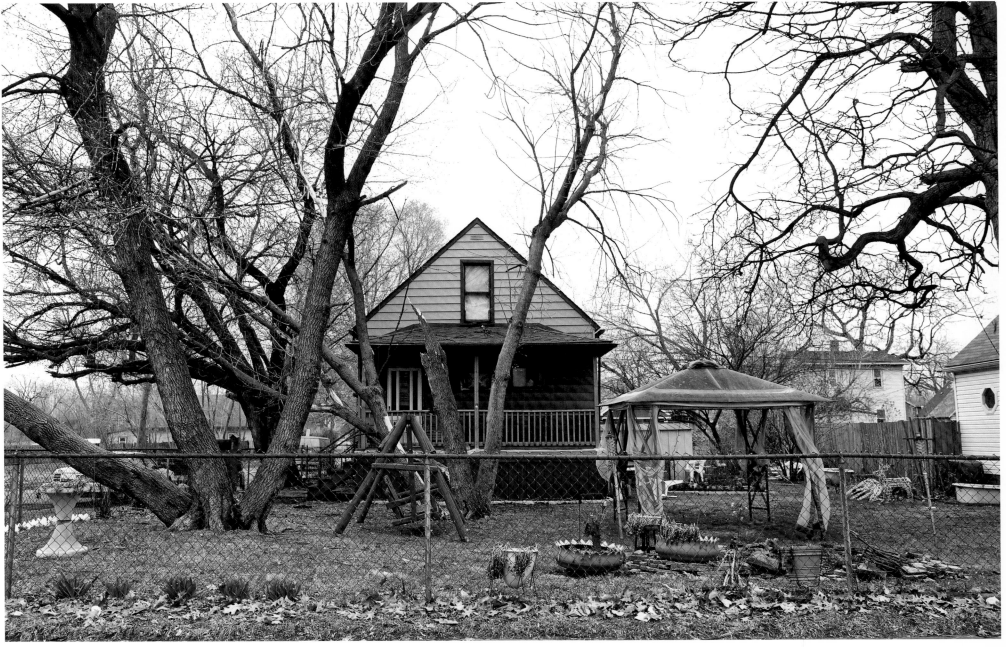

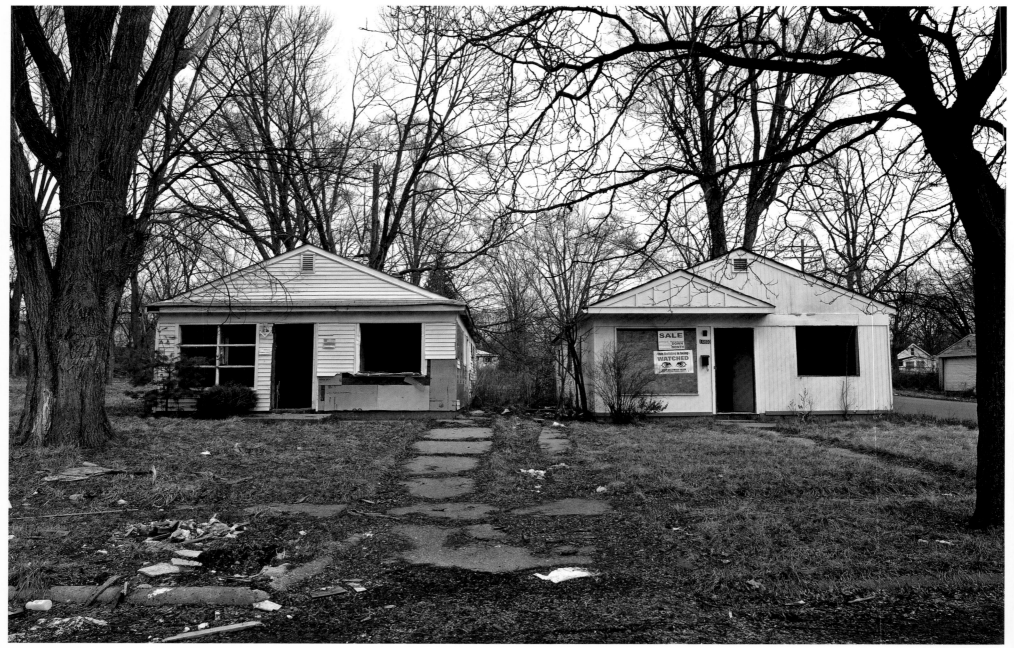

338

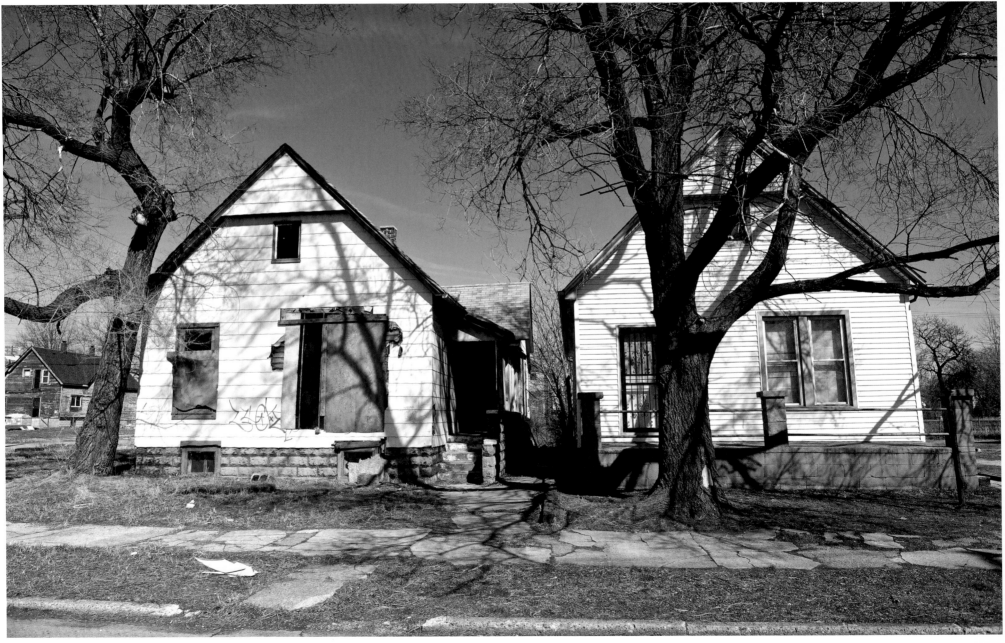

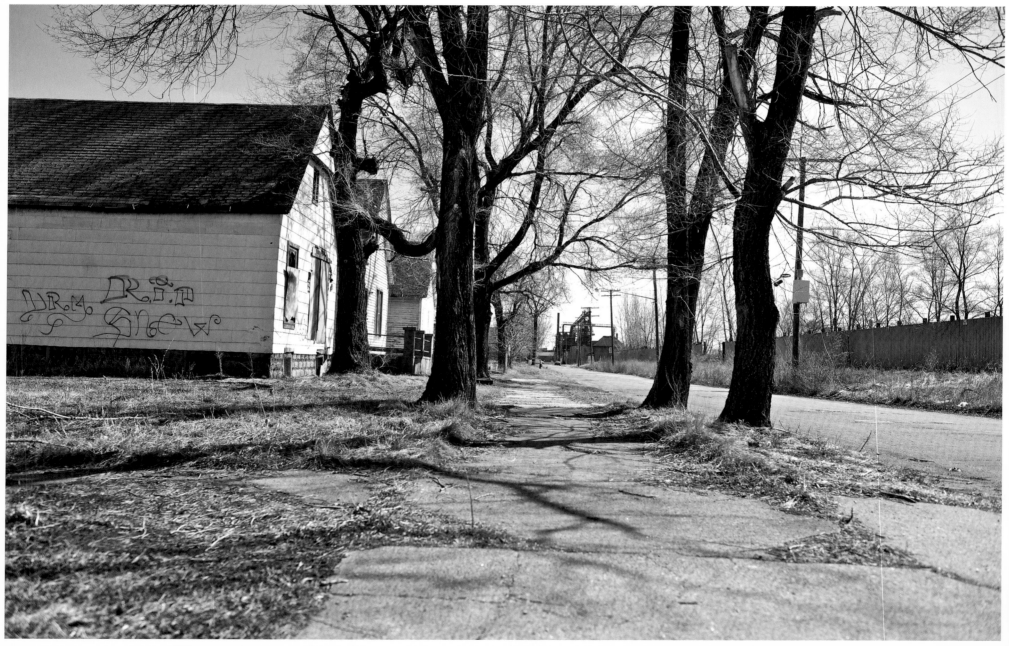

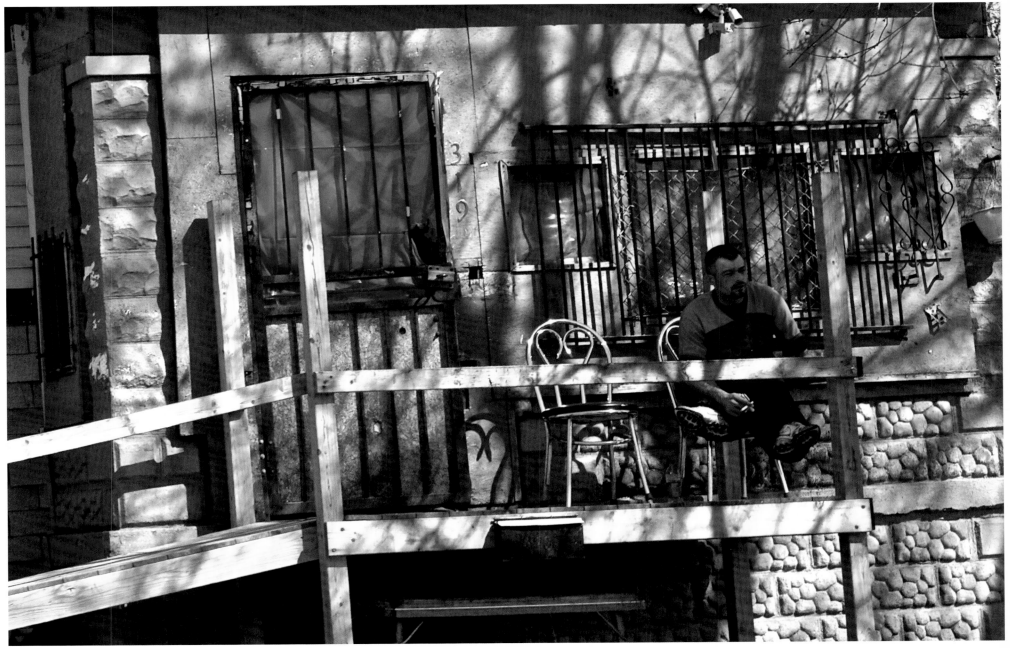

341

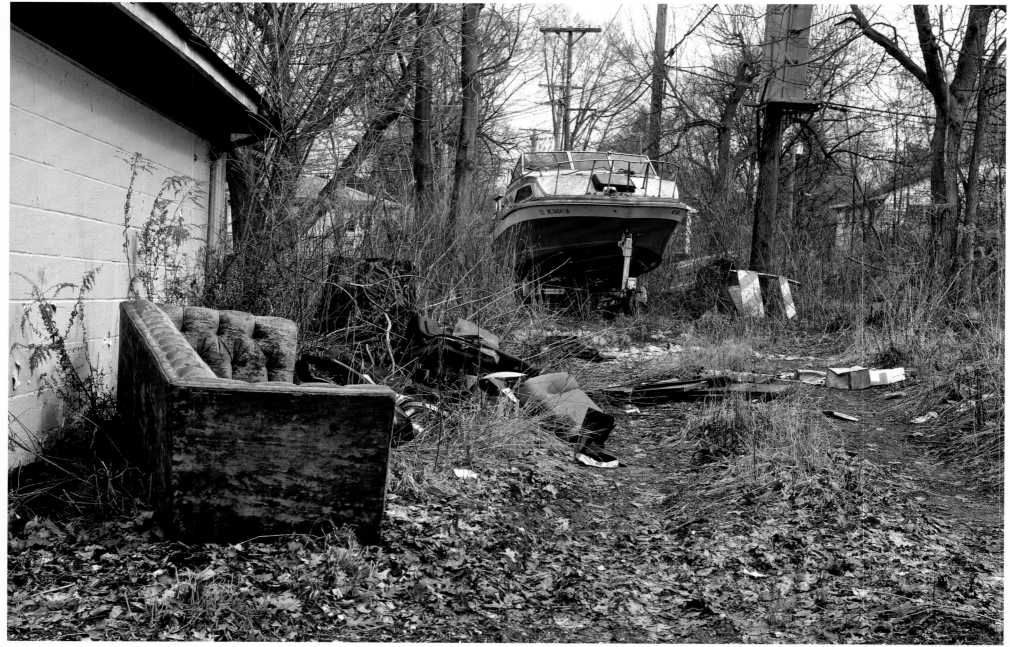

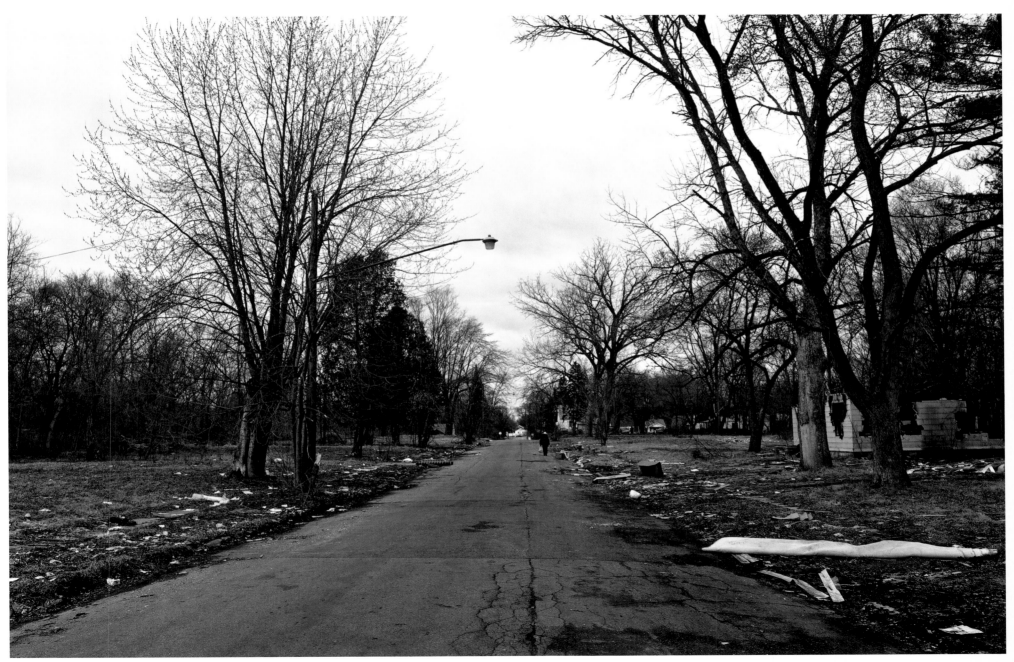

343

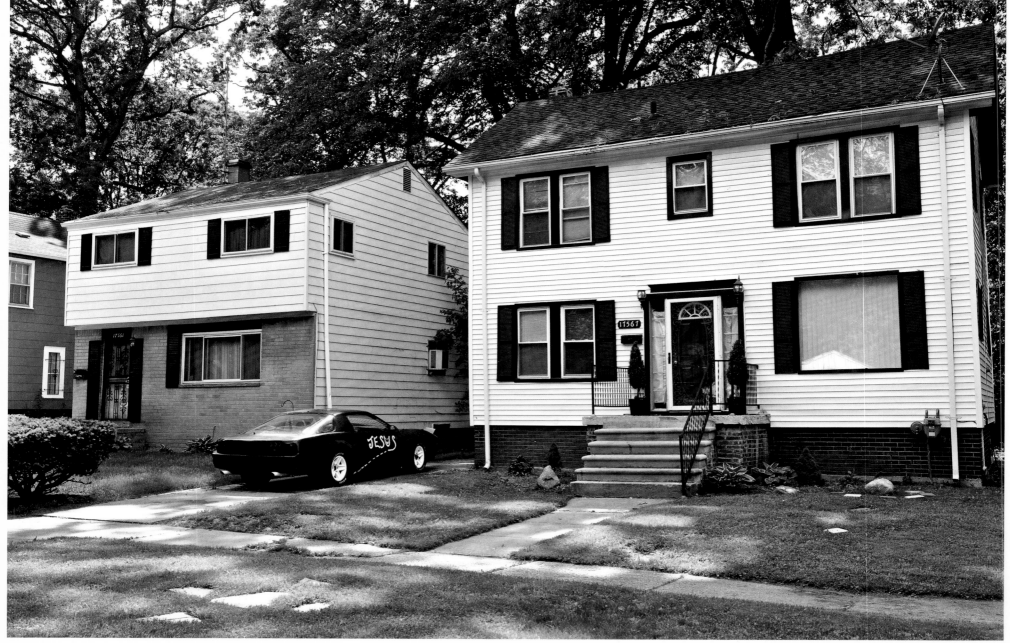

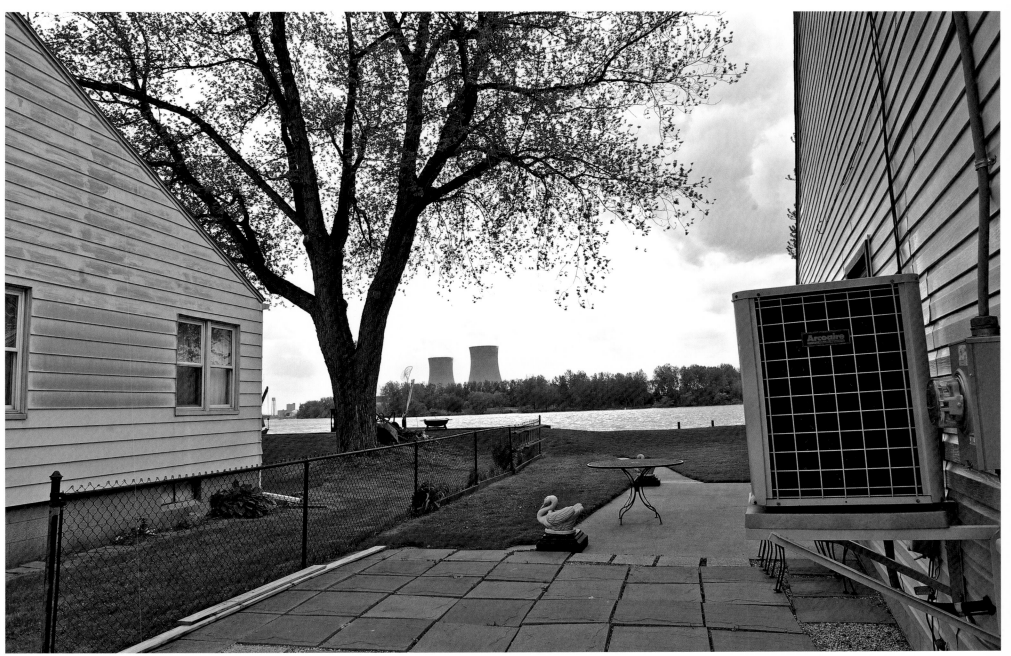

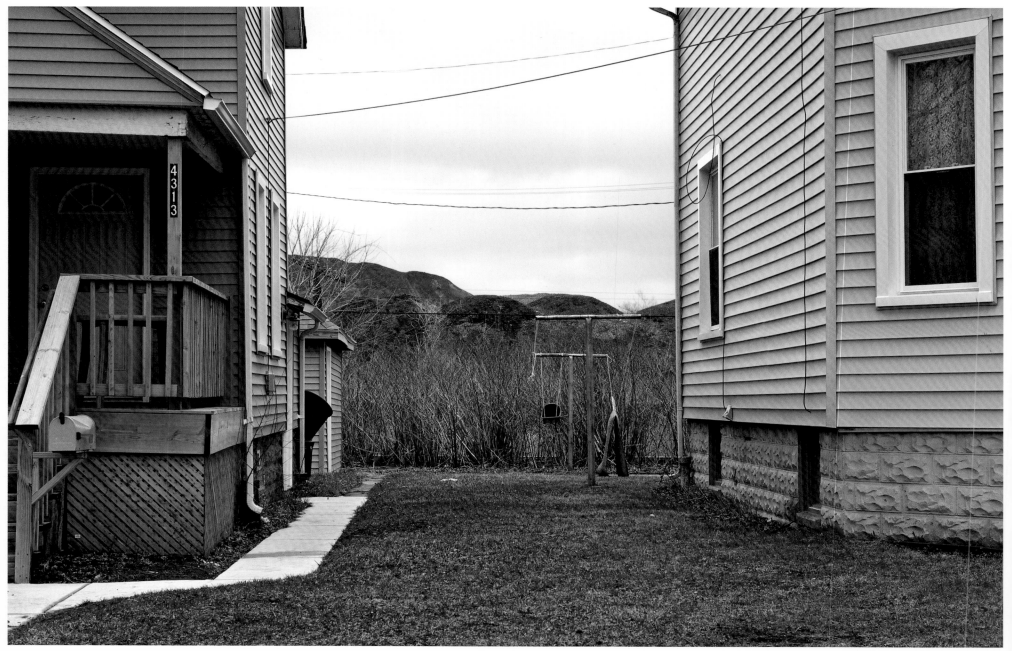

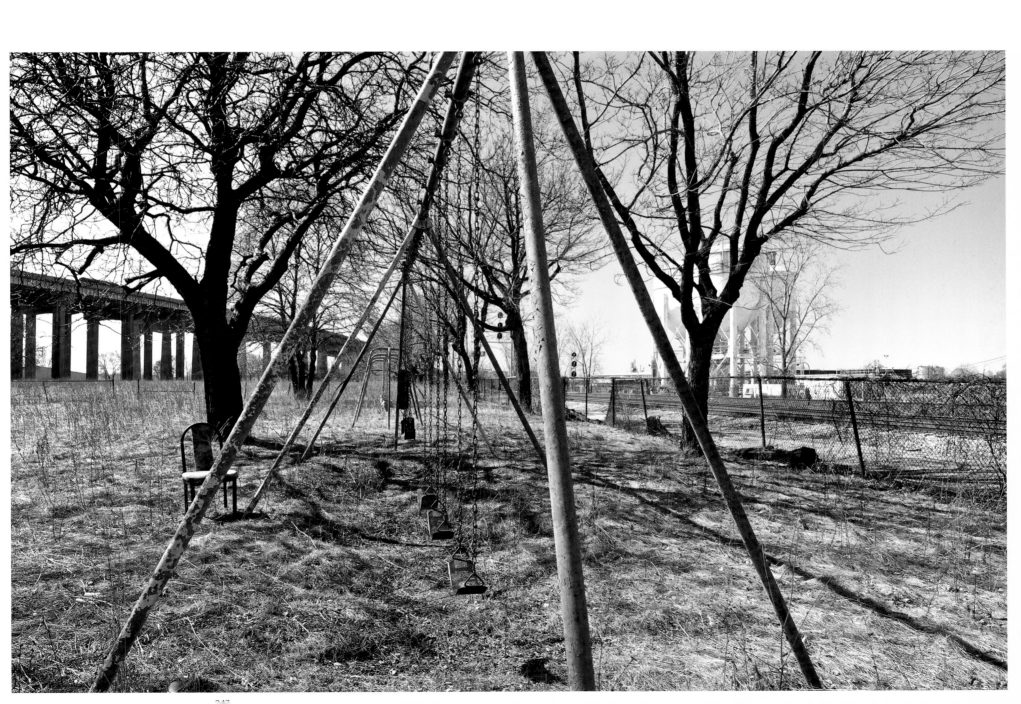

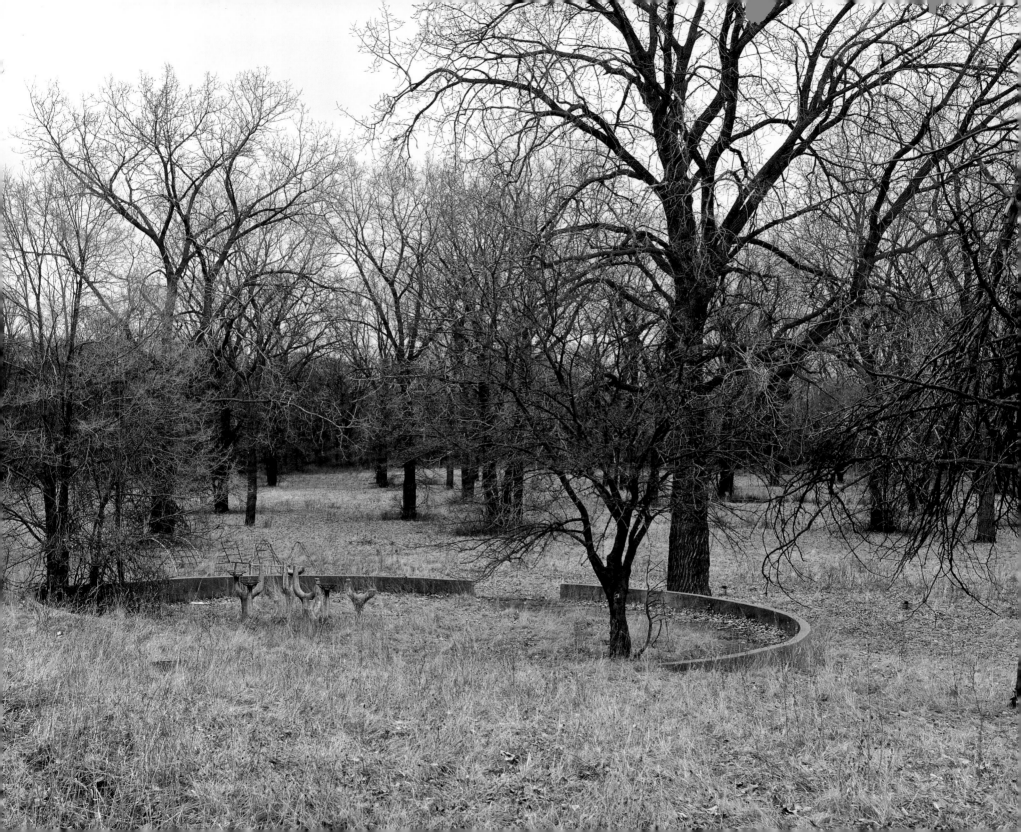

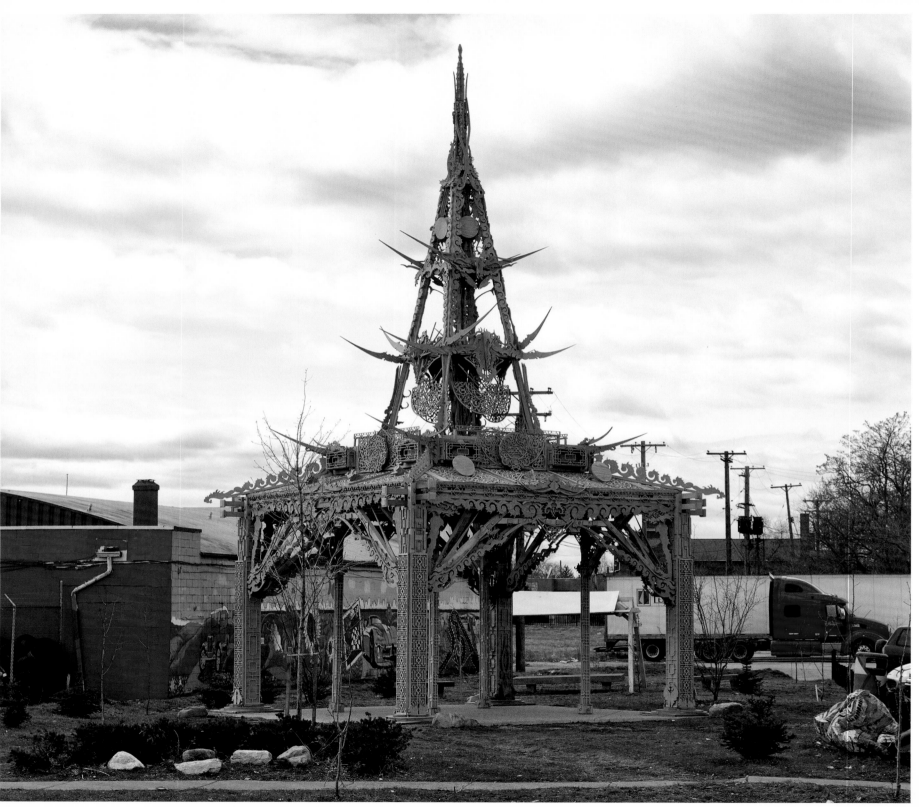

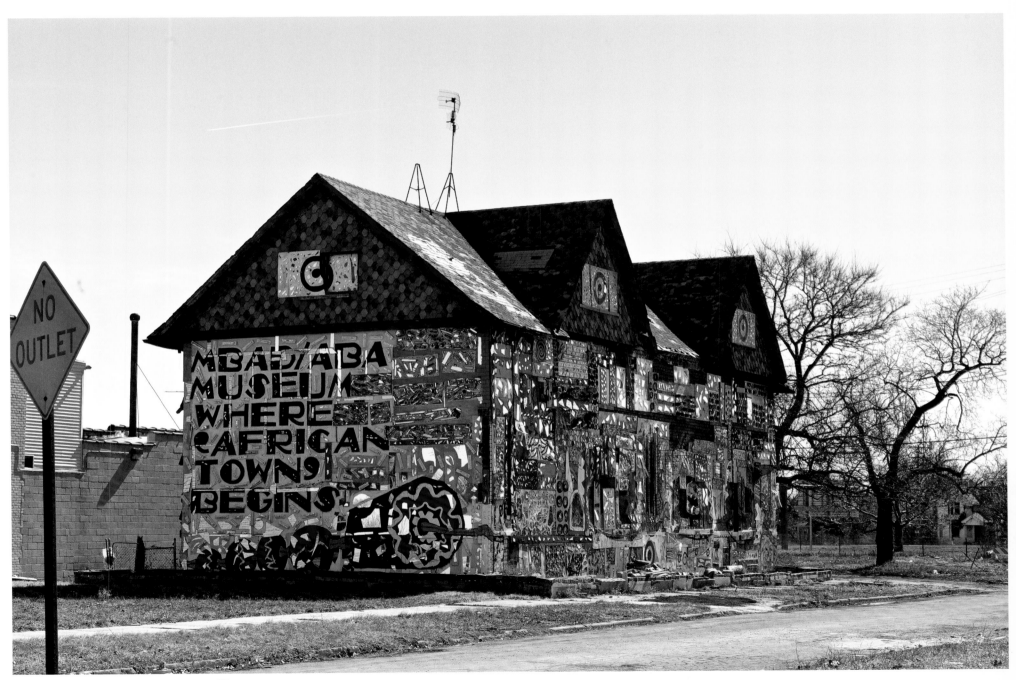

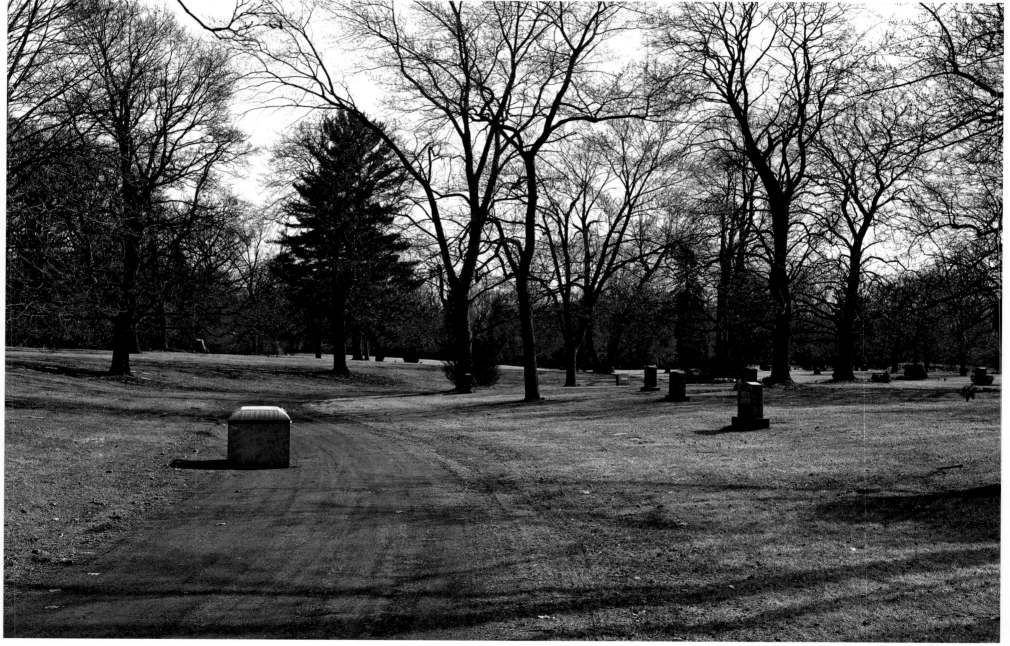

352

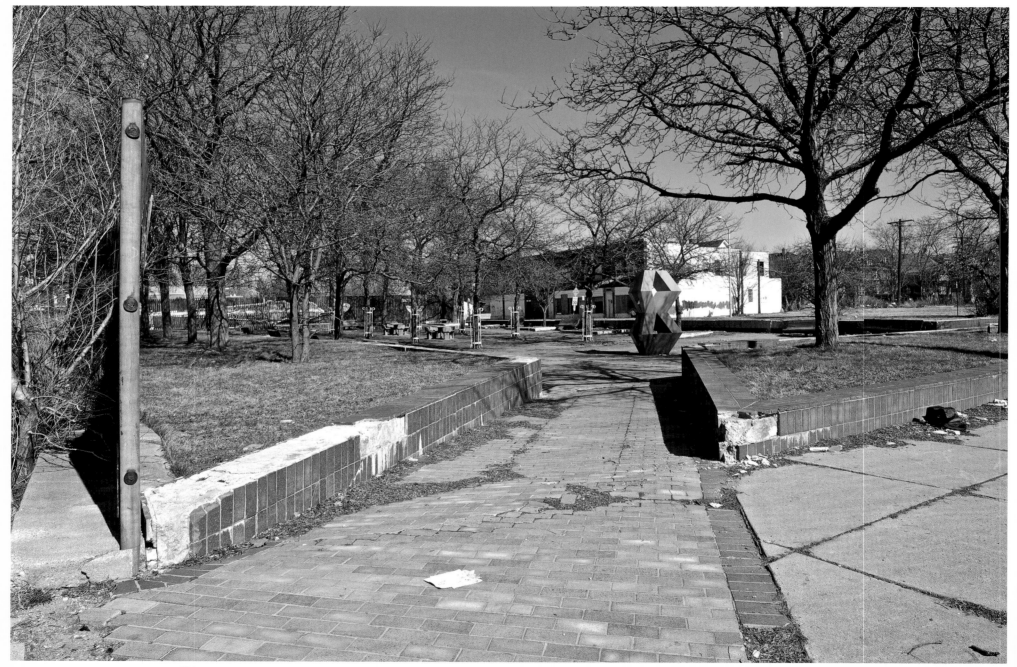

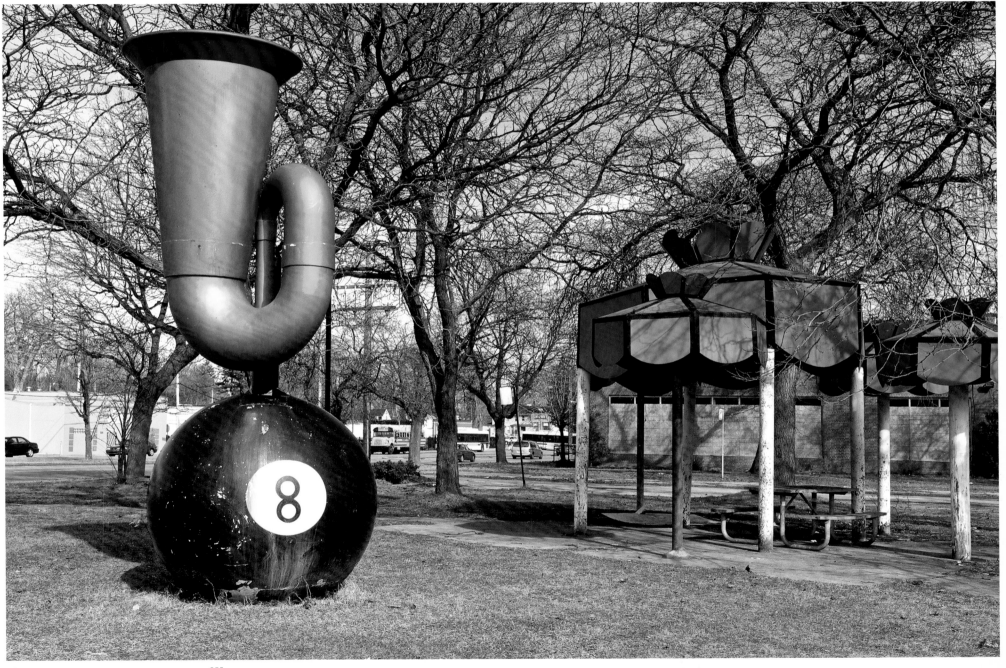

355

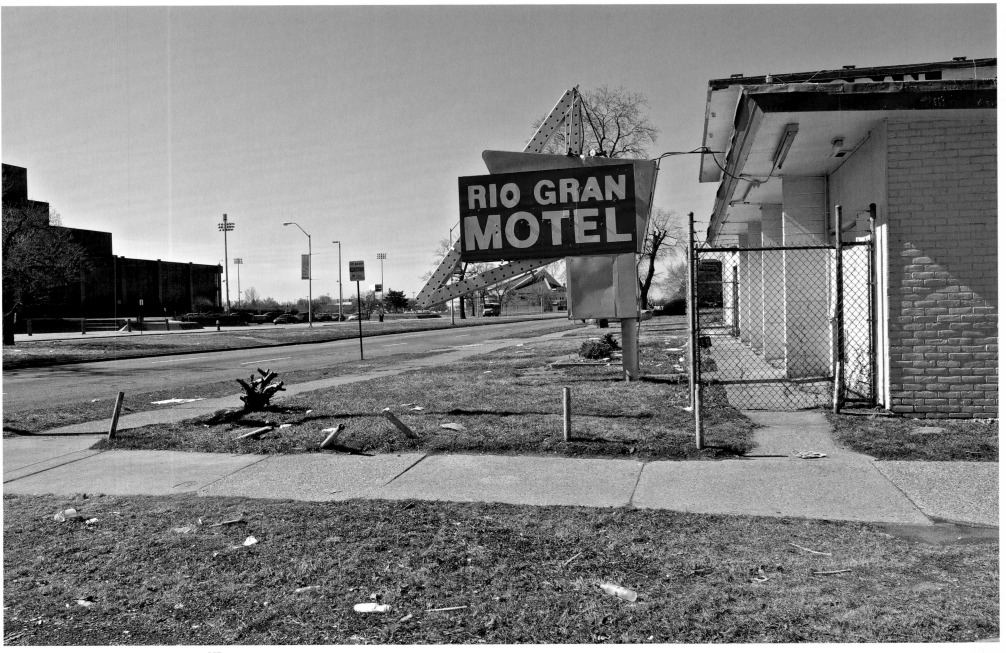

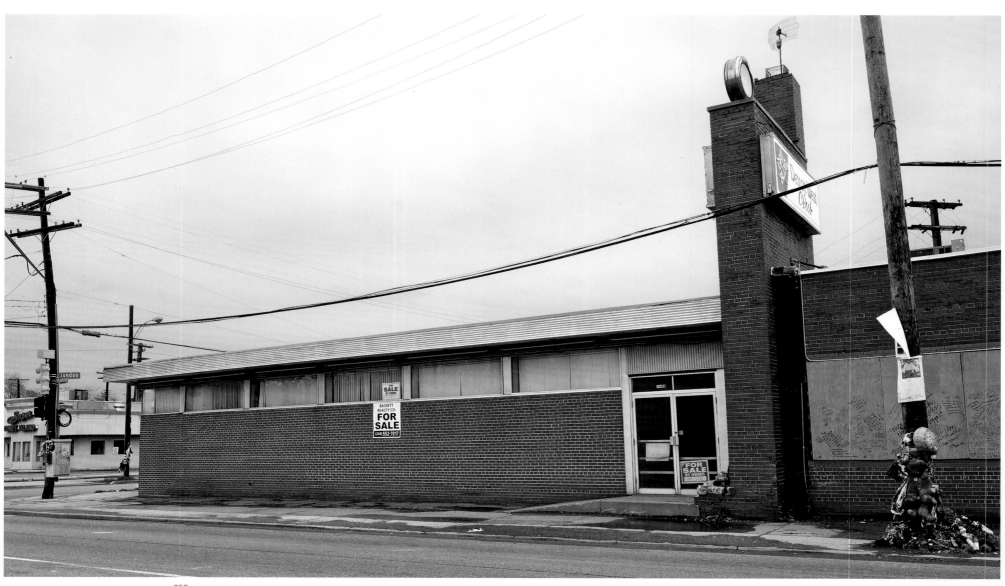

358

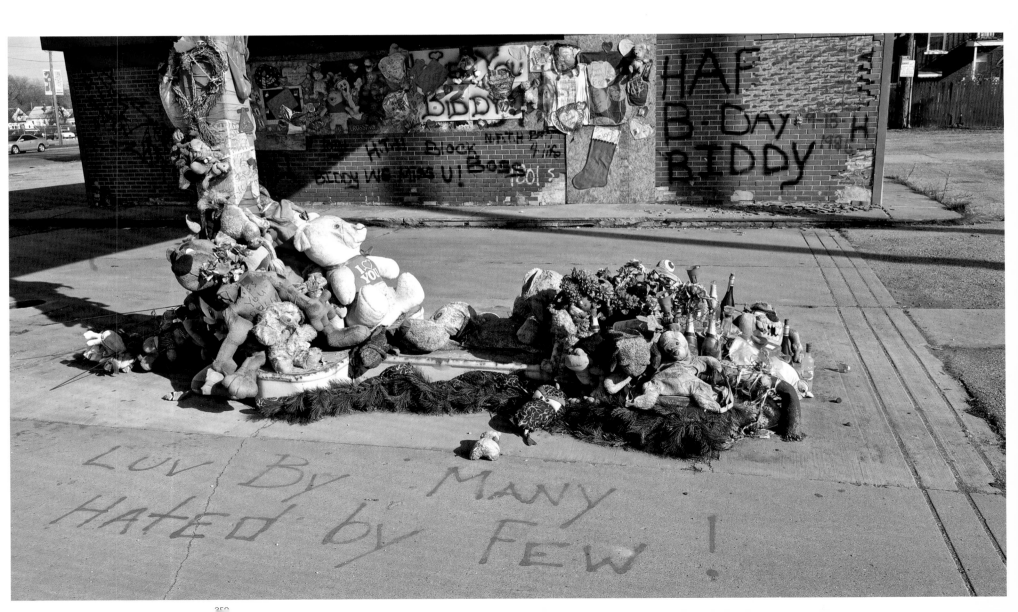

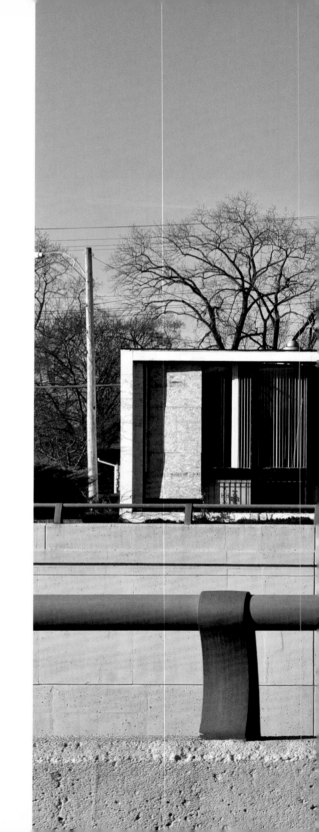

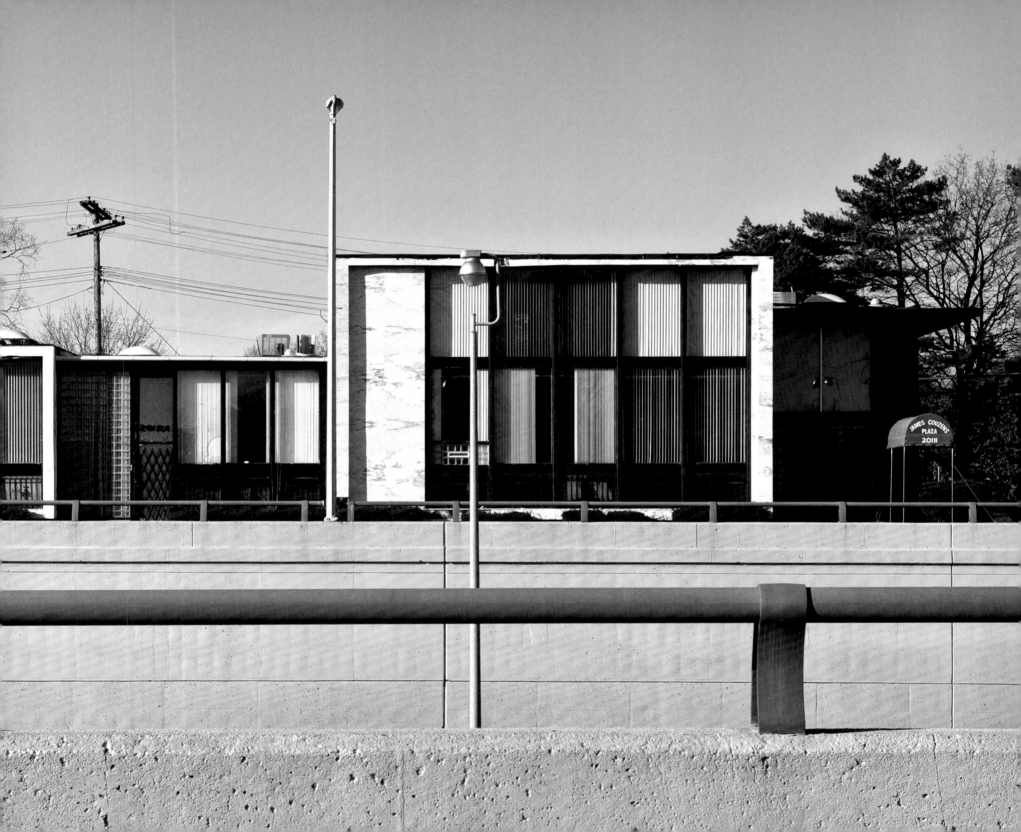

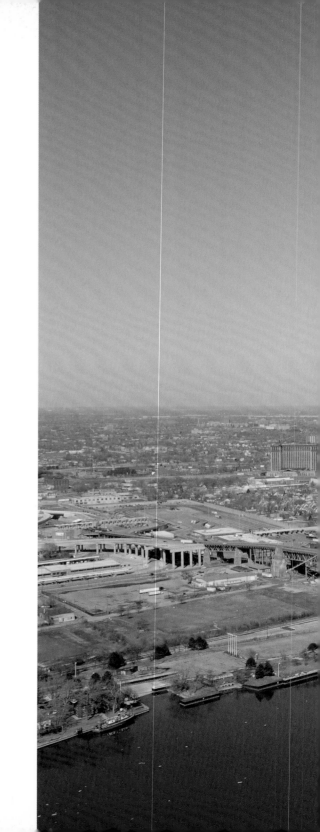

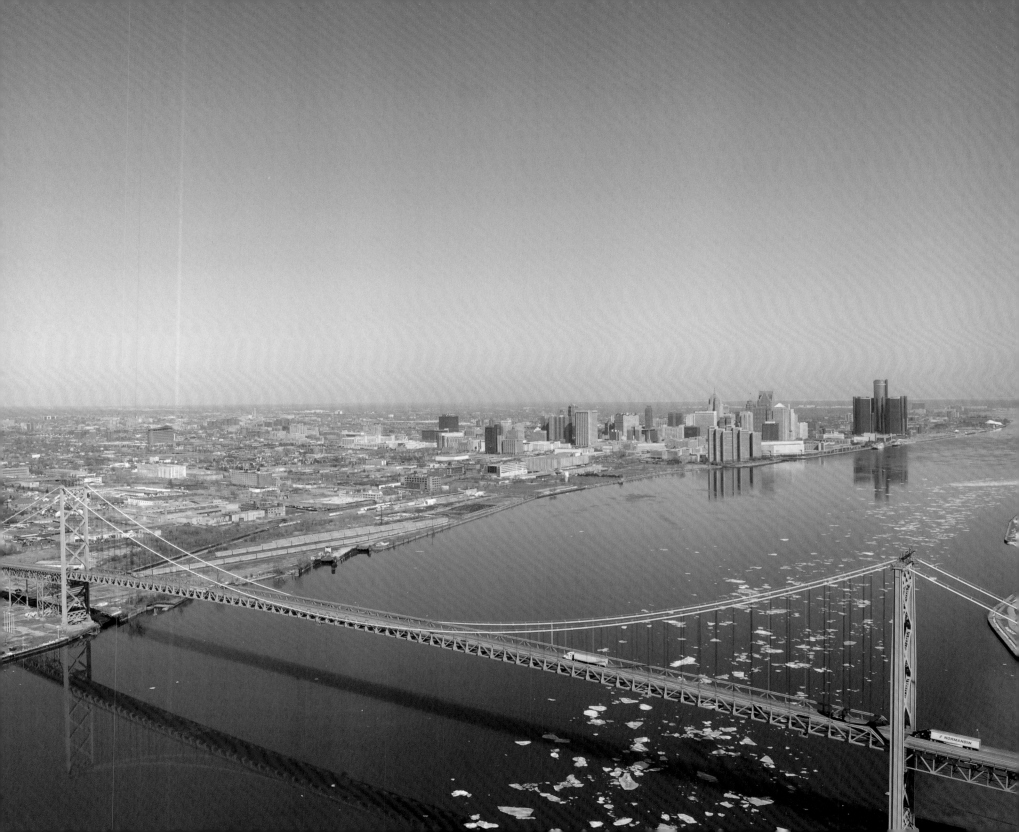

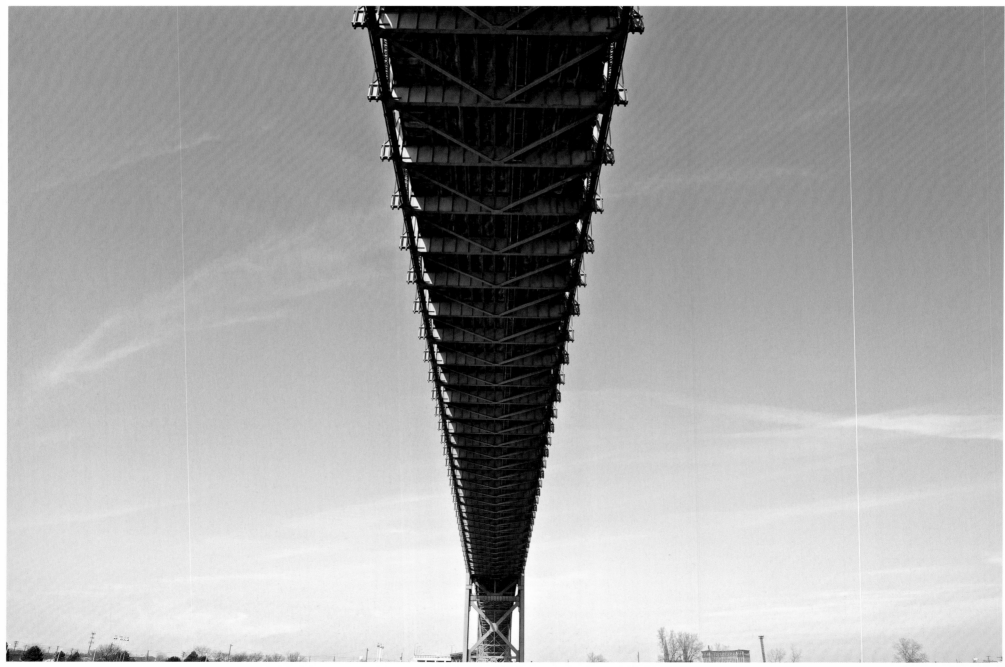

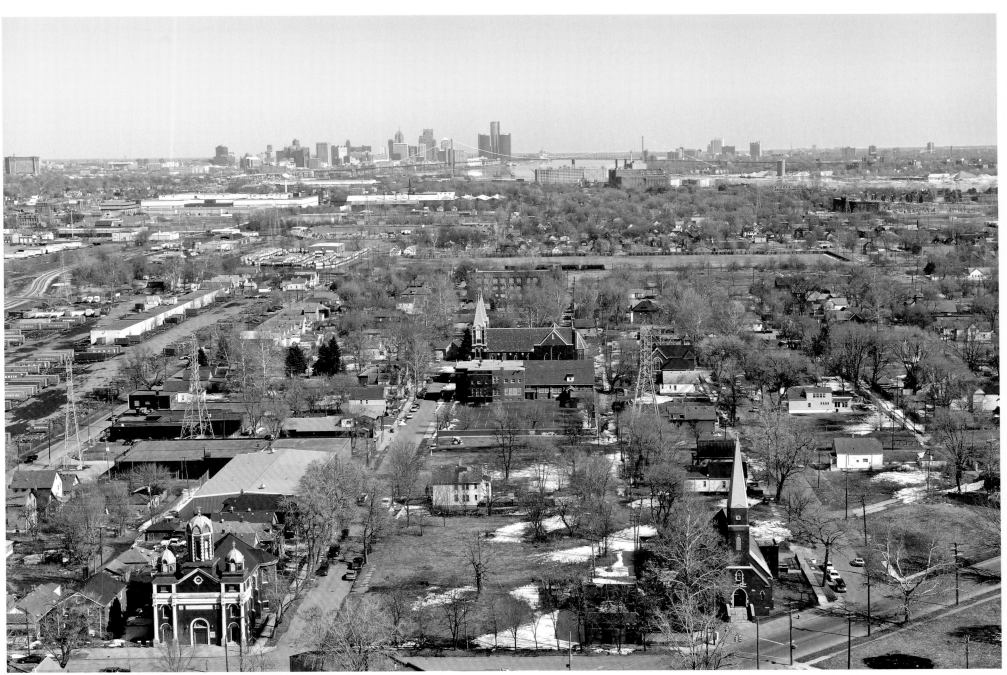

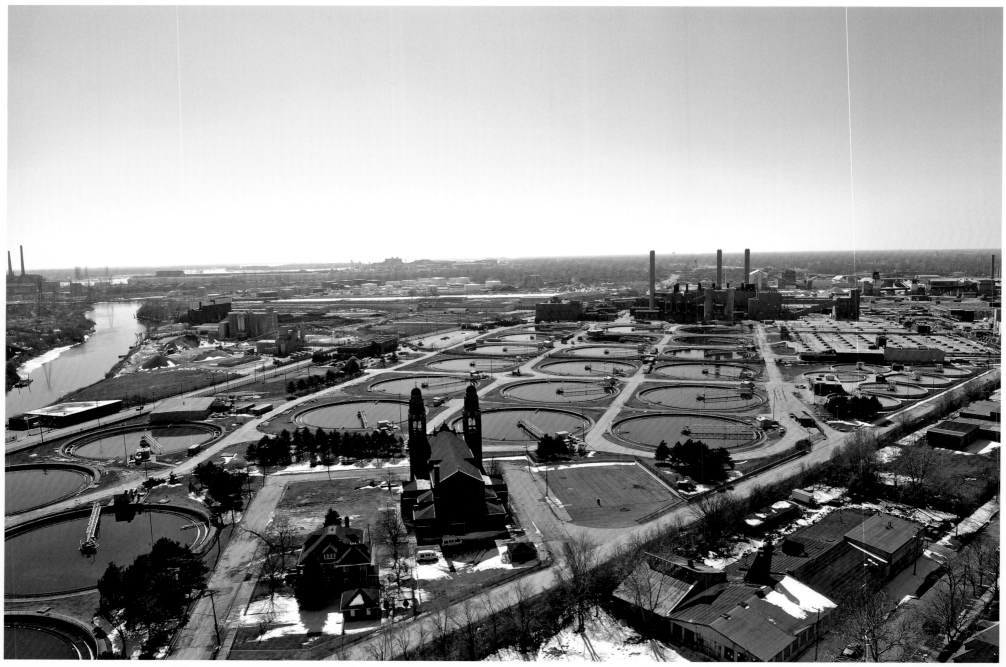

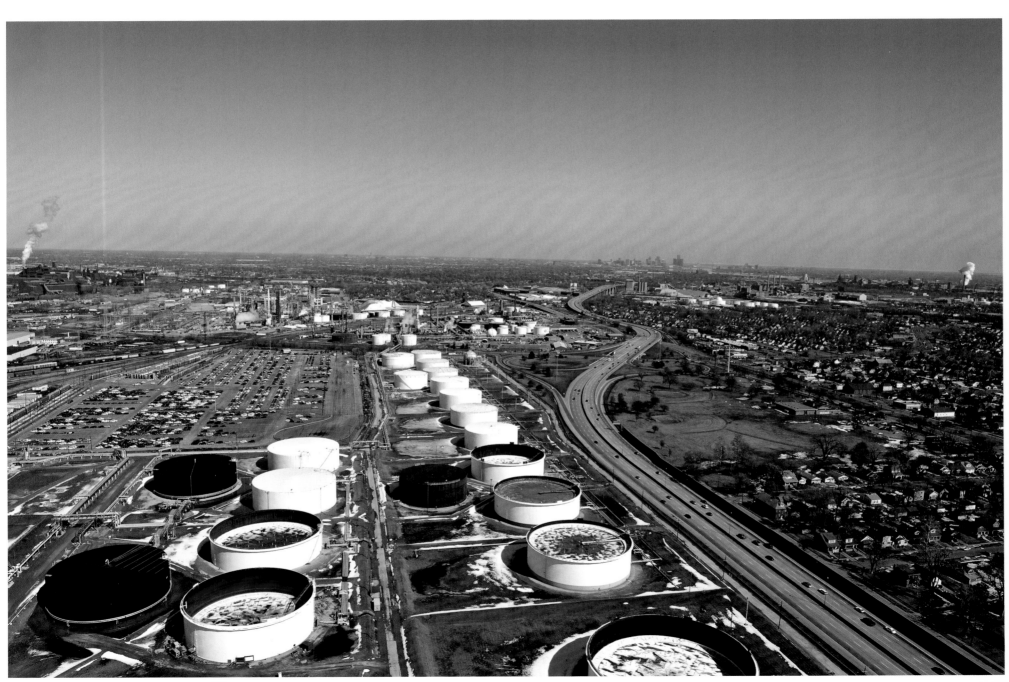

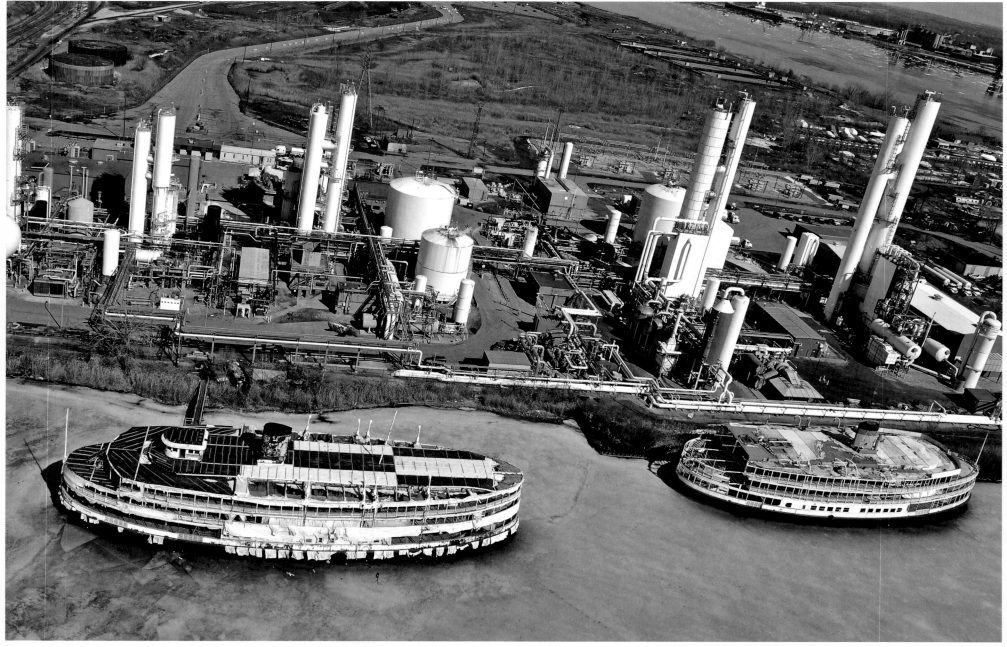

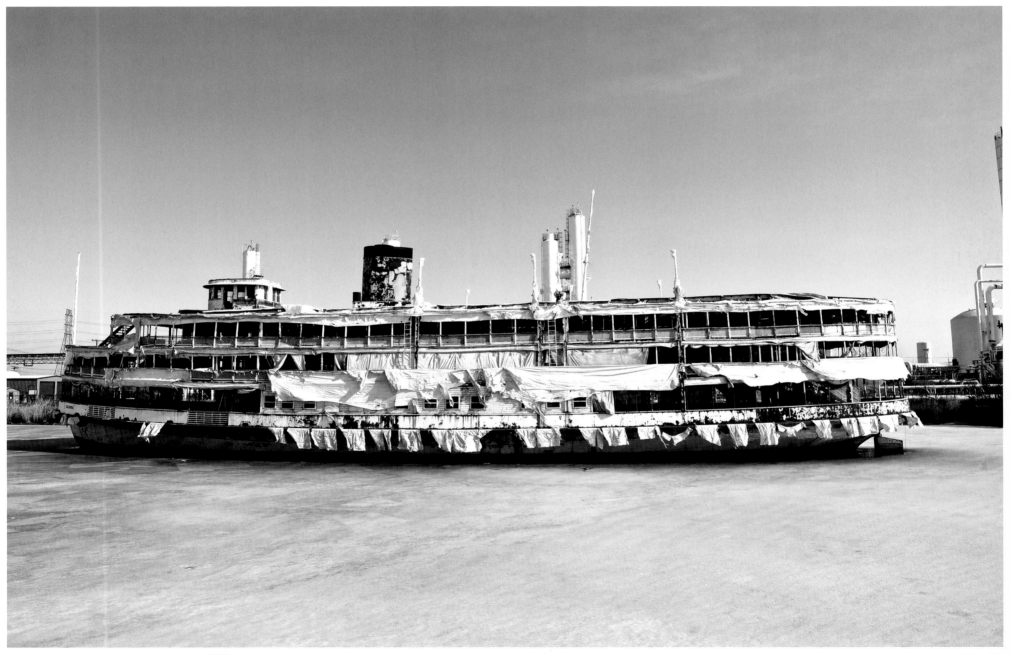

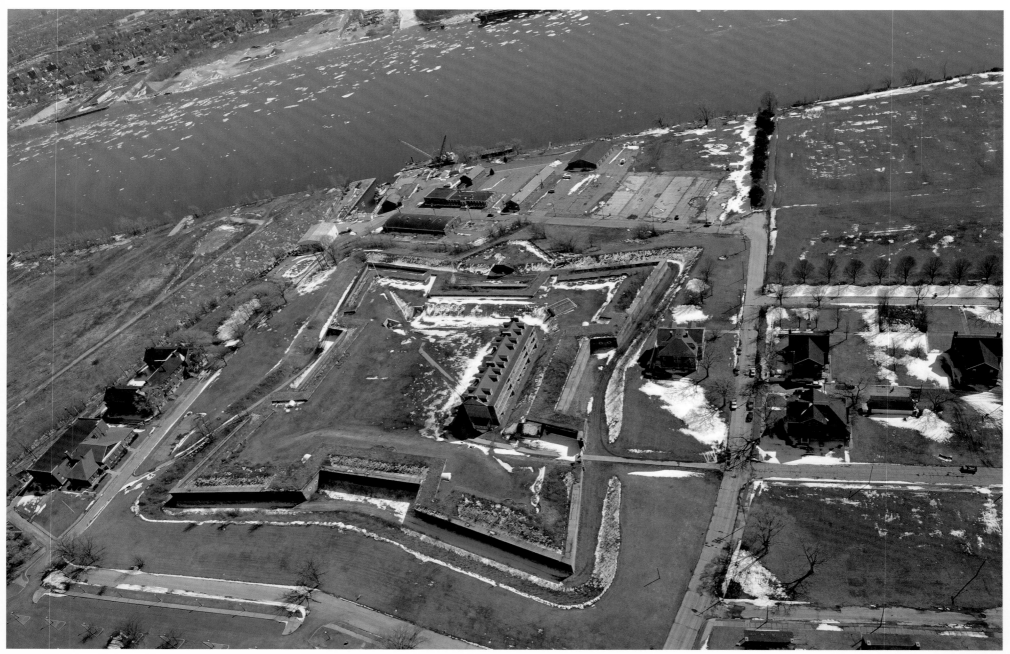

370

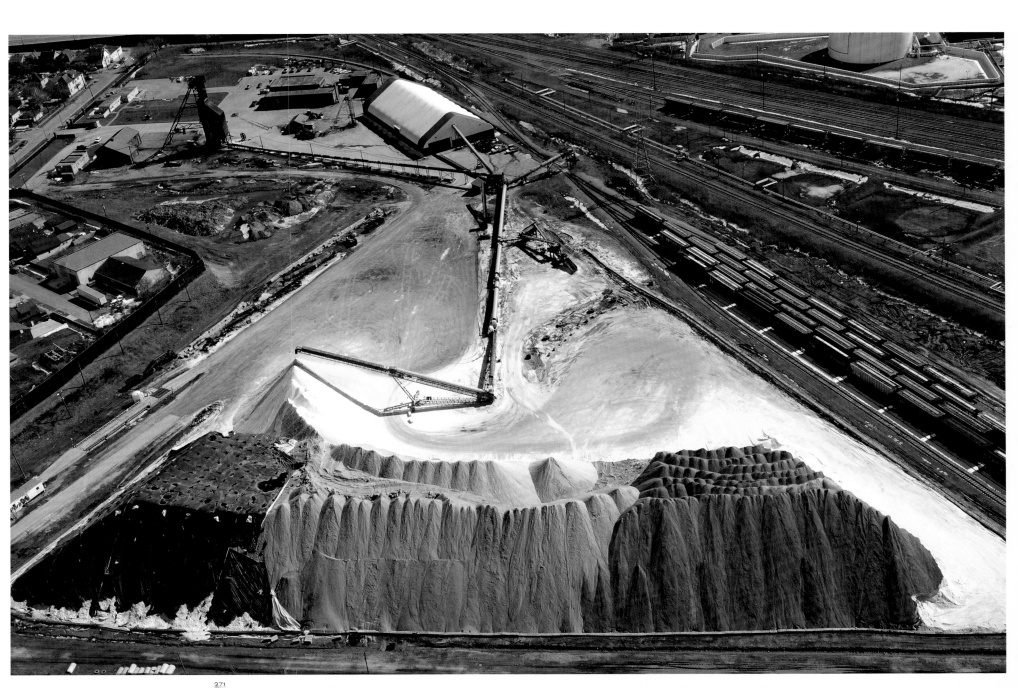

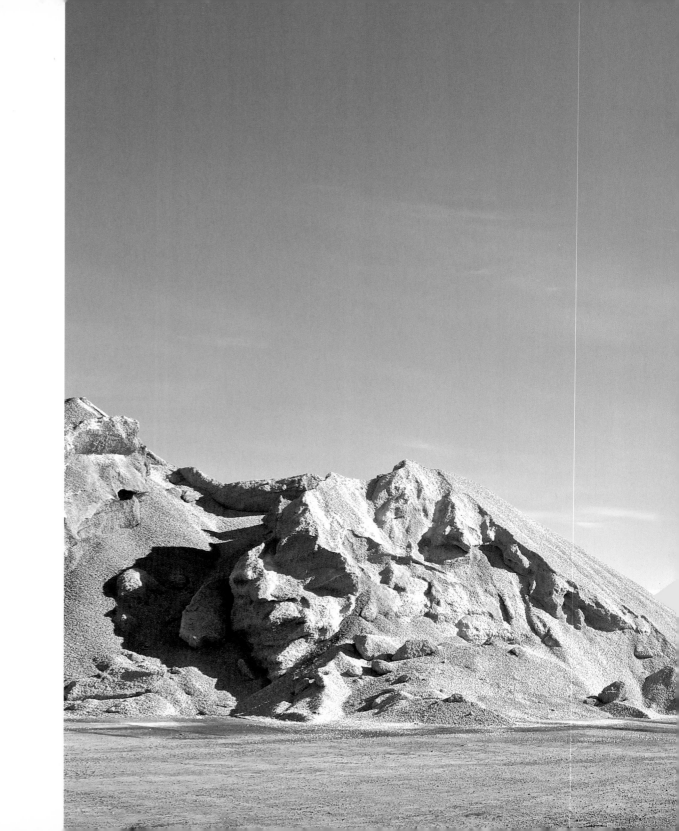

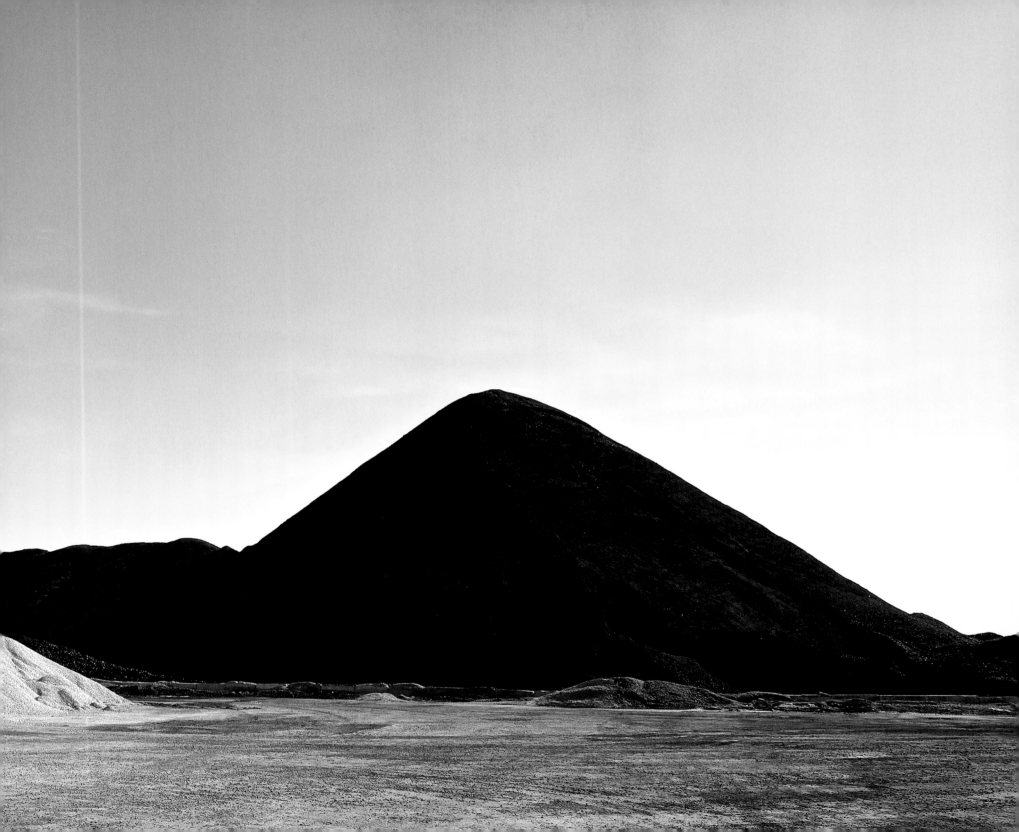

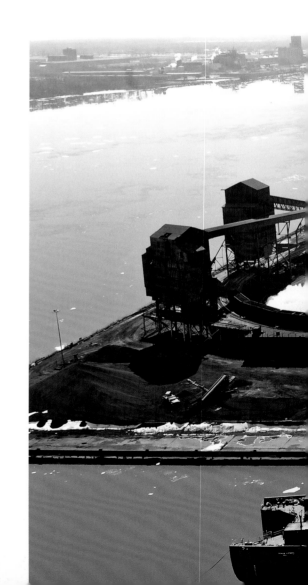

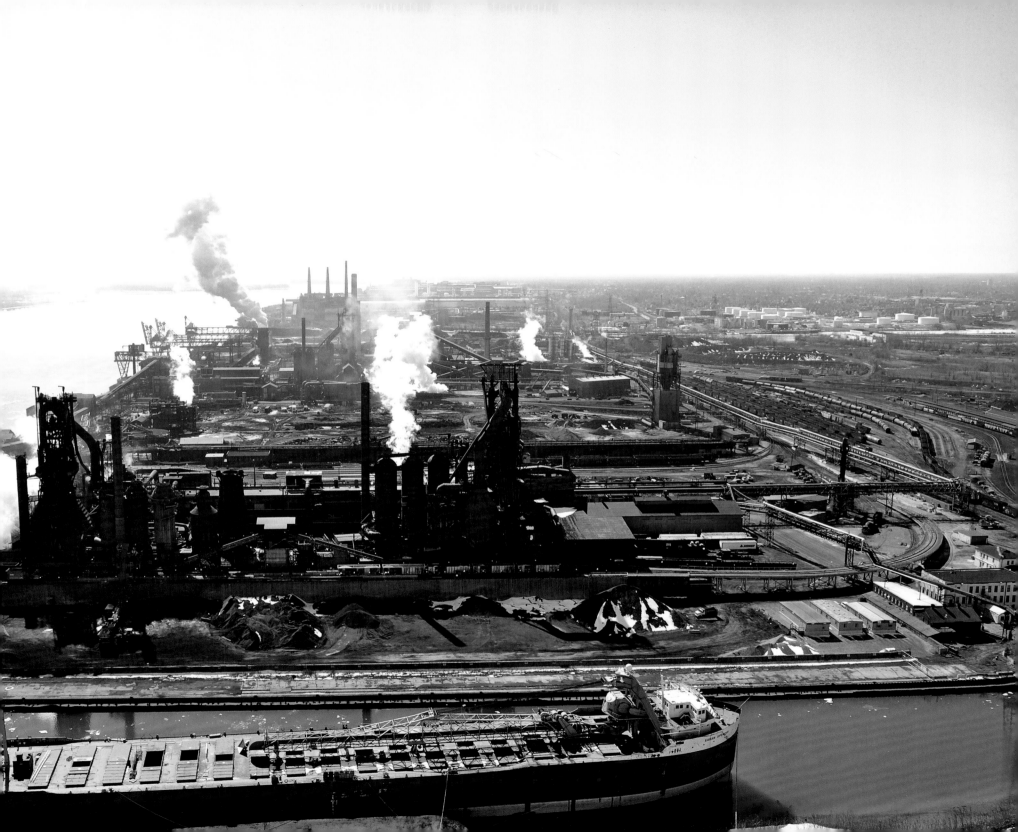

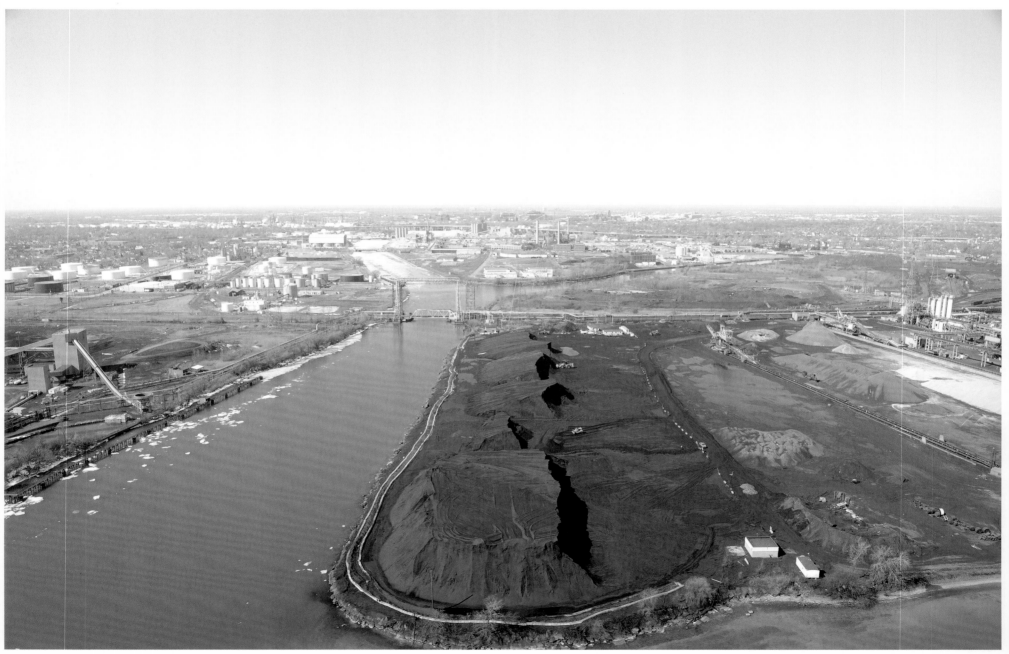

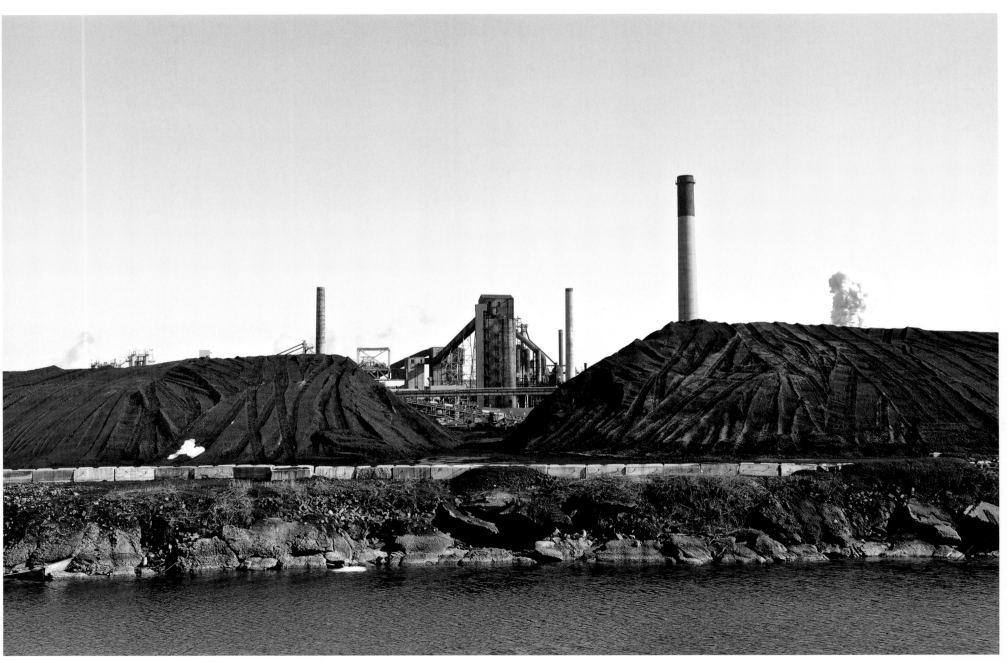

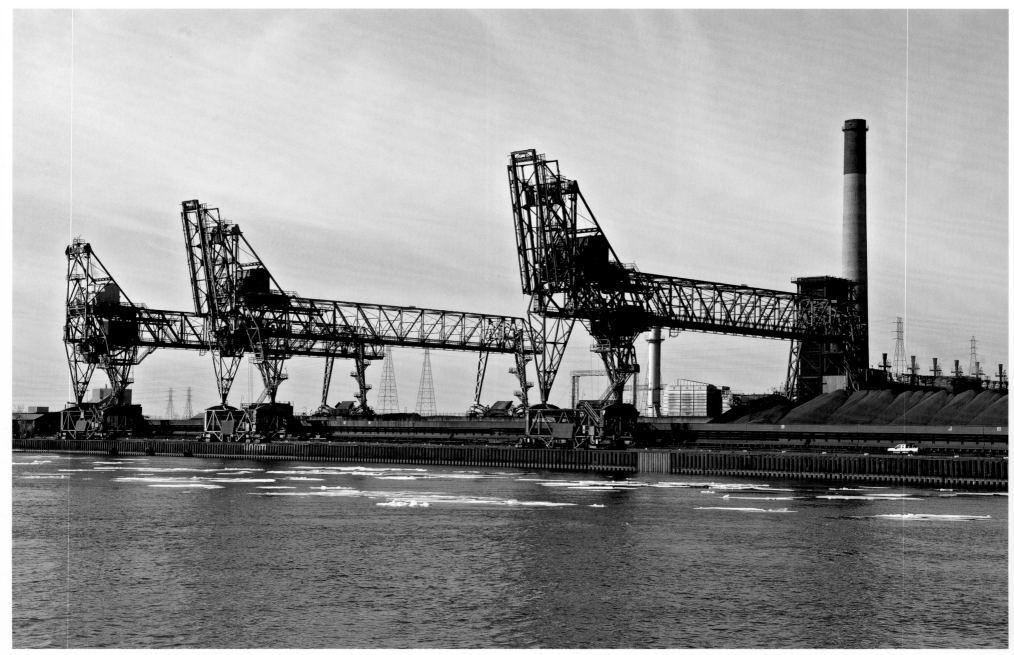

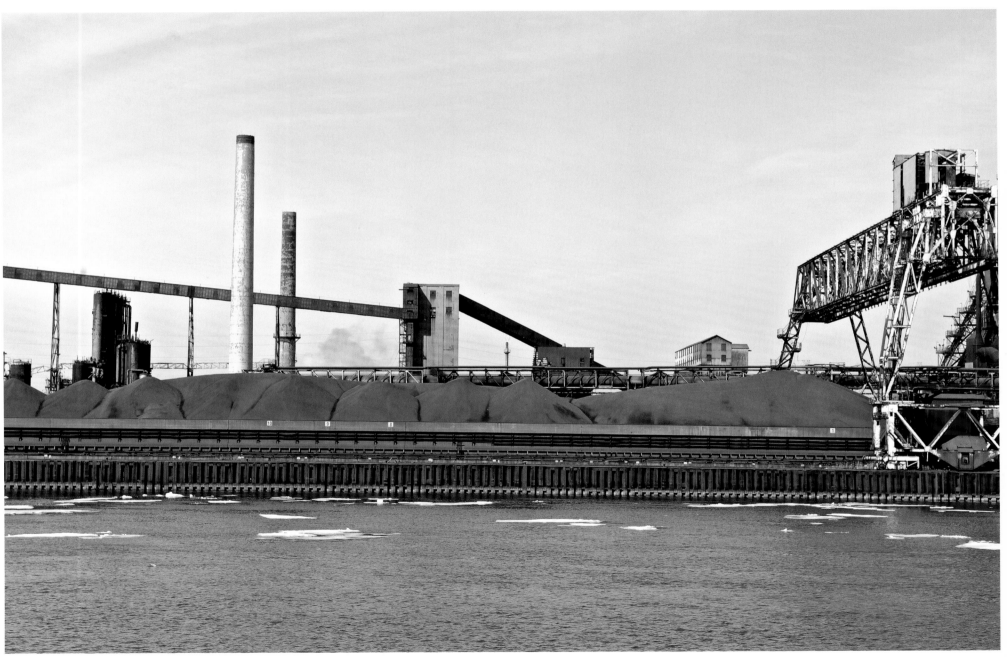

379

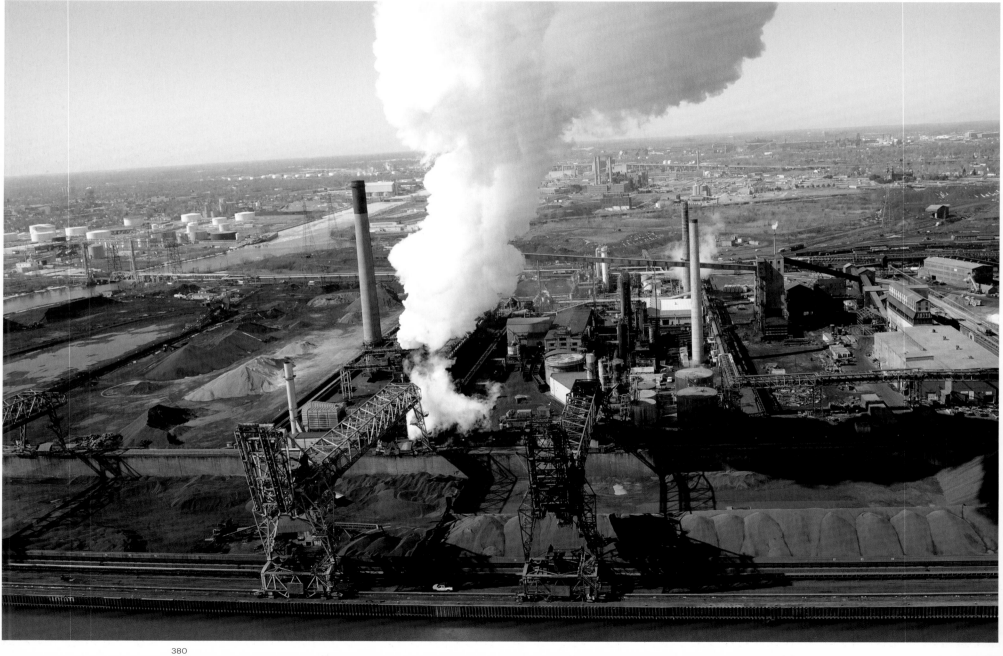

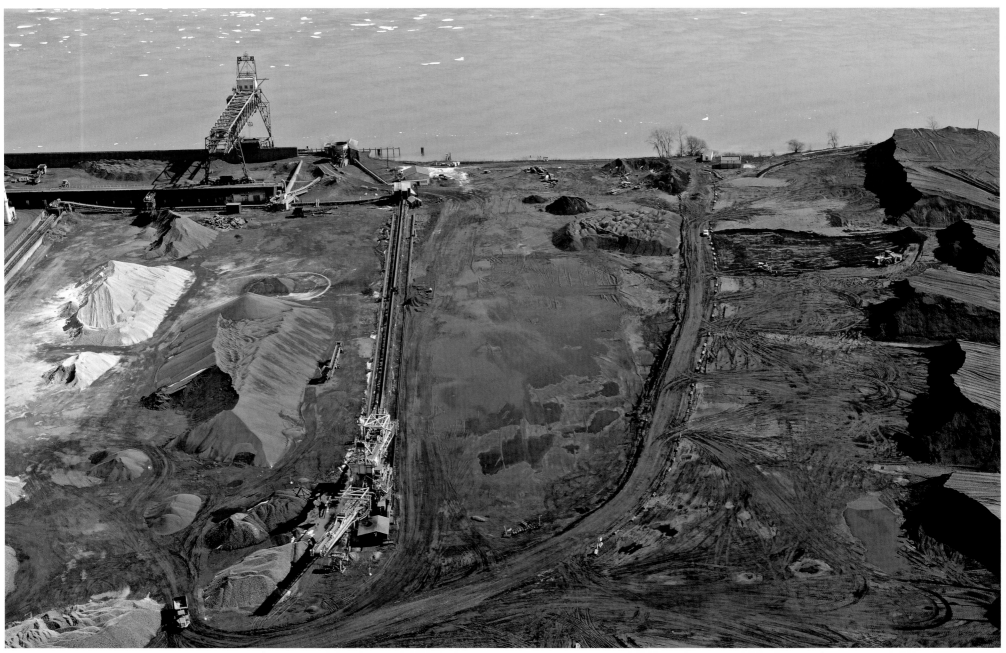

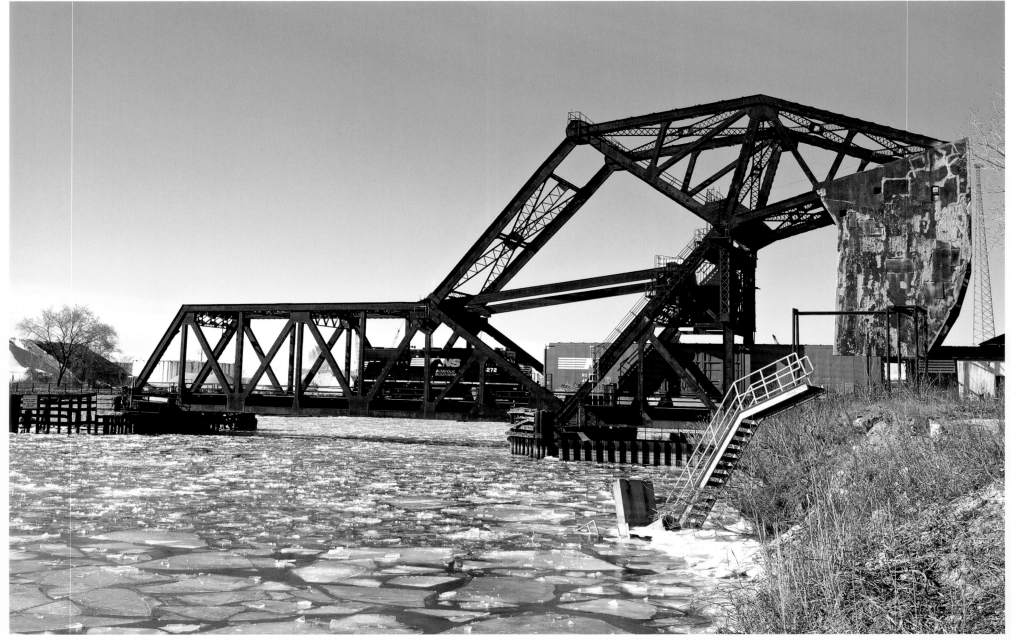

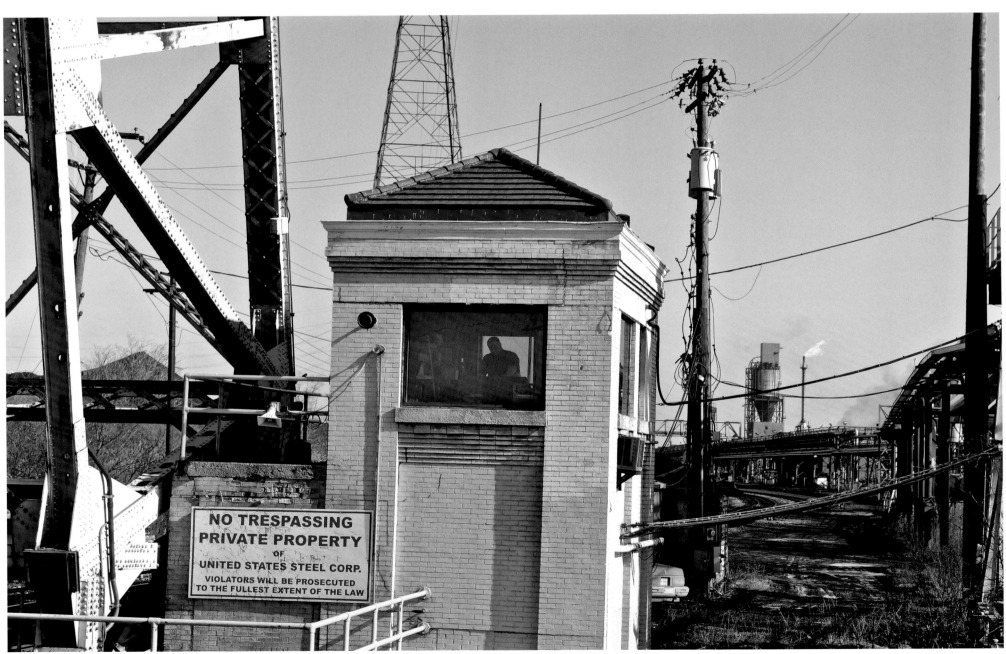

383

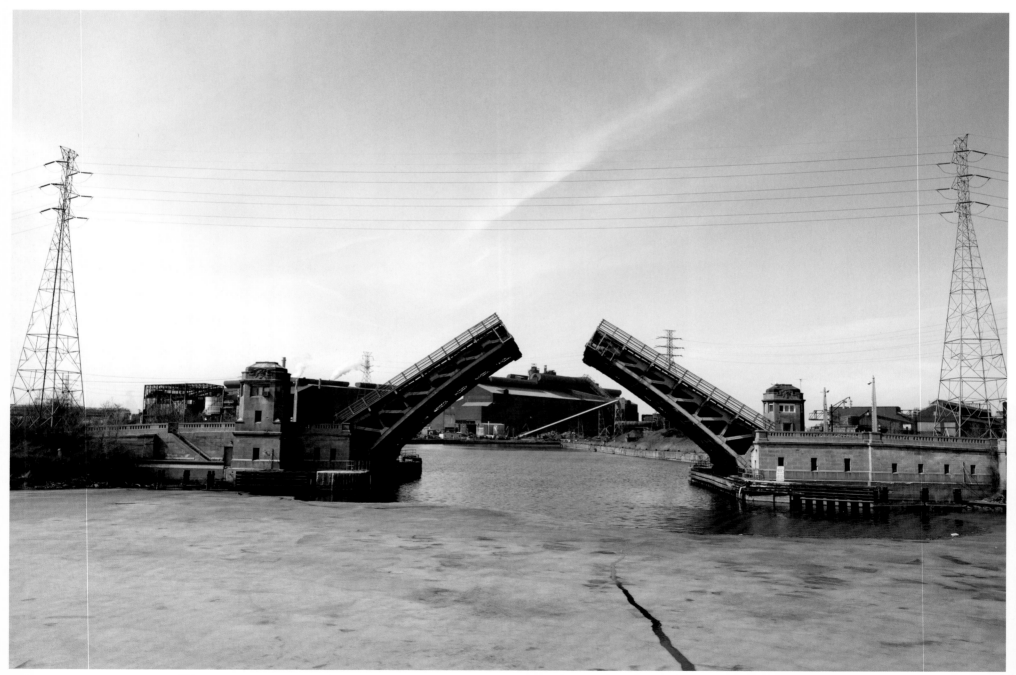

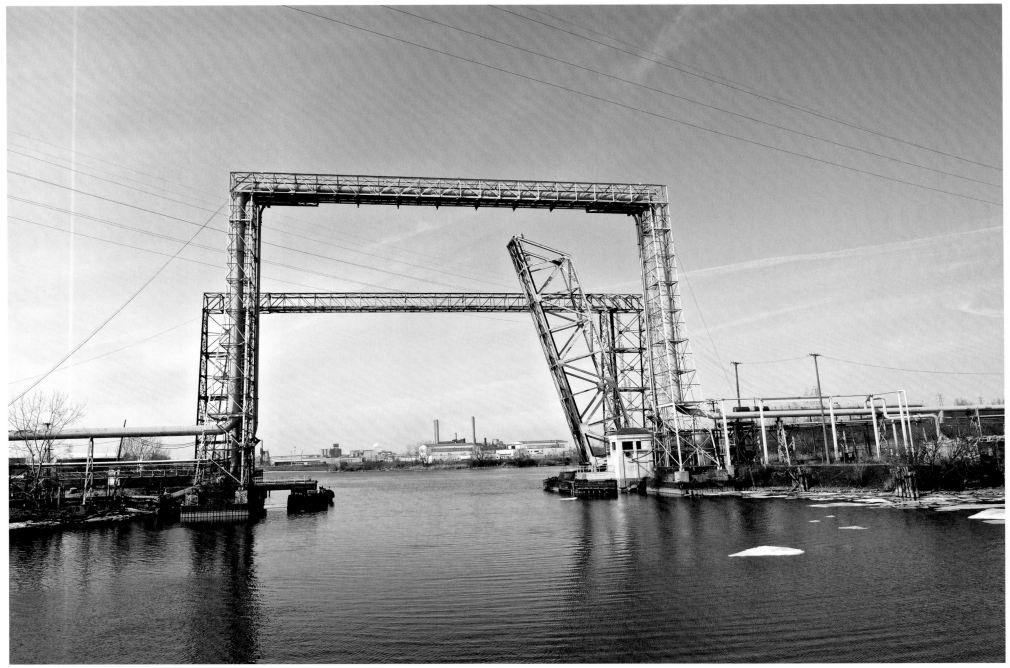

385

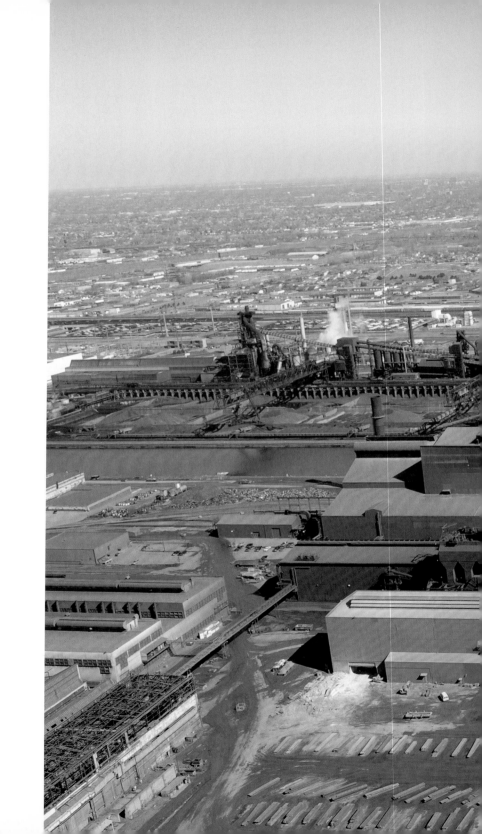

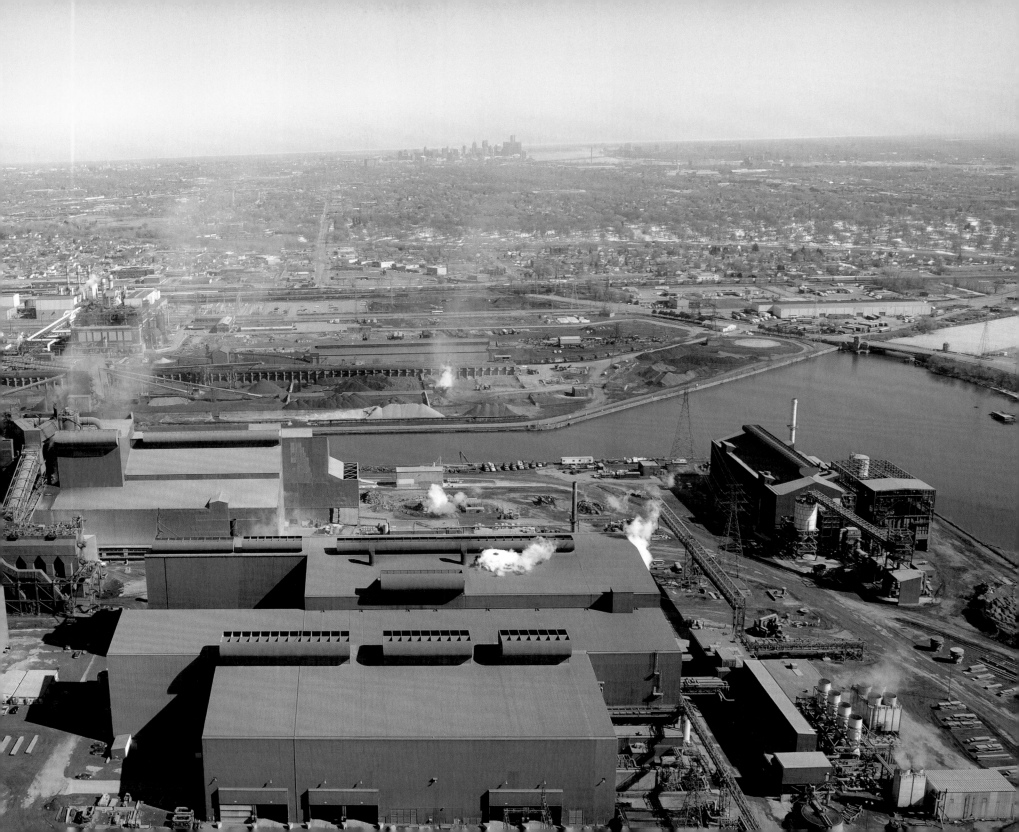

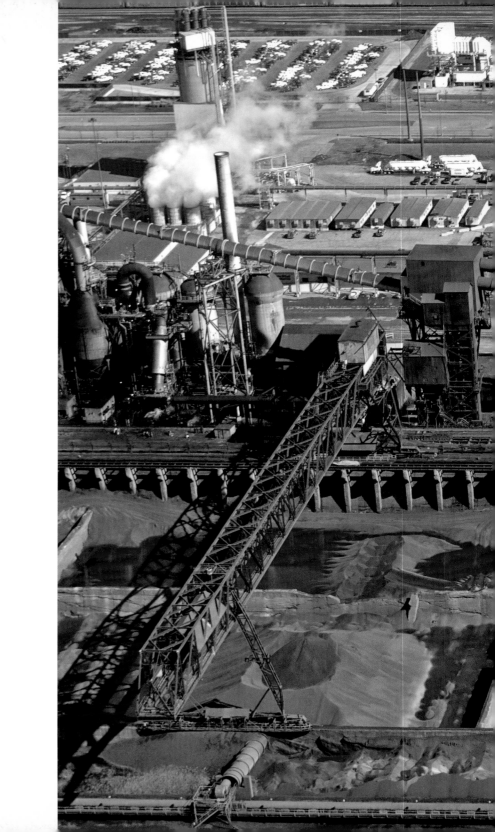

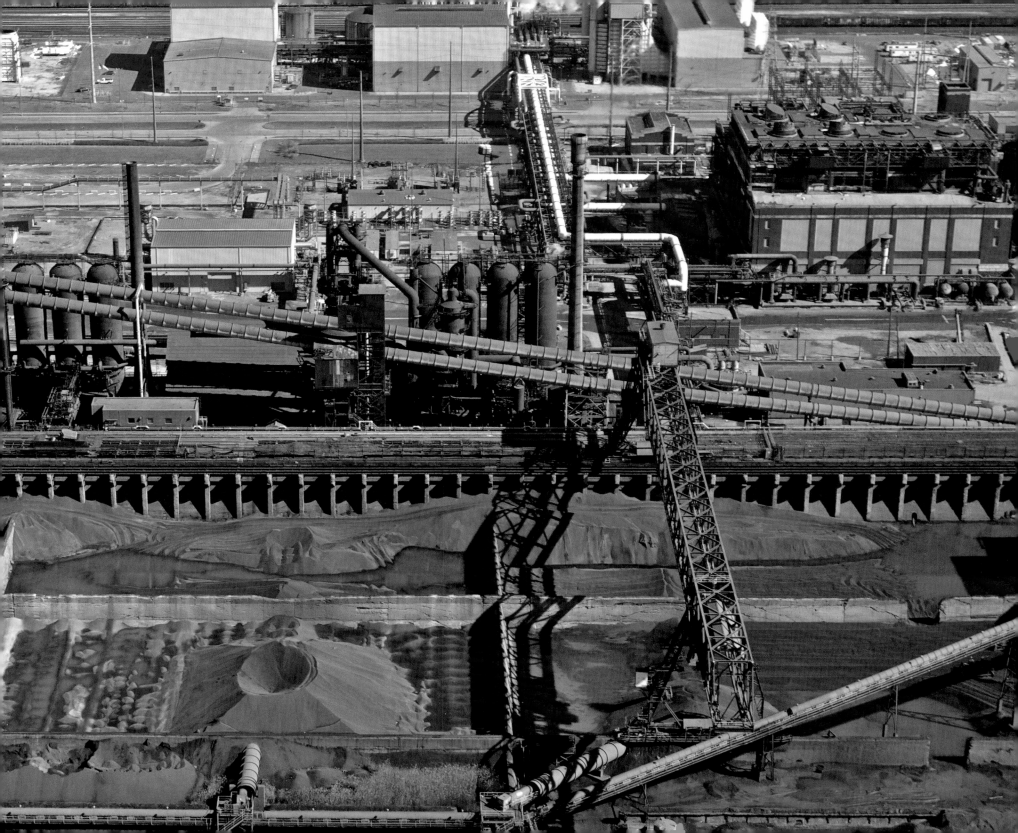

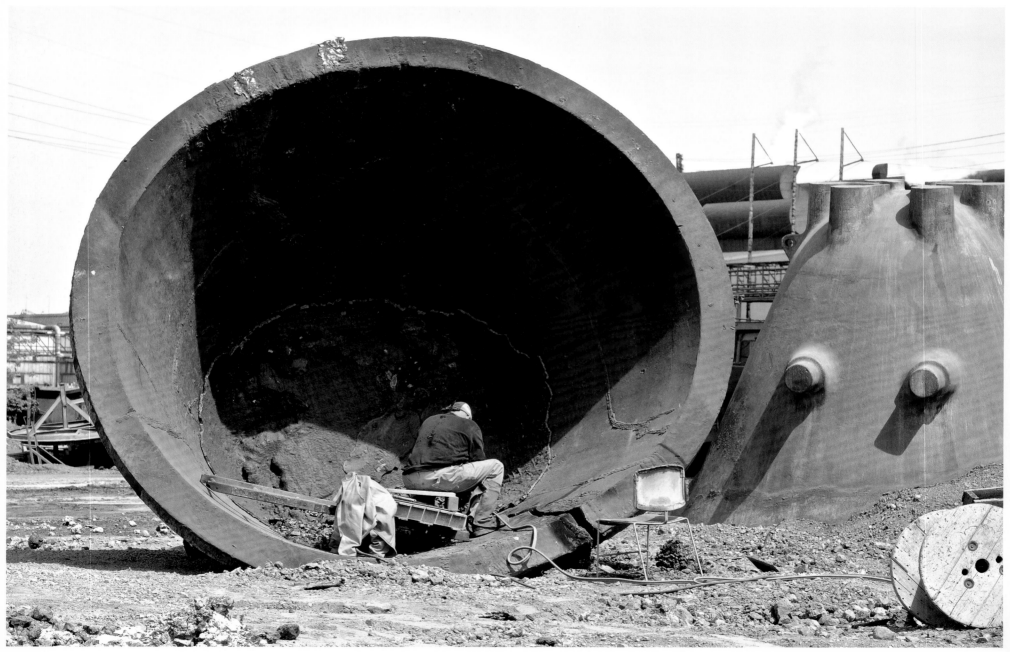

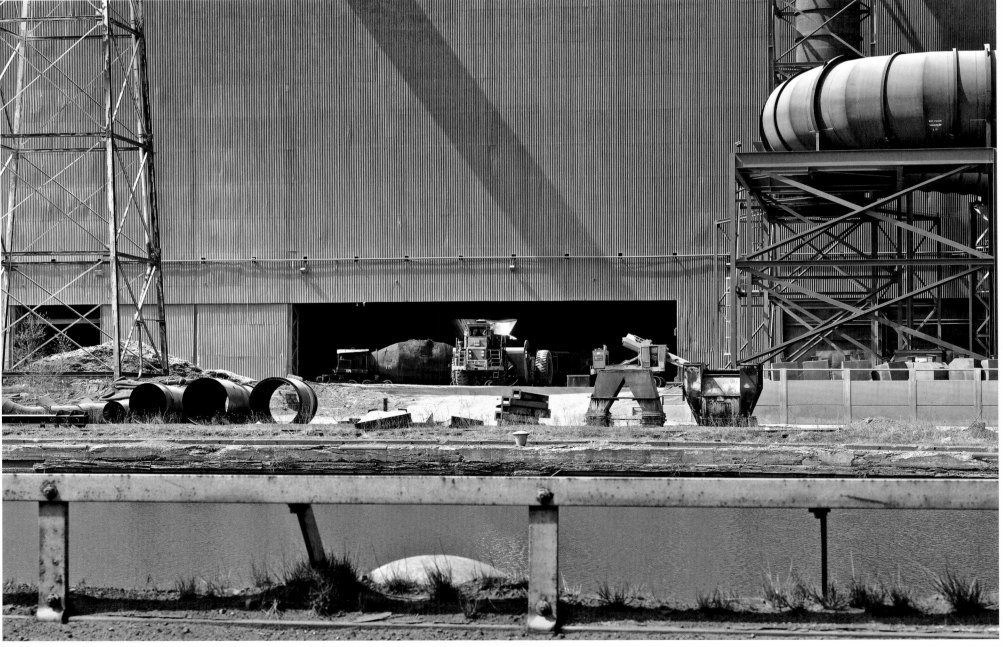

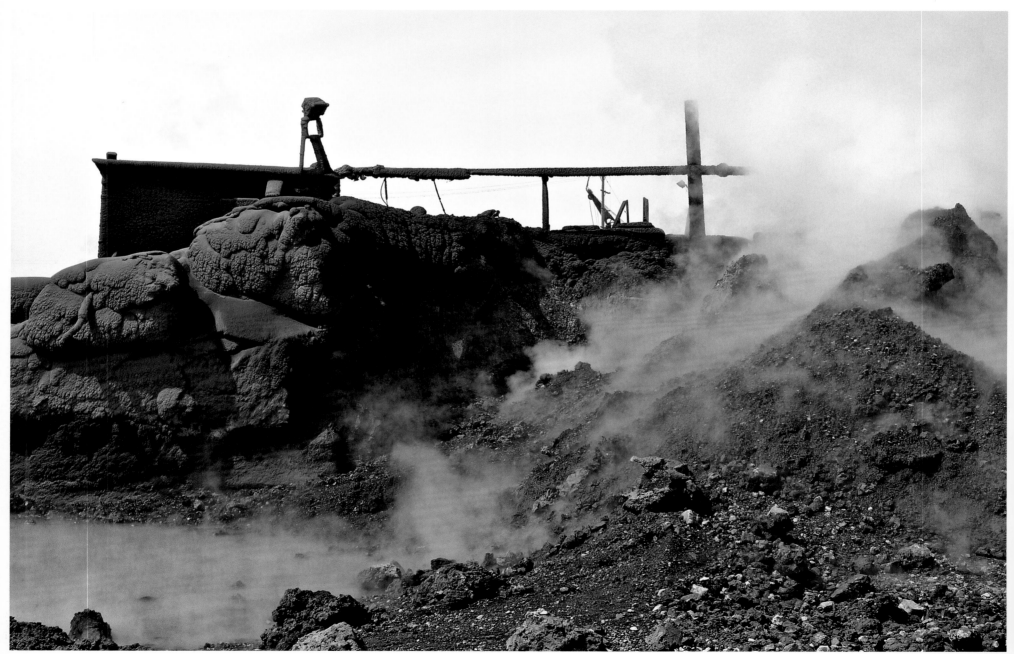

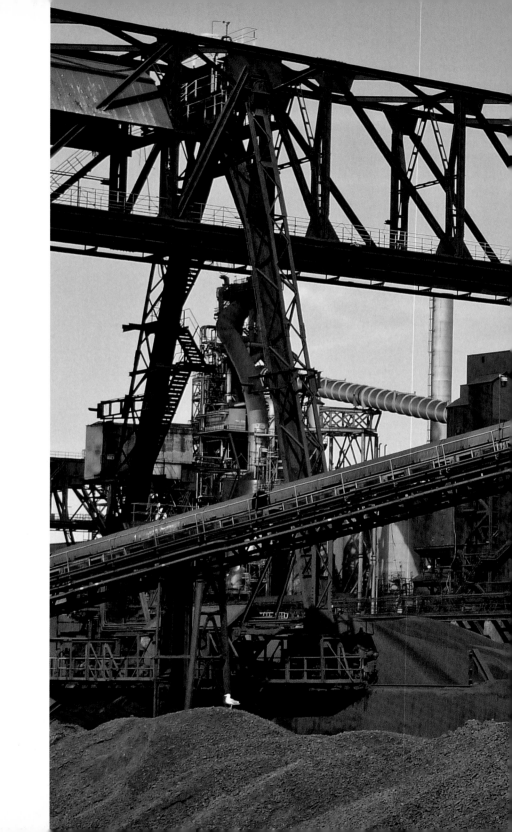

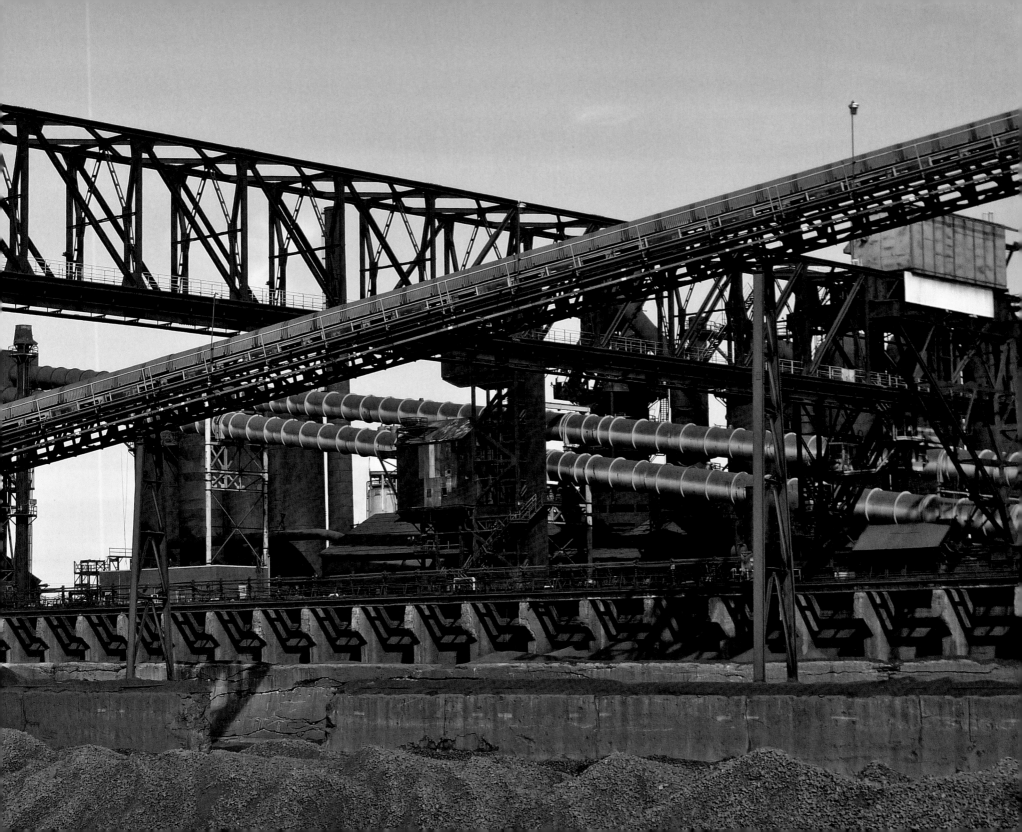

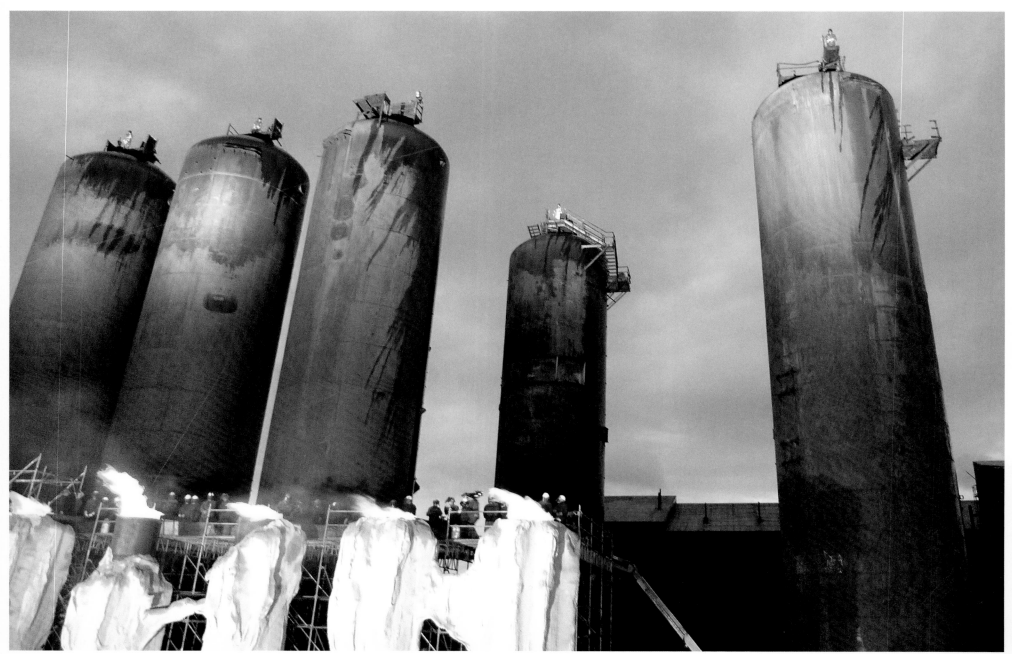

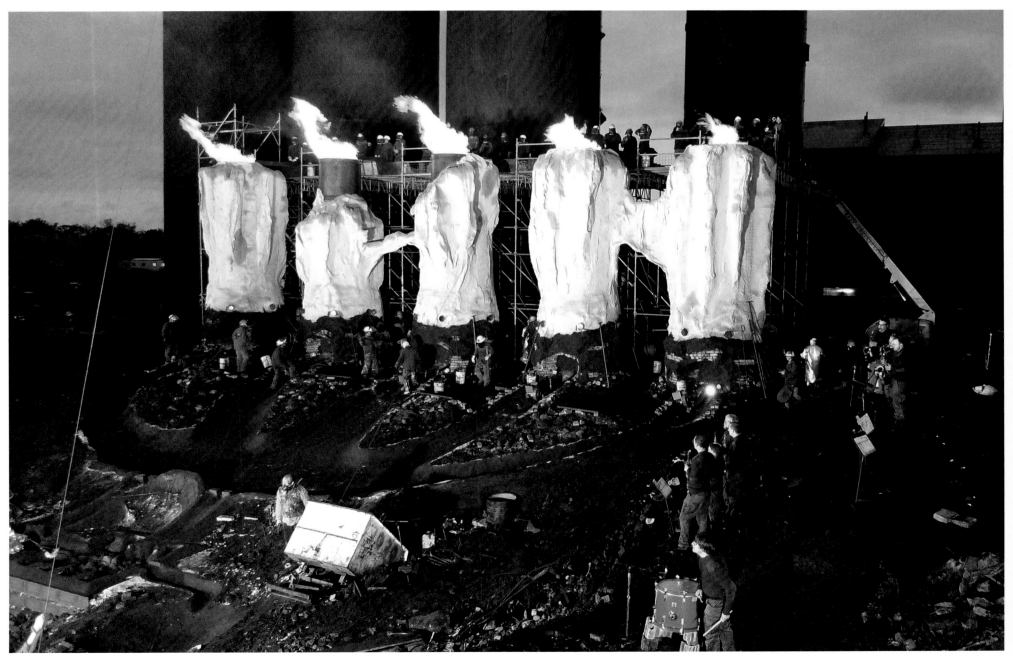

399

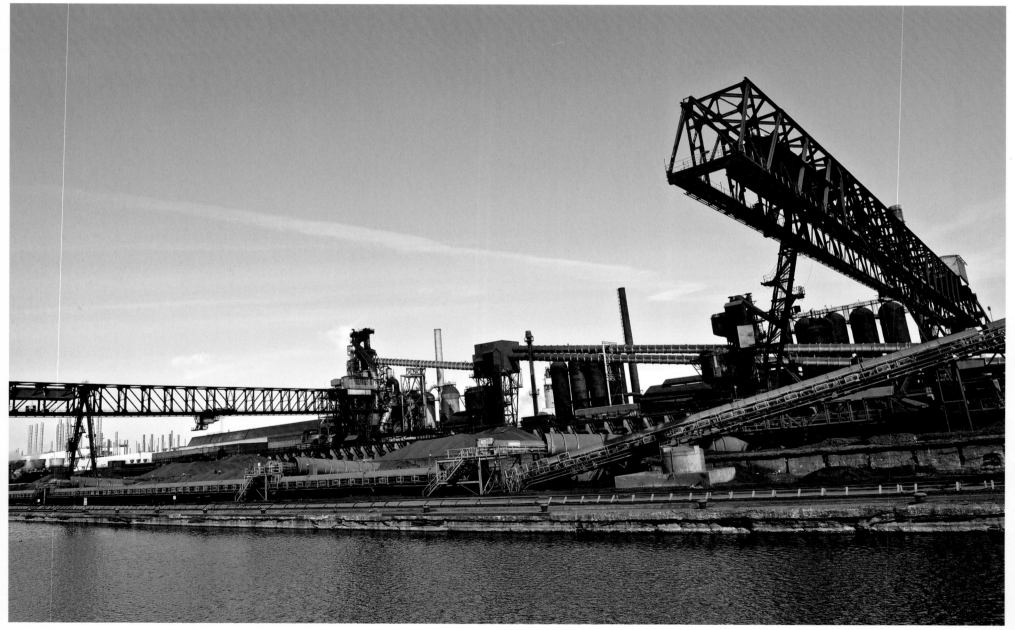

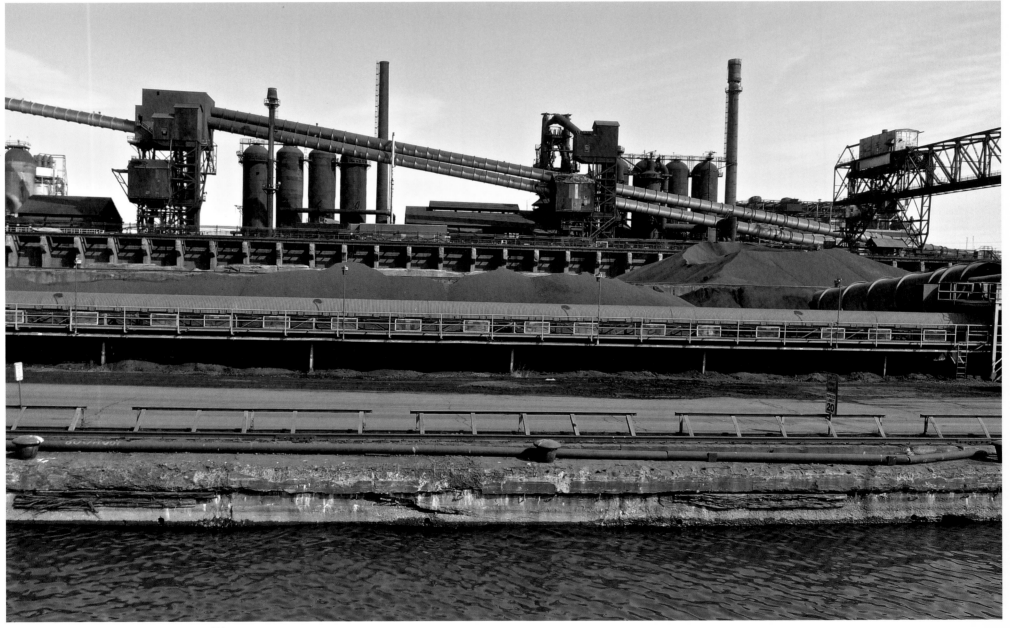

402

403

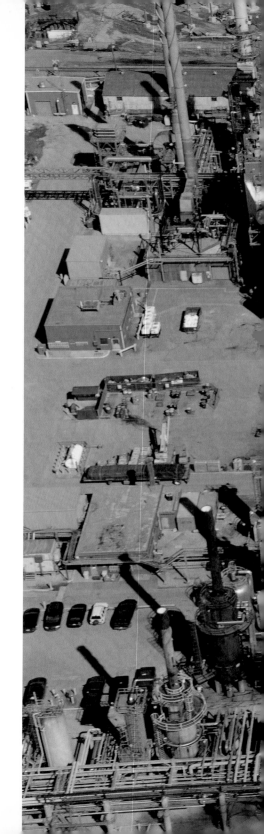

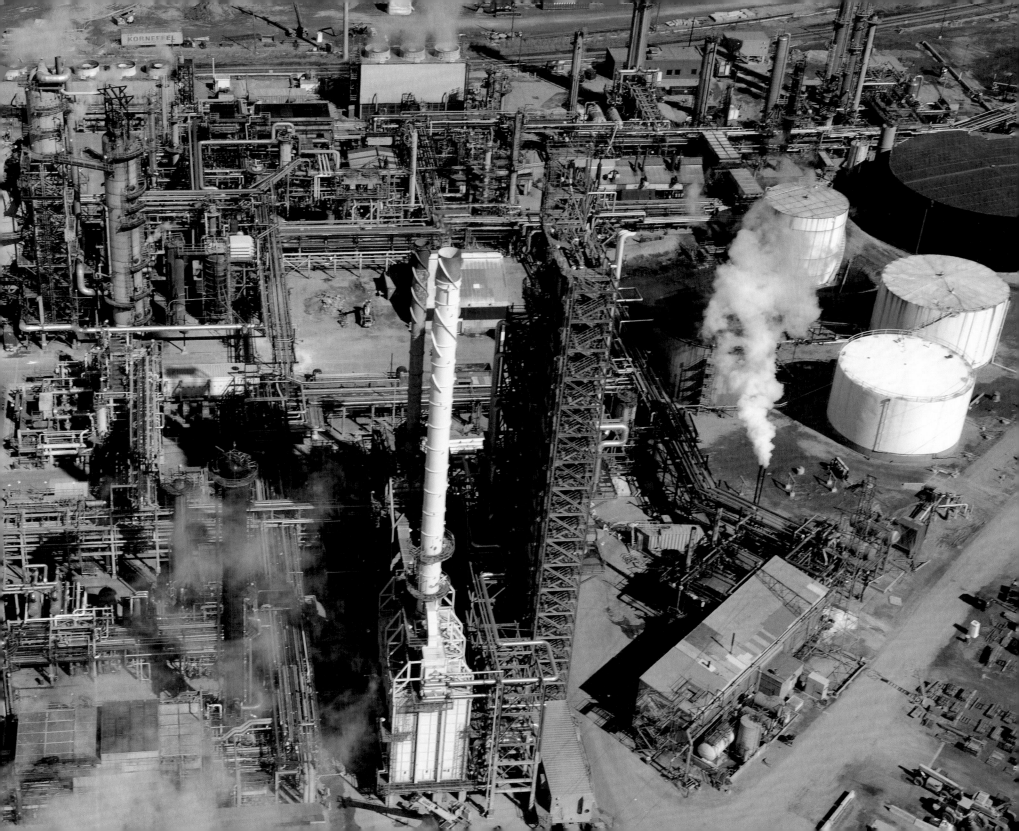

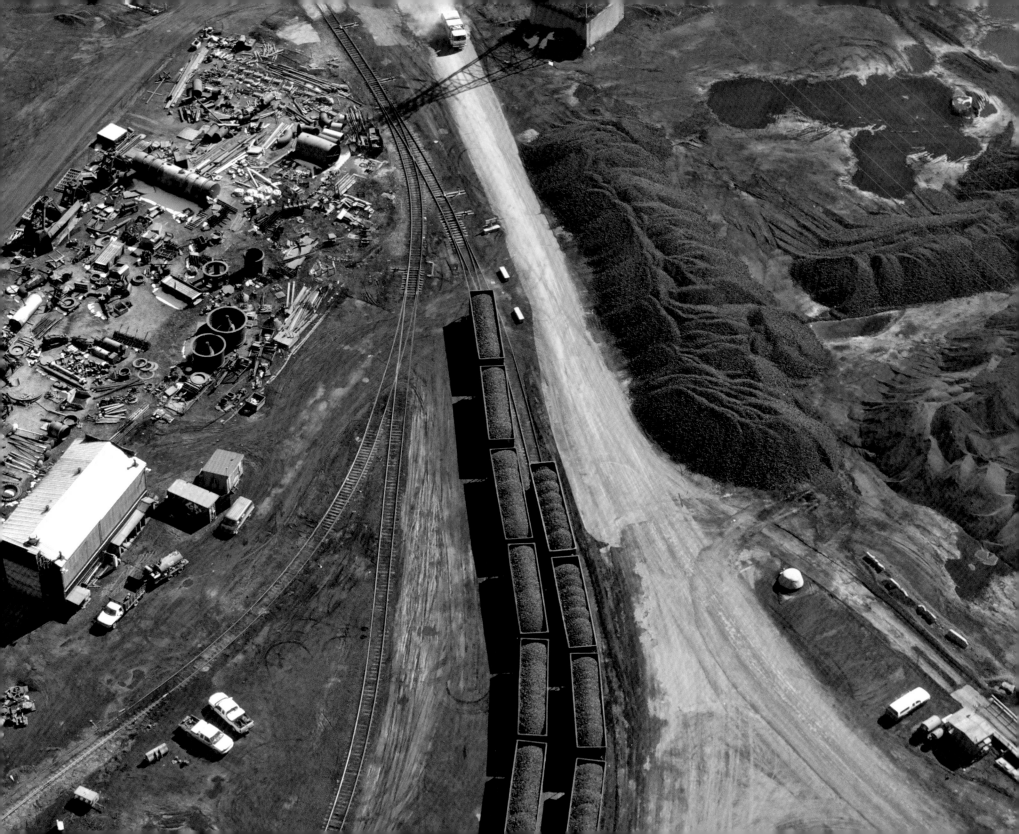

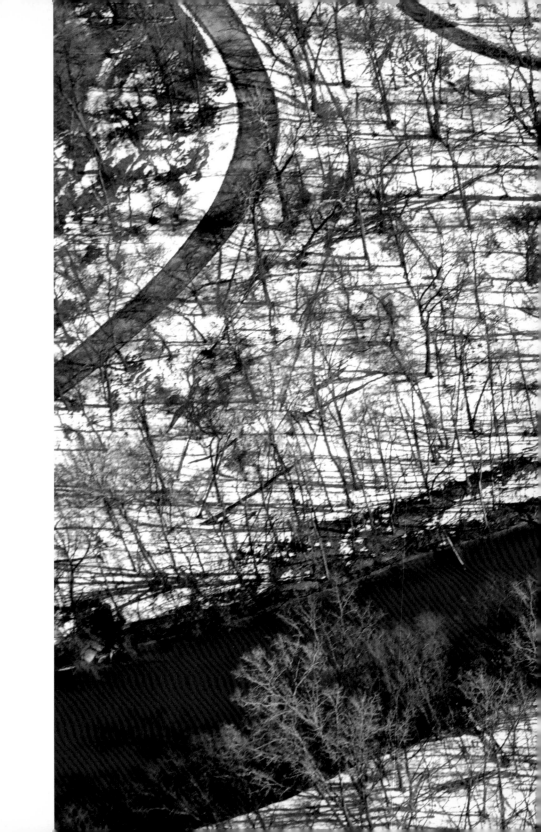

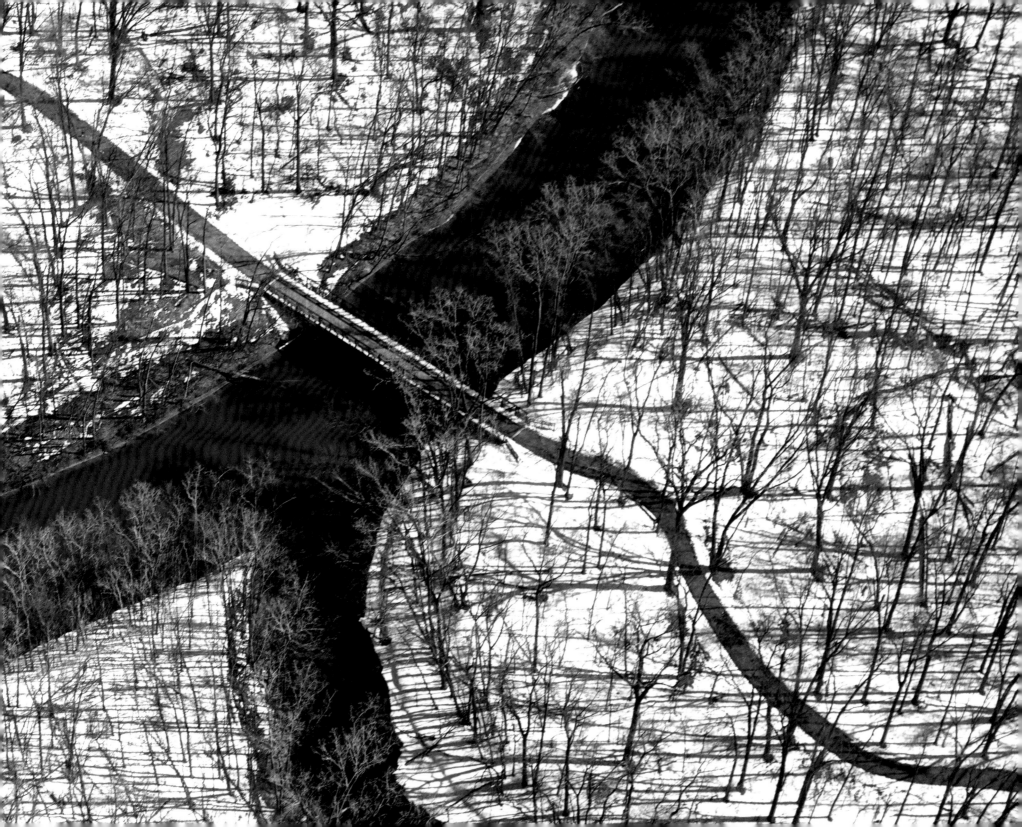

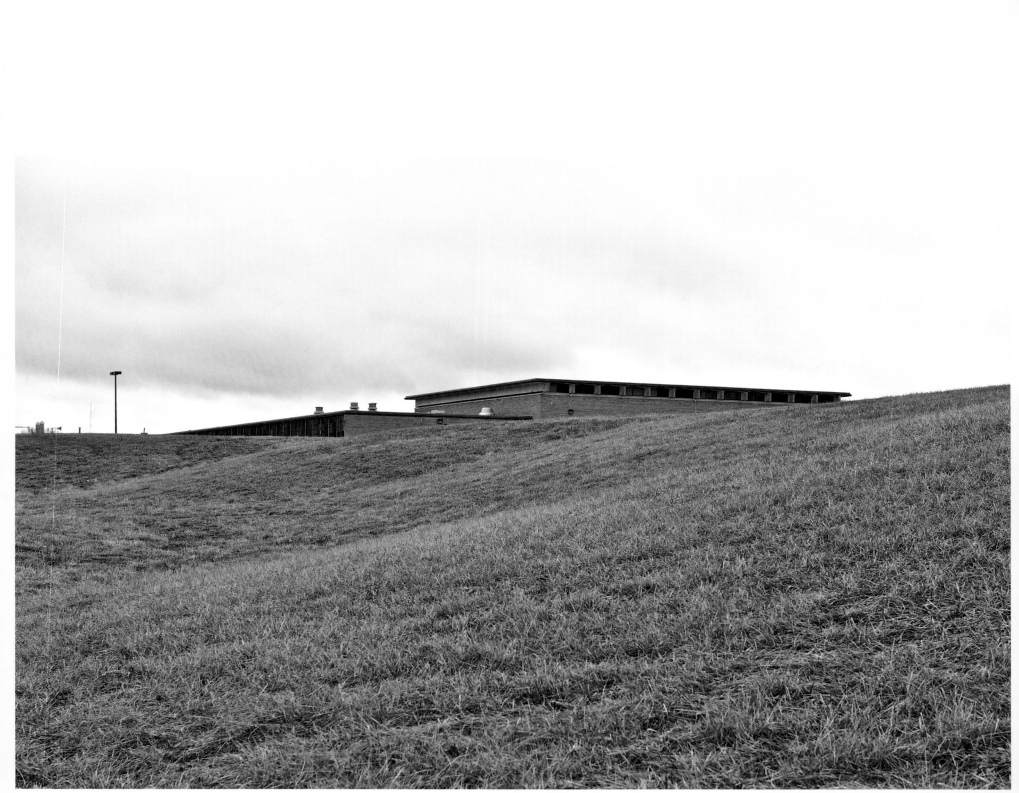

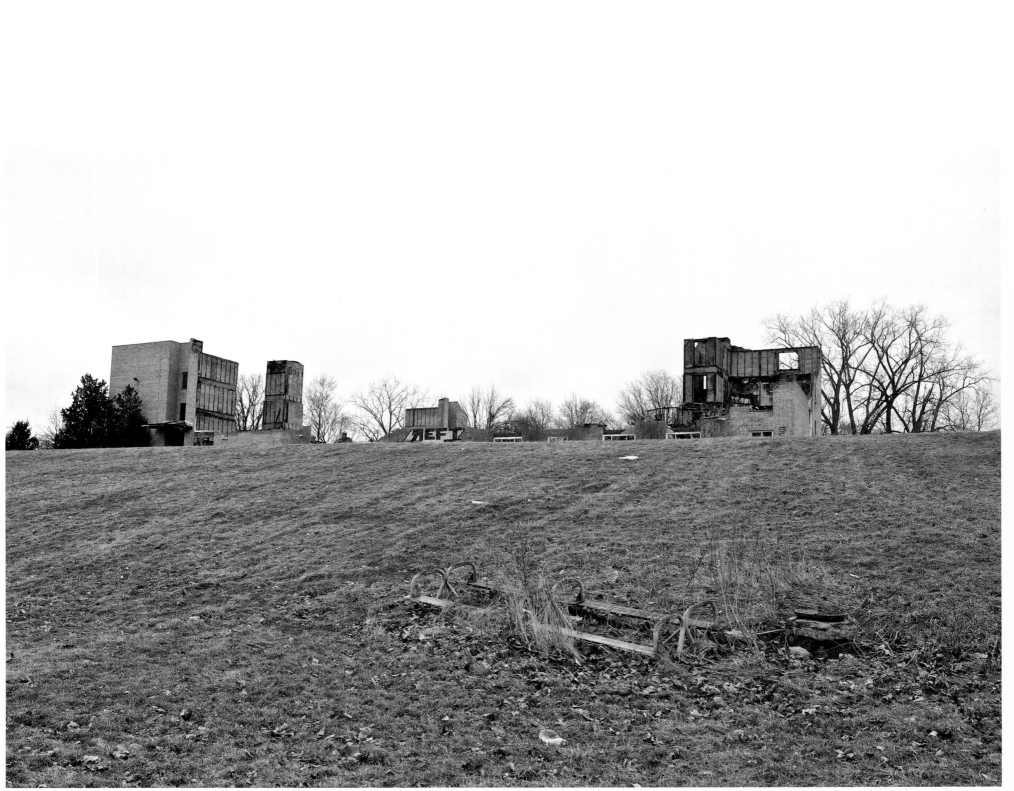

411

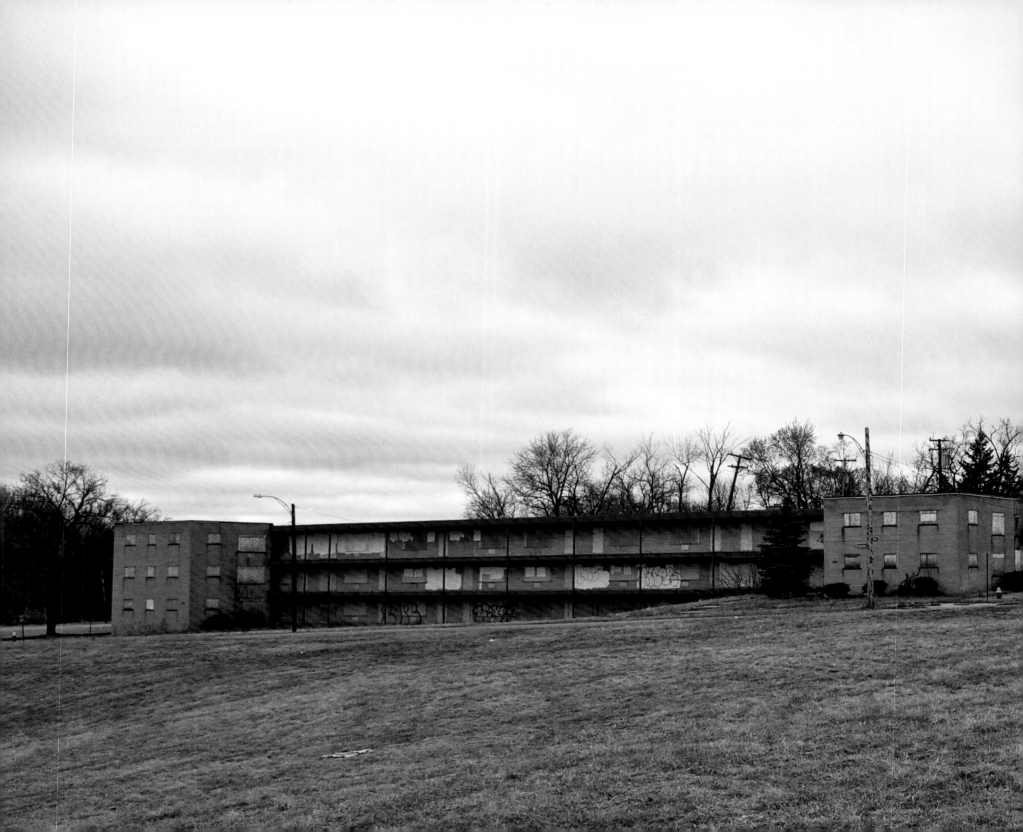

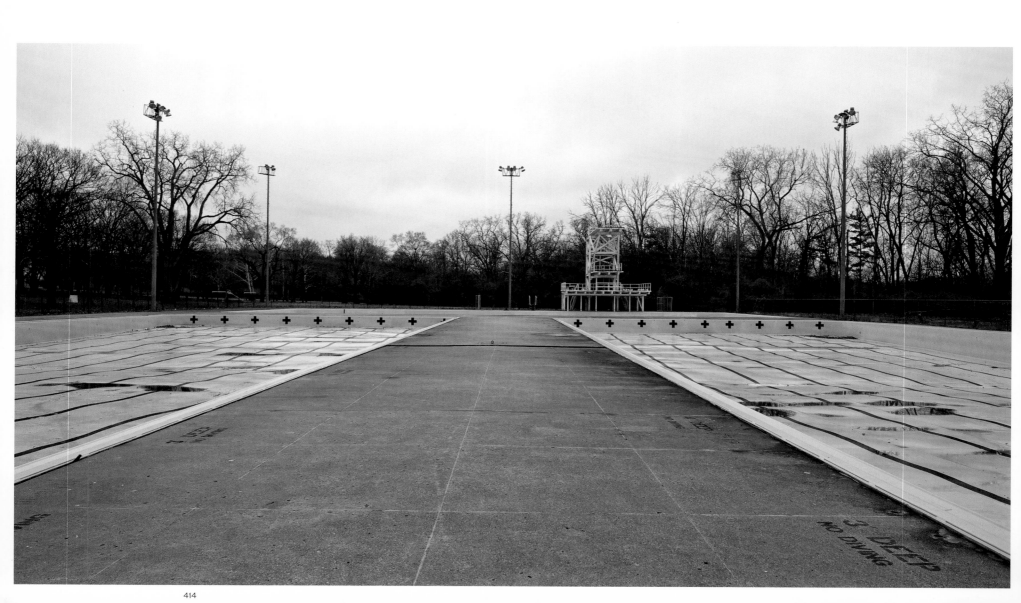

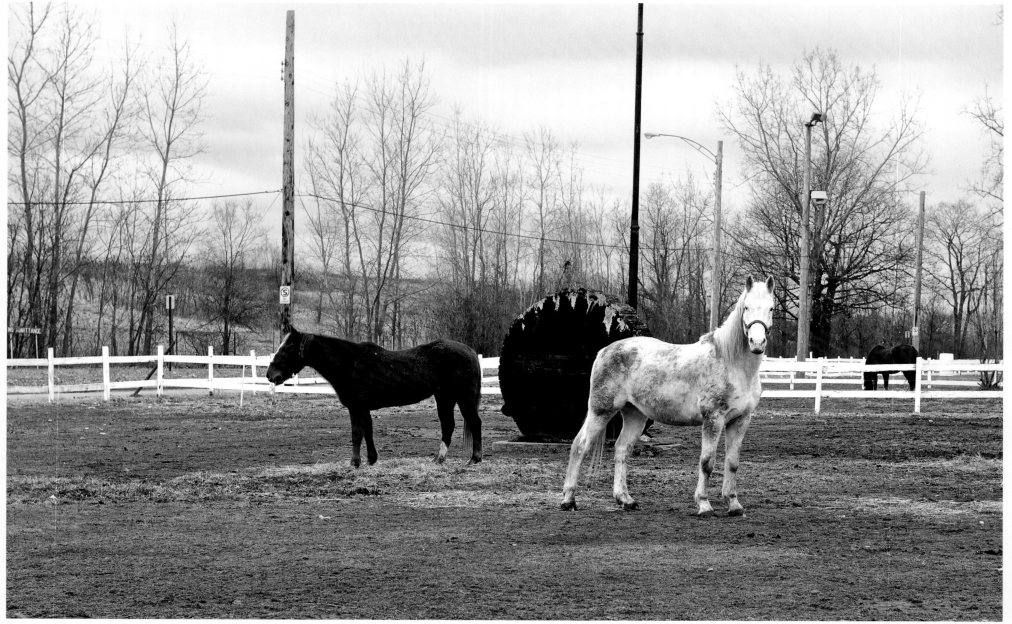

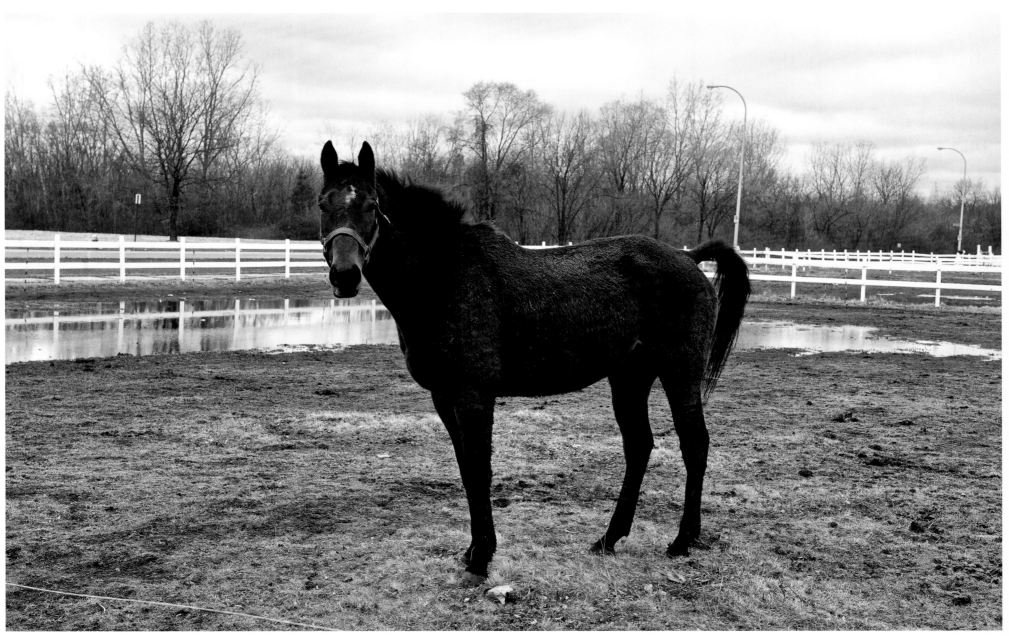

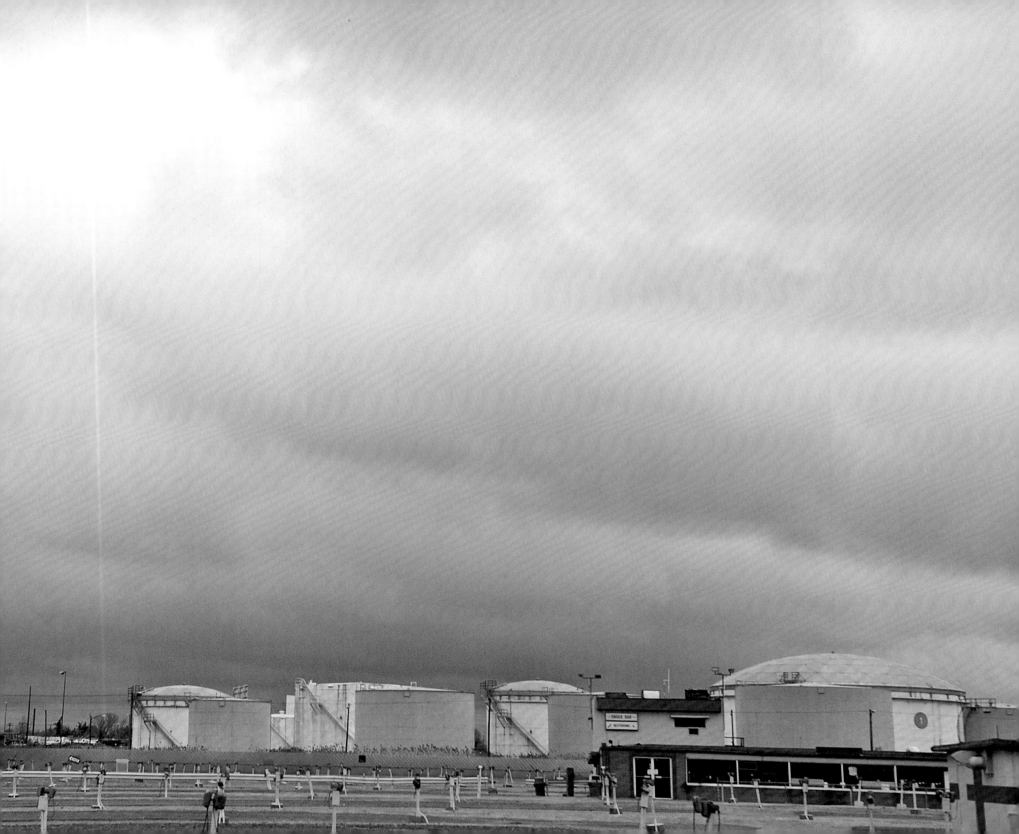

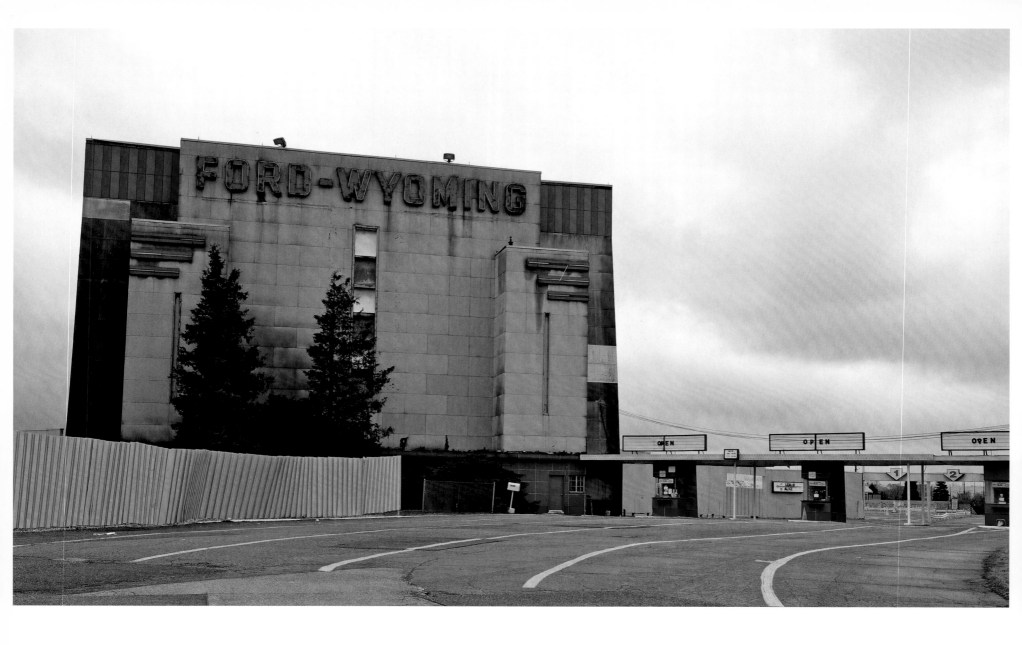

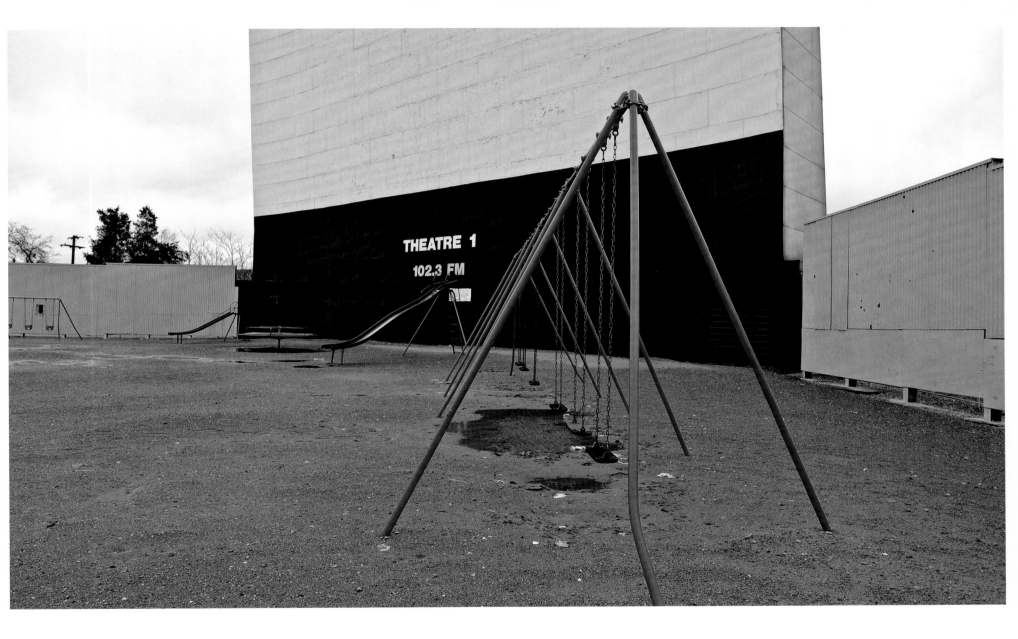

THEATRE 1
102.3 FM

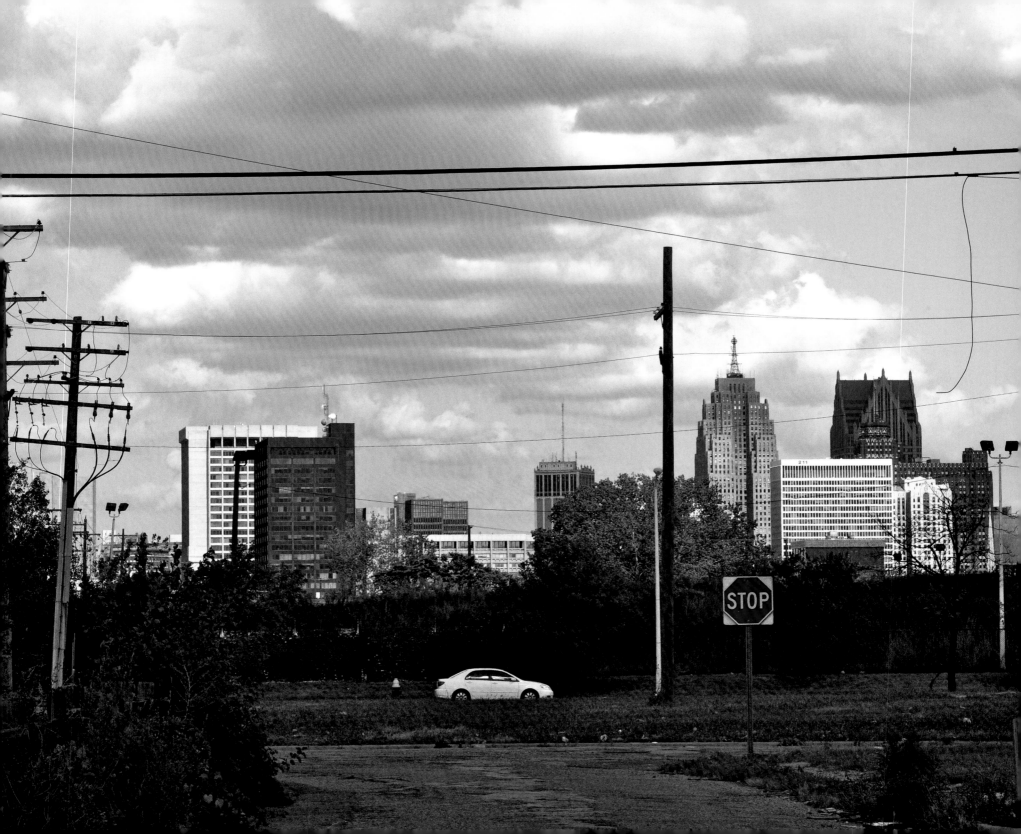

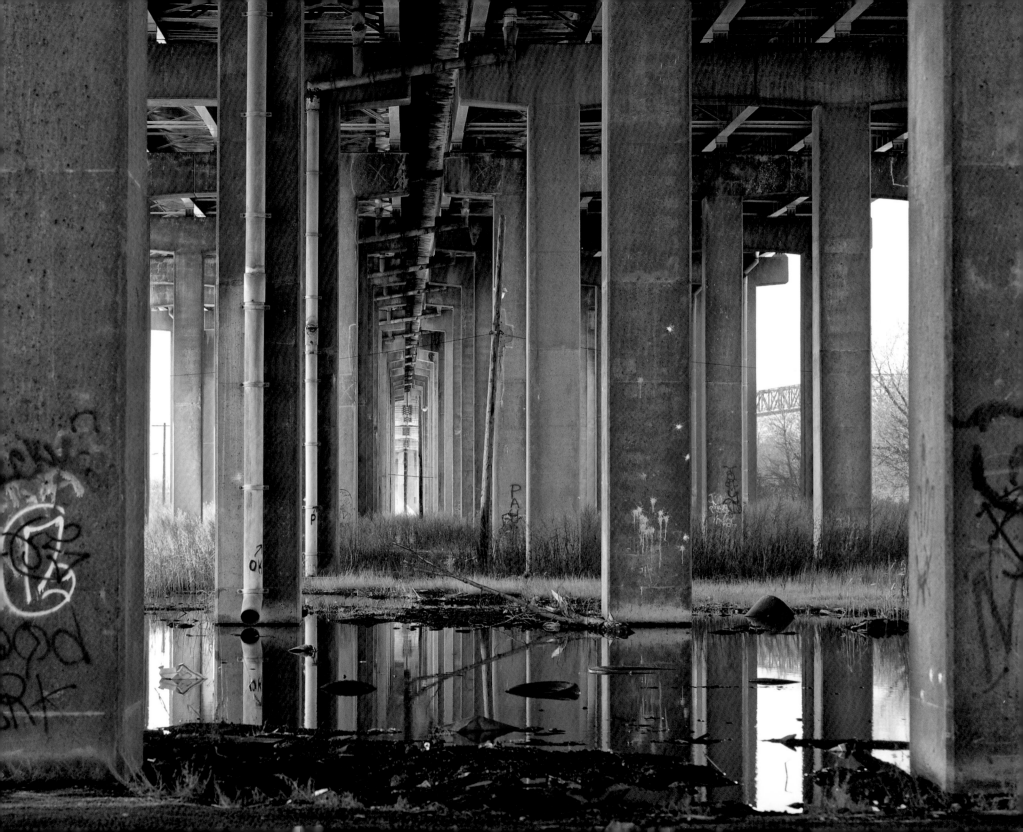

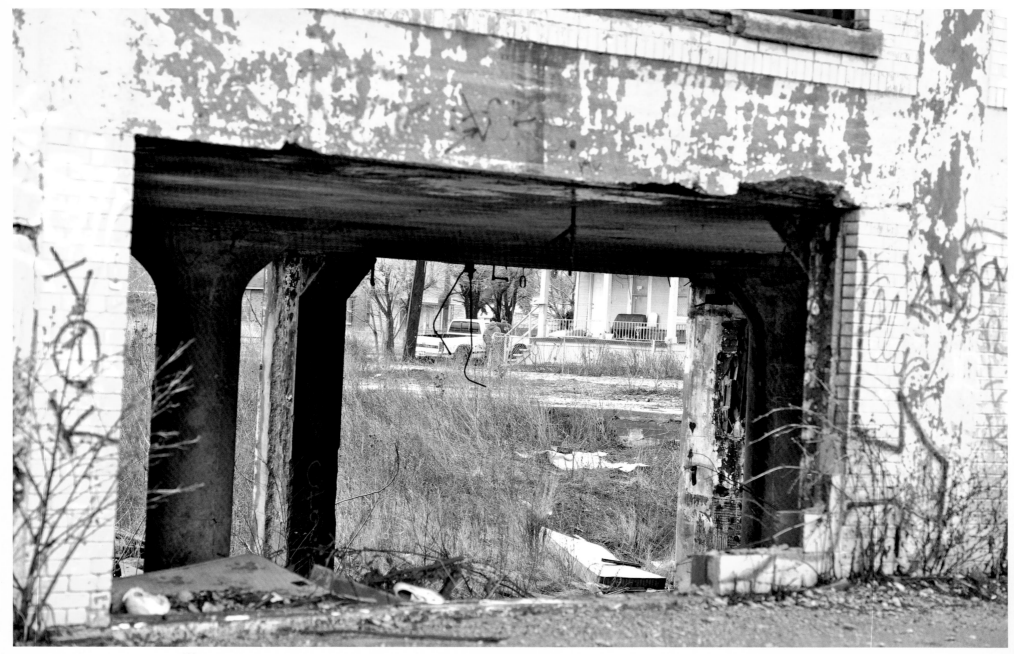

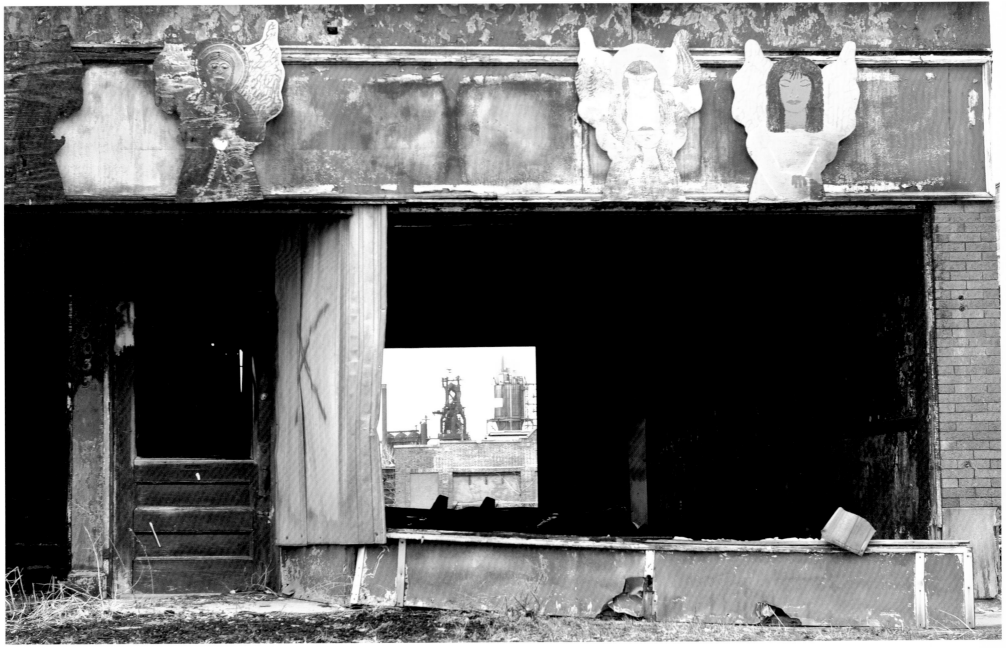

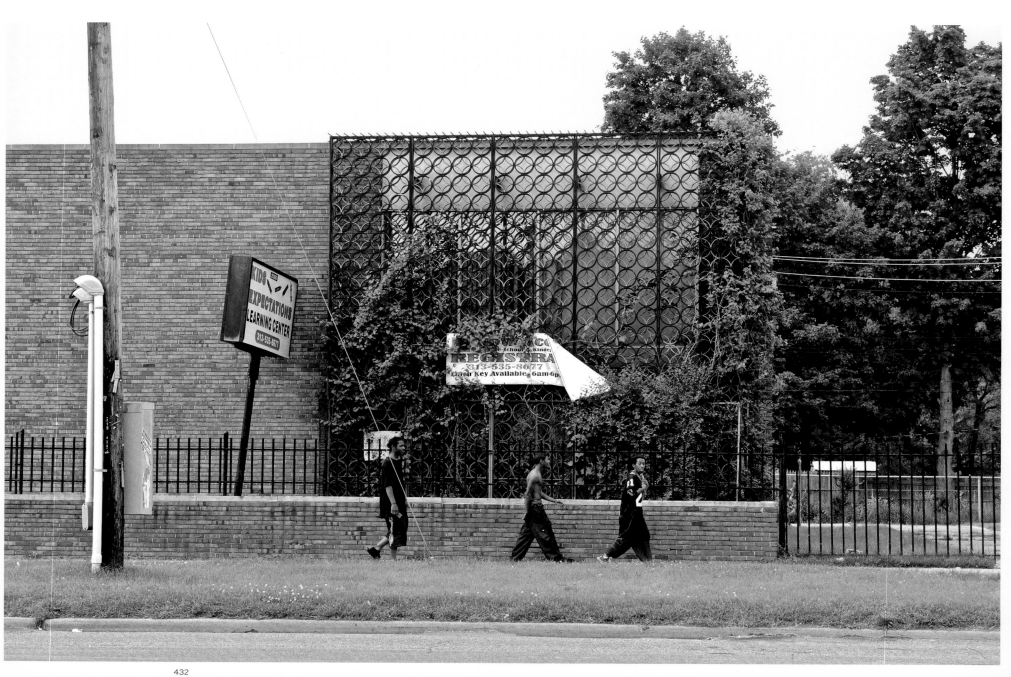

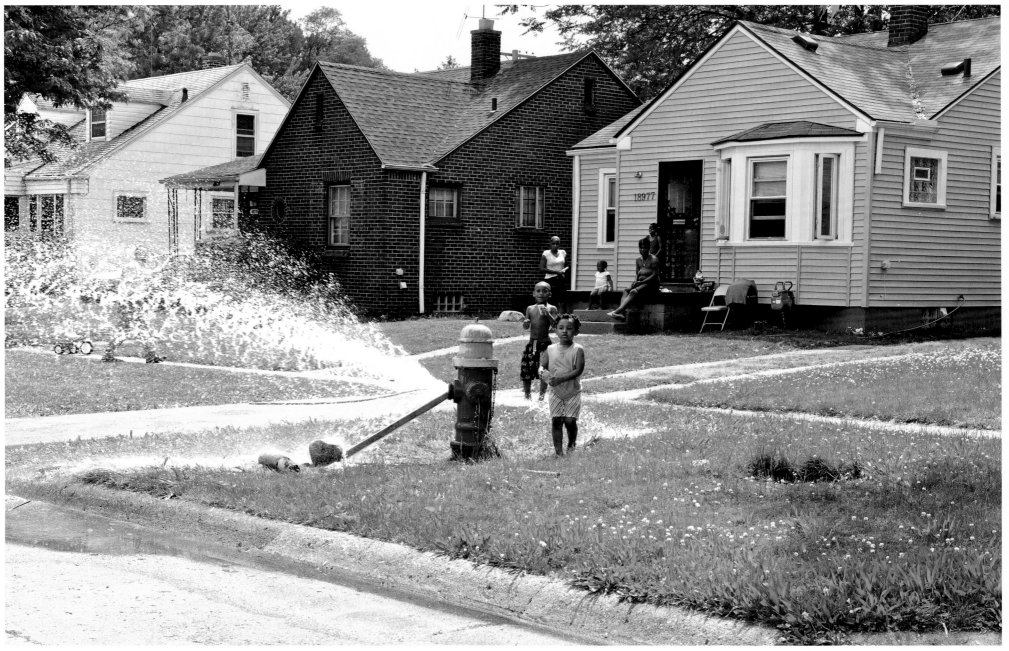

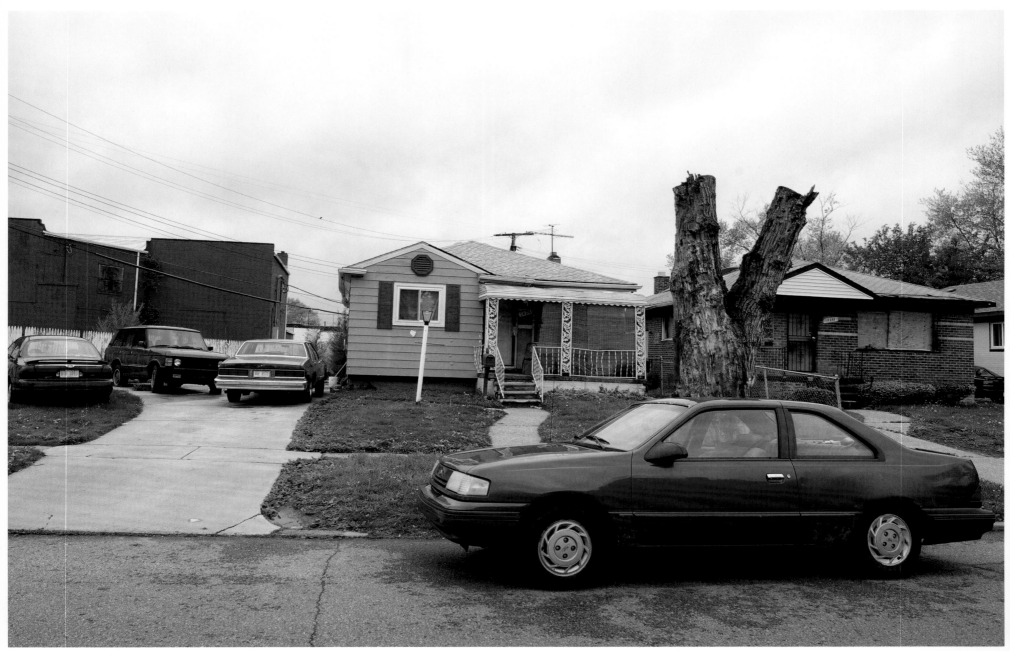

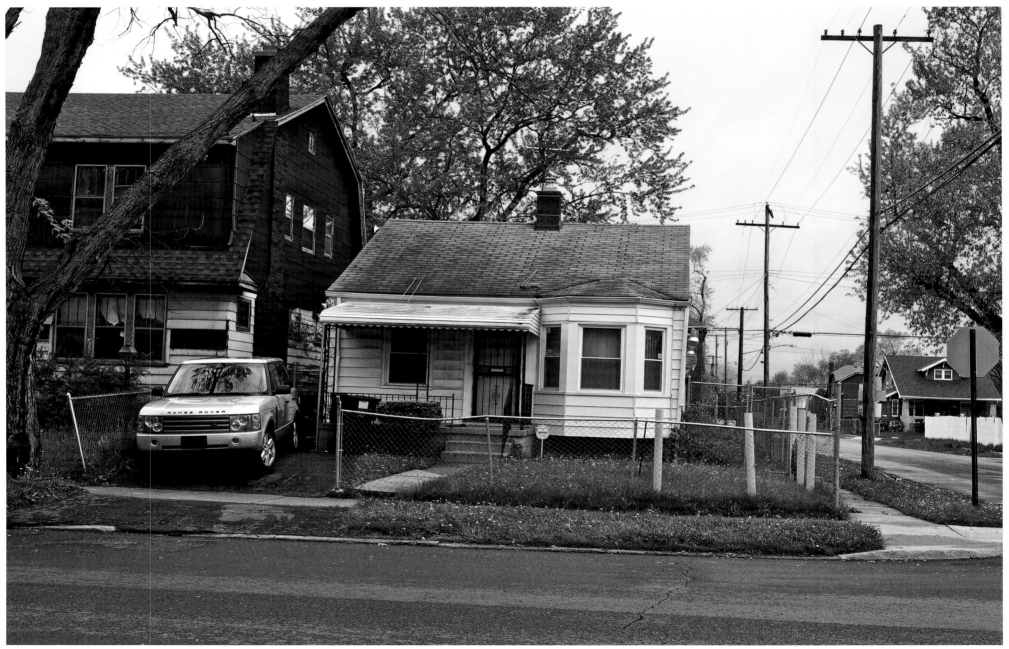

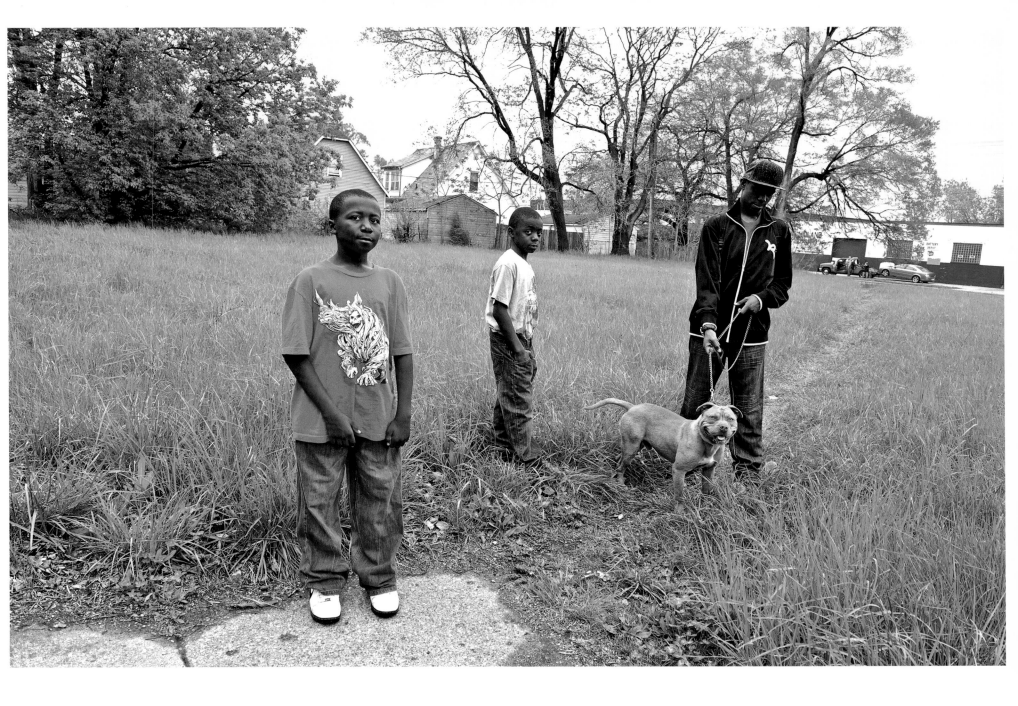

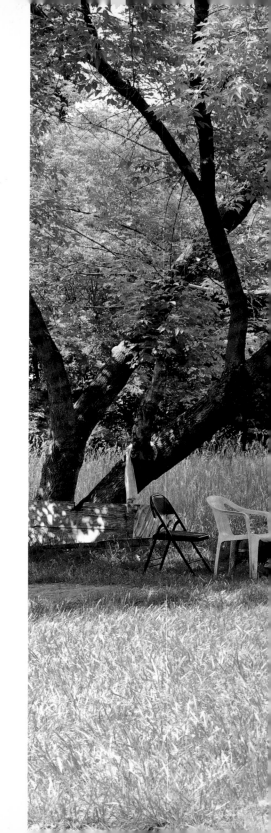

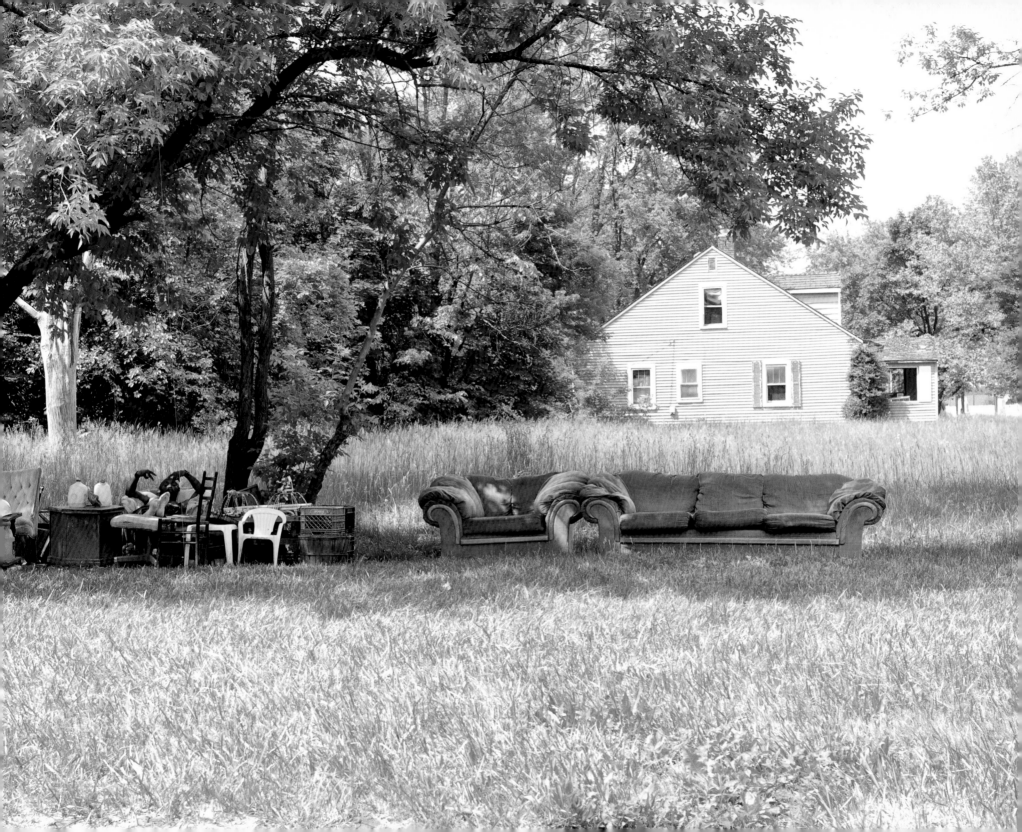

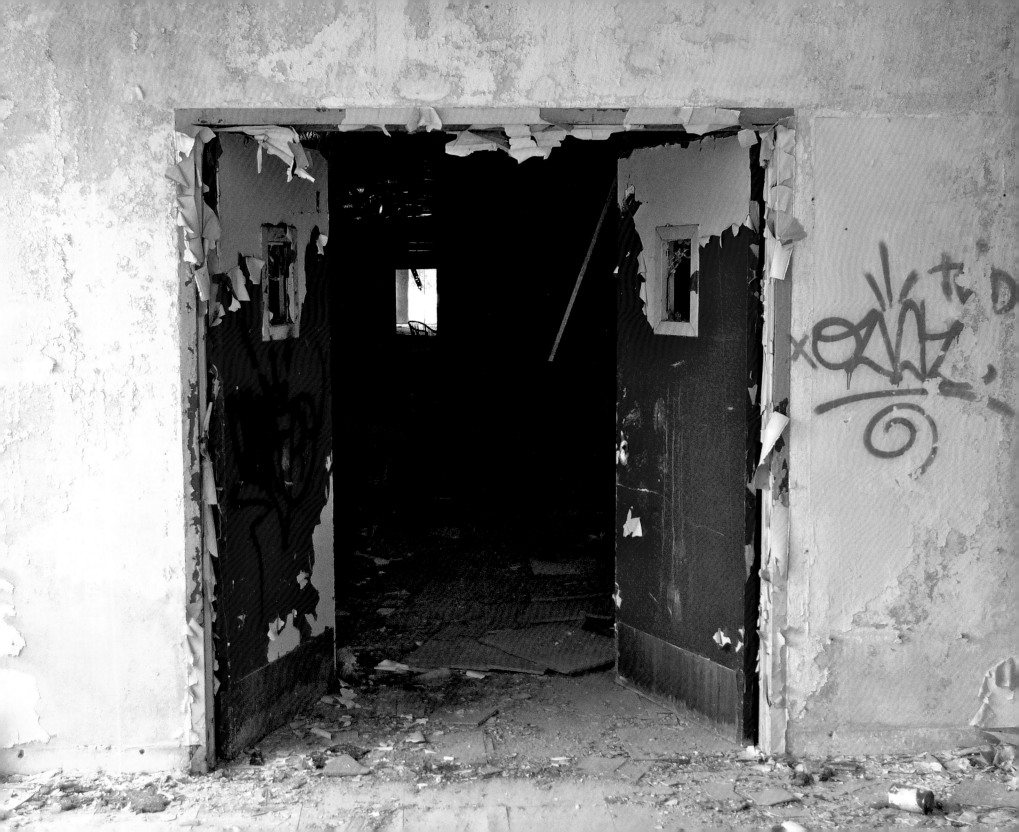

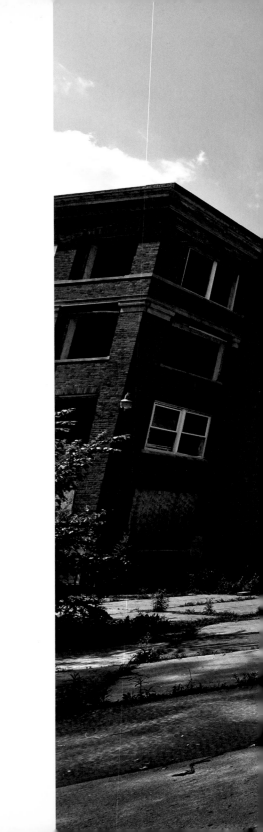

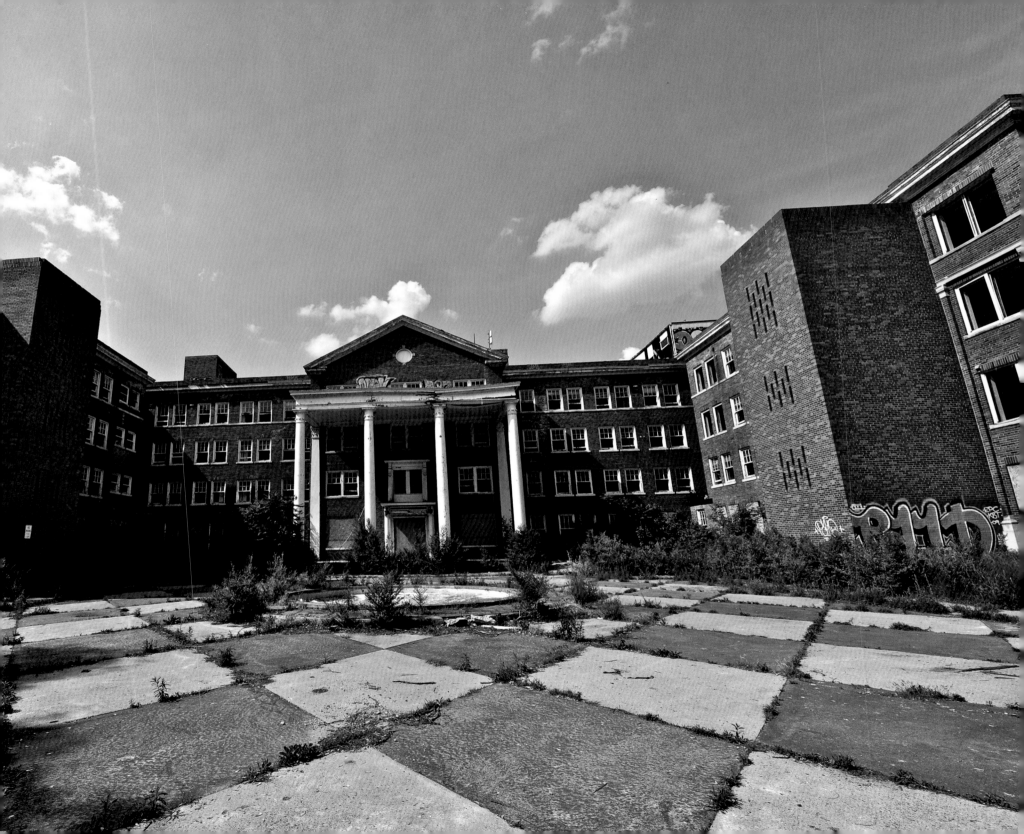

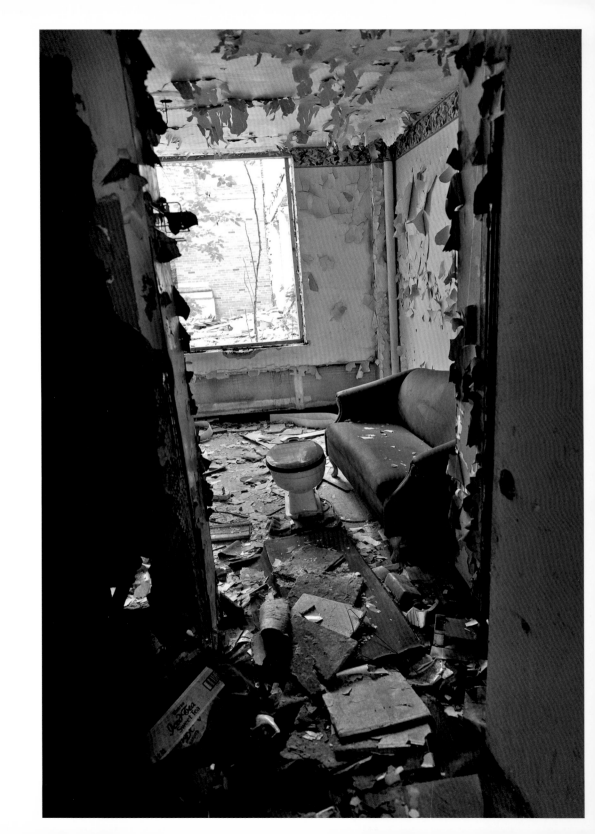

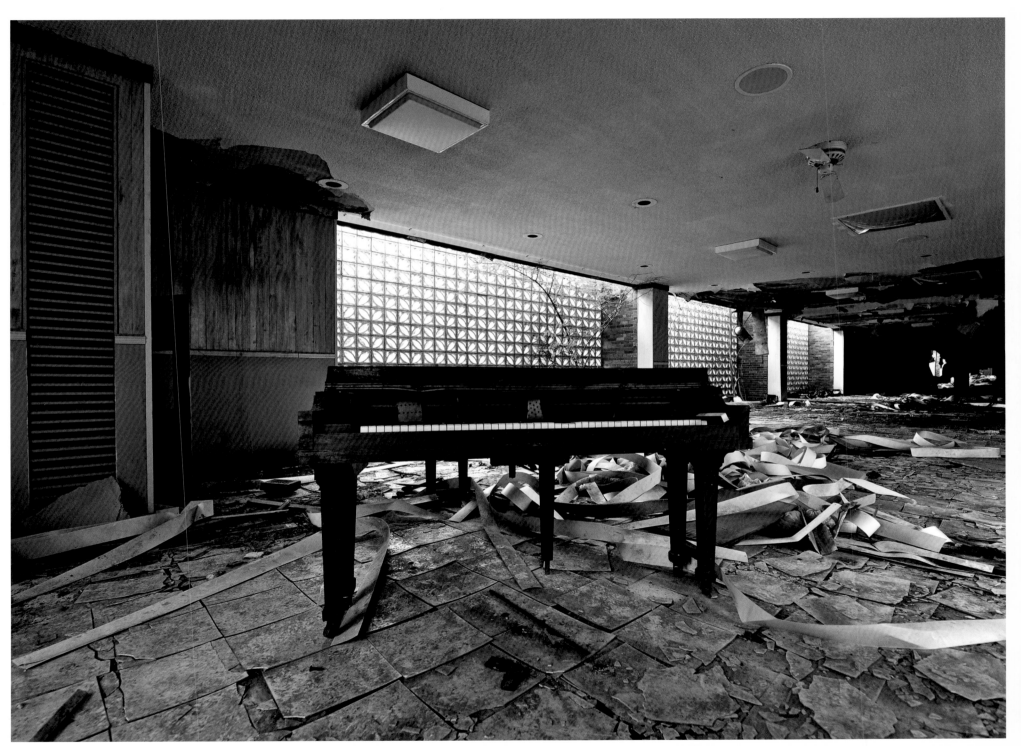

445

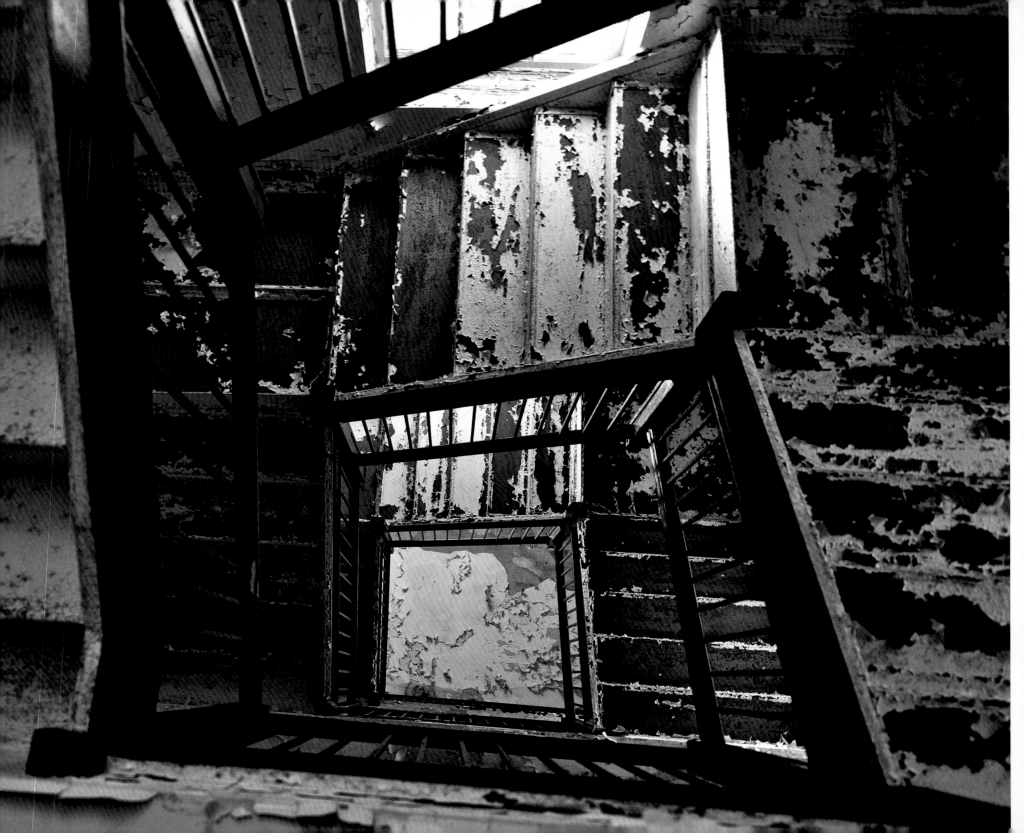

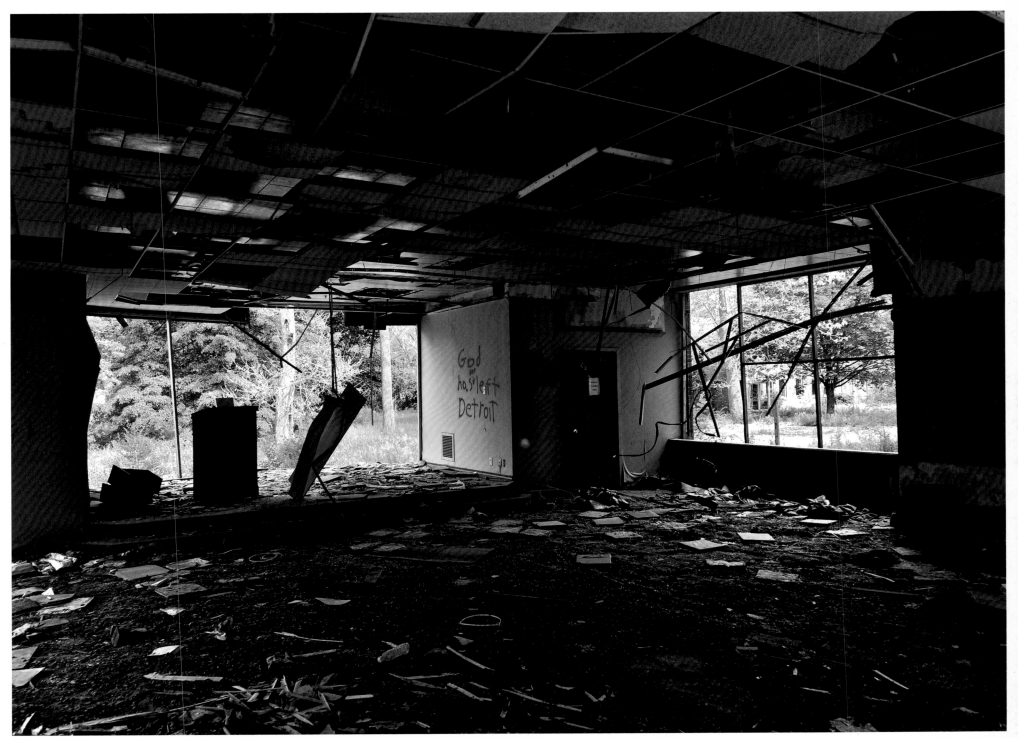

447

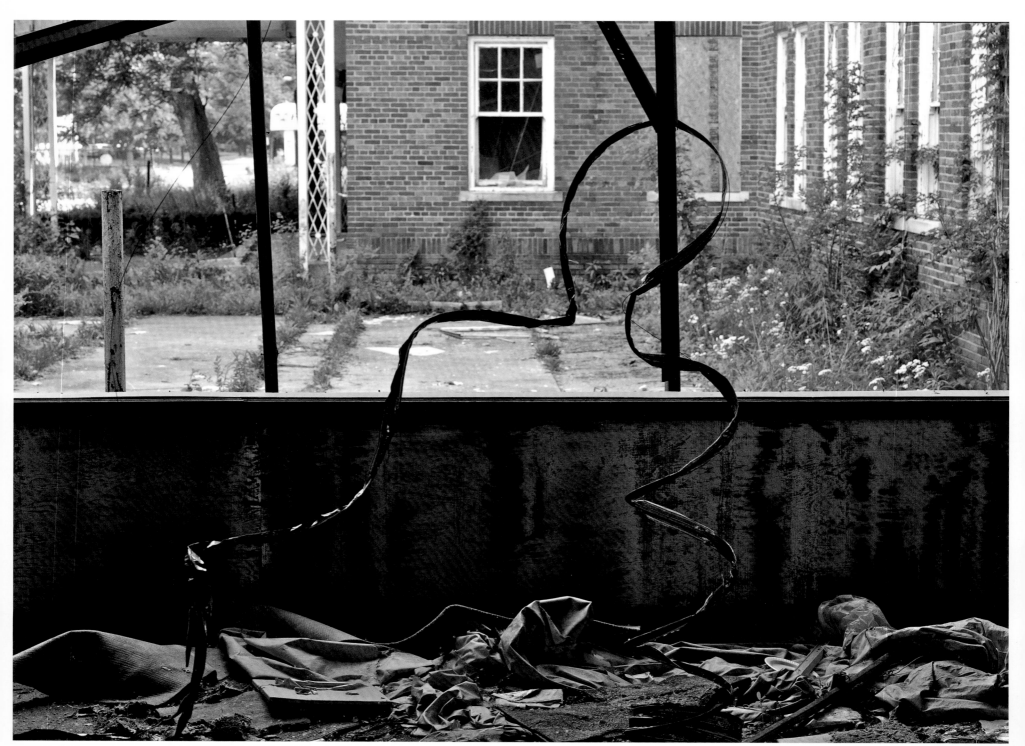

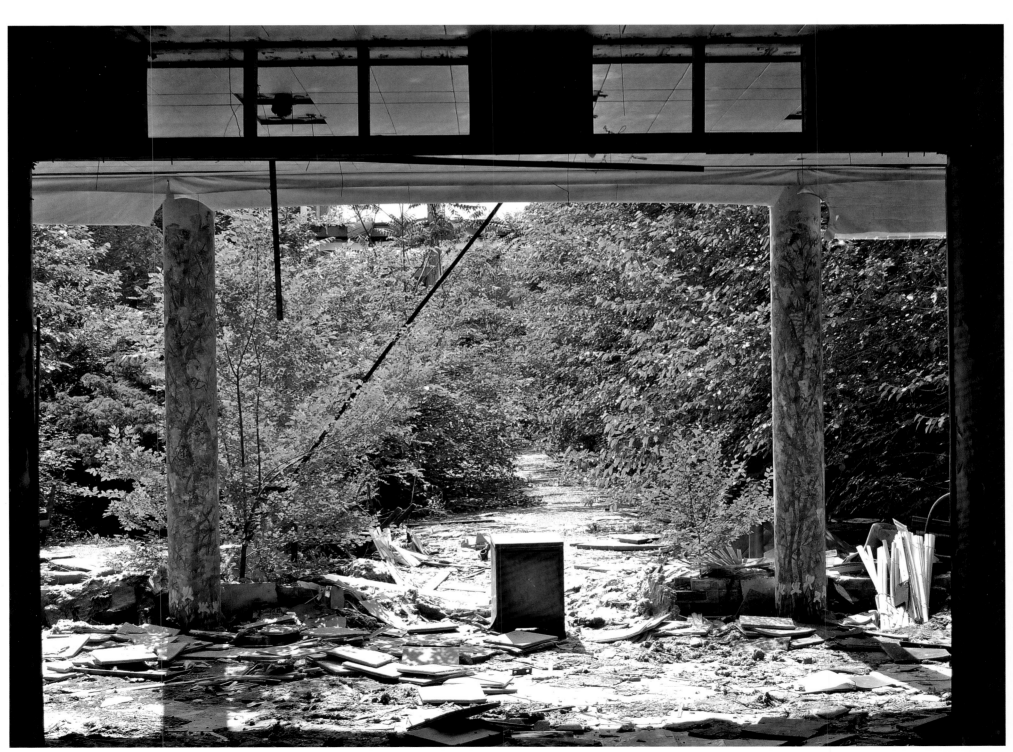

449

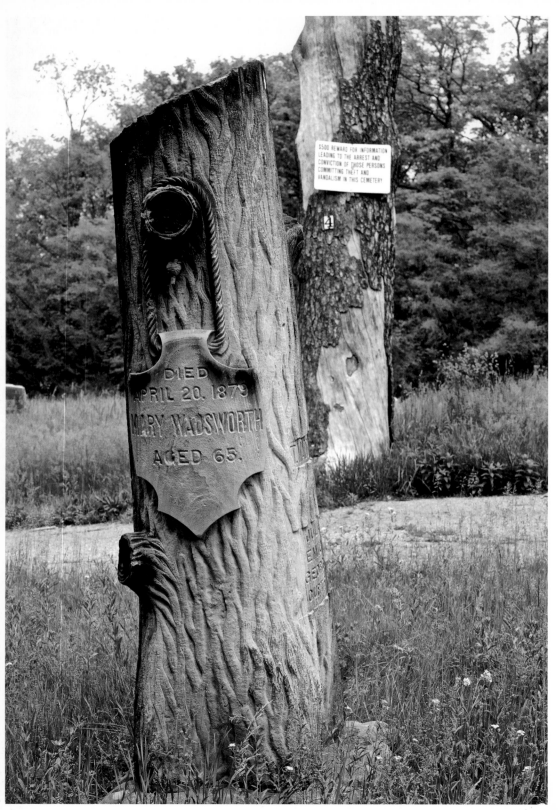

DIED
APRIL 20, 1879
MARY WADSWORTH
AGED 65.

$500 REWARD FOR INFORMATION
LEADING TO THE ARREST AND
CONVICTION OF THOSE PERSONS
COMMITTING THEFT AND
VANDALISM IN THIS CEMETERY

...n Hous...
...egan a s...
...y. He cl...
...arted in
...e went i
...e and ar
...r to Gr...
...place in
...determina...
...the story
...ould wat...

He was...
...tick by...

...sing the blues was an interval... ...ng, he became energized and the yea... ...ed his eyes and the sweat broke out... ...low voice which became louder and... ...o a trance and somehow willed himsel... ...ther place. He went to Robinsonville o... ...nville. He went back to 1931 or 1941... ...ime. The verses tumbled forth and the... ...length...five minutes...ten...fifteen...as... ...to be told. Other blues singers-great i... ...Son House sing the blues and just sh... ...the benchmark of their artistry. He was... ...ich blues singers are to be forever judg... ...every blues singer in the world moved...

A GUIDE TO THE PHOTOGRAPHS

with contributions by Robert Fishman and Michael McCulloch

2 Intersection of Alter Road and Charlevoix Street.

6 Detroit Renegades
Motorcycle Club.

10 Boston Boulevard.

East

17 Detroit River, view from Belle Isle. The city's name originates from the description of this river as 'the strait' (or *détroit* in French) between Lakes St. Clair and Erie.

Before this island in the Detroit River was made into a park, it had less pleasant associations. Native Americans referred to its marsh and forest land as Rattlesnake Island in the eighteenth century. In the nineteenth century, the island was rid of its many snakes and besides a picnic spot, it was used as a dueling ground and, in 1832, as a place to quarantine troops during a cholera epidemic. The island was made public parkland in conjunction with the building of then-peripheral Grand Boulevard, which connected the mainland to Belle Isle by bridge in 1889. Originally, the landscape was to be designed by Frederick Law Olmsted, who conceived of the park's formal central avenue. After some dissatisfaction with the Olmsted plan however, the project was handed over to architect John M. Donaldson, who completed the design to specifications proposed by a local newspaperman, Michael J. Dee.

In November 1906, Harry Houdini visited Detroit for a series of performances at the Temple Theatre. While in town, he threw himself, doubly handcuffed, from the Belle Isle Bridge into the cold Detroit River as a publicity stunt. Houdini managed to remove the police-issued cuffs while under water and swam safely to a nearby lifeboat. The dramatic events of that day were spun into ever-taller tales in subsequent decades, becoming more legend than fact.

During the Cold War, between 1955 and 1968, Belle Isle housed a Nike Air Defense System as Detroit's industry was believed to be a target for long-range missiles.

18–37 Belle Isle.

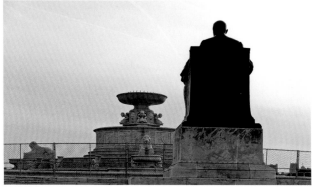

19 James Scott Fountain. Cass Gilbert, 1925. Scott, heir to a Detroit real estate fortune, left the funds to construct this fountain in his will with the qualification that his life-size likeness be included. The commission of the fountain's Beaux Arts composition in white marble was won in a national competition. Gilbert had previously designed the Detroit Public Library and is best known for the Woolworth Building, an early New York skyscraper.

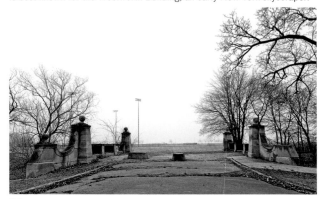

20

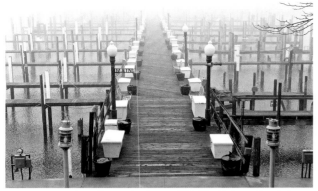

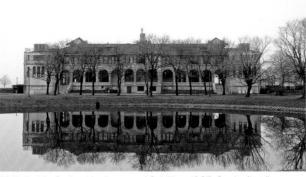

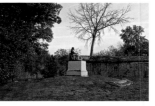

31 Statue of German poet Johann Friedrich von Schiller, 1908.

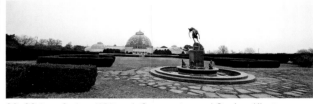

21 Detroit Yacht Club. George D. Mason, 1923. The Club was founded in 1868 and moved to Belle Isle in 1891. "Venetian Night" in its Mediterranean-Beaux-Arts themed clubhouse was described by a 1941 commentator as, "a high point in the Detroit midsummer social season."

23 Belle Isle Casino. Van Leyen and Schilling, 1907. On the first floor of the structure, light refreshments and supplies such as charcoal were once sold to park-goers, while the upper hall and porch were used as dining facilities.

32–33 Anna Scripps Whitcomb Conservatory and Garden. Albert Kahn Associates, 1903. Levi Barbour Fountain. Marshall M. Fredericks, 1936. The greenhouse structure is composed of a large central dome flanked by lower symmetrical wings. It faces a formal garden, creating a monumental composition in keeping with the ideals of the City Beautiful movement. The structure was rebuilt in the 1950s and its original wood framing was replaced with metal.

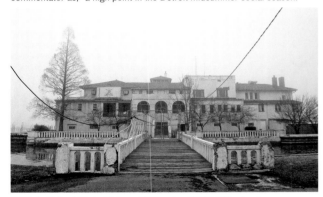

24 Detroit Boat Club.

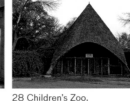

28 Children's Zoo.

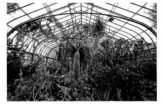

33

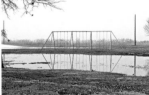

36

22 Detroit Boat Club. Alpheus Chittenden, 1902. This structure was home to the oldest river rowing club in the United States. The group was formed in 1839 and moved to the island in 1891. After two devastating fires, the club erected this fireproof structure. In 1980, historian Hawkins Ferry noted that the many pleasure boats moored at the club had begun to obscure its origins in rowing. Today, most of this structure is abandoned, although it remains home to many high school rowing clubs. The original club continues to operate by holding social and boating events around the Detroit area.

25 Detroit Yacht Club.

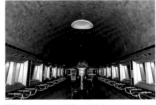

29 Aquarium. Albert Kahn Associates, 1904.

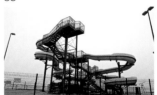

34

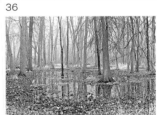

37

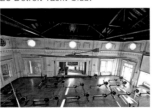

26 Detroit Boat Club.

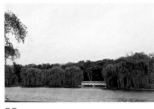

30

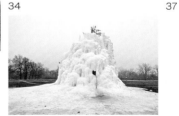

35 Frozen Fountains. A Belle Isle tradition for nearly 100 years. This natural fantasy is made of displaced trees arranged around a pipe that spouts water from the top in frigid weather.

27 Detroit Yacht Club.

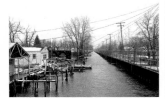

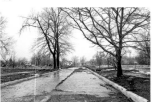

39 Canal system along Alter Road, separating Detroit from Grosse Pointe Farms.

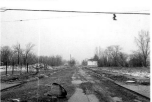

40

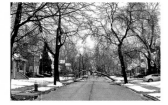

41

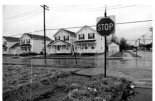

42

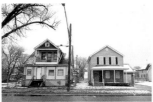

43

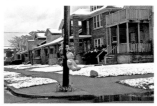

44

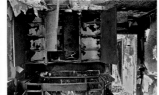

45

47

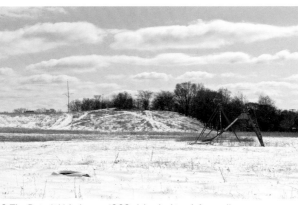

49 The Detroit Velodrome, 1969. A banked track for cycling races was built here in the city's Dorais Park to host an international competition. In the 1990s, the park slipped into disrepair and was largely abandoned.

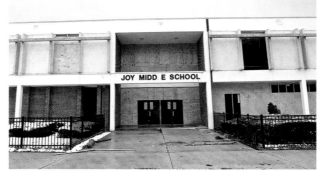

50

51–53 Joy Middle School, 1964, closed 2007. In 2008, the Detroit Free Press photographed the interiors of the closed school revealing that books, equipment, furnishings and records had been left behind in the abandoned structure and that informal salvaging of materials such as metal railings had begun.

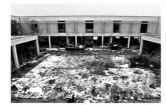

52

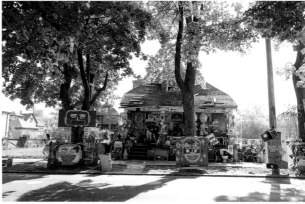

53

55

56–59 The Heidelberg Project, 1986. An open-air art environment founded by artist Tyree Guyton and his grandfather, folk artist Sam Mackey. The inspiration was to raise awareness and cause reflection upon issues of poverty, crime and abandonment of the deteriorating neighborhoods in Detroit after the 1967 riots. It has since bounced back from two city-ordered demolitions in the 1990s. Guyton, who grew up and still lives in the project's vicinity, continues to expand the two blocks of buildings and sculptures already filled with found objects and his signature dots.

57

58–59

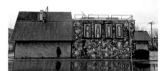

60 Rado Lounge.

66–71 Texas Bar & Grill.

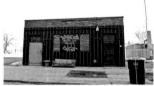

61 Wildcats Detroit Motorcycle Club.

67

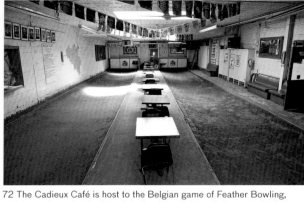

72 The Cadieux Café is host to the Belgian game of Feather Bowling, which was imported to Detroit by immigrants from that country in the 1930s. The Cadieux Café is known today as the only authentic site for this unusual game in the United States. Similar to bocce ball, feather bowlers roll cheese-wedge shaped balls down a concave lane, aiming to land the ball closest to a standing pigeon feather.

80–85 City of Detroit Police Department, Eastern District, Ninth Precinct Station.

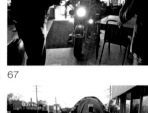

62 Liberty Riders Motorcycle Club.

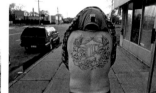

68 Fast Eddie.

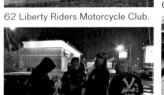

63–65 Vigilante's Motorcycle Club.

69

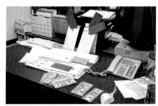

73 Texas Bar & Grill.

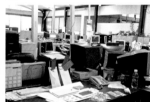

76–77 Ye Olde Tap Room.

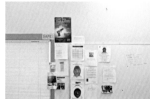

82

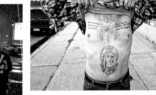

64

70–71

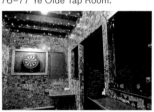

74–75 Nikki's Place bar.

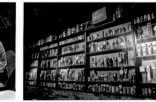

77

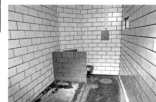

83

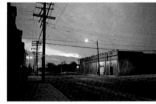

75

78–79 Alter Road
at Kercheval Street.

84

65

85

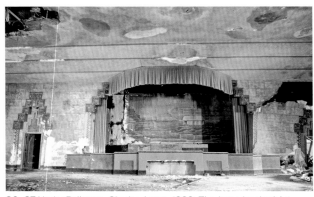

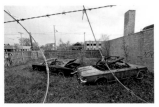

94 Seven Mile Road and
Queen Street.

98

99

86–87 Vanity Ballroom. Charles Agree, 1929. The Aztec-inspired Art
Deco style ballroom was a popular dance venue from its opening despite
the economic constraints of the Great Depression and the war years.
Juice and soda were sold at the Vanity's bars in lieu of alcohol. This venue
brought live performances from nationally-renowned jazz and swing
bandleaders Duke Ellington, Benny Goodman and Tommy Dorsey
to northeast Detroit. Radio broadcasts were also made from the Vanity.
Declining interest in ballroom dancing forced the hall to close in 1958,
only to be re-opened several times in subsequent decades. In the early
1970s, many rock shows were held at the Vanity, including important
Detroit bands and acts such as the MC5, The Stooges, and Ted Nugent
and The Amboy Dukes.

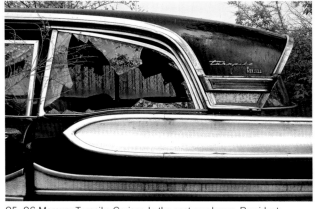

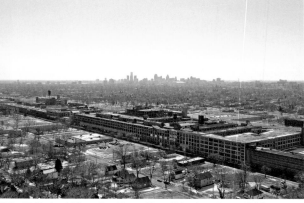

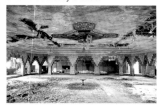

87

90–91

88–93 Mack Avenue Service Drive
at Connor Street.

92 Vanity Ballroom with
floor layered in ice.

95–96 Mercury Turnpike Cruiser. In the post-war boom, President
Eisenhower opened up 41,000 miles of freeways criss-crossing
America through the Federal Aid Highway Act of 1956. In 1957, *Sputnik*
was launched into Earth's orbit, and that same year Ford launched
its own space-age motorcar, the Mercury Turnpike Cruiser. Its futuristic
design was marked by a "Skylight Dual-Curve" windshield with roof
level air intakes, gold anodized trim on the rear fins, and an interior
outfitted with sparkling chrome, stainless steel and push buttons galore.
One of its hallmark features was a rear power window that retracted
to create a "Breezeway." The Turnpike Cruiser also boasted an elec-
tronic "Seat-O-Matic" memory driver seat and interior cooling, ideal for
cruising the new American highways stretching coast to coast. It came
complete with a map of the interstate turnpikes and its steering wheel
was slightly flattened at the top so as not to obscure the view. Perhaps too
far ahead of its time, it was only produced from 1957–58, but its hallmark
rear window "Breezeway" was reprised in later Ford and Mercury models.

100–115 Packard Motor Car Plant. Albert Kahn Associates, 1903.
Brothers J. W. and W. D. Packard developed plans for a "horseless
carriage" as early as 1893 while running an electric lamp manufacturing
business in Warren, Ohio. In 1899, their first model attracted the attention
of Detroit's Henry B. Joy and other investors, who supported Packard's
incorporation and its move to Detroit. Joy commissioned Albert Kahn to
design the Packard plant along the Michigan Central Belt Line encircling
the city. It was the first large-scale automobile plant in Detroit. Nine units
of the complex were built with traditional mill construction techniques,
and for the tenth unit, in 1906, Kahn used experimental techniques of
reinforced concrete construction. This emerging method provided fire
protection, wider column spacing and bright expanses of glass to light the
shop floor. With so many advantages over the mill type, reinforced concrete
would become broadly influential and set a new standard for industrial
architecture. Salvaging of steel and other materials from the site continues.
Perhaps the largest empty structure in America, the massive 3.5-million-
square-foot plant has been closed since 1956.

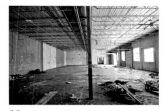

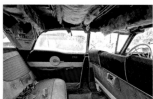

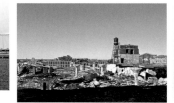

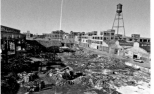

89

93 Mack Avenue Service Drive
at Connor Street.

96

97 Mega Pawn & Jewelry.

102–103

104–105

106

107

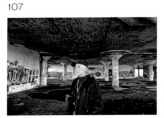

108

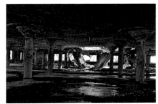

109

110–111

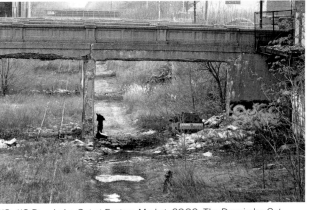

112–113

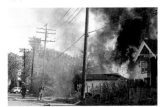

114

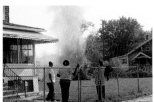

115

116 Trinity Lutheran Cemetery, viewed from the Packard plant, with Michigan Central's belt line separating the two properties.

117 Roosevelt Warehouse, also known as the Detroit Public Schools Book Depository. Albert Kahn Associates. Originally serving as Detroit's Post Office, the abandoned structure is used today as an informal shelter by homeless Detroiters. It was recently the site of a terrible discovery: in 2009, a dead body was found frozen in 2 to 3 feet of solid ice at the bottom of this building's open elevator shaft. The body lay there for at least a month before authorities were called. Police and fire offcials recovered it from the ice with a jackhammer and saw. The death remains unsolved and the incident has raised concerns about the safety of the abandoned building.

118–119 Dequindre Cut at Eastern Market, 2009. The Dequindre Cut is a 1.35-mile pedestrian link between the Riverfront, Eastern Market and their bordering neighborhoods. Formerly a Grand Trunk Railroad line, the Dequindre Cut is a below-street-level greenway with a 20-foot-wide path, which includes separate lanes for pedestrian and bicycle traffic. The graffiti on the bridge abutments and greenway walls has been intentionally left in place. The city encourages artists to add their signatures to the path.

120–121 Mount Elliott Street and Harper Avenue.

122

123

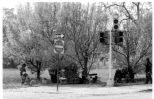

124–125

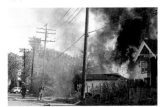

126

127

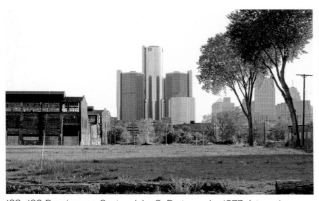

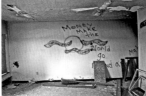

134–137 Saint Louis the King Convent.

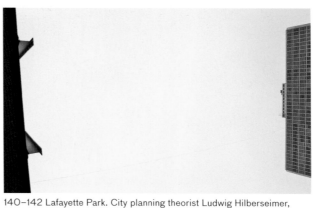

128–129 Renaissance Center. John C. Portman, Jr., 1977. A towering glass and steel "city within the city," this massive 5.6-million-square-foot riverfront office/hotel/retail complex comprises four 39-story towers, two flanking 21-story towers (1981), and a central 73-story hotel tower. The project was initially led by Henry Ford II and a business group called "Detroit Renaissance" as a centerpiece for extensive riverfront development and the revival of the downtown and the city itself. Portman was already credited with the revival of downtown Atlanta through his mixed-use "Peachtree Center" built around the first modern high-rise "atrium hotel" (1967). The atrium became Portman's signature at such projects as San Francisco's Embarcadero Center (1973) and the Bonaventure Hotel complex (1976) in downtown Los Angeles. However, in these other cities Portman was dealing with downtowns whose vitality could overcome what one scholar called a design formula that "does not want to be a part of the city, rather its equivalent and replacement." The "RenCen," as it is usually called, succeeded more as a highly photogenic symbol than as a catalyst for a Detroit renaissance. Close enough to downtown to drain tenants from older buildings, but far enough away to discourage easy pedestrian access, the RenCen is a confusing maze inside. Never financially successful, the complex was bought by General Motors in 1996 for its world headquarters (formerly located in the New Center). A 2000 renovation added a 5-story "Wintergarden" and attempted to address the confusing ground plan and separation from the downtown, but could not fully remedy the flaws inherent in Portman's "city within the city" model.

135

136

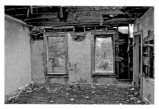

137

140–142 Lafayette Park. City planning theorist Ludwig Hilberseimer, architect Mies van der Rohe, and landscape architect Alfred Caldwell, 1958–63. Lafayette Park is considered to be one of the nation's most important middle class urban renewal projects. Hilberseimer and van der Rohe were affiliated with the Bauhaus school in Dessau before emigrating to Chicago in the late 1930s. The project is a striking modernist counterpoint to the prevailing single family residential blocks of the city. It utilizes a superblock strategy in which townhouses, high-rise apartments and a school are distributed within a large, park-like expanse with no through traffic. The project is one of the largest collections of buildings by Mies van der Rohe, and his emphasis on expansive and carefully-proportioned glass enclosures is visible throughout. The project came at a great social cost as its site was cleared through a massive demolition of dense, existing residential blocks in which almost eight thousand Detroiters, largely African-American, were displaced.

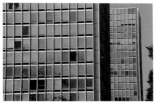

141

131 Ivanhoe Cafe, also known as the Polish Yacht Club, established 1909.

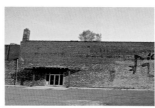

133 White Way Cafe.

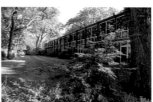

138–139 The Furniture Factory.

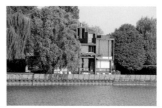

142

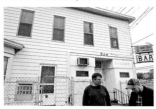

132 Two Way Inn.

143 Frank and Anne Parcells House. Paul Rudolph, 1970.

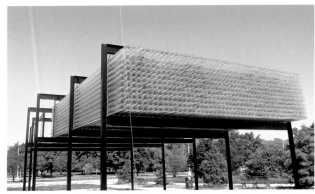

144 Greening of Detroit Park Pavilion. Andrew Zago, 2001. The pavilion's steel frame supports 576 translucent tubes suspended on cables that do not touch one another. Zago conceived the shelter as analogous to a tree's canopy, the tubes protect from the rain despite the spacing between them.

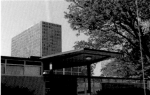

145 Chrysler Elementary School.

146–147 James Lincoln Hall of Juvenile Justice.

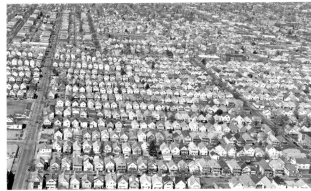

149 Hamtramck, Michigan. This independent municipality of 2.09 square miles is, geographically, completely surrounded by the city of Detroit. The area was largely undeveloped farmland before the boom in automotive manufacturing transformed it into a center of production. Hamtramck's population surged in the 1910s, rising tenfold to reach 47,000 by the decade's end. The Dodge Brothers established a large automobile plant here in 1914, which, along with Ford's nearby Highland Park plant, attracted a large population of working class Poles, among others. Polish fraternal, social and religious organizations have long animated the culture of Hamtramck. The city's population is exceptionally diverse today, including a large foreign-born population and strong Yemeni and Bangladeshi communities. The residential fabric of the city is dominated by tightly-packed, single-family and duplex frame structures, a persistent reminder of the labor that drove the city's expansion in the early twentieth century.

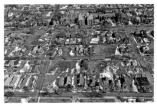

150 East Grand Boulevard between Saint Paul and Agnes Streets.

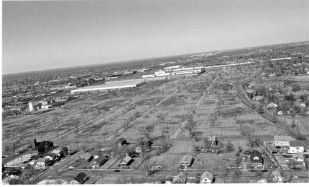

151 GM Detroit Hamtramck Assembly Plant. Desperate to reverse the 1970s exodus of automobile plants from Detroit, then Mayor Coleman Young and his administration, working with its counterparts in Hamtramck, agreed in 1980 to create a "Central Industrial Park" to bring a state-of-the-art General Motors assembly plant to a 362-acre site between the two cities that had been largely occupied by the closed Dodge Main plant. Unfortunately, clearing the site also required purchasing through eminent domain and then leveling a neighborhood called "Poletown" which included 1,300 homes, 16 churches, 2 schools, a hospital, and 114 small businesses. The plan echoed the urban renewal demolitions from the late 1940s that had leveled the black district of Paradise Valley for what eventually became Lafayette Park.

152–155 Shoemaker Carhouse opened in 1922 as a streetcar barn, then later converted to a bus garage in 1939.

153

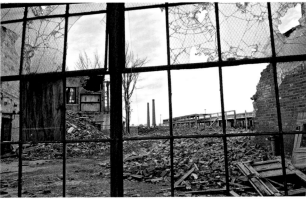

154–155

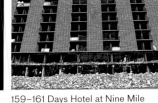

156–158 Valenti's Men's Formal Wear.

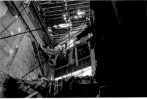

159–161 Days Hotel at Nine Mile Road and John R. Road.

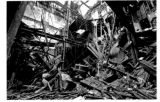

157

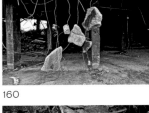

160

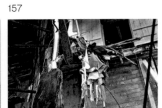

158

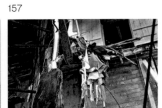

161

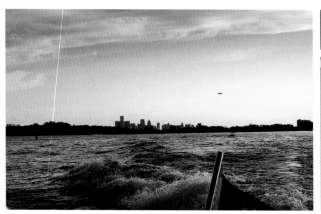

162–163 Detroit River looking southwest.

164–167 Shoemaker Carhouse Yard.

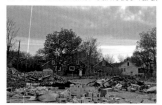

166–167

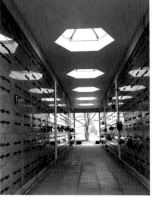

168–169 Mount Olivet Cemetery, 1888. At 320 acres, it is the largest cemetary in Detroit, and is affiliated with a Catholic non-profit organiza- tion, the Mount Elliott Cemetary Association. At the time of its conse- cration, the site was well outside of the city and was made accessible by the Grand Trunk Railroad line.

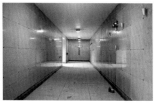

169

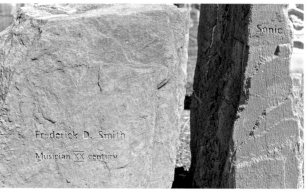

171 Gravestone of Fred "Sonic" Smith, guitarist of the MC5. Elmwood Cemetery, 1846. Elmwood sits on 86 acres and is one of Michigan's most historic cemeteries. In 1850, it sold a half-acre to Temple Beth El to estab- lish what is now Michigan's oldest Jewish cemetery. Elmwood was the first fully-integrated cemetery in the Midwest. In 1890, Frederick Law Olmsted reshaped the park to its current configuration. Many political, governmental and business leaders are interred here, including Mayor Coleman Young, the five-term Mayor of Detroit and first African-American to hold that office.

172–173 Mount Olivet Cemetery.

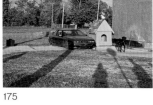

175

173

177 Lake St. Clair at the Detroit River.

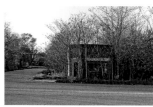

174 Mehlenbacher Fence Co., 1909.

Central

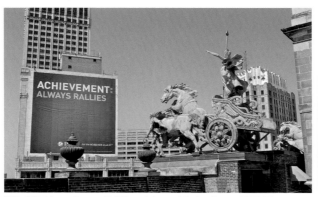

178–179 Wayne County Building. John and Arthur Scott, 1897. The structure illustrates the formality, symmetry and classical details characteristic of the Beaux Arts style. The Wayne County Building faces Cadillac Square, which it shared with Detroit's old City Hall. In 1961 old City Hall was demolished. It was thought to be the greatest building loss in Detroit's history.

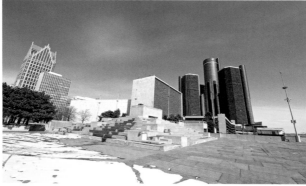

180–181 Hart Plaza. Isamu Noguchi with Smith, Hinchman and Grylls, 1979. The realization of a civic center on eight acres of Detroit's riverfront finally came after more than half a century of delay. After World War I, Eliel Saarinen developed the initial proposal, which was shelved for lack of funds. In 1947, the firm of Saarinen, Saarinen and Associates developed a second iteration which conceived of new civic buildings surrounding an open riverfront plaza. This concept informed the siting of Detroit's City County building, Veterans Memorial Hall and the Henry and Edsel Ford Civic Auditorium in the decade that followed. Ground was cleared for the plaza itself in the 1950s and the project underwent further design changes. Japanese-American sculptor Isamu Noguchi was chosen to design the site's central fountain, and went on to design the fountain and the plaza itself as an integrated whole. Unfortunately, a few new sculptures have been added, obscuring the original clarity of the Noguchi design.

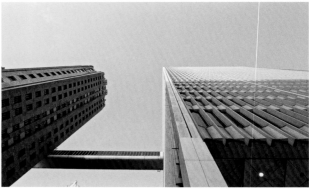

182 The Guardian Building. Wirt Rowland at Smith Hinchman & Grylls, 1929. One Woodward Avenue. Minoru Yamasaki & Associates and Smith, Hinchman & Grylls, 1963. These towers, shown here at their skybridge connection, represent two distinct eras in the building of Detroit's central business district. The Guardian Building was originally known as the Union Trust Building. Its owner and architect shared a desire for innovation and expressed this in the use of brick cladding and exceptionally colorful glazed tiles and terra cotta, composed in a consciously exotic Art Deco style. The building gained the name "Cathedral of Finance" with its elaborately-adorned, barrel-vaulted lobby. The One Woodward building expresses commercial innovation in entirely new architectural terms. The building's modernist expression is of pure vertical extrusion, wrapped in a skin of monochrome precast concrete panels and expansive glass. Where the Guardian's lobby formed an enclosed "cathedral" space, One Woodward's 30-foot-high lobby is wrapped in glass, revealing the lobby's movement and the coffered ceiling to the city.

183 Horace E. Dodge and Son Memorial Fountain. Isamu Noguchi, 1979.

185

186

184–187 Wayne County Building.

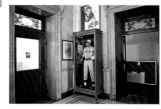

187 African-American Athletic Hall of Fame and Gallery.

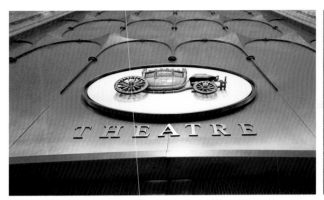

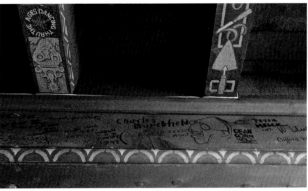

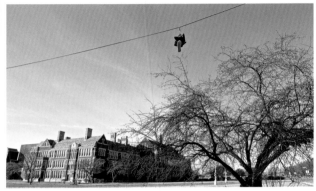

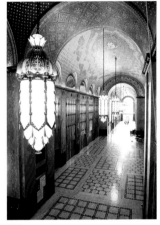

189

190

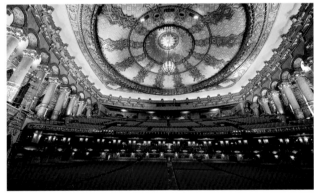

188–190 The Fisher Building. Albert Kahn Associates, 1928. The Art Deco tower that contains the Fisher Theatre anchors the area known as Detroit's New Center, three miles north of downtown along the encircling Grand Boulevard. The growth of this area illustrates an early trend toward decentralization of the city's business and cultural facilities. The building was constructed for the Fisher Body Company, an influential manufacturer in Detroit's growing auto industry from its founding in 1908. Originally designed to be part of a larger ensemble of three towers, the onset of the Great Depression reduced the scope of the development to a single tower.

191 Scarab Club. Lancelot Sukert, 1928. Home to an arts organization named after the scarab, an Egyptian symbol of rebirth, the club was founded in 1907 and moved to its present location in 1928. At this time, Detroit's mid-town arts and cultural center was growing and the design of automobiles and their advertising invigorated the local arts scene. The club's membership in the early twentieth century reveals a noteworthy diversity representing the fine arts, design, business community and architects. Myron Barlow, an internationally known painter and Detroit native was a member, as were auto industry pioneers Edsel Ford and Charles and Lawrence Fisher, and celebrated architects Albert Kahn and Eliel Saarinen. The real treasure of the Scarab Club can be found in the second floor lounge: the exposed ceiling beams have been decorated and autographed by some 263 visitors' signatures in all, including Marcel Duchamp, Norman Rockwell, Margaret Bourke White, Marshall Fredericks, Elmore Leonard, and Diego Rivera.

192–193 Fox Theatre. C. Howard Crane, 1928. Embedded within a ten-story Art Deco office building on Woodward Avenue, this immense movie palace seats over five thousand viewers. At the time of its opening, commentators celebrated the elaborate detailing of the theatre's interior. Its lavish ornament reinterpreted motifs from India, China and elsewhere, presenting them as exotic. The theatre was frequented during World War II as a place to receive war information and amusement through newsreels and films. A major restoration was completed in 1988 and the theatre operates today as a popular concert venue, its ten-story marquee visible from a great distance.

196 Central High School, 1858. Central High began on the second floor of a small frame building as the first public high school in Detroit. Central High would expand and relocate several times in the first 70 years of its service. It opened with a staff of one, Professor Chaney, and a student body of twenty-three boys. A one-story brick addition to its original Miami Avenue facility was completed in 1860 and enrollment was extended to girls. In 1863, the institution relocated to the former Capital Building until that was destroyed by a nighttime fire in 1893. A new school building was constructed in 1896 and remains in use at Wayne State University. Central High outgrew this building and moved for the last time in 1926 to the Gothic Revival building pictured here. After more than 150 years, Detroit's oldest public high school continues to educate the area's students today.

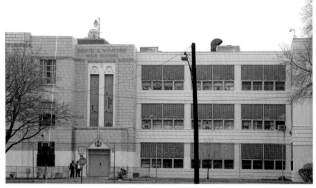

197–201 Samuel C. Mumford High School. The building was initially designed in 1941, but the intervention of World War II delayed its completion until 1949. It is named for a long-time Detroit Board of Education member known for combating corruption in the public school system. At the time of its completion, the northwest neighborhood where it is sited had long needed the school as its residents were traveling distances to attend class elsewhere.

Several students of Mumford High have gone on to success in film and television including Jerry Bruckheimer, producer for the series *CSI* and the film *Beverly Hills Cop,* and Judith Guest, whose novel *Ordinary People* became an Academy Award-winning film in 1980. Robert Shaye, founder of New Line Cinema, also attended Mumford. In the 1960s, the school had an enrollment of around 4,000 racially-integrated students. This monumental school is slated to be demolished and a new high school is set to be built where the football field is currently located.

198

199

200

201

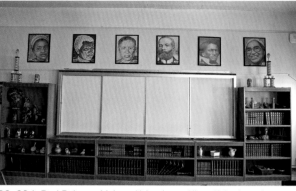

202–204 Paul Robeson Malcom X Academy. Albert Kahn Associates, 1917. Named in honor of the African-American singer and actor of the 1920s and 1930s and the African-American human rights activist of the 1950s and 1960s. A popular national figure, Robeson outspokenly defended civil liberties at home and abroad, condemning fascism in Europe and racism in America. The academy was formerly an orphanage, the Saint Francis Home for Boys, sited on 19 acres of land donated by Henry Ford.

203

204

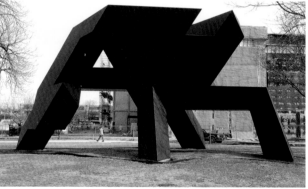

205 *Gracehopper*. Tony Halee Smith, 1972. Situated on the North lawn of the Detroit Institute of Arts, measuring 46 feet in length, 23 feet wide and 27 feet tall. Smith, one of the pioneers of the American minimalist movement, named it for a mythical beast appearing in James Joyce's *Finnegan's Wake.*

Detroit Institute of the Arts (DIA). Paul Phillipe Cret, 1927. Founded in 1883, the DIA is one of the largest municipally-owned museums in the United States. The museum has one of the best collections of American and European paintings in the world. The armor collection of William Randolph Hearst flanks the grand court.

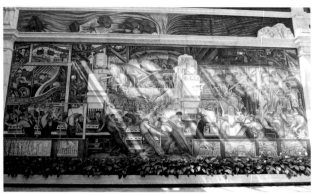

206–208 The *Detroit Industry* fresco cycle. Diego Rivera, 1932–33, DIA. In 1932, Edsel Ford commissioned Diego Rivera to paint the 27 murals that line the garden court of the DIA. From the start, the commission was controversial, with questions as to why a Mexican artist with Communist ties had been chosen over an American in the midst of the Great Depression. Rivera was given only one constraint: that the work must relate to the history of Detroit and the development of industry. When unveiled a year later, the monumental work brought shock waves with its depictions of workers of different races—white, black and brown—working side-by-side and nude figures that were labeled as both pornographic and blasphemous. A *Detroit News* editorial called the murals "coarse in conception...foolishly vulgar...a slander to Detroit workmen...un-American." The writer wanted the murals to be destroyed. Edsel Ford, patron of the murals, never publicly responded to the outcry. He only issued a simple statement: "I admire Rivera's spirit. I really believe he was trying to express his idea of the spirit of Detroit." This is the only remaining large-scale Rivera mural in the United States.

208 Portrait of Henry Ford. Detail, *Detroit Industry* mural by Diego Rivera, 1932–33. Detroit Institute of the Arts.

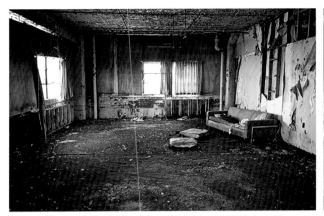

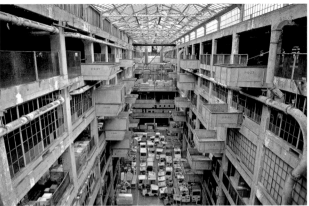

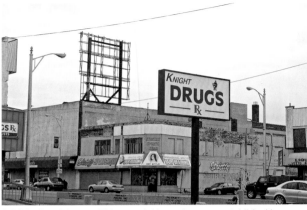

209 Highland Park Plant. Albert Kahn Associates, 1913. Before this plant was built, its 180-plus acre site was home to the Highland Park Club horse-racing track. What would become a major industrial city was largely farmland at this time, just entering the process of development to receive the northward growth of Detroit. Henry Ford and architect Albert Kahn walked the race track site and discussed plans for a building that would change the way cars were manufactured. Kahn extensively employed the reinforced concrete structural system here that had been first developed at the Packard Plant. The expansive steel sash windows that flooded the production floors with light caused the initial plant complex to be called the "Crystal Palace." In 1913, Ford introduced the continuously-moving assembly line here, a revolutionary change that shifted automobile making into the paradigm of modern mass production. This required many laborers to remain in place while materials came to them on the line, performing repetitive tasks at ever-increasing speeds. The difficulty of this work caused high turnover in a city with many competing industrial job opportunities, prompting Ford to offer a profit-sharing scheme dubbed the "five dollar day" in 1914.

210–212 Highland Park Plant. These craneways received materials on rail spurs and allowed them to be distributed to all floors. Both Ford and his architect conceived of the plant as an efficient means to contain all stages of the production process under one roof. With a multi-story building, this meant that production began on the highest floor and mate-rials flowed both laterally and vertically down through the building, with the completed product emerging on the lower level. This process would be further refined at Ford's River Rouge Plant, where single-story structures and miles of conveyor would remove the need to hoist materials in this way.

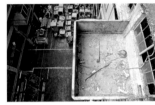

211

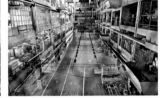

212

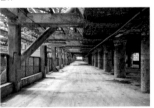

213

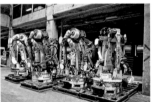

214 Retired robots.

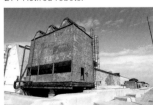

215

217 Woodward Avenue. This remarkable roadway was established by the city plan of Augustus Woodward following the devastating Detroit fire of 1805. He envisioned a new city organized by radial avenues converging at civic centers; an approach deeply indebted to L'Enfant's 1791 plan for Washington D.C. Woodward's vision was substantially realized in the building of Michigan, Grand River and Gratiot Avenues and the central Woodward Avenue, all of which converge at Campus Martius. Woodward Avenue was a major corridor for carriage and streetcar traffic in the nineteenth century, and home to many churches and elite residences. It was ill–equipped for the introduction of automobile traffic in the twentieth century and was adapted to this purpose over several decades. The first mile of concrete paving was poured on Woodward Avenue just north of Ford's Highland Park Plant between Six and Seven Mile Roads in 1908. The rest of its twenty-seven miles were paved beginning in 1916 and in 1919 the three-color traffic light was introduced. While its status as the city's major traffic artery has since been overshadowed by grade-separated highways, Woodward remains the central civic and commercial corridor of Detroit.

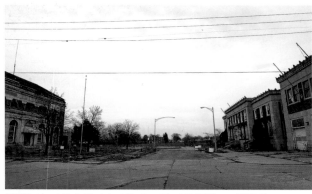

218 Highland Park Municipal Center. Albert E. Williams, 1917. The city's original police station, fire department headquarters and municipal building are vacant, but remain standing today at Woodward Avenue and Gerald Street. The structures are clad in brick and designed with the symmetry and classical detailing associated with early twentieth century Beaux Arts civic architecture. Constructed in the latter half of the 1910s, these structures became the center of government services for the newly-incorporated city of Highland Park in 1918. Even as these structures were being erected, Henry Ford had already determined that his Highland Park Plant was obsolete. The movement of Ford operations to the new Rouge River plant in Dearborn was inevitable, and a decade-long withdrawal of operations from Highland Park began.

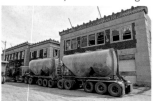

219

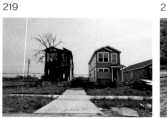

221

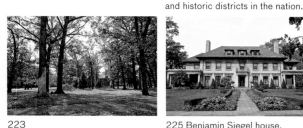

223

220 Ferris Street.

225 Benjamin Siegel house. Albert Kahn Associates, 1914.

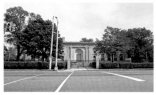

226–227 McGregor Library. Tilton and Githens with Burrowes and Eurich, 1926. This public library presents a symmetrical limestone facade with classical motifs to Woodward Avenue, exhibiting the prosperity that automobile production brought to Highland Park in the early twentieth century. Today, the library is closed due to financial constraints.

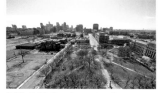

228–229 Southern view from the roof of the Masonic Temple.

231–233 Masonic Temple. George D. Mason, 1928. The structure is clad in limestone and expresses the Gothic style. Its fourteen-story Ritual Building is ornamented with eight carved figures on its turrets, and armored knights who guard the traditions of the Masonic Order.

222–225 Boston-Edison historic district. Located in the geographic center of Detroit on 256 acres, it consists of about 900 homes and is one of the largest residential and historic districts in the nation.

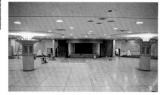

232

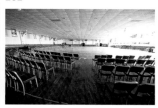

233

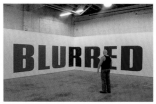

235–236 The Museum of Contemporary Art Detroit. Albert Kahn Associates, 1917. MOCAD was established in 2006 in a former Dodge showroom. (*Blurred* by Kay Rosen).

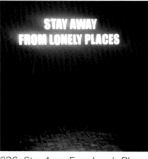

236 *Stay Away From Lonely Places* by Ron Terada.

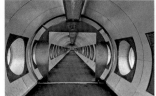

237 Cobo Center connection to Joe Louis Arena. Giffels and Rossetti, 1979.

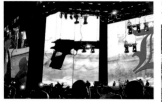

238–241 Eminem/Jay-Z Concert. Comerica Park, 2009.

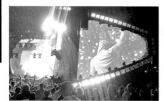

239

240

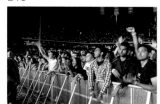

241

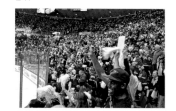

242–243 Joe Louis Arena, Detroit vs. Phoenix hockey playoff game, 2009.

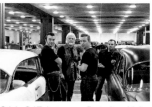

244–247 Autorama Detroit, which began in 1953 as a fundraiser for the Michigan Hot Rod Association, is now part of an exhibition series featuring custom-built hot rods.

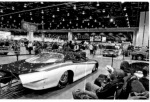

245

246

247

470

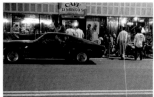

248–249 Cafe D'Mongo's Speakeasy.

250 Roast restaurant, Book Cadillac Hotel.

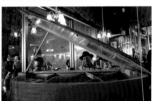

251–253 Cafe D'Mongo's Speakeasy.

253 Cary Loren and John Sinclair.

254–255 Magic Stick.

255

256 The Gaelic League of Detroit Police Benefit.

257

258–259 The Old Miami.

260–261 The Stone House Bar.

261

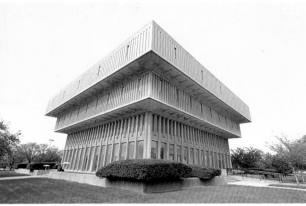

263–269 Wayne State University. Shapero Hall. Paulson, Gardner and Associates, 1965. Wayne State University was founded in 1868. Today, the main campus comprises over 100 buildings, many amongst Detroit's most architecturally significant. It is located on 203 acres in the cultural center. Minoru Yamasaki and Associates and Sasaki Associates updated the campus plan in 1954.

264 Education Building. Minoru Yamasaki, 1960.

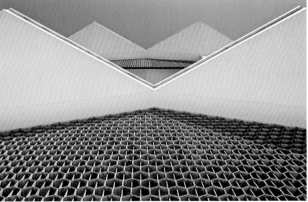

265–269 McGregor Conference Center. Minoru Yamasaki, 1958. The project is sited on the campus of Wayne State University. It is a memorial to Detroit philanthropists Tracy and Katherine McGregor, integrating a two-story structure with a sunken garden and reflecting pool. A V-shaped precast concrete roof sets a triangular motif repeated throughout the project, and the building's rich materiality includes end walls faced in travertine and interior doors of teak.

266–267

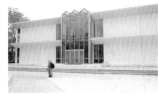

268

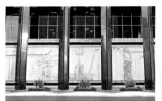

269

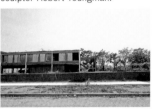

271 West Lafayette Boulevard. Louis G. Redstone Associates, 1971. Twenty concrete panels by sculptor Robert Youngman.

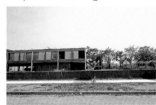

272–273 Midland School.

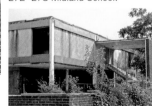

273

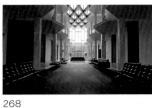

270 Henry Ford Hospital Parking Structure. Albert Kahn Associates, 1959. Twisted precast concrete panels span each floor of this structure creating a dynamic screen.

274 Motor City Casino and Hotel.

275 Leo Gillis Geodesic Dome House. Gillis is the brother of The White Stripes' Jack White.

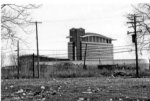

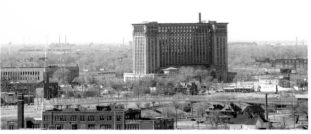

276–282 Michigan Central Railroad Station, known as Roosevelt Park. Warren and Wetmore, and Reed and Stem, 1913. This 1913 station replaced an earlier downtown station built in 1883. To the north it hides a vast landscape of commercial rail tracks. The station was a critical through-point for shipping between distant markets, as well as a gathering and switching point for industrial materials and products circulating in Detroit. The station is sited one and a half miles from the city center, a site chosen to align the station with the rail tunnel to Canada completed in 1910. Exemplary amenities for travelers' comfort were included in the structure, such as restaurants, baths and a reading room, perhaps due to the station's distance from downtown hotels. Hundreds of framebuilt, working-class cottages, part of the Corktown neighborhood originally established by Irish immigrants, were demolished to make way for the station and park. Michigan Central has been closed since the late 1980s.

The opening sequence of Godfrey Reggio's *Naqoyqatsi* featured the building's magnificent tower. It is currently being used for film and photography shoots.

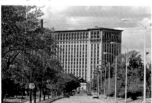

278–279

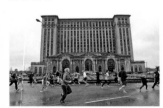

282

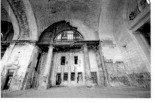

280

281

283 View to the East.

285

287 Bandshell, Michigan State Fairgrounds.

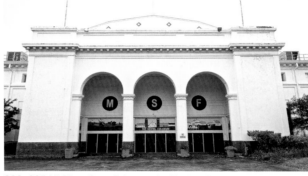

288–295 Michigan State Fair grounds. The first fair was held in 1849 and the event was moved to this site at the northern edge of Detroit in 1904. At the height of its popularity in 1966, one million people attended the Fair, though attendance was down to less than a quarter of that by 2009. The Fair was cancelled due to financial constraints in 2010 after 161 years of operation.

289

292

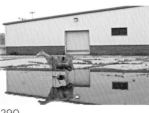

290

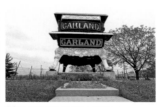

293 A 15-ton Garland Stove replica built for the 1893 World's Fair in Chicago. Garland stoves were manufactured in Michigan from the late 1800s through 1955.

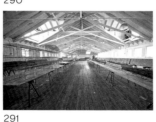

291

294 Ulysses S. Grant House, 1847. The only U.S. president to have lived in the Detroit area. The completed house was moved from near Fort Wayne to its present site at the Michigan State Fair Grounds in the 1950s.

295

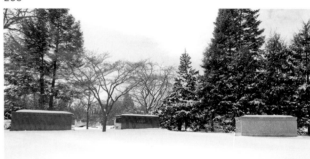

296–297 Ford family graves at Woodlawn Cemetery, 1895. Left: Edsel Bryant Ford 1893–1943, Eleanor Lowthian Clay Ford 1896–1967. Center: William Clay Ford, Martha Firestone Ford. Right: Benson Ford 1919–1978, Edith McNaughton Ford 1920–1980. The 140-acre cemetery has attracted some of Detroit's most notable names from business, government and entertainment. Members of the Ford and Dodge families, Detroit mayors Albert Cobo and James Couzens, civil rights leader Rosa Parks, and entertainers such as David Ruffin, the lead singer of the Temptations, Levi Stubbs, the lead singer of the Four Tops and the rapper DeShaun Dupree "Proof" Holton are buried at Woodlawn.

West

299

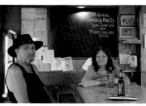

304 Ronald R. Moritz Memorial Hall.

312

305

313

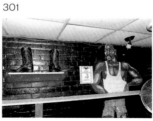

300–303 The R&R Saloon. This gay bar opened in 1977 and operates under the motto "Be Who You Are at the R&R."

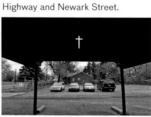

306–307 Graffiti at Vernor Highway and Newark Street.

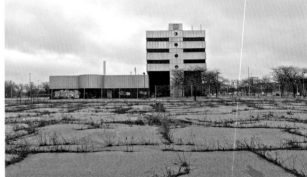

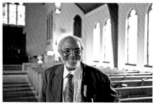

309–313 Calvary United Methodist Church.

301

302

310 Jacob Eddy.

314–317 Southwest Detroit Receiving Hospital. Eberle M. Smith Associates, 1975, closed in 1991. Aluminum was chosen for the building's facade to resist the industrial fumes omitted from nearby buildings. This African-American owned and operated hospital opened with the merging of four smaller institutions.

316

303

311

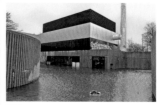

317

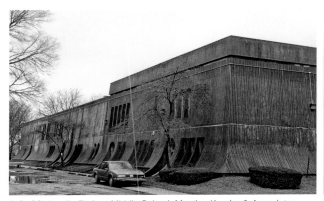

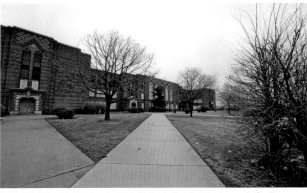

326

319

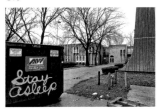

321

318–321 Amelia Earhart Middle School. Meathe, Kessler & Associates, 1964. The building was celebrated by *Architectural Record* in 1967 for its unique organization, which surrounds a large central structure with separate classroom clusters to provide environments for more personalized instruction. The central structure is expressed by the heaviness of its deep and sloping concrete walls, while the surrounding satellite classrooms were clad in lighter, panelized concrete. The school was sited to face the generous 30-acre Clark Park to the west, and less fortunately abutted the Fisher Freeway to the south. Amelia Earhart was demolished in 2010.

323–326 David Mackenzie High School. Smith, Hinchman & Grylls, 1928. Additions in 1929, 1931, 1939 and 1951. It is designed in a style described by one historian of the school as "modern American," clad in red brick with glazed tile ornamenting the doorways and cornice. The city's population had grown from the thirteenth-largest in the nation in 1900 to an incredible fourth-largest by 1920. The incremental expansion of Mackenzie High School illustrates the challenges these institutions faced in growing to meet rising populations and to serve what had become a major American city. In Mackenzie's early days, before the gym and auditorium were constructed, school dances were held in the corridors. Prior to the addition of its cafeteria facilities, lunch was prepared at the nearby Cooley High School facility and transported in thermos-type containers. The school was named in honor of David Mackenzie who had died just two years before its opening. Mackenzie was principal of Detroit's Central High School and founding dean of The City College that developed there, later to be integrated into Wayne State University.

324

325

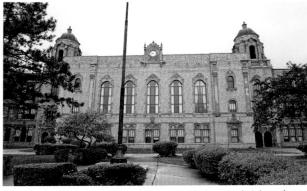

327 Cooley High School, 1928. Cooley extensively expanded thereafter as it was the first institution in its neighborhood to offer a complete secondary education. Along with Mackenzie High School, Cooley served the growing northeast neighborhoods of the city following the annexation of that territory earlier in the decade. It was named in honor of Thomas M. Cooley, a nineteenth century Justice of the Michigan Supreme Court who was known to have "fathered secondary education in Michigan," establishing the legal means for districts to develop high schools.

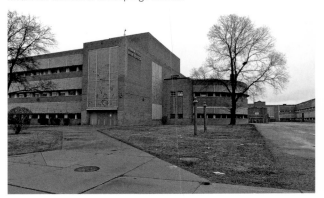

328 Frank Cody High School, 1952. Though the school opened initially in 1952, it was substantially complete in 1955 at a cost of $5.6 million. It was constructed on the site of the Everett Elementary School, together forming a large U-shaped complex. The school was named in honor of the late Dr. Frank Cody, long-serving superintendent of schools in Detroit and first president of what is today Wayne State University. At its opening, the curriculum included the full range of academic subjects and an emphasis on vocational specialties, including drafting, shop math, industrial arts and home science. In the 1950 census Detroit reached its height of population at over 1.8 million residents, and was the fifth-largest American city. In the decade to follow, Cody's district grew phenomenally and the school became overcrowded with an enrollment of 4,000.

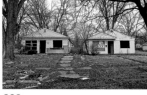

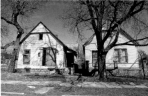

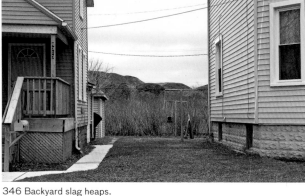

329 Saint Casimir statue outside Saint Hedwig Church, 1882. Saint Casimir was the first Catholic parish to serve the Polish community on Detroit's west side. Polish immigration to Detroit was bolstered in the following decades by expanding industrial work opportunities, and Saint Casimir became the mother church for a constellation of new Polish parishes. Saint Francis D'Assisi was the first off-shoot in 1889, and then Saint Hedwig followed in 1903. Our Lady Queen of Angels was established in 1915, Saint Stephen in 1920, and finally Saint Cunegunda in 1927. A patchwork of other ethnic-affiliated Catholic parishes emerged in Detroit alongside these Polish communities. Irish Detroiters established Most Holy Trinity, while Saint Boniface served Germans and Saint Nepomucene, just east of Polish Saint Casimir, served Detroit's Czechs.

338

340

339

341

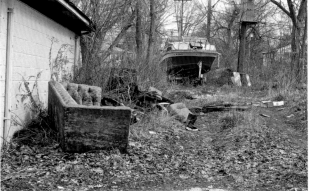

346 Backyard slag heaps.

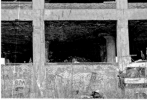

347 Playground below I-94.

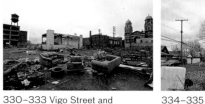

330–333 Vigo Street and Wesson Avenue.

334–335

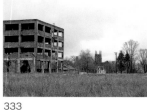

332

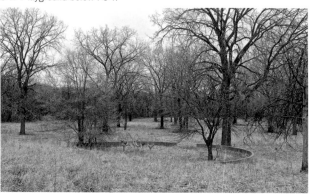

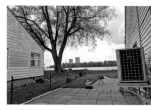

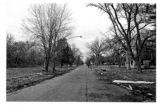

336

337

333

342 Brightmoor neighborhood. B.E. Taylor, early 1920s, annexed by the city of Detroit in 1926. Its homes were built to accommodate the families of laborers migrating to Detroit for work in the auto industry. Today, the neighborhood struggles with rates of poverty and vacant property higher than the Detroit average. Brightmoor contains a significant number of homes slated for demolition under current Mayor Dave Bing's Neighborhood Stabilization Program, "in an effort to reduce blight and eliminate potential hot spots for crime."

343

345 Enrico Fermi Nuclear Generating Station.

348–349 Eliza Howell Park. Land for this 138-acre park was donated to the city by real estate developer Eliza Howell in 1936. After years of neglect and a recent controversial attempt by Howell's grandson to retake possession of the land, grassroots efforts to clean up the park have been undertaken.

344

350 Redford Community Art Project: *The Detroit Dream Project, Temple of the American Dream.*

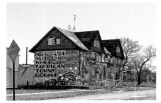

351 MBAD African Bead Museum.

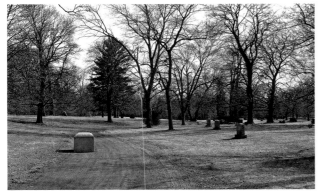

352–353 Grand Lawn Cemetery.

353 Male and female coffins.

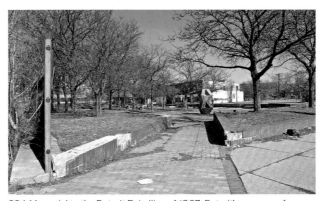

354 Memorial to the Detroit Rebellion of 1967. Detroit's was one of several riots that occurred in 1960s urban America along with Los Angeles, Philadelphia and Chicago. The violence in Detroit emerged within a charged social atmosphere of anger over long-standing employment and housing discrimination and mistrust of the city's disproportionately white police force. The riot was sparked when police officers raided a "blind pig" on Twelfth Street in the early morning of July 23, 1967. Looting and violence spread widely and continued for several days. A large force of city and state police along with National Guard troops were amassed in the city to restore order. In all, forty-three people died, thirty-four of whom were killed by armed officials.

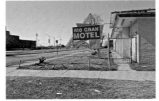

355 Eighth district Detroit police precinct.

357

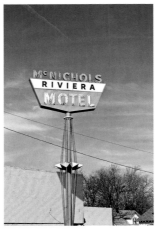

356

358 Three memorials, Lyndon and Wyoming Streets.

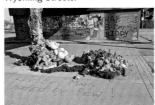

359 Memorial, Fort Street and Schaefer Highway.

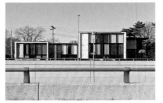

360–361 James Couzens Plaza.

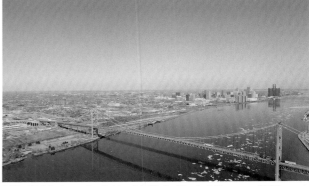

362–364 Ambassador Bridge. McClintic-Marshall Company, 1929. This two-mile-long suspension bridge over the Detroit River connects Detroit to Windsor, Ontario. When it was completed, it was the world's longest suspension bridge. With more than 10,000 vehicles crossing each weekday, the bridge is a critical link connecting the industrial economies of southeast Michigan and Ontario. The bridge is owned by an individual, Manuel "Matty" Moroun.

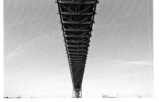

364 Ambassador Bridge.

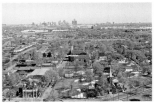

365 Delray churches.

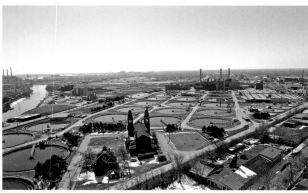

366 Delray is an industrial neighborhood that is thought to be the most affected by pollution in the city of Detroit. To combat this pollution, the Detroit Water and Sewage Department was established in 1972 when Congress passed the Clean Water Act. The Delray plant is one of the nation's largest, providing water to more than 4 million people, which is over forty percent of Michigan's population, and processes sewage for more than 3 million people. Also within Delray stands Saint John Cantius Catholic church. JG Steinbach, 1923. Hosting a parish largely made up of Polish immigrants, the church held its final mass in 2007. In 2009, artist Matthew Barney used the interior of the church to film *Khu Prologue, Act 2, Ancient Evenings*.

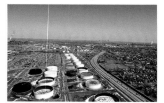

367 Marathon Oil tank farm.

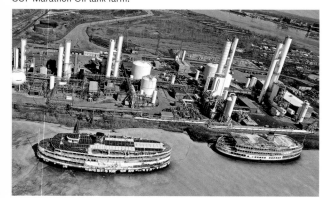

368–69 Bob-Lo Boats (foreground), U.S. Steel Ecorse Oxygen Plant (background). Two steam boats, the *Saint Claire* and the *Columbia*, ferried Detroiters to the amusement park at Bois Blanc or "Bob-Lo" Island for nearly a century. The park closed in the early 1990s and today presents a mixed legacy. It is recalled in the countless fond memories of those children who were taken there for special occasions, but it is remembered less nostalgically for a policy of refusing access to African-Americans in the 1940s.

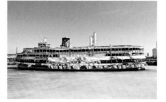

369

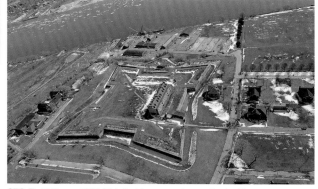

370 Fort Wayne, 1851. This fort has never been attacked by enemy troops. The fort is named for celebrated Revolutionary War hero General Anthony Wayne. It is sited on a bend in the Detroit River, a strategic control point for the Great Lakes system of waterways and a defensive position against feared attack from Canada. Michigan troops were mobilized at Fort Wayne during the Civil War and it was used as a garrison during World War I. In 1937, an extensive $3 million restoration of the fort's walls, roads and barracks was undertaken by the Works Progress Administration. The site was expanded to serve as a warehousing point for military vehicles and spare parts through the end of World War II, and in 1949 the original star-shaped fort was turned over to the City of Detroit's Historical Commission.

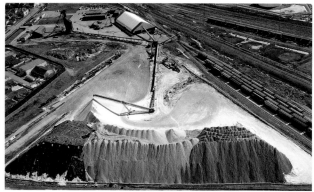

371 Detroit Salt Company. Since the late nineteenth century an extensive underground salt mine has operated 1,200 feet below southwest Detroit, Melvindale and Allen Park. For decades it was the largest rock salt producer in the U.S., with over 100 tunneled miles. Originally, the mine provided salt for cattle licks and ice cream making. In 1940, Detroit became one of the first major cities to use rock salt for snow and ice control on roadways.

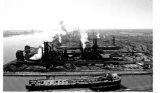

372–373 Limestone and coal.

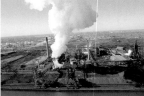

374–380 Zug Island is situated at the confluence of the Rouge and Detroit rivers where its wharves receive iron ore from Great Lakes freighters. A Native American burial ground for centuries, Zug Island, measuring at about 600 acres, became home to iron making in 1901. Its first two blast furnaces were reportedly the largest in the world. Zug Island's proximity to Ford's River Rouge Plant was critical to its growth. U.S. Steel continues production today and its manufacturing operations entirely occupy the island.

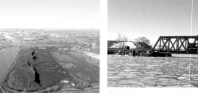

376 Zug Island at the Rouge River.

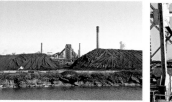

377 Zug Island coal piles.

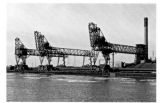

378 Zug Island, U.S. Steel.

379

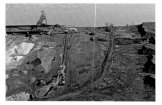

380 Zug Island. A steam plume is generated every 20 minutes during the coke-quenching cycle where it is heated without oxygen then cooled with a water spray.

381 Zug Island, iron ore.

382 Counterweighted drawbridge at Saint Mary's Cement, Detroit Plant.

383 Zug Island drawbridge. The series of drawbridges were designed to allow the industrial operations on and around Zug Island to be accessed both by rail and by river-going freighters.

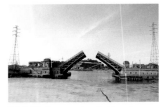

384 Dix Avenue drawbridge. In the early 1920s the Rouge River was dredged and drawbridges were constructed to allow freighters to access the Rouge Plant.

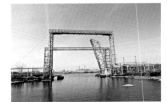

385 Pipe trestle over the Rouge River.

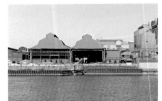

386 U.S. Steel.

387 Saint Mary's Cement, Detroit Plant.

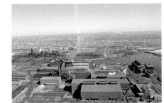

388–389 Rouge River plant.

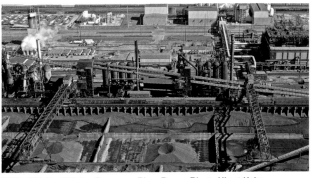

390–391 Ford Motor Company, River Rouge Plant. Albert Kahn Associates, 1917–27. The plant is regarded as Kahn's greatest achievement in industrial architecture. The Rouge complex illustrated a major advancement in Ford's drive toward vertically integrating the auto manufacturing process. Power, glassmaking, plastics, cement, steel plants, and a paper mill, as well as the full range of major production and finishing facilities were coordinated here at a single site. This, along with its vast size, made the plant's development a significant moment in the global history of the industry. The Rouge Plant housed the flow of materials and production across many single-story structures, gradually replacing Ford's less-efficient, multi-story Highland Park Plant. The powerful forms of its smokestacks, conveyors and rail tracks inspired the photography and painting of artist Charles Sheeler, becoming a symbol of the industrial strengh of the country. At its peak in the 1930s, the plant employed over 100,000 workers. Today, the complex continues to manufacture vehicles. The steel production is now owned by Russian-owned Severstal Steel North America. They have invested in excess of $1 billion, replacing a blast furnace and building a cold finishing plant.

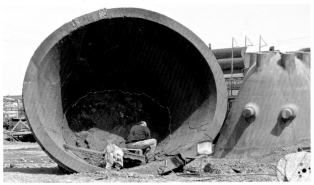

392 Edw. C. Levy slag pot at Severstal Steel North America. Levy was contracted by Ford in the 1920s to process slag, the byproduct of steel production, at the Rouge Plant. Each slag pot carries 45 tons of slag. Edw. C. Levy Co. went on to sell slag as a base material for road paving and many other industrial uses.

393 Severstal Steel North America. Basic oxygen furnace and steelmaking shop for filling slag pots. Edw. C. Levy Co. has serviced steel production at the Rouge Plant for over 90 years. It invented a vehicle in 1965 that hauls molton material at 2,800 degrees, increasing productivity by rapidly transporting steel from the blast furnace.

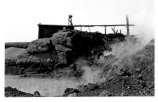

394 Slag pit at Severstal Steel North America.

395 Slag pit at Severstal Steel North America.

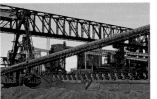

396–397 Ore bridge and conveyor. Raw materials handling and processing at Severstal Steel North America.

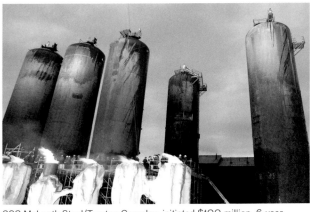

398 McLouth Steel/Trenton Complex: initiated $100 million, 6-year construction project on the riverfront in Trenton. It opened in 1954 as a fully-integrated steel mill and became the first plant in North America to make steel via the basic oxygen process. Several expansions of the plant were undertaken in the late 50s and 60s, including a major expansion in 1958. The plant closed in 1996 and sold to the Detroit Steel Corporation. After several failed start-up attempts, the Trenton complex stands vacant today. Matthew Barney and Jonathan Bepler used the decommissioned plant for their *Khu* performance in 2010.

399 *Khu*.

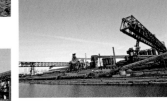

400

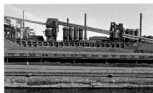

401 A furnace designed in 1920.

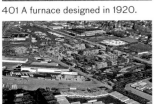

402 Southern Street looking north.

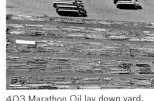

403 Marathon Oil lay down yard.

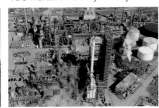

404–405 Marathon Oil refinery.

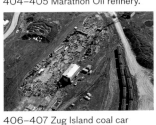

406–407 Zug Island coal car delivery from West Virginia.

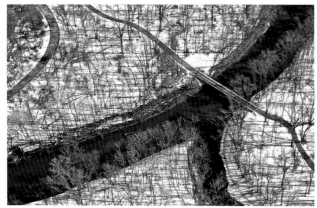

408–409 The Rouge River in winter. It totals 126 miles in length through 48 municipalities and flows into the Detroit River at Zug Island.

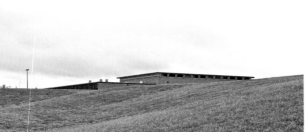

410 River Rouge Park. The largest park in Detroit, measuring 1,184 acres, it is forty percent larger than New York's Central Park. River Rouge Park follows the waterway for which it is named, as it runs across the far west side of Detroit. The city originally procured land for the park in the 1920s as its neighborhoods were expanding westward.

411 Parkview Manor Apartments.

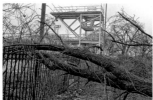

414

412–413 Parkview Manor.

415

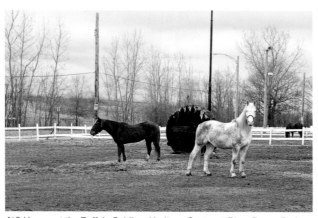

416 Horses at the Buffalo Soldiers Heritage Center at River Rouge Park. The land and barn were formerly the home of the disbanded Detroit Police Mounted Unit. The center celebrates the history of the Buffalo Soldiers, all African-American regiments used in the American West and the Spanish-American Wars. Five Buffalo Soldiers were awarded the Congresssional Medal of Honor.

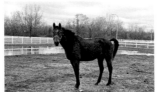

417

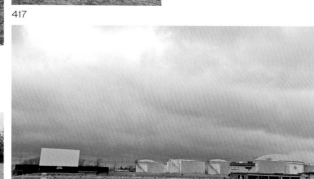

418–419 The Ford-Wyoming Drive-In theatre in Dearborn, 1950. It claims to be the largest drive-in theatre in the world, opening during a period of rising popularity for the drive-in theatre form. Most of these theatres, icons of mid-century car culture, have long closed but the Ford-Wyoming has persevered. Today the theatre operates five screens and shows films throughout the evening until early morning, attracting a niche market of late-night filmgoers.

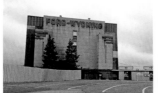

420

421

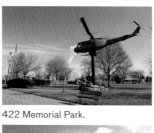

422 Memorial Park.

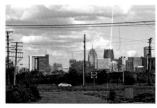

424–425 Northern view of downtown Detroit.

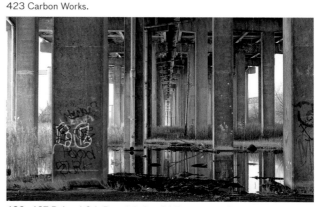

423 Carbon Works.

426–427 Below I-94, Detroit Industrial Expressway. Detroit's landscape has been transformed thoroughly by the cutting of highways through its urban fabric, beginning in 1942 with the introduction of the nation's first modern limited-access urban expressway, the Davison. This novel roadway was introduced to alleviate heavy traffic crossing east to west through Highland Park. The 1950s brought the Federal Aid Highway Act, which authorized the construction of 41,000 miles of highway nationwide, and advocates of urban renewal directed thousands of these miles into and through cities. In Detroit, this took the form of freeways I-94, I-96 and I-75, which are joined by state highway M-10, better known as the Lodge Freeway, all four of which converge in downtown Detroit. The extensive demolition of neighborhoods that this required was justified through claims of so-called slum clearance and downtown development, which were ex-ceptionally persuasive to urban governments, commercial interests and highway engineers in an era when suburban expansion threatened the city's economic base.

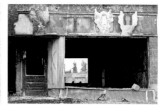

428 Vigo Street and Wesson Avenue.

429 Fort Street.

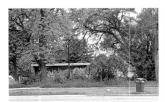

430–431

438–439

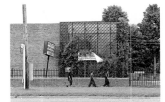

432 Kids Expectations
Learning Center.

441

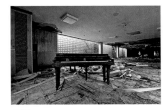

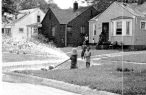

433

445

450

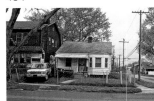

434

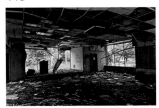

446

451

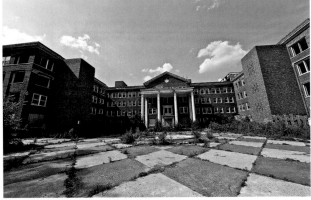

442–443 The Arnold Home, 1931. This large, 268-bed, former nursing
home on Seven Mile Road, closed in recent years and has since been loot-
ed and vandalized. There is little historical information about the structure.
It is referenced as the "Arnold Home for Aged Men" and the "Arnold Home
for the Aged and Incurable," and it is rumored that Aretha Franklin's mother
once lived there.

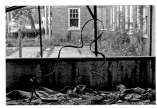

447

H House sing the blues was an incredible
egan a song, he became energized and the ye
. He closed his eyes and the sweat broke ou
rted in a low voice which became louder and
went into a trance and somehow willed hims
and another place. He went to Robinsonville
to Greenville. He went back to 1931 or 1941
place in time. The verses tumbled forth and th
eterminate length...five minutes...ten...fifteen...as
the story to be told. Other blues singers great
ould watch Son House sing the blues and just s
. He was the benchmark of their artistry. He w
ick by which blues singers are to be forever ju
blues singer in the world moves

452–453 Mount Hazel Cemetery.
Mississippi-born blues musician
Son House was buried here in 1988.
His gravestone was inscribed by
the influential blues promoter Dick
Waterman.

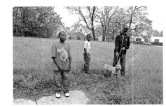

435

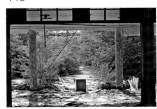

448

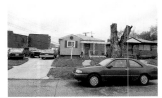

436–437

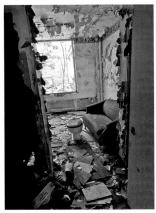

444

449

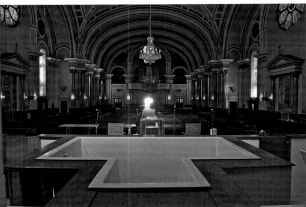

482 Saint Stanislaus Catholic Church. Harry J. Rill, 1889. Known
for the ornate quality of its stained glass and Baroque interior. Today
the building is utilized by Promise Land Missionary Baptist Church.

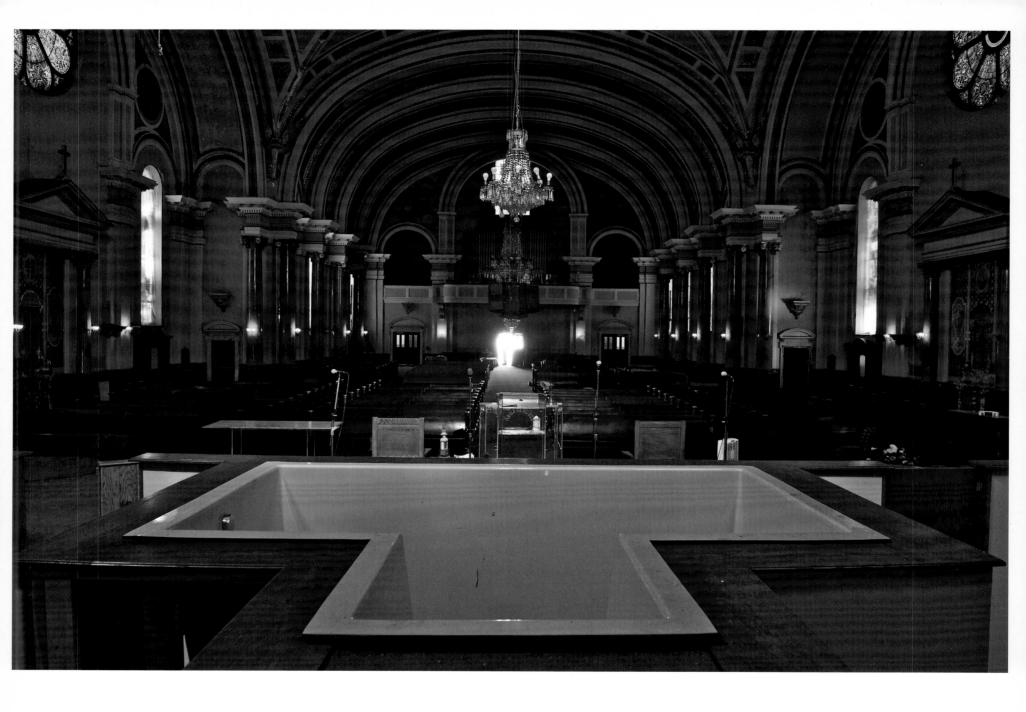

482

BIBLIOGRAPHY

Austin, Dan, Sean Doerr, and John Gallagher. *Lost Detroit: Stories Behind the Motor City's Majestic Ruins*. Charleston, SC: History Press, 2010.

Baulch, Vivian M. "Harry Houdini: Master of Illusion and Escape." *The Detroit News*, October 4, 2000.

Berman, Laura. "Renegade Rehabbers Get Detroit Velodrome Rolling." *The Detroit News*, September 28, 2010.

Board of Education, Detroit (Mich.). *Histories of the Public Schools of Detroit*. 1967.

Boone, Regina H. "Inside Joy Middle School." *The Detroit Free Press*, April 3, 2008.

Bulanda, George. "Rouge Park." *Hour Detroit*, February 2010.

Cousins, Garnet R. and Maximuke, Paul. "The Ceremony Was 61 Years Late." *Trains*, September 1978.

Cousins, Garnet R. and Maximuke, Paul. "The Station That Looks Like a Hotel." *Trains*, August 1978: 41-48.

Ferry, W. Hawkins. *The Buildings of Detroit: A History*. Rev. ed. Detroit: Wayne State University Press, 1980.

Ferry, W. Hawkins. *The Legacy of Albert Kahn*. Detroit: Wayne State University Press, 1987.

Gavrilovich, Peter, and Bill McGraw. *The Detroit Almanac: 300 Years of Life in the Motor City*. Detroit, Mich.: Detroit Free Press, 2000.

Goble, Emerson, Editor. "School Design Must Keep Pace with Educational Innovation." *Architectural Record*, March 1967: 167-86.

Godzak, Roman. *Make Straight the Path: A 300-Year Pilgrimage: Archdiocese of Detroit*. Strasbourg, France: Éditions du Signe, 2000.

Guiney, Anne. "The Light Box: P/A Award-Winner Andrew Zago Builds a Luminous Pavilion in a Detroit Park." *Architecture 90*, no. 8 (2001): 78-81.

Hersey, John. *The Algiers Motel Incident*. Baltimore, Md.: Johns Hopkins University Press, 1998.

Hill, Eric, John Gallagher, and American Institute of Architects. Detroit Chapter. *AIA Detroit: The American Institute of Architects Guide to Detroit Architecture*. Detroit: Wayne State University Press, 2003.

LeDuff, Charlie. "Frozen in Indifference." *The Detroit News*, January 28, 2009.

MacDonald, Christine. "Developer Wants Family's Gift Back from Detroit." *The Detroit News*, November 18, 2009.

Marzejka, Laurie J. "Detroit's Historic Fox Theatre." *The Detroit News*, January 25, 1998.

Meyer, Stephen. *The Five Dollar Day: Labor, Management, and Social Control in the Ford Motor Company, 1908–1921*, Suny Series in American Social History. Albany: State University of New York Press, 1981.

Nasar, Moffat. "The Heidelberg Project-Detroit, Michigan." *Places 16*, no. 3 (2004): 14–17.

Program, Urban + Regional Planning, and Taubman College of Architecture + Urban Planning. "A Land Use Plan for Brightmoor." (2008).

Renner, Christine, Patricia Reed, and Michael E. Crane. *The Scarab Club, Images of America*. Chicago, IL: Arcadia, 2006.

Smith, Terry. *Making the Modern: Industry, Art, and Design in America*. Chicago: University of Chicago Press, 1993.

Waldheim, Charles. Case--Hilberseimer/Mies Van Der Rohe, Lafayette Park Detroit, Case Series. Munich; New York [Cambridge, Mass.]: Prestel; Harvard University Graduate School of Design, 2004.

Writers' Program. (Mich.). *Michigan, a Guide to the Wolverine State*, American Guide Series. New York: Oxford University Press, 1946.

Zacharias, Patricia. "The Ghostly Salt City beneath Detroit." *The Detroit News*, January 23, 2000.

Zunz, Olivier. *The Changing Face of Inequality: Urbanization, Industrial Development, and Immigrants in Detroit, 1880–1920*. Chicago: University of Chicago Press, 1982.

ACKNOWLEDGMENTS

Julie Reyes Taubman

When I moved to Detroit in 1999 from New York City, one of the first things I did was research Jimmy Hoffa's disappearance. Then I explored the campus of Cranbook. I knew that Cranbrook was considered to be one of the greatest architectural campuses in the world. I wanted to know it. I wanted to understand how architecture could be shaped by a particular vision, how it could influence people and create a place that was universally accepted as "great." On my first visit, I was awed by this masterpiece and felt a deep connection. Why hadn't it been a required pilgrimage for every high school student in the country?

How amazing, I thought, my two favorite buildings—an airport terminal and an office tower were designed by Eero Saarinen a half-mile away from my new home.

In retrospect I have always felt connected to architect Eero Saarinen. Growing up in Washington, D.C., Dulles Airport was a weekly journey for me and a brother or two, late at night, sleeping in my mom's car to pick up my dad from a West Coast flight. My mom would wake all of us in the car when we got to the Dulles Toll Road—landscape architect Dan Kiley's brilliant approach to our emerald city of the Saarinen-designed airport. That approach and that building always thrilled me.

I can hear the announcements and the flaps of the changing flight numbers. I remember my mom parking next to the curb at arrivals, sometimes napping while we tried to climb the terminal's concrete sloping walls inside and out, often for hours. It never mattered how long my dad's flight was delayed because the building was exhilarating.

Later, when I lived in New York, I worked in Black Rock, Saarinen's magnificent—and only—skyscraper. I reveled in each of the building's details. I began to recognize that the spaces that Eero designed always appeared original and well-considered, better than any I had ever seen.

Now living in suburban Detroit, I had the chance to study the genius of the whole Saarinen family: the father Eliel, mother Loja, sister Pipsan and son Eero, who changed the very nature of design in America. Eliel designed the buildings and interiors of Cranbrook, and his family designed many of the parts. Eliel was head of Cranbrook Academy of Art, where Eero taught and so many others worked or studied. The great furniture designers—The Eames, Florence Knoll, Harry Bertoia—all had roots in the Academy, as did such other gifted artists, designers and architects' people like Marc Awodey, Edmund Bacon, Peter Bohlin, Chunghi Choo, Richard DeVore, Niels Diffrient, Ed Fella, Paul Granlund, Leza McVey, Frederic James, Jeffery Keedy, Walter Hamady, Duane Hanson, Jack Lenor Larsen, Daniel Libeskind,

P. Scott Makela and Laurie Haycock Makela, Fumihiko Maki, Fred Mitchell, Gyo Obata, Ralph Rapson, Bernard Rosenthal, Joseph Allen Stein, Toshiko Takaezu, Lycia Trouton, Harry Weese, Lorraine Wild, and Anne Wilson.

My first winter, I shoveled the snow away from Eero's gravestone. It could have been anybody's grave.

Gradually my fascination turned from the suburbs to the City. It was not my intention to spend years researching and understanding Detroit. I have taken almost 40,000 pictures of the City. This project has been the most exciting, gratifying, humbling experience that I will ever hope to have. Detroit is so different from the splendid isolation of Cranbrook. The City oozes with the residue of humanity.

These documentary photographs, which I shot from 2005 thru 2011, demonstrate my belief that it is important for us to allow the buildings and factories decaying in our midst to decompose as they have been: slowly and naturally. It is not a disgrace to listen to the stories only ruins can tell. They tell us a lot about who we were, what we once valued most, and where we may be going.

In "Wakes of Babylon" poet Stephen Vincent Benet laments:
And, little town, thy streets
for evermore will silent be,
And not a soul, to tell why
thou art desolate, can ever be.

We are blessed in Detroit that our streets are not silent. Our town's abandoned factories, train stations, warehouses and school buildings speak to us in ways that demand our attention and respect. It is a privilege to know this place. I hope I've captured even a fraction of its magic.

There are many people to thank for helping create this project and, hopefully, a new perception about Detroit and other cities with buildings that are not occupied.

This book would have looked a lot different without Marsha Miro's dedication and direction. Marsha may be the only person I never question, because her intentions are always pure and her wisdom is boundless. She inspires all who know her, but especially me. Artists are moving to Detroit. Ultimately, Marsha had a part in this change.

I have yet to meet two people who I would rather hang out with than Chuck Flanigan and Marty Siersma. I am not sure if I was safer before or after meeting them. Their knowledge of the east side of Detroit is without equal. I will always be grateful for their experience, thoroughness, and commitment to this project, and mostly, our friendship. We held our own in a room full of toothless beer drinkers; rifles pointed at our heads, survived flat tires, $1 gas station stops, and cars that barely started. These guys cared about the light at Valenti Formal Wear

a lot more than I did when we shot it three times one day. Drinking Polish brandy is not easy. Someone should make a movie about the lieutenant and the landlord.

From the beginning there was Bobcat, Dennis Freedman, Marsha Miro, Marc Schwartz, Cary Estes Leitz, Chris Byrne, Susanne Hilberry and Stuart Parr. You all continue to be the backbone of my curiosity.

Clinton Snider, Mitch Cope, Scott Hocking and Corine Vermeulen, you all are gifted artists and I appreciate your years of help.

Thanks to Mary Anne Drew, Brad Dunning, Bill Massie, Linda Dresner Levy and Edward Levy, Robyn Jacobson, Becky Hart, Reed Kroloff, Michael Stone Richards, Leon Johnson, Kathy Wilson, Julie Leonard, Robin Boyle, Michelle Perron, Phillip Cooley, Brian Siurek, Terry and John Rakolta, Robert Bobb, Kisha Verdusco, Amy Farbman, Claire Zimmerman, the Ambassador Bridge Company, John Arnold, Chris Tennyson, Camille Reyes, Luis Croquer, Elyse and David Foltyn, Kristine McKenna and Matthew Barney.

Robert Fishman and Michael McCulloch, it was a great privilege to learn from you.

Connie and Mickey Ross are heroes for owning and maintaining Ford Highland Park.

Elmore Leonard, I am not sure if it was all the cigarettes we smoked together or maybe that no one else thinks like you do, but I cannot help being madly in love with you.

I admire the way Jerry Herron writes, and most importantly what he says.

Jennifer Calliea quit, but still wanted to see this book completed. She is cool and can do anything.

Detroit is somewhere between 138 and 143 square miles, but Toby Barlow said 138 sounded best. The title is his.

Lorraine Wild, we have worked together so long on this project. I am honored and deeply impacted by how you work, how you see things, and who you are. You have no right to be humble because you are a genius with the best demeanor on the planet. Victor Hu, thank you. The Green Dragon Office of Los Angeles always has such a good vibe.

Bobcat, Al, Go Go, Theo and Sebs, thank you for sustaining my passion for this project in all the ways I needed.

Because of my parents I have never been fearful of exploring.

Refusing the false securities of a stable and linear past, such an approach celebrates heterogeneous sensations and surprising associations, random connections, the ongoing construction of meaning and also admits into its orbit the mysterious agency of artifacts, space and non-humans from the past.

"Industrial Ruins," by Tim Edensor

BIOGRAPHIES

ELMORE LEONARD has written forty-eight books including bestsellers *Road Dogs, Up in the Honey Room, The Hot Kid, Mr. Paradise* and *Tishomingo Blues*, and the critically acclaimed collection of short stories *When the Women Come out to Dance*. Many of his books have been made into movies including, *Get Shorty, Out of Sight* and *Be Cool* and adapted for the movie *Jackie Brown*. He is currently working on the hit TV series for FX *Justified*. The New York Times Book Review wrote, "Elmore Leonard is the greatest crime writer of our time, perhaps ever." He lives in Bloomfield Village, Michigan.

JERRY HERRON is the founding dean of the Irvin D. Reid Honors College at Wayne State University in Detroit. Herron, a professor of English and American Studies, has been resident of downtown Detroit for more than 25 years. As someone who is deeply committed to Detroit, he focuses the Honors first-year course on his diverse metropolitan home and created a cultural passport program that allows first-year students to immerse themselves in Detroit's culture, arts, and attractions. A gifted scholar and teacher, his publications include two books, *Universities and the Myth of Cultural Decline*, and *AfterCulture: Detroit and the Humiliation of History*. His essays and critical articles have appeared in *South Atlantic Quarterly, Raritan, Social Text, Representations, Georgia Review, Antioch Review,* and *Harper's*. He has also written for the *London Times*

Higher Education Supplement, Detroit News, Hour Detroit, the *MetroTimes*, and *Playboy*. He is currently finishing a book about Americans' sense of the past: "Not From Detroit: An All-Purpose Guide to American Forgetting."

ROBERT FISHMAN, PH.D. is a Professor of Architecture and Urban Planning, teaches in the Urban Design, Architecture, and Urban Planning programs at the Taubman College of Architecture and Urban Planning at the University of Michigan. He received his Ph.D. and A.M. in History from Harvard University and his A.B. in History from Stanford University. An internationally-recognized expert in the areas of Urban History, Policy and Planning, he has written several books regarded as seminal texts on the history of cities and suburbs including *Bourgeois Utopias: The Rise and Fall of Suburbia* (1987) and *Urban Utopias in the Twentieth Century: Ebenezer Howard, Frank Lloyd Wright, and Le Corbusier* (1977). His honors include the 2009 Laurence Gerckens Prize for lifetime achievement of the Society for City and Regional Planning History and the Emil Lorch Professorship at the University of Michigan, School of Architecture, 2006–09. He held the Cass Gilbert Professorship at the University of Minnesota, 1998; and visiting professorships at the University of Paris, Nanterre; the University of Pennsylvania; and Columbia University. He is currently working on the history of sustainability.

MICHAEL P. MCCULLOCH, AIA is a doctoral student in Architectural History and Theory at the University of Michigan. His research interest is the history of American cities with an emphasis on the city of Detroit. His current project focuses on Detroit's early twentieth century growth, and he has recently presented this work at the ACSA 2011 Annual Meeting in Montreal and the 7th Savannah Symposium. His essay "Michigan Central Station: Reframing the Narrative of Detroit's Grand Past" was published in the 2011 Taubman College journal *Dimensions 24*. Michael was trained as an architect and urban designer, earning a Bachelor of Architecture degree from the University of Detroit Mercy and a Master of Science degree in Architecture and Urban Design from Columbia University. His professional practice includes work with Albert Kahn Associates, and he has been a registered architect since 2008. He was Assistant Professor of Architecture at Drury University from 2006–09.

JULIA REYES TAUBMAN is a documentary photographer who concentrates on the American urban and industrial landscape. Reyes Taubman is an advocate for artists and the preservation of buildings and art. She is one of the founders of the Museum of Contemporary Art Detroit (MoCAD), where she serves as chairman of the board. She is a current member of the Michigan Council for Arts and Cultural Affairs and was previously a board member at the Rock and Roll Hall of Fame for 8 years. Reyes Taubman is active as an architectural critic and juror at Cranbrook Academy of Art and has been on their board of directors for 10 years.

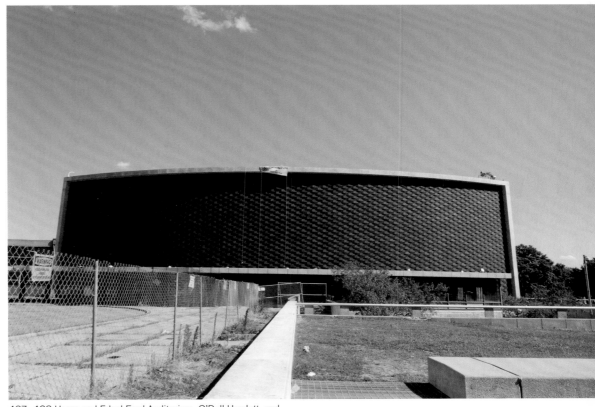

487–488 Henry and Edsel Ford Auditorium. O'Dell Hewlett, and
Luckenbach, 1955. Eliel Saarinen was hired by the city in 1924 and
again, along with his son Eero in 1947, to design a master plan for
the area at the foot of Woodward Avenue. Originally conceived as a
Civic Center, the master plan encompassed multiple buildings including
a City/County building, convention hall, an auditorium and four govern-
ment buildings. Ultimately, only Ford Auditorium and the convention
hall (Cobo Hall) were constructed. The auditorium was a gift of the
Ford family and became the home of the Detroit Symphony Orchestra
for 33 years. Malcolm X delivered his historic "Last Message" speech
here on February 14, 1965. After the symphony left, the building fell
into disrepair. Ford Auditorium was an icon, built in the height of Detroit's
power in 1955. It was demolished in July 2011.

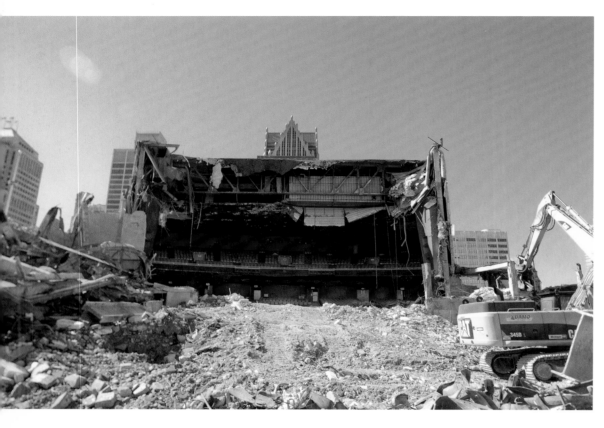

Photographs © Julie Reyes Taubman
All essays © the authors

Designed in collaboration with
Julie Reyes Taubman
by Lorraine Wild with Victor Hu,
Green Dragon Office, Los Angeles

Printed and bound in Germany

First published in 2011 by
Museum of Contemporary Art, Detroit
4454 Woodward Avenue
Detroit, Michigan 48201
www.mocadetroit.org

MO
CAD

Second printing, 2012

ISBN 978-0-9823896-0-7

Available through D.A.P./
Distributed Art Publishers
155 Sixth Avenue, 2nd floor
New York, New York 10013
212.627.1999 p
212. 627.9484 f
www.artbook.com